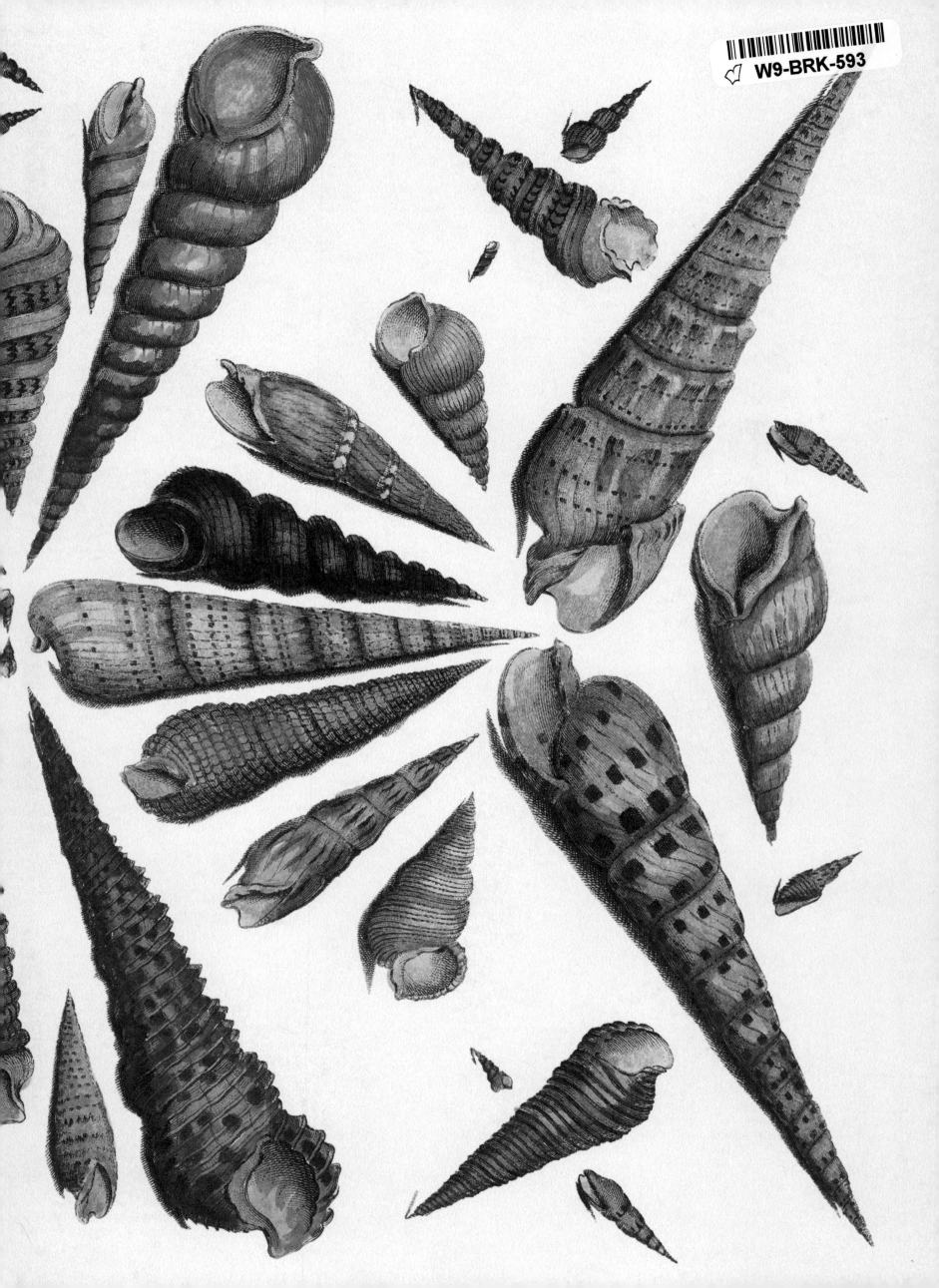

Shells
Muscheln
Coquillages

Antoine-Joseph
Dezallier d'Argenville

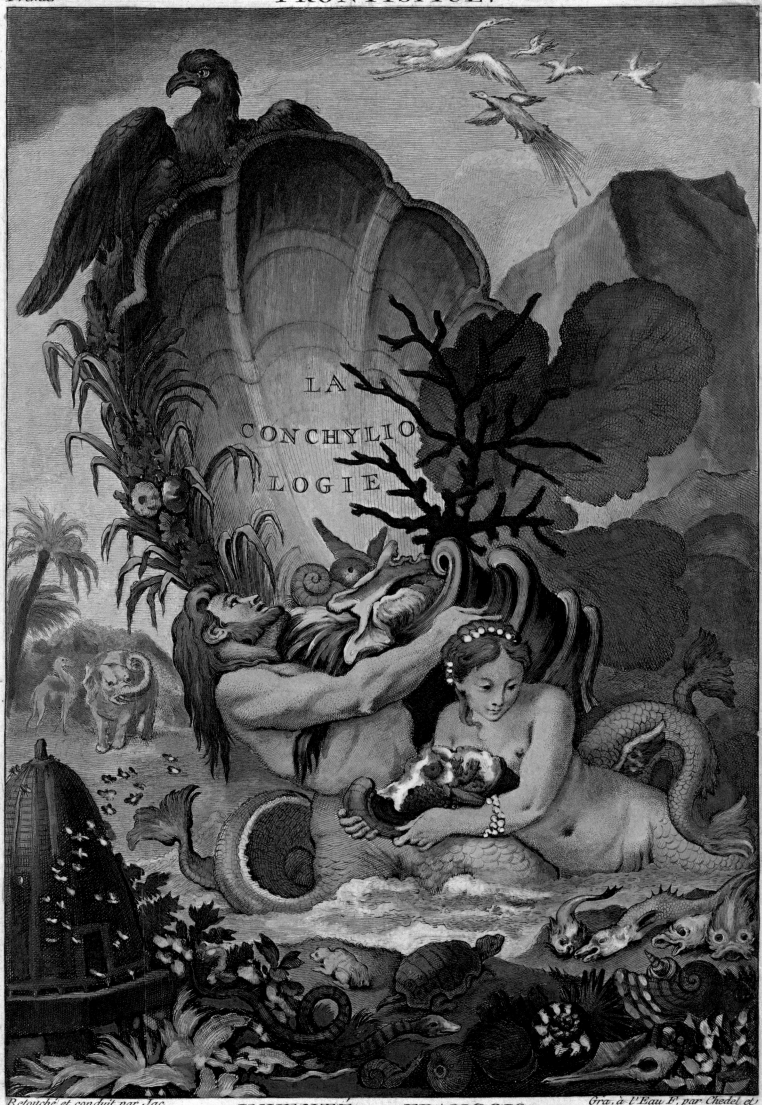

LA
CONCHYLIO
LOGIE

Retouché et conduit par Jac.
De Favanne.

INVENTÉ par FRANÇOIS
BOUCHER.

Gra. à l'Eau F. par Chedel et
Ter. au Bu. par J. Robert.

Antoine-Joseph Dezallier d'Argenville

Shells
Muscheln
Coquillages

Conchology or the Natural History of Sea,
Freshwater, Terrestrial and Fossil Shells
1780

The copy used for printing belongs to
Der Druck erfolgte nach dem Exemplar von
L'impression a été effectuée d'après l'exemplaire de
Claire Cernoia,
President of Vasari Rare Books and Prints

TASCHEN

HONG KONG KÖLN LONDON LOS ANGELES MADRID PARIS TOKYO

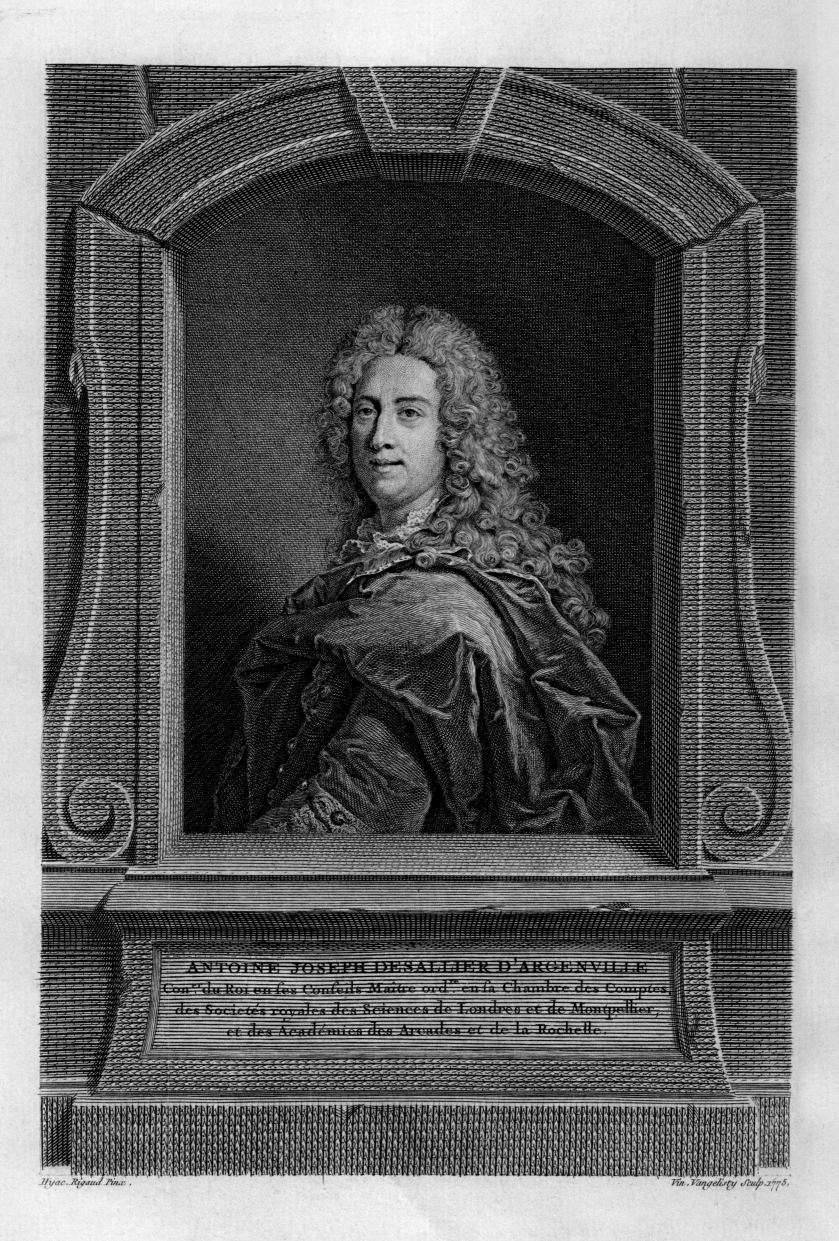

ANTOINE JOSEPH DESALLIER D'ARGENVILLE
Con.er du Roi en fes Confeils Maitre ord.re en fa Chambre des Comptes,
des Societés royales des Sciences de Londres et de Montpellier,
et des Académies des Arcades et de la Rochelle.

Hyac. Rigaud Pinx.

Vin. Vangelisty Sculp. 1775.

CONTENTS | INHALT | SOMMAIRE

A passion for shells:
Art and science in the *Conchyliologie* by Dezallier d'Argenville

Veronica Carpita

Antoine-Joseph Dezallier d'Argenville was one of the most fascinating intellectuals and collectors in France during the 18th century. Born in Paris in 1680, he took up literary studies and obtained a doctorate in law from the University of Paris. His parents, publishers and owners of a bookstore in the rue Saint Jacques, wanted their only son to be versed in the arts, so the young man studied under the tutelage of the most authoritative figures of his time. Thanks to his frequent association with the artists, men of letters and scholars who convened in the rue Saint Jacques, and to his already eclectic background in both the humanities and the sciences, Dezallier d'Argenville could don the various hats of lawyer, naturalist, connaisseur of arts and letters and collector, as well as musician and amateur composer. He was not even 30 years of age when he published *La Théorie et la pratique du jardinage* (Paris 1709), a volume issued in four different editions, which was translated into English and German, reprinted several times and even plagiarized by others. As befitted a scion of high society, in 1713 Dezallier d'Argenville began his Grand Tour of Italy, returning after a period of some two years. His stay in the *Bel Paese* refined his sensibilities in the fields of art and literature, and brought him the reward of being elected a member of the Accademia dell'Arcadia in 1714. Back in Paris, he focused on his public career: he purchased an appointment as a Secretary to the King, an honorary title that gave him the status of nobility, and became a parliamentary lawyer. After buying the title of *Maître des comptes* of Paris, his social ascent culminated in 1748, when he was invested with the title of *Conseiller du Roi et ses conseils*, which ensured him a crown pension. This privilege rewarded him not only for the commitment he had shown to his public functions, but also for the numerous literary and scientific works that he had personally presented to King Louis XV (1710–1774) and that ultimately brought him his fame.

The passions of Dezallier d'Argenville

In his elegant *hôtel particulier* in the rue du Temple, Dezallier d'Argenville established a veritable *cabinet de curiosité*, where he would retire to study and write. His *cabinet* contained a richly endowed library, as well as a collection of objects from the worlds of art and the natural sciences, the two branches of knowledge that most commanded his interest. After his father's death he inherited a substantial collection of paintings, prints, drawings, bronze sculptures, medals and shells; although he only possessed about 100 paintings, his prints and drawings amounted to several thousand, and were the pride of their owner. Dezallier d'Argenville, however, did not confine himself to complete isolation within his *cabinet*: he was glad to receive visitors to his collection, and he maintained epistolary contact with the scholars, collectors and intellectuals he had met during his European travels. After his long tour of Italy, in fact, he spent time in England in 1728 and probably also visited Holland and Germany, where many collections of exotic shells could be found. His love of art inspired him to enrich his collection with frequent acquisitions, while his connoisseurship found a tangible expression in the publication of his *Abrégé de la vie des plus fameux peintres* (1745). Later, in spite of his old age – he was 65 – he continued to work at his *Abrégé* to correct and expand it, publishing it in two further editions in 1752 and 1762.

His favourite occupations, however, had always been gardening and hydraulics. His early *La Théorie et la pratique du jardinage* was an international success: the plates for this work were prints taken from drawings executed by Dezallier d'Argenville himself and by his celebrated teacher, Jean-Baptiste Alexandre Le Blond (1679–1719), initially believed to be the author of the book published under the pseudonym M***. These achievements earned him the attention of Denis Diderot (1713–1784) and Jean Le Rond d'Alembert (1717–1783), who asked him to contribute 600 entries to their *Encyclopédie* on the subjects of garden planning and hydraulics. His passion found an outlet in the actual projects of gardens, boscages, labyrinths, vegetal theatre structures and fountains for his estate at d'Argenville, and then for his *ermitage* in Bièvres, near Versailles. He was also the planning advisor for his friend the Comtesse de Fuligny Rochechouart for the realization of her garden in Agey in Burgundy. In a letter to the countess he described one of his unusual banquets at Bièvres, at which he had treated his lady guests – devotees of fossils and natural history – to dessert served directly from shells.

The Conchyliologie

A passion for shells, fossils and minerals was the natural consequence of Dezallier d'Argenville's interest in hydraulics and gardens, and of his commitment to organizing and classifying information according to a systematic method in his *cabinet de curiosité*. Indeed he made a distinction between the mere *curieux* who displayed their objects with the intent of producing esthetic pleasure of a purely visual nature, and the *savants* – considering himself – to belong in this latter group – who studied the systems of displaying the specimens of the natural world according to their different types. The experience gained through the visits to museums all over Europe, and, of course, through his own collection, inspired the 1727 publication of his *Lettre sur le choix et l'arrangement d'un cabinet curieux*, in which

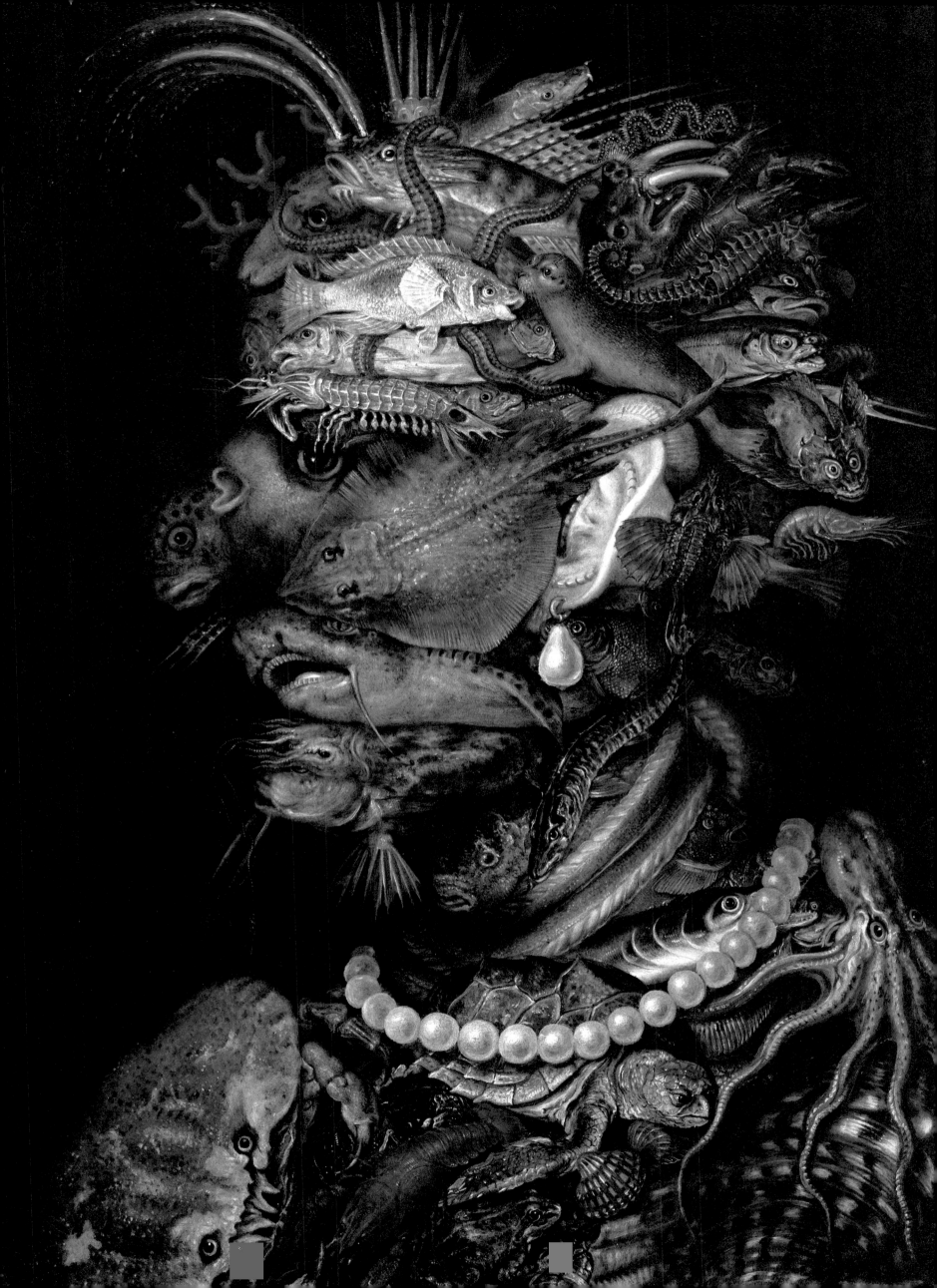

he claimed that medals were the curios most favoured by contemporaries. This trend, however, changed precisely as a consequence of his own writings, and also of the activity of the famous French collector and art dealer Edme-François Gersaint (1694–1750), who introduced in Paris the fashion of auctions accompanied by *catalogues raisonnés*. In 1733, realizing that the public's taste for exotic shells was reaching remarkable levels, he went to the Netherlands to select the rarest and most beautiful specimens extracted from remote oceans, and in 1736 he organized the first auction of shells and curios in Paris ever to be accompanied by a catalogue. The unprecedented success of this and other auctions determined the dramatic increase of *cabinets* devoted to shells and other natural objects in Paris and in the whole country; at the same time, it gave rise to conchology as a science in France. Gersaint attempted to compile a classification and develop a nomenclature of these objects by drawing on earlier publications, but, hindered by complex and untranslatable Latin and Greek terms, he soon admitted the difficulty of his enterprise and expressed the hope that one day a general study would be realized in French on the subject of shells and molluscs that included illustrations drawn from life. The sudden death of the celebrated botanist Joseph Pitton de Tournefort (1656–1708), author of the seminal work *Elémens de botanique* (1694) in which he classified plants by genre and species, had brought his research on shells to an abrupt end. Tournefort's personal shell collection was acquired by Louis XIV for his *cabinet* in Paris, although his unprecedented method of classification was published in Italy in 1742 by Niccolò Gualtieri (1688–1744) rather than in France. It fell to Dezallier d'Argenville – inspired directly by Tournefort's classification of plants – to publish the first study of conchology in France in 1742. When, in 1736, Gersaint included Dezallier d'Argenville's vast shell collection in his catalogue along with the most famous *cabinets* in France and Holland, he revealed that its owner was working on an *Histoire des coquilles & des minereux* that was soon to be published. Indeed, as the title *L'Histoire naturelle éclaircie dans deux de ses parties principales, la lithologie et la conchyliologie* indicates, the author studied these related aspects of the natural kingdom. This publication, which was dedicated to the Société Royale de Montpellier, of which Dezallier d'Argenville had been a member since 1740, was an instant success and quickly sold out. The frontispiece, a magnificent Rococo creation, was based on a drawing by François Boucher (1703–1770), whose stellar career culminated in 1765 with his nomination as first painter to the king of France (cf. p. 2). Aided by a mirror, Dezallier d'Argenville himself executed life-size drawings of the rarest and most beautiful shells from his *cabinet* so that the shells would appear in the cor-

rect direction when they were reproduced in the 32 magnificent prints by Pierre-Quintin Chedel (1705–1763). This luxurious publication was financed by several scholars and amateurs, to whom the plates of the *Histoire* were subsequently dedicated (ill. 6). As well as subdividing shells into the principal categories of marine, terrestrial and fluvial, and then further dividing them into the sub-classifications of kinds, species and varieties, Dezallier d'Argenville provided an exhaustive explanation of their formation, the places and techniques for their collection, and their different uses, as well as practical advice on cleaning them and the methods for displaying them in a *cabinet*; he also extended the publication with a list of the most celebrated natural history collections in Europe and a table containing approximately 2,000 Latin and Greek terms and their French translations. The success of this book, confirmed also by Dezallier d'Argenville's appointment to the Royal Society of London in 1750, encouraged the author to further his research. In 1751 he published a short treatise on fossils found in the French provinces, *Enumerationis fossilium, quae in omnibus Galliae provinciis reperiuntur, tentamina*. In 1755 the French translation of the *Enumerationis* appeared, as well as an extended version of the *Lithologie*, which had been previously published with the *Conchyliologie* in 1742 (*L'Histoire naturelle éclaircie dans une de ses parties principales, l'oryctologie, qui traite des terres, des pierres, des métaux, des minéraux et autres fossiles*, reprinted in 1760). Finally, in 1757 Dezallier d'Argenville published the second edition of the *Conchyliologie*; the section dedicated to lithology was, however, replaced with the *Zoomorphose*, a study of molluscs, fulfilling the wish that Gersaint had expressed in 1736 (*L'Histoire naturelle éclaircie dans une de ses parties principales, la Conchyliologie, qui traite des coquillages de mer, de rivière et de terre. ... Augmentée de la Zoomorphose*). This book boasted 41 printed illustrations, the majority of which had been taken from the original engravings of the 1742 edition; several copies were also furnished with an appendix and three new prints depicting rare shells. This second edition of 1757 was therefore expanded in content – the illustrated objects rose to 572 – as well as corrected and improved: Dezallier d'Argenville worked on it for over ten years and had the drawings of the molluscs sent to him from the Indies and several European locations. The images of the *Zoomorphose* had the advantage of reproducing the inhabitants of shells from life for the first time.

The market success of *L'Histoire naturelle* encouraged Dezallier d'Argenville and his publisher, Guillaume François de Bure, to have certain plates of the second edition coloured. This prestigious edition was bound in morocco leather with gilded edges; its price was 240 French *liras*, about

five times the price of the previous version. Dezallier d'Argenville carried out his research on shells until the end of his life. He gave de Bure several additions for the *Histoire naturelle*, but his unexpected death on 29 November 1765 prevented him from editing this work one last time. In March 1766 his natural history *cabinet* with thousands of shells was sold at auction; the same destiny awaited his paintings, prints and drawings. Unlike his collection, however, the fame of *L'Histoire naturelle* would outlive its author: Jacques De Favanne de Montcervelle and his son Guillaume, artists in the service of the French king who were themselves passionate shell collectors, decided to produce a third edition of Dezallier d'Argenville's work: *La Conchyliologie, ou Histoire naturelle des coquilles de mer, d'eau douce, terrestres et fossiles, avec un traité de la zoomorphose, ou représentation des animaux qui les habitent* appeared in 1780, also with de Bure. The De Favannes' project was an ambitious one: they hoped to make *La Conchyliologie* the most exhaustive and up-to-date work on this subject in France. They thus proceeded to correct all of Dezallier d'Argenville's inaccuracies in his classification of shells, make extensive additions to different chapters and enrich the publication with a reproduction of Dezallier d'Argenville's portrait (cf. p. 4) painted by Hyacinthe Rigaud (1659–1743), as well as 83 new prints after their own drawings. The 1780 version of *La Conchyliologie* was eventually published in two volumes. The first opens with two frontispieces, the one by Boucher, the other a seascape illustrating various techniques of shell fishing (cf. p. 44); the second volume contains a view of the island of Aix (cf. p. 206). Of the remaining 80 plates, two (pls. LXXVII and LXXVIII) illustrate the anatomy of some molluscs taken from the book by Martin Lister (1639–1712) and a landscape populated with animals feeding on shells; the others depict 2,008 species or varieties of testaceans, many of which had been still unknown. Jacques and Guillaume De Favanne included all the shells that Dezallier d'Argenville had published in his previous editions, excluding only the seriate variety and adding innumerable others published by earlier authors, as well as drawings of shells collected in *cabinets* from all around the world. From this vast body of material, the De Favannes prepared coloured drawings for the plates, so that they would be accurately reproduced in the prints. To accelerate this process, they enlisted the aid of 12 printmakers, foremost among them Vincent Vangelisty (c. 1740–1798). For the 1780 version of the *Conchyliologie* the publisher planned to leave some of the plates in black and white. The rare coloured copies available, therefore, must be considered luxury items for which the illuminations were commissioned by their owners; this means that the quality of these illustrations is very uneven, and that while there are copies

that have been coloured with immense skill and accuracy, such as the one reproduced here, others were more carelessly executed. The absence of a precise model also had the effect of producing substantial differences and inaccuracies in the coloration of the shells, possibly explaining why some book owners chose to have the illustrations bound separately in a third volume. Consequently, already in the late 18th century the price of this edition began to fluctuate: depending on the quality of the watercolours and the degree of preciousness of their bindings, these books could sell for as much as 500–600 French *liras*.

Whereas Dezallier d'Argenville intended to make *L'Histoire naturelle* a work of art as well as science, Jacques and Guillaume De Favanne emphasized the purely hedonistic aspect of *La Conchyliologie*, crowding the plates with illustrations of shells in decorative and symmetrical patterns arranged according to the model of the *Thesaurus* by Albert Seba (1665–1736). The contribution made by Dezallier d'Argenville and the De Favannes to the science of malacology was soon surpassed by other more modestly produced, but scientifically up-to-date, publications; however, its importance in the divulgation of knowledge of the natural world remained crucial. A fascination with natural history, and particularly with shells, in fact, was escalating all over France, eclipsing even the passion for antiquities. In the 18th century the *cabinets* of *naturalia* proliferated dramatically: in 1742, in Paris, Dezallier d'Argenville counted 17, and in 1757, he counted 20, but in 1780 the De Favannes could list 135.

Conchology and conchiliomania:
Books and shell collections in the modern age

When *La Conchyliologie* was published in 1780, the study of conchology was in its third century. In 1553 Pierre Belon (1517–1564), a physician and an herbalist, published in Paris *De aquatilibus, Libri duo*, a work dedicated to aquatic animals in which, for the first time, numerous shells were described and illustrated in prints by Pierre Gourdelle. Belon observed and copied molluscs and other creatures during his travels in the Mediterranean and Atlantic regions. His book preceded by one year the publication of *Libri de Piscibus Marinis* by the Montpellier physician and professor Guillaume Rondelet (1507–1566), a precious volume in *folio* with hundreds of woodcuts by Georges Reverdy illustrating marine creatures. The second part of Rondelet's work, the *Universae aquatilum Historiae pars altera* published in 1555, contained a section dedicated to shells observed with greater precision and reproduced more accurately than those of Belon's book. These two pioneering works were republished in their entirety in the *His-*

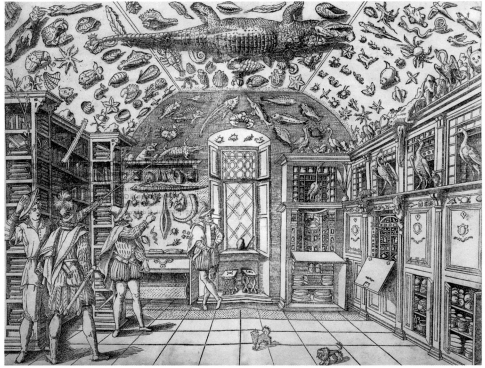

toriae animalium liber III by the Swiss Konrad Gesner (1516–1565) in 1558 with over 700 prints. This volume was one section of Gesner's grandiose encyclopedic project that aimed to contain all human knowledge in a single work: the *Libri historiae animalium* (1551–1558) for the animal kingdom and the *Bibliotheca universalis* (1545) for literary culture. The publications by these 16th-century physicians and zoologists, though containing personal observations, were, above all, vast collations of ancient texts. Aristotle (384–322 BC) and Pliny the Elder (AD 23–79) constituted the inevitable starting point. In his treatise *De animalibus*, Aristotle divided shells into terrestrial and marine, of which the latter were subdivided into univalve and bivalve. Pliny, in his *Naturalis historiae*, recognized shells of three kinds: molluscs, crustaceans and testaceans. Nevertheless, identifying species described by ancient authors was an arduous task, because of the ambiguous literary descriptions and the variance in nomenclature. Furthermore, the undisputed *auctoritas* of the ancient authors still allowed fantastic and monstrous creatures such as the monk seal and the hydra to be included in these catalogues. Starting in the 16th century, therefore, the scientific image based on mimesis through drawing and printing became fundamental in its didactic and documentary observation and classification of the animal and vegetal kingdom. The success of treatises and naturalist imagery in the 16th century was not a phenomenon restricted to small circles of scholars, but rather was fuelled by the erudite exchanges and relationships between virtuoso collectors, princes and especially scientists and artists specialized in the naturalist genre. The first known shell collections were formed in the Low Countries: Erasmus of Rotterdam (1467–1536) possessed one, and Albrecht Dürer (1471–1528) visited many when he was in Antwerp. The inexorable colonial expansion of the Dutch in Asia, Indonesia, South Africa and Australia, carried out through the Company of the East Indies (1602) and the Company of the West Indies (1616), ensured that the United Provinces possessed the highest concentration of shell collections in Europe. It should be noted that, in its early days, even Shell Oil Company was involved in the commerce of shells. The discovery of America and the consequent increase of travel to and commerce with the West Indies and the Far East allowed Europeans to discover many animal and vegetal species that had been previously unknown. Shells were precious, and they arrived from exotic countries to the ports of the most important European sea powers, where they were contended for by collectors and naturalists.

During the second half of the 16th century, the most intensive research on the subject of shells and the natural world was carried out at the courts of the more enlightened Italian and German sovereigns, who were establishing huge collections of *naturalia* and *artificialia*, and welcomed among their *protégés* scientists and artists specializing in the depiction of natural objects. Among the most celebrated was the collaboration between the Sienese physician Pietro Andrea Mattioli (1500–1577) and the Udinese painter Giorgio Liberale (1527–*c.* 1579) at the court of the archduke Ferdinand II of Tyrol (1529–1595) in his castle of Ambras. From 1562 until 1576 Liberale worked on the illuminations of a parchment codex of 100 sheets with marine animals from the Adriatic (ill. 2). This was the first and most extensive sampling of a local ichthyc fauna, and it served, in part, as a model for the prints published by Mattioli in his introduction to the *Materia medica* (1564) by Dioscorides (1st century AD). Liberale's large watercolour plates are fine and accurate depictions of marine creatures, but they also display sophisticated *trompe l'oeil*, thereby pairing scientific analysis with attractive ornamental elements. During the same years, the Milanese Giuseppe Arcimboldo (1526–1593) worked as an illustrator of scientific subjects in Vienna and Prague for the Habsburg emperors. His artistry in the naturalist genre is evident both in his life studies of animals and in his extravagant "composite heads", or anthropomorphic portraits formed by the most disparate elements, such as objects, fruit, vegetables or animals. For Maximilian II (1527–1576) Arcimboldo executed an *Allegory of Water* composed from 62 different kinds of fish, crustaceans, shells and molluscs (ill. 1). The Veronese Jacopo Ligozzi (*c.* 1547–1627), a descendant of a family of painters and embroiderers in the service of the Habsburgs, illuminated a parchment codex in Prague for Rudolf II with 20 plates presenting illustrations of fishes. Ligozzi, who soon became the most celebrated and desirable miniaturist working from life, was active at the court of Grand Duke Francesco I de' Medici (1541–1587), who, following the example of his father Cosimo I, founder of the botanical gardens of Pisa and Florence, became a passionate collector of *naturalia* and a keen experimenter in the fields of science and alchemy. Starting in 1570, Francesco collected in the celebrated Studiolo of Palazzo Vecchio all his rarest and most precious objects. An entire wall of the Studiolo was dedicated to the theme of water, one of the four elements chosen as the organizing principle for the Grand Duke's collection. Within the cabinets of that wall, enclosed by doors decorated with allegories and marine myths, were kept nautiluses, shells, sponges, corals, pearls and aquatic fossils. The complex astrological meanings and the mysterious cosmic allegories contained in the decoration of Francesco's Studiolo were further amplified in the magnificent Tribuna of the Uffizi, built in 1584. Here the Grand Duke transferred his precious

Ill. 4

collection of ancient and contemporary art, as well as rare natural objects, and again emphasized the beauty of the theme of water: the high octagonal dome of the Tribuna was entirely encrusted with glittering mother-of-pearl oyster shells, and Jacopo Ligozzi painted a frieze with fishes and shells (now lost) that ran along the base of the eight walls. Some of Ligozzi's and Arcimboldo's much sought-after depictions of animals and plants also enriched the collection of a celebrated physician and naturalist from Bologna, Ulisse Aldrovandi (1522–1605). He formed and sponsored a team of illuminators and printers to illustrate his vast encyclopedia of the natural world. The ambitious graphic material, comprising more than 2,900 illuminated plates that are now at the university library in Bologna, also includes 100 shells that appeared in the *De reliquis animalibus exanguinibus*, which was published in Bologna in 1606 with 650 illustrations.

Undoubtedly, during the 16th and up to the mid-17th century, the pursuit of knowledge by scientists and amateurs was still characterized by a strong attraction to the marvellous and the rare, and by an encyclopedic approach. Nonetheless, these private amateurs formed collections that were increasingly specialized from a scientific point of view, and their laboratory-museums, organized according to a more specialized taxonomy, started to lose the connotations of chaotic eclecticism that had characterized the *Wunderkammern* of northern Europe. One of the earliest depictions of *cabinets* of this kind is a print of 1599 that portrays the Neapolitan chemist Ferrante Imperato (1550–1625; ill. 3) as he gives some visitors a tour of his private museum, which teems with natural objects and books, as well as shells and crustacean specimens.

In the early 17th century the research carried out by the Accademia dei Lincei, the discoveries that Galileo Galilei (1564–1642) – also a member of the Accademia dei Lincei from 1611 – made using the telescope and the microscope, broadened the possibilities of exploration of the natural world, focusing on sight as the principal instrument of reason and knowledge. An example of this new approach is found in the studies conducted by Fabio Colonna (1567–1640), a Neapolitan jurist who was another member of the Accademia dei Lincei and was passionate about natural research: by carrying out a methodical comparison of fossilized and living shells, Colonna claimed that these creatures had organic (not vegetative) origins, and his findings became a fundamental starting point for subsequent research on fossilized and living shells. One of his followers was the painter and scientist Agostino Scilla (1629–1700) who, in his work *La vana speculazione disingannata dal senso* (1670), illustrated with beautiful etchings by Pietro Santi Bartoli (1635–1700), demonstrated the organic origin of fos-

silized shells through autopsic analyses. A few years later, in 1675, a physician from Kiel, Johann Daniel Major (1634–1693), published a new edition of the *Opusculum de purpura* by Colonna in which, for the first time, a classification of living shells was attempted. Major's subdivision into *univalves*, *bivalves* and *turbinates* was also adopted by the Jesuit priest Filippo Buonanni (1638–1725) in his *Ricreatione dell'occhio e della mente nell'Osservation' delle Chiocciole* (1681; the Latin edition was published in 1684, and then was updated in 1691 and reprinted in the *Musaeum Kircherianum* of 1709). In this edition, enriched by beautiful etchings (ill. 4), Buonanni promoted Aristotle's theory of the spontaneous generation of fossils from the *vis plastica* (or "modelling power") of stones. In the museum of the Collegio Romano founded by the Jesuit Athanasius Kircher (1602–1680), of which Buonanni became custodian in 1698, he observed hundreds of shells through the microscope. But autopsic analysis, focused on the colours as well as on the anatomy of shells, did not dissuade him from the idea that Nature was the creator of actual mines of "illustrated stones" (*pietre figurate*) that reproduced animal or vegetal morphologies. His blind belief in the existence of such "freaks" of nature even induced him to give credence to the existence of the legendary Sarmatian snail, which is reproduced in one of the illustrations of his *Ricreatione*.

The experiments on the reproduction of molluscs carried out in the same period by Francesco Redi (1626–1697), Antonio Felice Marsili (1649–1710) and, later, by René-Antoine de Réamur (1683–1757) definitively dismantled the belief in spontaneous generation. Nevertheless, these revolutionary – and dangerous – theories came up against some resistance: they implied that fossils attested to the existence on earth of extinct species, thus questioning the eternal perfection of God's creation. During the second half of the 17th century the discovery of shells and other fossils inspired some naturalists to study the earth without limiting their scope to its present state: it was becoming apparent that nature was the product of a long process of development. Embracing an evolutionary view of nature, however, was far from straightforward, as we know from the experience of the English physician Martin Lister. Although his research methods on shells and molluscs were based on accurate observation, Lister nonetheless claimed the existence of seeds within the earth that, depending on their environmental conditions, generated different types of creatures. In his *Historia animalium Angliae* (1678), and especially in the five volumes of the *Historia conchyliorum* (1685–1692), Lister proposed a new system of classification for over 1,000 shells he observed in his own collection, in that belonging to William Courten *alias* Charlton (1572–1636) and in the one in

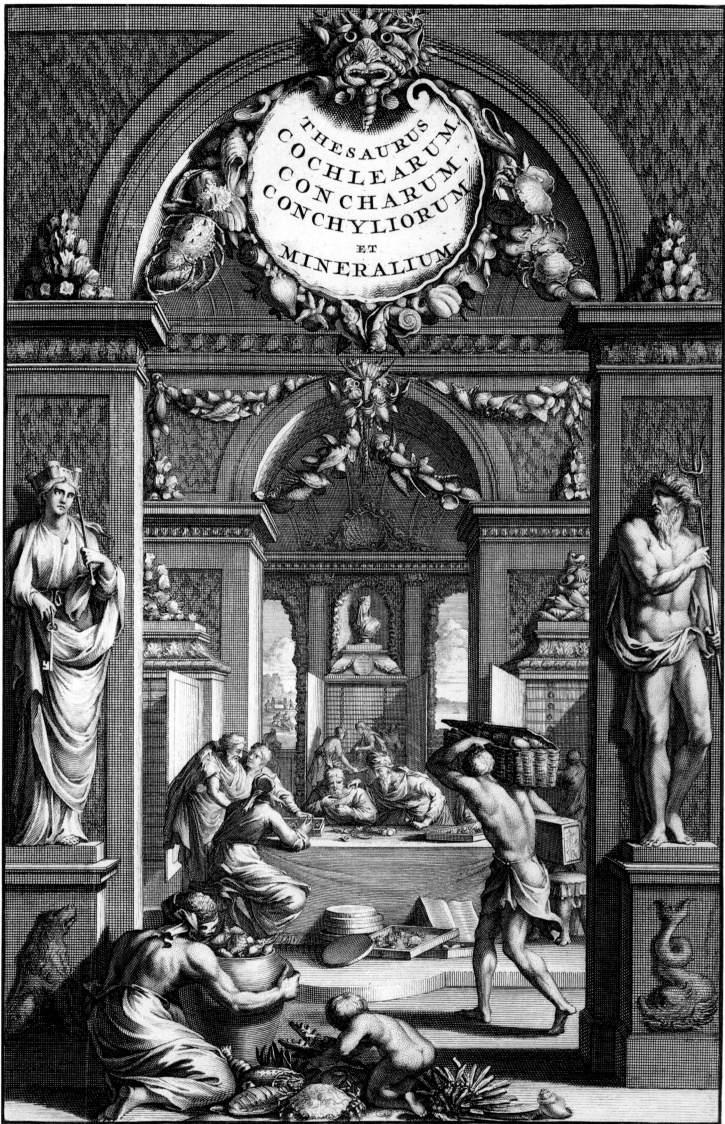

THESAURUS
COCHLEARUM
CONCHARUM
CONCHYLIORUM
ET
MINERALIUM

Ill. 5
*Representation of a theatrically displayed
gallery-cabinet with collectors and conchologists*, 1711
*Darstellung eines Naturalienkabinetts im Stil
einer Wunderkammer mit Sammlern und Muschelforschern
Représentation d'une cabinet de curiosités en forme de théâtre,
avec collectionneurs et savants férus de conchyliologie*
In: Georg Eberhard Rumpf, *Thesaurus imaginum Piscium
Testaceorum; quales sunt Cancri, Echini, Echinometra,
Stellae Marinae, etc. ut et Cochlearum*, LEIDEN, 1711

the Ashmolean Museum in Oxford. Differently from previous publications, Lister's shells were printed for the first time in the correct direction, rather than reversed, thus reproducing faithfully the position of important details such as the *stoma* (shell opening) of gastropods.

In the Netherlands at the dawn of the 17th century when the "tulipomania" that would result in the famous financial crash of 1637 was rampant, the other prevalent obsession was the collection and exhibition of exotic and rare shells, which were sold at exorbitant prices. This "conchiliomania" drove the merchant and poet Roemer Visscher (1547–1620) to accompany a print depicting shells on a beach with the following barbed witticism: "It is disgusting to witness what a madman can do with his money" (*Sinnepoppen*, 1614). La Bruyère (1645–1696), a severe critic of contemporary mores, commented sardonically on those collectors and speculators who gave their shells the most unlikely names: "Would you imagine, listening to someone talking about his *Leopard*, his *Feather*, his *Music*, exalting these as the rarest, most marvellous objects on earth, that he was trying to sell his shells? Why not, if he purchased them at the price of gold?" Shell collections were numerous all over Europe. Among the most celebrated to note are that of John Tradescant (*c.* 1570–1638), which was enriched by his son John Tradescant, Junior (1608–1662), and then acquired by the Ashmolean Museum in Oxford; in London, the collection of the chemist James Petiver (1658–1718) and the Jamaican shell collection of the president of the Royal Society, Sir Hans Sloane (1660–1753), now at the British Museum; in Copenhagen, the museum formed by Ole Worm (1588–1654); in Paris, the museum of the monastery of Sainte-Geneviève, the *cabinets* of Cardinal Jules Mazarin (1602–1661), Nicolas Boucot († 1699) and Joseph Pitton de Tournefort (1656–1708), and the collection belonging to Gaston d'Orléans (1608–1660). In Italy, Andrea Vendramin (1554–1629) formed a museum in Venice, which was transferred to Amsterdam after his death, Ludovico Moscardo (*c.* 1611–1681) had a collection in Verona and Manfredo Settala (1600–1680) had another in Milan, while in Florence, the grand duke Cosimo III de' Medici (1642–1723) owned a stunning shell collection that was enlarged in 1682 when he acquired the specimens belonging to the celebrated Dutch naturalist Georg Eberhard Rumpf (1627–1702). In 1683 Cosimo donated a significant section of the Rumpfian collection to the Bolognese Marquis Ferdinando Cospi, who commissioned Jacopo Tosi to depict all 400 shells in a volume now at the University Library of Bologna. In turn, the Museo Cospiano was donated by its founder to the Bolognese senate, transferred at first to the Palazzo Pubblico and subsequently to the Istituto delle Arti e delle Scienze, together with the museum founded by Aldrovandi (1742). Rumpf, an agent for the Company of the Indies in Amboine, Indonesia, carried out extensive research on marine creatures of the Indian and Pacific oceans. This rare opportunity, however, was hindered by a sequence of misfortunes: at the age of 40 Rumpf went blind, and in 1687 the fire of Amboine destroyed the illustrations executed by his son, which were already ready for publication at the time. The 60 newly engraved plates and the manuscript finally reached Holland, where they were published in German in 1705 (*D'Amboinsche Rariteitkamer*). This work was fundamental to the fields of tropical conchology and the biology of animals in their habitat. The Latin translation *Thesaurus cochlearum* of 1711 (ill. 5), followed by further reprints and translations in other languages, secured this "Pliny of the Indies" European fame. The naturalist Niccolò Gualtieri also acquired some shells from Rumpf's collection. These specimens, subsequently acquired in part for the scientific collections of the University of Pisa, were published by Gualtieri in the 110 beautiful plates of his *Index Testarum Conchyliorum* of 1742. The same year also witnessed the publication of Dezallier d'Argenville's *L'Histoire naturelle*. Dezallier d'Argenville disapproved of those who collected natural objects, and shells in particular, favouring aesthetic considerations over methodical order, but well into the 19th century collectors and natural history museums continued to approach this material with the goal of generating wonder and surprise by means of dazzling displays (ill. 6). Some celebrated examples were the ornate, anthropomorphic arrangements by the chemist Albert Seba that were published in the third volume of his *Thesaurus* (1758), which represents one of the first examples of the colour illustration of molluscs (1734–1765; ill. 7). So many ambitious initiatives came to a standstill because of financial difficulties. One famous example is the *Choix de coquillages et de crustacés* (*Auserlesene Schnecken, Muscheln*, a bilingual publication of 1758) by Franz Michael Regenfuss (*c.* 1712–1780), a printmaker at the service of Frederick V, king of Denmark and Norway. Of the three sumptuous volumes in *folio* originally planned, only the first was published, with outstanding watercolour plates (ill. 8): these 12 exquisite illustrations by Regenfuss deploy his egregious technical expertise and eye for composition, and provided a model for all successive works of this kind up until the 19th century. These fascinating and virtuoso illustrations were, however, far from the advanced research carried out in those same years by Carl Linnaeus (1707–1778). In his *Systema naturae* (1735–1767), the Swedish botanist developed the system of classification of living beings based on the reproductive organs, an approach that is still in use today. First identifying eight kinds of shells, in his last edition Linnaeus established the founda-

tions of the correct classification of these creatures, subdividing them into 35 types with 807 species.

From the mid-18th century, Linnaeus's system became the fundamental starting point for natural scientists, among which must be mentioned F. H. W. Martini and J. H. Chemnitz, the authors of a work in 11 volumes accompanied by watercolour illustrations (*Neues systematisches Conchylien-Cabinet*, 1769–86), and Ignace de Born (1742–1791), who published the shells from the museum of Emperor Francis of Austria and his wife Mary Therese (*Testacea Musei Caesarei Vindobonensis*, 1780) with 18 fine colour plates. The escalation of research conducted on shells furthermore led to the necessary publication of the early digests that, in an abridged form, synthesized all the developments of malacology up to the most recent discoveries. In Paris in 1775, the *Dictionnaire* by the abbot Christophe Elisabeth Favart d'Herbigny (1725–1793) appeared, and the following year it was the turn of Mendez da Costa (1717–1791) to publish his *Elements of Conchology* in London. In 1776, the same London publisher, Benjamin White, printed the fourth volume of the *British Zoology* by Thomas Pennant (1726–1798) dedicated to *Crustacea, Mollusca, Testacea*, which was accompanied by 100 small etchings. In 1803 George Montagu (1753–1815) renewed his study of Pennant's local fauna in the *Testacea Britannica*, illustrated with 16 modest plates. The florid English publishing industry of the late 18th century yielded another fundamental work on malacology in 1784: *The universal Conchologist* by Thomas Martyn (1735–1825) came out in a folio edition embellished with 120 watercolours that, together with those by Ignace de Born, set the standard for all subsequent illustrations of shells. International acclaim was bestowed also on the Frenchmen Jean-Guillaume Bruguière (1750–1798) and Jean-Baptiste-Pierre de Monet de Lamarque (1744–1829), researchers whose models of classification were adopted by the Englishman George Perry (c. 1780–1859) in his *Conchology, or the Natural History of Shells* (1811) with 61 plates by John Clarke. The last important volume on malacology published in the 18th century came out in Italy: this was the *Testacea utriusque Siciliae* of 1791 by Giuseppe Saverio Poli (1746–1825), who was a famous Italian physician, a member of the Royal Society.

The fascination of shells in art

Shells have always been considered "artifices of nature", and therefore a tangible reflection of the wonder and perfection of Creation. George Perry, in his introduction to the *Natural History of Shells*, reflected on how these objects, with their astoundingly complex architecture based on a log-arithmic spiral, invite the viewer to contemplate divine excellence. One of the earliest depictions of shells linked to this theological significance is found in the splendid *Book of Hours* of Catherine of Cleves (1417–1479), which was illuminated by an anonymous master from Utrecht around 1440 (ill. 9). Depicted on the margins of the sheet with extremely accurate realism and virtuoso *trompe l'oeil*, shells and a crab frame the figure of Saint Ambrosius: to illustrate the perfect design of Creation, the saint had recounted the story of the crab who succeeded in eating the oyster by shrewdly inserting a pebble between its valves.

The "recreation of the eye and of the mind" – to quote Bonanni – inspired by these marine creatures is a concept that dates back to Cicero (106–43 BC) and enjoyed a great fortune in literature and in humanist circles all over Europe: in the *De oratore*, Cicero exalted the value of the *otium* and *amicitia* cultivated by two friends who spent their hours of leisure collecting shells. The activity and expression of *conchas legere* ("collecting shells") coined by Erasmus then became a distinguishing trait for all those men of learning who, through the contemplation of these natural objects, sought spiritual meditation and a solace of the mind. It is in this vein that we can interpret the portraits of collectors viewed in the act of displaying their shells, such as the two paintings representing Jan Govertsz van der Aar, the first executed by Hendrick Goltzius (1558–1617) in 1603 (ill. 10), the second in the form of an allegory by Cornelis van Haarlem in 1607; the same is true of the still lifes and *vanitas* with shells that became a fashionable genre in the Low Countries during the 17th century. The most sought-after were those by Jan Brueghel the Elder (1568–1625), Ambrosius Bosschaert (1573–1621) and his brother-in-law Balthasar van der Ast (c. 1593–1657; ill. 11) and Jan van Kessel (1626–1679). The beauty of shells, furthermore, was believed to possess not only the twin faculty of elevating the spirit and recreating the senses, but also the quality of refining the taste and creativity of artists. The innumerable shapes and appearances of shells, sometimes immaculately white, other times dazzlingly coloured, have in fact always inspired the manufacture of artistic objects in all forms, from painting to the work of goldsmiths, from architecture to textiles, from sculpture to furniture, and from weapons to stage design. As early as in some coins and paintings from Pompeii, the shell was linked to the iconography of the birth of Venus. In the celebrated painting by Sandro Botticelli (1445–1510; ill. 13), or in a more recent work by William Adolphe Bouguereau (1825–1905) of 1879, the goddess approaches the island of Cyprus on the huge valve of a shell. This image is a more palatable version of the myth, whereby Venus was born from Uranus's genitalia after these

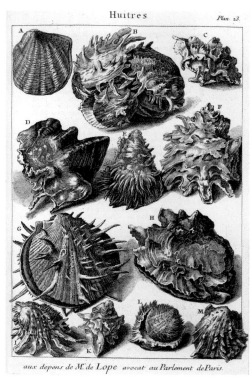

Huitres Plan. 23.

aux depens de M.^r de Lope avocat au Parlement de Paris.

ILL. 6

were severed and thrown away in the sea by Cronus. Generated from water – the origin of life – and being itself the protective shelter of a living creature, the shell was always associated from the earliest civilizations with symbols of fertility, reproduction and love, partly due to its uterine morphology. The still widely accepted belief in the aphrodisiac power of oysters derives precisely from this ancestral symbolism.

In Christian tradition, the shell that produces a pearl without the need for male insemination became a symbol of the virginity of the Madonna. A noticeable example can be found in the *Sacra conversazione* by Piero della Francesca (*c.* 1420–1492), in which the valve of the apse, as immaculately white and smooth as porcelain, aside from being reminiscent of themes from antiquity, alludes to the mystery of Christ's virginal conception (ill. 12). This symbolic function, emphasized in Piero's panel also by the ostrich egg, which medieval mystics believed was impregnated by the rays of the sun, enjoyed ample fortune. An example of this is the central bronze door of the cathedral in Pisa (1596–1603) on which, above the panel with the *Annunciation*, we see the depiction of an open pearl oyster welcoming the fertilizing dew. In Christian iconography the shell is also the attribute of the apostle Saint James, who is buried in Santiago de Compostela, Spain. The reasons for this association are unknown, but it is certain that the saint's name designates the shell *Pecten jacobaeus*, which became the symbol of Christian pilgrims.

By nature linked to water, shells were used to decorate or inspire the architectural shapes of innumerable nymphaea, gardens and fountains: among the most celebrated is the *Fountain of the Triton* in Rome by Gianlorenzo Bernini (1598–1680) in which the god is represented blowing into his shell, originating storms. Shells of various shapes and kinds are often present in the depiction of marine divinities, as in the *Triumph of Galatea* (1511) by Raphael (1483–1520) in the Villa Farnesina in Rome, or in the *Neptune and Amphitrite* (1515, Berlin, Gemäldegalerie) by the Dutchman Jan Gossaert (1478–1532). The same couple of marine divinities is the theme of a painting by another Dutch artist, Jacob de Gheyn the Younger (1565–1629; ill. 14). The pictorial virtuosity, visible in the rendering of the skin of the lovers as they emerge from the waters, culminates in the sparkling mother-of-pearl surface of the shells. A precious rarity offered by the aged Neptune to his young bride as a token of love, the shells emptied of their molluscs were undoubtedly studied by De Gheyn in one of the numerous collections found in Amsterdam.

A tribute to the extravagant shells, precious pearls and corals newly arrived from the far Indies into the collection of Ferdinando I de' Medici (1549–1609) is the *Reign of Amphitrite* (ill. 16), a small oil painting by Jacopo Zucchi (*c.* 1541–1596). The nymph ruler of the seas may be a portrait of Clelia Farnese, Ferdinando's lover before his marriage to Christine of Lorraine (1565–1636) in 1598. Cosimo II, Ferdinando's heir, commissioned a painting of two extraordinary gastropods from the East Indies (ill. 15) from the naturalist painter Filippo Napoletano (1587/1591–1629). During the 17th century the celebrated Stanza dei Nicchi (now lost) in the Uffizi inspired numerous still lifes by Giovanna Garzoni (1600–1670), who was a miniaturist, and by Bartolomeo Bimbi (1648–1725). The latter executed two canvases commissioned by the Crown Prince Ferdinand (1663–1713) in which he portrayed from life the most beautiful and capricious specimens from the Medicean museum, arranging them in a theatrical choreography illuminated by a soft, diffused light. A painting from the same decades of the late 17th or early 18th century features an exotic display of shells with a parrot and a bird of paradise in a gloomy seascape (ill. 17); the uncertain attribution to either a Dutch anonymous master or an Italian one is symptomatic of the widely diffused taste for this genre at the time, as well as being indicative of the frequent contact between northern and Italian painters within the same courts, as was the case in Florence.

By the mid-18th century, the fashion for conchology was widespread in Europe: the publication of important illustrated volumes, above all that by Antoine-Joseph Dezallier d'Argenville, and a noticeable shift in collecting taste, attracted a growing number of amateurs from the European aristocracy and the emerging bourgeoisie. Even among the ladies of the nobility the natural sciences became a favourite diversion, as can be seen in the portrait of Marquise Gentili Boccapaduli sitting in her *cabinet* of *naturalia* (ill. 18). And while the *rocaille* fashion that had dominated until 1760 came to be supplanted by the Neoclassical style, the theme of the still life with shells nonetheless retained its appeal in the new artistic climate. Indeed, we must not think that the fortune of conchiliomania would die out with the advent of the modern era: these extravagant artifices of nature continue, in fact, to exert their undisputed fascination on contemporary collectors and amateurs, and there is no sign that the passion for shells will decline.

Eine Passion für Muscheln. Dezallier d'Argenvilles *Conchyliologie* im Spannungsfeld von Naturwissenschaft und Kunst

Veronica Carpita

Eine der faszinierendsten Persönlichkeiten unter Frankreichs Gelehrten und Sammlern des 18. Jhs. ist Antoine-Joseph Dezallier d'Argenville. 1680 in Paris geboren, widmete er sich zunächst dem Studium der Literatur, um dann an der Pariser Universität in Rechtswissenschaften zu promovieren. Seine Eltern, Verleger und Buchhändler in der Rue Saint Jacques, in der Künstler, Schriftsteller und Gelehrte zusammentrafen, legten großen Wert darauf, dass ihr einziger Sohn von den besten Lehrern der damaligen Zeit auch in den freien Künsten unterwiesen wurde. Dank seiner universalen Bildung war Dezallier d'Argenville im Laufe seines Lebens als Advokat, Naturforscher, Landvermesser und Gartenarchitekt tätig und trat zugleich durch wichtige Werke zu Literatur und Kunst sowie als Sammler hervor. Er beschäftigte sich darüber hinaus auch noch mit Musik und Kompositionslehre. Einen Namen machte er sich bereits im Alter von knapp dreißig Jahren mit dem Werk *La Théorie et la pratique du jardinage* (Paris 1709). Das Opus wurde viermal neu aufgelegt und ins Englische und Deutsche (*Die Gärtnerey sowohl in ihrer Theorie oder Betrachtung als Praxi oder Übung*, Augsburg, 1731) übersetzt. Sein nachhaltiger Erfolg führte schließlich zu zahlreichen Nachdrucken und selbst zu Plagiaten.

Wie es sich für einen Spross der guten Gesellschaft ziemte, brach Dezallier d'Argenville 1713 zu einer *Grand Tour* nach Italien auf, von der er erst nach mehr als zwei Jahren zurückkehrte. Der Aufenthalt im *Bel Paese* führte zu einer solchen Verfeinerung seiner Kenntnisse auf dem Gebiet der Kunst und Literatur, dass er 1714 in Rom zum Mitglied der Accademia dell'Arcadia ernannt wurde. Nach Paris zurückgekehrt, setzte er alles daran, sich eine brillante Karriere als hoher Beamter zu sichern. Er kaufte sich ein Amt als königlicher Sekretär, einen Ehrentitel, der ihn gleichzeitig in den Adelsstand erhob, und wurde Parlamentsadvokat. Die nächste Stufe auf der Karriereleiter sicherte er sich mit dem Kauf des Amtes eines *Maître des comptes* von Paris. Sein gesellschaftlicher Aufstieg gipfelte schließlich mit der 1748 erfolgten Verleihung des Titels *Conseiller du Roi et ses conseils*, der ihm eine Leibrente der französischen Krone gewährleistete. Dieses Privileg war die Anerkennung für seinen Einsatz als hoher Beamter und seinen Erfolg als Verfasser zahlreicher literarischer und wissenschaftlicher Werke, die er König Ludwig XV. (1710–1774) persönlich überreicht hatte.

Dezallier d'Argenvilles Sammelleidenschaft

In seinem in der Rue du Temple gelegenen, eleganten *Hôtel particulier* hatte Dezallier d'Argenville ein wahres Kuriositätenkabinett eingerichtet, in das er sich gerne zurückzog, um sich seinen naturwissenschaftlichen Studien und seiner schriftstellerischen Arbeit zu widmen. Neben zahlreichen Büchern beherbergte es Gegenstände aus der Welt der Kunst und der Natur-

wissenschaften, den beiden Wissensgebieten, denen seine Leidenschaft galt. Sein Vater hatte ihm eine beachtliche Sammlung von Bildern, Stichen, Zeichnungen, Bronzefiguren, Medaillen und Muscheln hinterlassen. Die Gemäldekollektion bestand aus knapp hundert Exponaten, aber der eigentliche Stolz des Besitzers war die graphische Sammlung, die Tausende von Zeichnungen und Stichen umfasste.

In seinem Kabinett empfing Dezallier d'Argenville jedoch auch gerne Besucher, die seine Schätze bewunderten. Zudem führte er regen Briefwechsel mit Gelehrten, Sammlern und Intellektuellen, die er im Laufe seiner Europareisen kennen gelernt hatte. Denn nach seinem langen Italienaufenthalt hatte er 1728 einige Monate in England verbracht und vermutlich auch die Niederlande und Deutschland bereist, die Länder, in denen eine Vielzahl von Sammlungen exotischer Muscheln zu besichtigen war. Seine Liebe zur Kunst trieb ihn jedoch nicht nur dazu an, seinen Bestand häufig um neue Exponate zu erweitern, sondern bewegte ihn auch dazu, aus seinem umfangreichen Wissen praktischen Nutzen zu ziehen. Deshalb verfasste er 1745 einen Abriss der Lebensgeschichten berühmter Maler (*Abrégé de la vie des plus fameux peintres*), den er trotz seines fortgeschrittenen Alters – er war damals bereits fünfundsechzig Jahre alt – kontinuierlich verbesserte und ergänzte. 1752 und 1762 erschienen erweiterte und überarbeitete Neuausgaben.

Gartenkunst und Bewässerungsanlagen gehörten von jeher zu Dezallier d'Argenvilles bevorzugten Beschäftigungen. Seinen ersten internationalen Erfolg verdankte er wie gesagt seinem Jugendwerk *La Théorie et la pratique du jardinage*. Die Vorlagen für die Bildtafeln dieses Werkes hatten sowohl der Autor selbst als auch sein berühmter Lehrmeister Jean-Baptiste Alexandre Le Blond (1679–1719) gestaltet, der ursprünglich als Verfasser des unter dem Pseudonym M*** erschienenen Werkes galt. Dank dieser Verdienste hatten Denis Diderot (1713–1784) und Jean Le Rond d'Alembert (1717–1783) Dezallier d'Argenville zur Mitarbeit an ihrer *Encyclopédie* aufgefordert, für die er fast sechshundert Lexikoneinträge über Gartenkunst und Bewässerungs- und Brunnenanlagen verfasste. Seine Leidenschaft hatte unter anderem auch konkreten Ausdruck gefunden in der Planung von Gärten, Parks, Labyrinthen, Gartentheatern und Brunnen für sein Landgut in Argenville und in der Folge für seine Ermitage in Bièvres in der Nähe von Versailles. Auch die Gräfin de Fuligny Rochechouart hatte er mit Ratschlägen und Entwürfen für ihren Park in Agey in der Bourgogne versorgt. Der Freundin hatte er eines seiner originellen Bankette beschrieben, bei dem er einigen an Naturkunde und Fossilien interessierten Damen als Dessert ein in Muscheln serviertes Gebäck aufgetischt hatte.

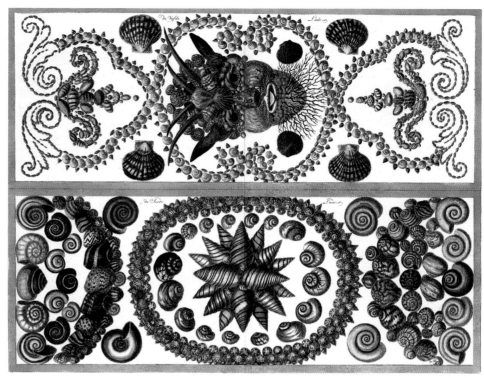

Die Muschelkunde

Dezallier d'Argenvilles Passion für Muscheln, Versteinerungen und Mineralien entstand als natürliche Folge seines Interesses für Bewässerungstechniken und Gartenkunst. Aufgrund seiner Auseinandersetzung mit den Methoden der Organisation und Klassifikation des Wissens in seinem Kuriositätenkabinett unterschied er die *simples curieux*, die die Exponate nach rein ästhetischen Gesichtspunkten anordneten, von den *savants* – zu denen er sich selbst zählte –, die nach Systemen suchten, um die Naturalien nach den jeweiligen Gattungsarten zu gruppieren. Seine Erfahrungen mit der eigenen Kollektion und mit den ihm bekannten Museen und Sammlungen in ganz Europa fasste Dezallier d'Argenville 1727 in der Schrift *Lettre sur le choix et l'arrangement d'un cabinet curieux* zusammen, in der er die Ansicht vertrat, dass das Hauptaugenmerk immer noch den Medaillen gelte. Die Situation sollte sich jedoch schnell ändern, nicht zuletzt aufgrund seiner Studien und der Tätigkeit des berühmten französischen Kunsthändlers und Sammlers Edme-François Gersaint (1694–1750). Denn kaum hatte dieser sich in Paris niedergelassen, führte er dort die Mode der von Auktionskatalogen begleiteten Versteigerungen ein. Als er bemerkte, dass sich eine Vorliebe für exotische Muscheln und Schnecken durchzusetzen begann, reiste Gersaint 1733 in die Niederlande, um die schönsten und seltensten Exemplare auszuwählen, die von weit entfernten Meeren dorthin verbracht worden waren. 1736 führte er in Paris die erste, von einem Katalog begleitete Versteigerung von Muscheln und anderen kuriosen Naturalia durch. Dem durchschlagenden Erfolg dieser Auktion und Gersaints Verkaufstalent ist es zu verdanken, dass sich in Paris und im gesamten Königreich nicht nur schlagartig die Muscheln- und Naturalienkabinette vermehrten, sondern auch die Wissenschaft der Conchologie in Frankreich ihren Anfang nahm. Denn unter Bezugnahme auf bestehende Werke versuchte Gersaint eine systematische Einordnung der *Conchylien*, gestand aber die Schwierigkeit ein, die Schalentiere mit den komplizierten und unübersetzbaren lateinischen und griechischen Ausdrücken zu bezeichnen. Er plädierte für eine auf Französisch verfasste, groß angelegte Studie über Muscheln und ihre Bewohner, die mit naturgetreuen Zeichnungen illustriert sein sollte. Mit dem plötzlichen Tod des berühmten Botanikers Joseph Pitton de Tournefort (1656–1708), der in den grundlegenden *Élements de botanique* (1694) die Pflanzen nach Art und Spezies klassifiziert hatte, war die Erforschung der Mollusken tatsächlich zum Stillstand gekommen. Obwohl Tourneforts Muschelsammlung in Paris blieb und mit der Kollektion Ludwig XIV. zusammengelegt wurde, kam seine neue Klassifikationsmethode nicht in Frankreich heraus, sondern wurde 1742 von Niccolò Gualtieri (1688–1744) in Italien veröffentlicht. Der Verfasser des ersten, ebenfalls 1742 in Frankreich erschienenen Werkes über Muschelkunde sollte hingegen Dezallier d'Argenville werden, der sich an Tourneforts systematischer Einordnung der Pflanzen orientierte. Im Katalog von 1736 nahm Gersaint nicht nur Dezallier d'Argenvilles reichhaltige Muschelsammlung in die Liste der berühmtesten *cabinets* Frankreichs und der Niederlande auf, sondern wies auch darauf hin, dass der Besitzer gerade an einer *Histoire des coquilles & des mineraux* arbeite, die in Kürze in Druck gehe. Wie bereits aus dem Titel *L'Histoire naturelle éclaircie dans deux de ses parties principales, la lithologie et la conchyliologie* hervorgeht, untersuchte der Naturforscher darin zwei zusammenhängende Aspekte der Naturgeschichte. Das der königlichen Gesellschaft der Wissenschaften zu Montpellier gewidmete Werk, deren Mitglied Dezallier d'Argenville 1740 geworden war, hatte sofort einen so großen Erfolg, dass es in kürzester Zeit vergriffen war. Das phantasievolle Frontispiz im Rokokostil stammte von François Boucher (1703–1770), dessen glänzende Karriere 1765 mit der Ernennung zum ersten königlichen Hofmaler ihren Höhepunkt fand (vgl. S. 2). Die schönsten und seltensten Muscheln seines Kabinetts zeichnete Dezallier d'Argenville selbst im Maßstab 1:1. Dabei bediente er sich eines Spiegels, damit die Exemplare auf den zweiunddreißig Tafeln, exzellenten Radierungen aus der Hand des Pierre-Quintin Chedel (1705–1763), naturgetreu wiedergegeben wurden. Die aufwendige Edition wurde von zahlreichen *savants* und *amateurs* finanziert, denen jeweils eine Tafel der *Histoire* gewidmet ist (Abb. 6). In seiner Abhandlung unterteilte Dezallier d'Argenville die Schalenweichtiere in Gattungen, Arten, Klassen und Familien. Neben ausführlichen „Erklärungen und Anmerkungen über jede Familie" und Hinweise auf die Orte und Methoden ihres Fanges sowie auf ihre unterschiedliche Nutzung lieferte Dezallier d'Argenville auch eine Anleitung, wie die Mollusken zu behandeln und ein *cabinet* aufzubauen seien. Darüber hinaus enthielt das Werk noch eine Liste der bedeutendsten naturkundlichen Sammlungen Europas und ein Verzeichnis von ungefähr zweitausend lateinischen und griechischen Fachausdrücken mit den jeweiligen Erklärungen auf Französisch. Der durch seine Ernennung zum Mitglied der Londoner Royal Society (1750) gekrönte Erfolg der Abhandlung spornte Dezallier d'Argenville dazu an, sich weiter seiner Forschung zu widmen. 1751 veröffentlichte er eine kurze Abhandlung über die in Frankreichs Regionen aufgefundenen Fossilien, *Enumerationis fossilium, quae in omnibus Galliae provinciis reperiuntur, tentamina*, deren Übersetzung ins Französische 1755 zusammen mit einer erweiterten Ausgabe der bereits zeitgleich zur *Conchyliologie* (1742) erschienenen *Lithologie* herauskam (*L'Histoire naturelle éclaircie dans une de ses parties principales, l'oryctologie, qui traite des terres, des pierres, des métaux, des minéraux et autres fossiles*, 1760 neu aufgelegt). Schließlich gab er

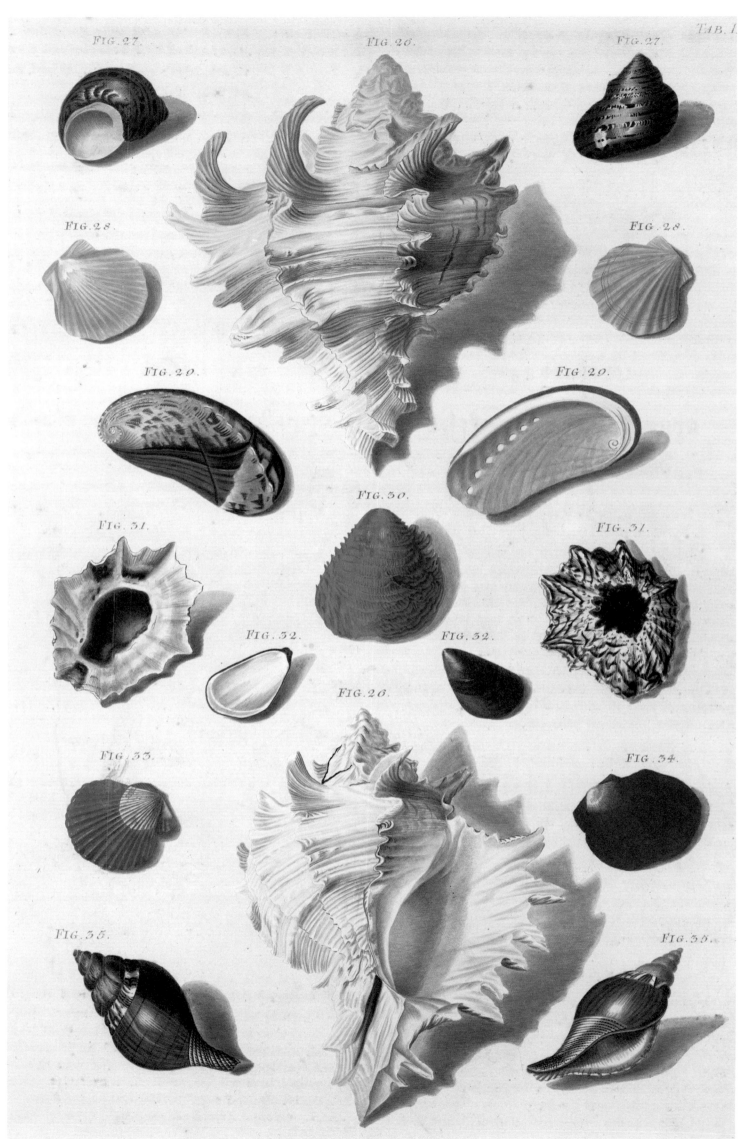

TAB. I.

FIG. 27. FIG. 26. FIG. 27.

FIG. 28. FIG. 28.

FIG. 29. FIG. 29.

FIG. 30.

FIG. 31. FIG. 31.

FIG. 32. FIG. 32.

FIG. 26.

FIG. 33. FIG. 34.

FIG. 35. FIG. 35.

Ill. 7
Ornamental arrangement of shells
depicting a stylised face, 1758
Ornamente aus Gehäusen von Weichtieren mit
Darstellung eines stilisierten Gesichts
Arrangement ornemental de coquilles de
mollusques représentant un visage stylisé
In: Albertus Seba, *Thesauri Rerum*
Naturalium locupletissimi,
Amsterdam, 1758, vol. III, plate 37

Ill. 8
Franz Michael Regenfuss
Ill. 26 *Chicoreus ramosus* L., 1758 (Ramose Murex, Giant Murex/
Riesenstachelschnecke/Pourpre), 27 *Turbo petholatus* L., 1758
(Tapestry Turban/Turbanschnecke/Turbo), 28 *Chlamys* sp. – (Scallop/
Kammuschel/Pétoncle), 29 *Haliotis asininus* L., 1758 (Donkey's Ear
Abaone/Esels-Meerohr/Oreille d'âne), 30 *Chama* sp. (Jewelbox/
Juwelendose/Chame), 31 *Patella granatina* L., 1758 (Sandpaper Limpet/
Napfschnecke/Patelle), 32 *Mytilidae* (Sea Mussel/Miesmuschel/Moule),
33 *Pectinidae* sp. (Scallop/Kammmuschel/Pecten), 34 *Pectinidae* sp. –
(Scallop/Kammmuschel/Pecten), 35 *Buccinidae* (Whelks and allies,
Wellhornschnecken und Verwandte, Buccins) oder *Fasciolariidae*?
(Tulips and Spindles/Spindelschnecken/Fasciolaires)
In: Franz Michael Regenfuss, *Auserlesene Schnecken,*
Muscheln und andre Schaalthiere, Copenhagen, 1758, plate IX

1757 das Werk in Druck, das heute als die zweite Ausgabe der *Conchyliologie* gilt. Der der Lithologie gewidmete Teil wurde hier durch die *Zoomorphose* ersetzt, eine „Abbildung und Beschreibung der Thiere, welche die Gehäuse bewohnen", wie Gersaint es 1736 als Desiderat formuliert hatte (*L'Histoire naturelle éclaircie dans une de ses parties principales, la Conchyliologie, qui traite des coquillages de mer, de rivière et de terre … augmentée de la Zoomorphose*). Das Werk wurde mit 41 Radierungen illustriert, die großteils aus der ersten Ausgabe des Jahres 1742 stammten. Zahlreiche Exemplare verfügten zudem über einen Anhang und drei neue Stiche mit der Abbildung einiger seltener Muscheln. Diese 1757 erschienene zweite Ausgabe war demnach sowohl inhaltlich erweitert – sie enthielt 572 bebilderte Objekte – als auch überarbeitet und verbessert. Dezallier d'Argenville hatte mehr als zehn Jahre in diese Arbeit investiert und sich aus Indien und zahlreichen Teilen Europas Zeichnungen der Mollusken zusenden lassen. Das Verdienst der Illustrationen der *Zoomorphose* bestand darin, dass sie zum ersten Mal Muscheln und ihre Bewohner naturgetreu wiedergaben. (Die dt. Übersetzung erschien 1772: *Conchyliologie oder Abhandlung von den Schnecken, Muscheln und andern Schaalthieren, welche in der See, in süssen Wassern und auf dem Land gefunden werden.*)

Der Verkaufserfolg der *Histoire naturelle* brachte Dezallier d'Argenville und seinen Verleger Guillaume François de Bure auf die Idee, die Bildtafeln einiger Exemplare der zweiten Ausgabe von Hand kolorieren zu lassen und die Bände mit Maroquinledereinband und Goldschnitt zu versehen. Diese Luxusedition kostete 240 französische Livre, etwa fünf Mal so viel wie die gewöhnliche Ausgabe. Bis an sein Lebensende beschäftigte sich Dezallier d'Argenville mit Muscheln. Seinem Verleger, dem Buchhändler de Bure, hatte er weitere Ergänzungen seiner *Histoire naturelle* anvertraut, doch sein Tod am 29. November 1765 setzte dem Vorhaben einer neuen Ausgabe definitiv ein Ende. Im März 1766 wurde sein Naturalienkabinett mit Tausenden von Muscheln und Schnecken auf einer Auktion angeboten und in alle Winde zerstreut. Das gleiche Schicksal erlitten seine Gemälde- und seine Graphiksammlung. Anders als seine Kollektion überlebte der Ruf der *Histoire naturelle* das Ableben ihres Verfassers: Jacques de Favanne de Montcervelle und dessen Sohn Guillaume, naturkundliche Zeichner im Dienste der französischen Krone und passionierte Muschelsammler, beschlossen, eine dritte Ausgabe von Dezallier d'Argenvilles Lebenswerk herauszugeben. Die *Conchyliologie, ou Histoire naturelle des coquilles de mer, d'eau douce, terrestres et fossiles, avec un traité de la zoomorphose, ou représentation des animaux qui les habitent* erschien 1780 in demselben Verlag de Bure wie auch die vorhergehende Edition. Vater und Sohn de Favanne verfolgten ein ehrgeiziges Vorhaben: La

Conchyliologie sollte das aktuellste und vollständigste Werk sein, das je in Frankreich zu diesem Thema erschienen war. Um diesem hochgesteckten Ziel gerecht zu werden, verbesserten sie alle Fehler, die Dezallier d'Argenville in der Klassifikation der Schalentiere unterlaufen waren, und fügten erhebliche Ergänzungen zu den einzelnen Kapiteln hinzu. Überdies statteten sie das Werk zusätzlich mit einem von Hyacinthe Rigaud (1659–1743; vgl. S. 4) geschaffenen Porträt Dezallier d'Argenvilles aus und ergänzten es mit einem Apparat von dreiundachtzig von ihnen selbst gezeichneten und eigens für den Band in Kupfer gestochenen Tafeln. Die 1780 erschienene, zweibändige Ausgabe der *Conchyliologie* hat zwei unterschiedliche Frontispize, zum einen das von Boucher entworfene Titelblatt, zum anderen die Darstellung verschiedener Muschelfangmethoden vor dem Hintergrund einer Meereslandschaft (S. 44). Das Titelblatt des zweiten Bandes zeigt eine Ansicht der Insel Aix (S. 206). Eine der 80 Tafeln enthält die vom Werk Martin Listers (ca. 1638–1712) übernommene Anatomie einiger Mollusken, auf einer anderen ist eine von muschelfressenden Tieren bevölkerte Landschaft zu sehen (Tafeln LXXVII und LXXVIII). Auf den übrigen Tafeln sind 2008 zum Teil bis dato unbekannte Arten der Schalentiere abgebildet. In diese dritte Ausgabe nahmen Jacques und Guillaume de Favanne alle von Dezallier d'Argenville beschriebenen *Conchylien* auf, mit Ausnahme der allseits bekannten, fügten jedoch auch neue hinzu, die von anderen Autoren bereits beschrieben oder in Muschelkabinetten der ganzen Welt abgebildet worden waren. Aus dieser Fülle zusammengetragenen Materials gestalteten Vater und Sohn de Favanne die farbigen Entwürfe für die Radierungen. Um schneller voranzukommen, stellten sie ein Team von zwölf Spezialisten zusammen, unter denen Vincent Vangelisty hervorstach. Für diese Ausgabe hatte der Verleger jedoch keine kolorierten Tafeln vorgesehen. Bei den wenigen farbigen Exemplaren handelt es sich demnach um besonders kostbare Einzelstücke, die die Besitzer bzw. Käufer in eigenem Auftrag von Hand kolorieren ließen. Ihre Qualität ist daher sehr unterschiedlich. Die Spannbreite geht von flüchtig und dilettantisch ausgeführten Tafeln bis zu akkurat und künstlerisch wertvoll kolorierten Bänden wie der exzellenten Vorlage für den hier präsentierten Nachdruck. Da es kein einheitliches Vorbild gab, auf das man sich hätte beziehen können, sind die Farben der Muscheln nicht immer naturgetreu und weisen gravierende Unterschiede auf. Das erklärt auch den Entschluss einiger Eigentümer des Werkes, die kolorierten Tafeln in einem dritten Band gesondert binden zu lassen. Aus diesem Grund waren die Marktpreise bereits Ende des 18. Jhs. sehr unterschiedlich. Je nach Qualität der Radierungen und des Einbandes konnten die Exemplare bis zu 500 oder 600 französische Livres kosten.

Dezallier d'Argenville beabsichtigte mit seiner *Histoire naturelle,* ein gleichermaßen künstlerisches wie wissenschaftliches Werk zu verfassen, während Jacques und Guillaume de Favanne den hedonistischen Zweck der *Conchyliologie* betonten. Nach dem Vorbild des *Thesaurus* von Albertus Seba (1665–1736) überwogen bei ihnen die Tafeln mit dekorativen und symmetrischen Muschelabbildungen. Dezallier d'Argenvilles und de Favannes Beitrag zur Malakologie wurde bald von editorisch bescheideneren, aber unter wissenschaftlichem Gesichtspunkt aktuelleren Veröffentlichungen übertroffen. Ihre Bedeutung für die Verbreitung naturwissenschaftlichen Wissens blieb jedoch grundlegend, denn die Vorliebe für Naturgeschichte und insbesondere für Muscheln hatte nunmehr die Passion französischer Sammler für antike Kunst auf den zweiten Rang verwiesen. Im 18. Jh. entstanden immer mehr naturkundliche Sammlungen: 1742 führte Dezallier d'Argenville noch siebzehn auf, während er 1757 bereits zwanzig verzeichnete. 1780 waren Vater und Sohn Favanne de Montcervelle bereits 135 Kollektionen dieser Art bekannt.

Muschelkunde und Muschelmanie.
Bücher und Muschelsammlungen in der Neuzeit

Als im Jahr 1780 die *Conchyliologie* in Druck ging, war das Thema seit fast zweieinhalb Jahrhunderten Gegenstand gelehrter Studien. Bereits im Jahr 1553 veröffentlichte der Arzt und Heilpflanzensammler Pierre Belon (1517–1564) in Paris den Band *De aquatilibus, Libri duo,* ein den Meerestieren gewidmetes Werk mit dreißig von Pierre Gourdelle angefertigten Holzschnitten, in dem zum ersten Mal zahlreiche *Conchylien* beschrieben wurden. Im Laufe seiner Reisen in die Mittelmeerländer und an den Atlantik hatte Belon Mollusken und andere Tiere beobachtet und abgebildet. Sein Werk erschien ein knappes Jahr vor den *Libri de Piscibus Marinis* von Guillaume Rondelet (1507–1566), Arzt und Professor der Universität zu Montpellier. Es handelte sich um einen kostbaren Folioband mit der Darstellung von Meerestieren auf Hunderten von Holzschnitten aus der Hand des Künstlers Georges Reverdy. Der zweite, 1555 erschienene Teil von Rondelets *Universae aquatilum Historiae pars altera* enthält ein den Muscheln und Schnecken gewidmetes Kapitel, die hier im Vergleich zu Belon präziser beobachtet und akribischer wiedergegeben werden. Die Werke dieser beiden französischen Vorreiter wurden in der *Historiae Animalium Liber III* des Schweizer Naturforschers Konrad Gessner (1516–1565) vollständig zitiert. Der mit einem Apparat von mehr als 700 Holzschnitten versehene Band erschien 1558 und stellte einen Teil von Gessners umfangreichem enzyklopädischen Projekt dar, einen Überblick über den Kenntnisstand der Zeit zu vermitteln.

Während die *Libri historiae animalium* (1551–1558) das gesammelte Wissen über die Tierwelt enthalten sollten, bezog sich die *Bibliotheca universalis* (1545) auf die literarische Kultur.

Die Ärzte und Zoologen des 16. Jhs. ergänzten ihre Veröffentlichungen zwar auch durch eigene Beobachtungen, trugen jedoch weitgehend Schriften antiker Autoren zusammen. Unverzichtbarer Ausgangspunkt waren Aristoteles (384–322 v. Chr.) und Plinius der Ältere (23–79 n. Chr.). Ersterer hatte in seiner Abhandlung *De animalibus* die *Conchylien* nach ihrem Habitat eingeteilt, d. h. in Schalentiere, die sich auf dem Land bewegen und solche, die im Meer leben, wobei er bei letzteren zwischen *univalvia* und *bivalvia* unterschied. Plinius der Ältere hingegen hatte in seiner *Naturalis historiae* die Schalen tragenden Weichtiere in drei Familien – Mollusken, Krustazeen und Testazeen – geordnet. Die Identifizierung der von den antiken Autoren behandelten Arten blieb jedoch ein eher kühnes Unterfangen, da ihre literarischen Beschreibungen oft zweideutig waren und sie die Namengebung nicht durchgängig beibehalten hatten. Zudem führte die nicht hinterfragte *auctoritas* der antiken Naturforscher dazu, dass auch Fabelwesen wie die Hydra oder der Mönchsfisch in die Verzeichnisse aufgenommen wurden.

Ab Mitte des 16. Jhs. spielte die wissenschaftliche Abbildung in Form von Zeichnungen oder Stichen nach der Natur eine unverzichtbare dokumentarische und didaktische Rolle in der Beobachtung und Klassifikation der Tier- und Pflanzenwelt. Der Erfolg der im 16. Jh. verfassten naturkundlichen Abhandlungen und Abbildungen war nicht nur einem kleinen Kreis von Gelehrten zu verdanken, sondern erklärte sich hauptsächlich aus dem Interesse herausragender Sammler und Fürsten, die sowohl untereinander als auch besonders mit Naturforschern und Künstlern einen regen Kontakt und Austausch pflegten. Die ersten Muschelsammlungen sind aus den Niederlanden überliefert. Eine davon besaß Erasmus von Rotterdam (1466–1536), zahlreiche andere bekam Albrecht Dürer (1471–1528) auf seiner Reise nach Antwerpen zu sehen. Durch den unaufhaltsamen Aufstieg der Niederlande als Kolonialmacht in Asien, Indonesien, Südafrika und Australien und die Schaffung von Handelsgesellschaften wie der Niederländischen Ostindien-Kompanie (1602) bzw. der Westindien-Kompanie (1616) konnte sich die Republik der Sieben Vereinigten Provinzen der höchsten Konzentration an malakologischen Sammlungen in ganz Europa rühmen. Bekanntlich war auch die Shell Oil Company ursprünglich dem Handel mit Muscheln nicht abgeneigt. Die Entdeckung Amerikas und der daraufhin zunehmende Reise- und Handelsverkehr mit Indien und dem fernen Orient hatten zur Folge, dass die Europäer viele bisher unbekannte Pflanzen- und Tierarten kennen lernten. Muscheln und Schnecken, gleichermaßen begehrt von Sammlern

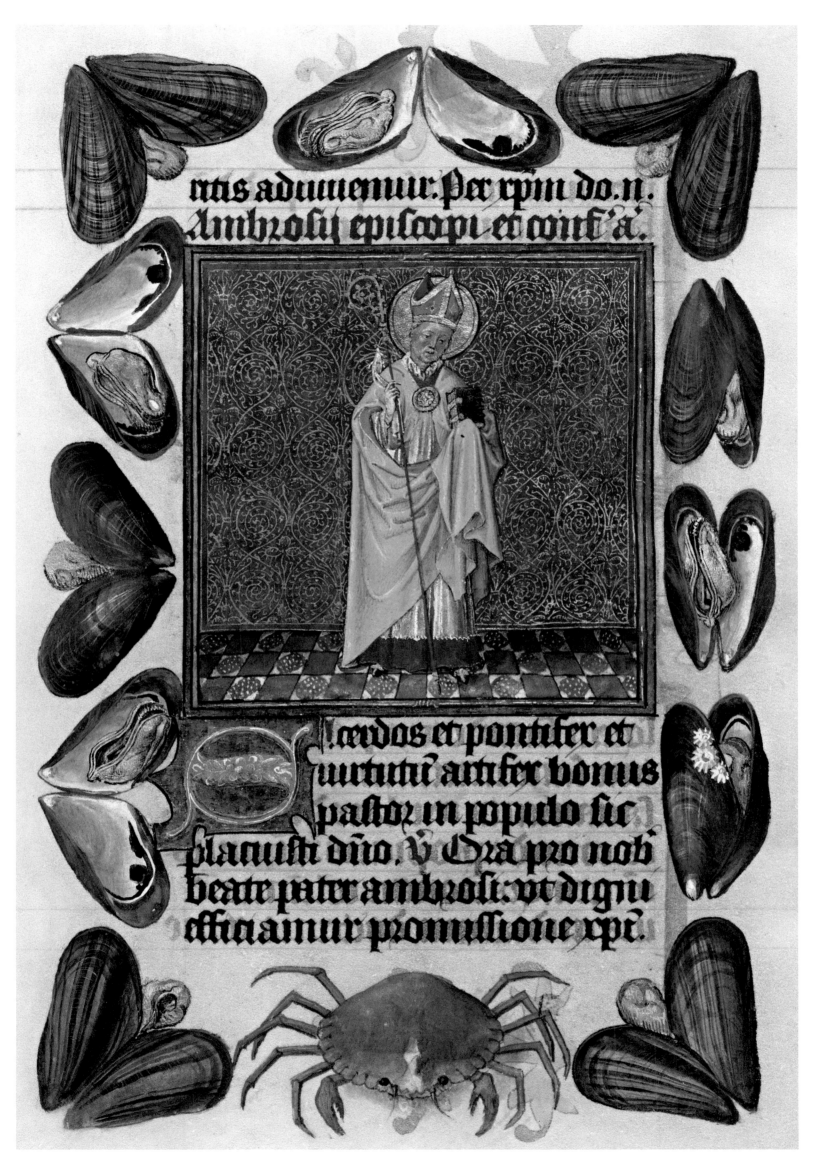

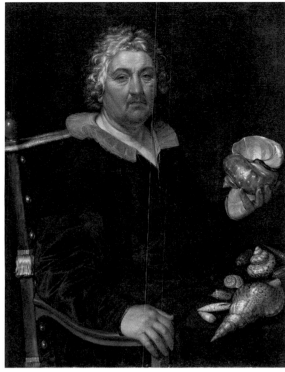

und Naturforschern, galten als kostbare Ware und trafen aus fernen exotischen Ländern in den Häfen der bedeutendsten Seemächte Europas ein.

In der zweiten Hälfte des 16. Jhs. waren die Höfe besonders aufgeklärter italienischer und deutscher Herrscher rege Zentren naturkundlicher Forschung, die auch die Beschäftigung mit Muscheln berücksichtigte. Die Regenten legten umfangreiche Sammlungen von *naturalia* und *artificialia* an und umgaben sich mit einschlägigen Naturforschern und Künstlern. Bekannt ist die Zusammenarbeit zwischen dem Sieneser Arzt Pietro Andrea Mattioli (1500–1577) und dem Udineser Maler Giorgio Liberale (ca. 1527–1579/80), die am Hofe des Tiroler Erzherzogs Ferdinand II. (1529–1595) im Schloss Ambras ihren Anfang genommen hatte. Von 1562 bis 1576 malte Liberale für den Erzherzog einen Kodex von 100 Blättern auf Kalbspergament mit Darstellungen von Meerestieren aus der Adria (Abb. 2). Es handelt sich um die erste und umfangreichste Dokumentation von Exemplaren der Meeresfauna der Adria, die zum Teil als Vorlage für die Holzschnitte diente, mit denen Mattioli seinen Kommentar zur Arzneimittellehre des Griechen Dioskurides (1. Jh. n. Chr.), *De Materia medica* (1564), illustrierte. Auf den von Giorgio Liberale aquarellierten, großformatigen Tafeln werden die Meerestiere mit feinster Präzision wiedergegeben. Die raffinierten *Trompe-l'Œil*-Effekte lassen gleichzeitig erkennen, dass der Künstler trotz des naturwissenschaftlich orientierten Ansatzes nicht auf eine ästhetische und ornamentale Formensprache verzichten wollte. Zur selben Zeit arbeitete der Mailänder Giuseppe Arcimboldo (1526–1593) als naturkundlicher Illustrator in Wien und Prag für das Haus Habsburg. Seinen Ruf begründeten nicht nur naturalistisch gemalte Tierstudien, sondern vor allem bizarre, aus unterschiedlichsten Gegenständen wie Früchten, Gemüse oder Tieren zusammengesetzte „Köpfe". Unter diesen anthropomorphen „Porträts" sticht eine im Auftrag Maximilians II. (1527–1576) entstandene *Allegorie des Wassers* hervor, die aus sage und schreibe zweiundsechzig unterschiedlichen Arten von Fischen, Schalentieren, Muscheln und Mollusken besteht (Abb. 1).

Als Nachkomme einer traditionsreichen Veroneser Familie von Malern und Stickern, die seit Generationen im Dienste des Hauses Habsburg stand, zeichnete Jacopo Ligozzi (ca. 1547–1627) für den Prager Hof Rudolfs II. zwanzig Pergamenttafeln mit Fischdarstellungen. Nachdem er bald zum berühmtesten und begehrtesten naturkundlichen Zeichner aufgestiegen war, rief ihn Großherzog Francesco I. de' Medici (1541–1587) an seinen Hof, der sich auf den Fußspuren seines Vaters Cosimo I., des Gründers der botanischen Gärten von Pisa und Florenz, zu einem passionierten Naturaliensammler und einem kühnen Vorreiter auf dem Gebiet der Naturwissenschaften und der Alchemie entwickelt hatte. Seit 1570 hatte Francesco I. im berühmten *Studiolo* des Palazzo Vecchio, seinem privaten Gelehrtenzimmer, die kostbaren Kuriositäten in seinem Besitz zu einer Sammlung geordnet. Eine ganze Wand war dem Wasser gewidmet, einem der vier Elemente, das der Großherzog als Ordnungskriterium für seine Kollektion ausgewählt hatte. Die Schränke auf dieser Seite des Arbeitszimmers, deren Schubladen mit allegorischen und mythischen Meeresmotiven dekoriert waren, beherbergten Nautiliden, Muscheln, Schwämme, Korallen, Perlen und Wasserfossilien. Die komplexen astrologischen Bedeutungen und esoterischen kosmischen Allegorien der Dekorationen wurden in der später errichteten *Tribuna* der Uffizien (1584) noch stärker betont. Hier brachte der Großherzog seine kostbaren Sammlungen antiker und moderner Kunst und naturkundlicher Raritäten unter, wobei er das Element Wasser besonders effektvoll betonte. Die achteckige hohe Kuppel war vollständig mit glänzendem Austernperlmutt ausgekleidet, während der Sockel der acht Seiten von Ligozzi mit einem heute nicht mehr erhaltenen Fries aus Fischen und Muscheln abgeschlossen wurde.

Einige der äußerst gefragten Tier- und Pflanzenabbildungen aus der Hand Ligozzis und Arcimboldos erregten auch die Aufmerksamkeit des berühmten Bologneser Arztes und Naturforschers Ulisse Aldrovandi (1522–1605). Für die Illustrierung seiner umfangreichen zoologischen Enzyklopädie beschäftigte er auf eigene Kosten eine Gruppe naturkundlicher Maler und Kupferstecher. Der eindrucksvolle graphische Apparat, heute Bestandteil der Universitätsbibliothek Bologna, enthält mehr als 2900 Bildtafeln. Auf den 650 Holzschnitten des 1606 in Bologna erschienenen Bandes *De reliquis animalibus exanguinibus* sind rund hundert Schalentiere abgebildet.

In ihrer Annäherung an die Welt der Natur waren die Ärzte und Naturforscher des 16. Jhs. zweifellos noch von dem Kuriosen und Wunderbaren angezogen. Obwohl dieser eher enzyklopädische und universelle Ansatz bis Mitte des 17. Jhs. dominierend war, spezialisierten die privaten „Liebhaber" ihre Sammlungen jedoch immer mehr unter dem Gesichtspunkt der naturwissenschaftlichen Erkenntnis. Ihre Kabinette, eine Mischung aus Museum und Versuchsanstalt, die nach gewissen taxonomischen Kriterien geordnet waren, verloren zunehmend den Aspekt eines chaotischen und hedonistischen Eklektizismus, wie er die nordeuropäischen Wunderkammern gekennzeichnet hatte. Als älteste Darstellung einer dieser naturwissenschaftlichen Sammlungen gilt ein Holzschnitt aus dem Jahr 1599, auf dem der neapolitanische Apotheker Ferrante Imperato (1550–1625; Abb. 3) einige Edelleute durch sein privates Museum führt. In dem mit Bücherregalen und Schaukästen gefüllten Raum sind die verschiedensten Naturalien ausgestellt, darunter auch ein Dutzend Muscheln und Schalentiere.

Die im Rahmen der Accademia dei Lincei durchgeführten naturwissenschaftlichen Untersuchungen und die Entdeckungen des Galileo Galilei (1564–1642) – seit 1611 Mitglied dieser Akademie zur Förderung der Naturwissenschaften – hatten Anfang des 17. Jhs. neue Horizonte für die Erforschung der Natur eröffnet. Dank des Einsatzes von Fernrohr und Mikroskop wurde dem Sehen als Hauptinstrument der Vernunft und der Erkenntnis ein besonderer Wert zugewiesen. Exemplarisch für dieses neue Klima waren die Untersuchungen des neapolitanischen Rechtsgelehrten und passionierten Naturforschers Fabio Colonna (1567–1640), ebenfalls Mitglied der Accademia dei Lincei. Durch den Vergleich zwischen versteinerten und lebenden Schalenweichtieren konnte Colonna den organischen (und nicht anorganischen) Ursprung dieser Tiere nachweisen. Seine Untersuchungen waren grundlegend für die weitere Forschung über fossile und lebende Muscheln.

Einer seiner Anhänger war der Maler und Naturforscher Agostino Scilla (1629–1700). In seinem von Pietro Santi Bartoli (1635–1700) mit exzellenten Radierungen illustrierten Werk *La vana speculazione disingannata dal senso* (1670) wies er mit Hilfe von anatomischen Sektionen den organischen Ursprung fossiler Mollusken nach. 1675 gab der Kieler Arzt Johann Daniel Major (1634–1693) eine neue Ausgabe von Colonnas *Opusculum de purpura* heraus, in der zum ersten Mal der Versuch unternommen wurde, lebende Schalenweichtiere zu klassifizieren. Majors Einteilung in *univalvia, bivalvia* und *turbinata* wurde auch von dem Jesuitenpater Filippo Buonanni (1638–1725) in seiner *Ricreatione dell'occhio e della mente nell'Osservation' delle Chiocciole* übernommen (1681; die lateinische Ausgabe stammt aus dem Jahr 1684, wurde 1691 überarbeitet und im *Musaeum Kircherianum* 1709 neu aufgelegt). In dieser mit schönen Radierungen versehenen Edition (Abb. 4) vertrat Buonanni die aristotelische These der Urzeugung der Fossilien aus der *vis plastica* (einer Art ‚gestalterischen Kraft') des Gesteins. Seit 1698 Kustos des Museums des Collegio Romano, einer Gründung des Jesuitenpaters Athanasius Kircher (1602–1680), konnte Buonanni dort die Anatomie und Farbe Hunderter von Muscheln und Schnecken unter dem Mikroskop untersuchen. Diese neue Perspektive brachte den Naturforscher jedoch nicht von der Überzeugung ab, die Natur sei die unerschöpfliche Quelle „gestalteten Gesteins", das pflanzliche oder tierische Formen wiedergebe. Der blinde Glaube an die Existenz solcher „Naturspiele" veranlasste Buonanni, selbst der Legende der sarmatischen Schnecke Glauben zu schenken, die auf einer Tafel der *Ricreatione* abgebildet ist.

Zur selben Zeit führten Francesco Redi (1626–1697) und Antonio Felice Marsili (1649–1710) sowie später René-Antoine de Réamur (1683–1757) Untersuchungen über die Vermehrung der Mollusken durch, die dem Glau-

ben an die Urzeugung endgültig den Boden entzogen. Dennoch setzten sich diese revolutionären – und gefährlichen – Theorien nur gegen große Widerstände durch, denn sie implizierten das Eingeständnis, dass einige Fossilien die Existenz ausgestorbener Arten bezeugten, was wiederum die ewige Vollkommenheit der göttlichen Schöpfung in Frage stellte. In der zweiten Hälfte des 17. Jhs. veranlasste das Auffinden von Muscheln und anderen Fossilien die Naturforscher dazu, die Erde nicht mehr ausschließlich in ihrem gegenwärtigen Aspekt zu untersuchen. Allmählich begann sich die Erkenntnis durchzusetzen, dass die Natur das Ergebnis einer langen Entwicklung sei. Der Fall des englischen Arztes Martin Lister (ca. 1638–1712) zeigt jedoch, wie schwierig es war, sich diese evolutionistische Weltsicht tatsächlich zu eigen zu machen. Obwohl seine Methodenlehre über die Erforschung der Schalenweichtiere auf genauer Anschauung basierte, vertrat er weiterhin die These, auf der Erde vorhandene Samen seien in der Lage, je nach verschiedenen Umweltbedingungen unterschiedliche Arten von Lebewesen zu erzeugen. In der *Historia animalium Angliae* (1678) und vor allem in den fünf Bänden seiner *Historia Conchyliorum* (1685–1692) schlug er ein neues Klassifikationssystem für die mehr als tausend Mollusken vor, die er in seiner eigenen Sammlung, in der Sir William Courtens alias Charlton (1572–1636), sowie im Oxforder Ashmolean Museum mit eigenen Augen gesehen hatte. Im Unterschied zu vorangegangenen Veröffentlichungen sind bei Lister die Gehäuse tragenden Tiere zum ersten Mal nicht seitenverkehrt dargestellt, und geben so wichtige Einzelheiten wie die Muschelmündung (*stoma*) der Gasteropoden naturgetreu wieder.

Anfang des 17. Jhs., zur selben Zeit, als in den Niederlanden die Tulpenmanie grassierte, die 1637 schließlich zum Börsenkrach führte, war es in den Niederlanden auch Mode geworden, seltene exotische Muscheln zu sammeln und zur Schau zu stellen. Für diese Objekte der Begierde wurden zum Teil exorbitante Preise gefordert. Diese wahre „Muschelmanie" war der Anlass für das Motto, das der Händler und Dichter Roemer Visscher (1547–1620) unter eine Darstellung von Muscheln an einem Strand setzen ließ: „Grässlich ist mit anzusehen, was ein Tor mit seinem Geld anstellen kann" (*Sinnepoppen*, 1614). Auch ein scharfsinniger Moralist wie La Bruyère (1645–1696) verspottete Sammler wie Spekulanten, die ihren Muscheln die unglaublichsten Namen gaben: „Wenn Sie jemanden von seinem *Leoparden*, seiner *Feder* oder seiner *Musik* sprechen hören, die als die seltensten und wunderbarsten Dinge auf Erden gepriesen werden, käme es Ihnen dann in den Sinn, er wolle nur seine Muscheln verkaufen? Warum nicht, wenn er sie zu einem gepfefferten Preise erwirbt?" Zu den berühmtesten Muschelsammlungen, die sich damals in ganz Europa großer Beliebtheit erfreuten, zählten

die Kollektion des englischen Botanikers John Tradescant (ca. 1570–1638), die von John Tradescant dem Jüngeren (1608–1662) erweitert und schließlich vom Oxforder Ashmolean Museum erworben wurde, die Londoner Sammlung des Apothekers James Petiver (1658–1718) und das auf jamaikanische Muscheln spezialisierte Kabinett des Vorsitzenden der Royal Society, Sir Hans Sloane (1660–1753), heute im Besitz des British Museum. Erwähnenswert sind weiterhin das von Ole Worm (1588–1654) gegründete Museum in Kopenhagen und das Museum der Abtei Sainte-Geneviève in Paris, sowie die *cabinets* des Kardinals Jules Mazarin (1602–1661), Nicolas Boucot (†1699), Joseph Pitton de Tournefort (1656–1708) und Gaston d'Orléans (1608–1660). In Italien waren zwei Museen von großer Bedeutung, das des Venezianers Andrea Vendramin (1554–1629), nach dessen Tod nach Amsterdam verlagert, und das des Veronesers Ludovico Moscardo (ca. 1611–1681). Berühmt war auch die Kollektion des Mailänders Manfredo Settala (1600–1680). Internationalen Ruhm jedoch genoss die außergewöhnliche malakologische Sammlung im Besitz des Großherzogs Cosimo III. de' Medici (1642–1723), der 1682 die des bekannten niederländischen Naturforschers Georg Eberhard Rumpf (1627–1702) erworben hatte. Im Jahr 1683 schenkte Cosimo III. einen beträchtlichen Teil der Rumpfschen Sammlung dem Marchese Ferdinando Cospi aus Bologna, der die rund vierhundert! Muscheln von Jacopo Tosi in einem heute in der Bologneser Universitätsbibliothek aufbewahrten Band abbilden ließ. Das Museum Cospi wiederum wurde von seinem Gründer dem Senat von Bologna gestiftet, der es zunächst im Palazzo Pubblico und in der Folge zusammen mit dem Kabinett Aldrovandi im Istituto delle Arti e delle Scienze unterbrachte (1742).

Rumpf, ein Inspektor der Niederländischen Ostindien-Kompanie auf der Molukken-Insel Ambon, hatte lange Zeit die Seetiere des Indischen Ozeans und des Pazifiks erforscht. Diese seltene Gelegenheit wurde jedoch durch eine Reihe von Schicksalsschlägen behindert. Im Alter von erst vierzig Jahren erblindete Rumpf, während die von seinem Sohn angefertigten, druckreifen Illustrationen der Brandkatastrophe des Jahres 1687 zum Opfer fielen. Die neu gestochenen 60 Tafeln und der handgeschriebene Text gelangten schließlich unversehrt in die Niederlande, wo sie 1705 auf deutsch veröffentlicht wurden (*D'Amboinsche Rariteitkamer*). Das Werk stellt einen grundlegenden Beitrag zur tropischen Muschel- und Schneckenkunde und zur biologischen Erforschung der Tiere in ihrer natürlichen Lebensumwelt dar. Die 1711 erschienene Übersetzung ins Lateinische, *Thesaurus cochlearum* (Abb. 5), auf die weitere Auflagen und Übertragungen in andere Sprachen folgten, trug dazu bei, dass sich der Ruf dieses „Plinius Indicus", wie sein Beiname lautete, in ganz Europa verbreitete. Einige *Conchylien* aus Rumpfs

Sammlung gingen später in den Besitz des italienischen Naturforschers Niccolò Gualtieri über. Auf den 110 Tafeln von Gualtieris *Index Testarum Conchyliorum* (1742) sind die später zum Teil in den Bestand der naturwissenschaftlichen Sammlungen der Universität Pisa verbrachten Schalentiere meisterhaft abgebildet.

Im selben Jahr erschien in Paris Dezallier d'Argenvilles *Histoire naturelle*. Obwohl unser Autor die *curieux* tadelte, die Naturalien, und insbesondere Muscheln sammelten und dabei die methodische Ordnung dem Genuss des Auges opferten, gaben die Naturalienkabinette und naturkundlichen Museen bis mindestens Ende des 19. Jhs. weiterhin einer in ästhetischer Hinsicht ansprechenden Präsentation der Exponate den Vorzug, die beim Besucher Bewunderung und Erstaunen erregen sollte (Abb. 6). Ein bekanntes Beispiel dafür sind die Bildtafeln im dritten Band von Albertus Sebas *Thesaurus* (1758), auf denen die Muscheln aus Sebas Sammlung ornamental und anthropomorph angeordnet sind. Bei diesen Illustrationen handelt es sich um eine der ersten farbigen Abbildungen von Mollusken (1734–1765; Abb. 7). Viele dieser ehrgeizigen Unternehmen scheiterten an Finanzierungsproblemen. Von den drei ursprünglich geplanten, aufwendigen Foliobänden des Kupferstechers Franz Michael Regenfuss (ca. 1712–1780) etwa, der im Dienste König Friedrichs V. von Norwegen und Dänemark stand, erschien ausschließlich der erste Band, *Choix de coquillages et de crustacés* (*Auserlesene Schnecken, Muscheln*, eine zweisprachige Ausgabe, 1758), der zwar nur zwölf, dafür aber umso erlesener gestaltete Bildtafeln enthielt (Abb. 8). Die meisterhaft ausgeführten, kolorierten Kupferstiche mit den kunstvollen Kompositionen galten bis zum 19. Jh. als Vorbild für weitere Werke dieser Art.

Diese faszinierenden Illustrationen spiegelten jedoch keineswegs den neuesten Erkenntnisstand wider. Denn der Zeitgenosse Carl von Linné (1707–1778, auch als Carolus Linnaeus bekannt), ein schwedischer Botaniker, hatte in seinem bahnbrechenden Werk *Systema naturae* (1735–1767) ein heute noch verwendetes, auf den Geschlechtsorganen beruhendes Klassifikationssystem der Lebewesen entwickelt. Nachdem er zunächst nur acht Gattungen von Mollusken ermittelt hatte, legte Linné in der letzten Ausgabe mit seiner neuen Einteilung in 35 Gattungen und 807 Arten die Grundlagen für eine korrekte Klassifikation dieser Tiere.

Ab Mitte des 18. Jhs. wurde Linnés Systematik zum obligatorischen Ausgangspunkt für alle Naturforscher, darunter F. H. W. Martini und J. H. Chemnitz, Verfasser eines elfbändigen, mit farbigen Bildtafeln illustrierten Werks, *Neues systematisches Conchylien-Cabinet* (1769–1786), sowie Ignaz von Born (1742–1791), der im Auftrag der österreichischen Kaiserin Maria Theresia 1780 die Schnecken- und Muschelsammlung des Kaisers Franz Stephan

Ill. II

von Lothringen in einem Band mit achtzehn handkolorierten Darstellungen verewigte (*Testacea Musei Caesarei Vindobonensis*). Die Zahl von Untersuchungen über Muscheln und Schnecken war so sprunghaft angestiegen, dass ein Bedarf an ersten Nachschlagewerken entstand. Sie sollten einen Überblick vermitteln über die gesamte Entwicklung der Malakologie bis hin zum neuesten Forschungsstand. 1775 erschien in Paris das *Dictionnaire* des Abtes Christophe Elisabeth Favart d'Herbigny (1725–1793), während im Jahr darauf in London Mendez da Costas (1717–1791) *Elements of Conchology* in Druck ging. 1776 war bei Mendez' Londoner Verleger, Benjamin White, der vierte Band der *British Zoology* von Thomas Pennant (1726–1798), der den *Crustacea, Mollusca, Testacea* gewidmet und mit rund hundert kleinformatigen Bildtafeln illustriert war, bereit für die Drucklegung. 1803 griff George Montagu (1753–1815) Pennants Untersuchungen der einheimischen Fauna in dem mit sechzehn schlichten Tafeln versehenen Werk *Testacea Britannica* wieder auf. Dem auf dem Gebiet der Muschelkunde blühenden englischen Markt ist ein weiteres grundlegendes Werk der zweiten Hälfte des 18. Jhs. zu verdanken: 1784 erschien die vierbändige Ausgabe von Thomas Martyns (1735–1825) *The universal Conchologist*. Die mit 120 farbigen Bildtafeln illustrierten Folianten dienten zusammen mit Ignaz von Borns Prachtbänden allen späteren Muschelabbildungen als Vorbild. Internationalen Ruhm erlangten auch die Studien der beiden französischen Naturforscher Jean-Guillaume Bruguière (1750–1798) und Jean Baptiste Pierre de Monet de Lamarck (1744–1829), auf die der Engländer George Perry (ca. 1780–1859) in seiner *Conchology or the Natural History of Shells* (1811) Bezug nahm. Perrys Werk, das von John Clarke mit 61 Bildtafeln illustriert wurde, beruht auf den Klassifikationen der französischen Naturforscher. Das letzte bedeutende Opus des 18. Jhs. zur Muschelkunde mit dem Titel *Testacea Utriusque Siciliae* erschien 1791 in Italien. Es stammt aus der Hand des bekannten italienischen Arztes Giuseppe Saverio Poli (1746–1825), Mitglied der Royal Society.

Das Muschelmotiv in der Kunst

Muscheln galten stets als „Wunderwerke der Natur" und insofern als greifbares Spiegelbild der Vollkommenheit der Schöpfung. In seinem Vorwort zur *Natural History of Shells* vertrat George Perry den Standpunkt, diese Lebewesen, deren komplexe Gestaltung auf einer logarithmischen Spirale beruhe, forderten zur Betrachtung der göttlichen Vollendung auf. Eine der ersten Muscheldarstellungen mit impliziter theologischer Bedeutung ist in dem Stundenbuch der Katharina von Kleve (1417–1479) zu finden, das um 1440 von einem anonymen Meister aus Utrecht mit außergewöhnlichen Miniaturen versehen wurde (Abb. 9). Mit hyperrealistischer Akribie sind dort

auf einer Marginalie Muscheln und Krabben gemalt, die in einem virtuosen Trompe-l'œil-Effekt den hl. Ambrosius einrahmen. Der Kirchenvater hatte in der Tat zur Verherrlichung des Schöpfungsplanes das Gleichnis der Krabbe erzählt, der es gelang, eine Auster zu fressen, indem sie listig einen kleinen Stein zwischen die beiden Schalen schob.

Die bereits von Cicero vertretene Ansicht, von diesen Meerestieren gehe eine „Erholung für das Auge und den Geist" aus – um es mit Buonanni auszudrücken –, hatte in den literarischen und humanistischen Kreisen ganz Europas Furore gemacht. In seinem Werk *De Oratore* pries Cicero (106–43 v. Chr.) am Beispiel von zwei Freunden, die ihre Freizeit mit gemeinsamem Muschelsuchen verbrachten, die Werte der Muße und der Freundschaft. Mit dem von Erasmus von Rotterdam (1466–1536) geprägten Motto *conchas legere* („Muscheln sammeln") identifizierten sich alle Gelehrten, die bei der Betrachtung dieser Naturalien Meditation und Erholung für den Geist suchten. In diesem Sinne sind die Porträts Muscheln zeigender Sammler zu interpretieren, wie die beiden Bildnisse des Niederländers Jan Govertsz van der Aar, der sich 1603 von Hendrick Goltzius (1558–1617; Abb. 10) und 1607 in Form einer Allegorie von Cornelis van Haarlem verewigen ließ. Dieselbe Lesart gilt für die Stillleben und *Vanitas*-Bilder mit Muscheln, die sich im 17. Jh. in den Niederlanden großer Beliebtheit erfreuten. Besonders gefragt waren Bilder dieses Genres von Jan Brueghel dem Älteren (1568–1625), Ambrosius Bosschaert (1573–1621), dessen Schwager Balthasar van der Ast (ca. 1593–1657; Abb. 11) und von Jan van Kessel (1626–1679). Der Schönheit der Muscheln wurde also nicht nur das Vermögen zugeschrieben, den Geist anzuregen und die Sinne zu zerstreuen, sondern auch der dritte Vorzug zuerkannt, den Geschmack der Künstler auszubilden und ihre Phantasie zu stimulieren. Die Formenvielfalt und der Farbenreichtum der Muscheln, deren Schalen ebenso schneeweiß wie farbenprächtig sein können, hatte seit je zur Herstellung kunsthandwerklicher Gegenstände und künstlerischer Produkte aller Art angeregt. Muschelmotive sind in der Malerei wie in der Goldschmiedekunst zu finden, in der Baukunst wie im Stoffdruck, in der Bildhauerei wie in der Innenarchitektur, auf Waffen wie auf der Bühne. Bereits in der Numismatik und auf einigen pompejanischen Wandmalereien steht die Muschel mit der Ikonographie der Geburt der Venus in Zusammenhang. Wie auf Botticellis (1445–1510) berühmtem Gemälde (Abb. 13) dargestellt, entsteigt die Göttin Aphrodite an Zyperns Küste einer riesigen Muschelschale. Dasselbe Motiv wird 1879 auch von William Adolphe Bouguereau (1825–1905) aufgegriffen. In beiden Fällen handelt es sich um eine verklärte Übertragung des Mythos, der die Geburt der Liebesgöttin den von Kronos abgeschnittenen und ins Meer geworfenen Geschlechtsteilen des Uranus zuschreibt. Vom Wasser er-

zeugt, Ursprung des Lebens und selbst schützende Schale eines Lebewesens, wird die Muschel bereits von den ältesten Kulturen mit Fruchtbarkeit, Zeugung und Sinnesfreude in Zusammenhang gebracht – nicht zuletzt auch dank ihrer uterusähnlichen Form. Der immer noch verbreitete Glaube an die aphrodisische Kraft der Austern rührt von dieser uralten Symbolik her.

In der christlichen Welt wurde die Muschel, die ohne männliche Befruchtung eine Perle erzeugt, zum Symbol der Jungfräulichkeit Mariens. Ein bewundernswertes Beispiel dafür ist auf Piero della Francescas (ca. 1420–1492) Andachtsbild *Sacra conversazione* (Abb. 12) zu sehen. Dort ist die Apsiskalotte mit einer schneeweißen und porzellanglatten Muschel ausgefüllt, die nicht nur traditionelles dekoratives Element ist, sondern auch auf das Mysterium der unbefleckten Empfängnis anspielt. Diese symbolische Bedeutung – auf Pieros Altarbild zusätzlich noch durch das Straußenei betont, das nach dem Glauben der mittelalterlichen Mystiker von den Sonnenstrahlen befruchtet wurde – erfreute sich allgemein großer Beliebtheit. Auf der Bronzetür des Doms von Pisa (1596–1603) ist über dem Abschnitt mit der Verkündigung eine geöffnete Perlenauster dargestellt, die den befruchtenden Tau aufnimmt. In der christlichen Ikonographie ist die Muschel zudem das Attribut des im galizischen Santiago de Compostela begrabenen Apostels Jakob. Die Gründe für diese Zuweisung sind bis heute ungeklärt, sicher ist nur, dass die Jakobsmuschel, mit lateinischem Namen *Pecten jacobaeus*, nach dem Heiligen benannt ist.

Da die Muscheln naturgemäß mit dem Wasser in Verbindung gebracht werden, erfreute sich das Muschelmotiv als Ornament oder architektonische Form beim Entwurf von Brunnen, Gärten oder Nymphäen großer Beliebtheit. Eines der berühmtesten Beispiele gestaltete Gian Lorenzo Bernini (1598–1680) mit seinem Brunnen *Fontana del Tritone* in Rom. Der auf einer Muschel sitzende Gott Triton bläst dort in ein Muschelhorn und erschafft so den Sturm. Auch Meeresgötter werden gern mit Muscheln unterschiedlichster Gestalt dargestellt, wie z. B. auf Raffaels (1483–1520) berühmtem Fresko *Triumph der Galatea* (1511) in der römischen Villa Farnesina oder auf dem Bild *Neptun und Amphitrite* (1515, Berlin, Gemäldegalerie) des niederländischen Malers Jan Gossaert (1478–1532). Dasselbe Meeresgötterpaar wurde auch von einem anderen niederländischen Maler zum Sujet auserkoren. Jakob de Gheyn der Jüngere (1565–1629; Abb. 14) porträtierte mit großer Meisterschaft das sichtlich gerade dem Wasser entstiegene Paar mit zahlreichen perlmuttglänzenden Muscheln im Vordergrund. Die Vorlagen für die leeren Muschelschalen, die der alternde Neptun seiner jungen Braut als Liebespfand darreicht, standen de Gheyn sicher in einer der zahlreichen Amsterdamer Sammlungen zur Verfügung.

Als Hommage an die erlesene Sammlung des Großherzogs Ferdinando I. de' Medici (1549–1609) mit ihren aus dem fernen Indien stammenden exotischen Muscheln, kostbaren Perlen und Korallen ist das kleine Ölbild *Das Reich der Amphitrite* (Abb. 16) von Jacopo Zucchi (ca. 1541–1596) zu interpretieren. In der Gestalt der die Meere beherrschenden Nymphe ist vermutlich Clelia Farnese abgebildet, Ferdinands Geliebte vor seiner 1589 gefeierten Heirat mit Christine von Lothringen (1565–1636). Sein Nachfolger Cosimo II. beauftragte den Maler naturkundlicher Sujets Filippo Napoletano (1587/1591–1629) mit einem Bild, auf dem zwei außergewöhnliche ostindische Schnecken abgebildet sind (Abb. 15). Im Lauf des 17. Jhs. lieferte das berühmte (leider nicht mehr erhaltene) „Muschelzimmer" der Uffizien Motive für zahlreiche Stillleben, unter anderem für Arbeiten der Künstler Giovanna Garzoni (1600–1670) und Bartolomeo Bimbi (1648–1725). Im Auftrag des Großfürsten Ferdinando (1663–1713) schuf Bimbi zwei Gemälde, auf denen die schönsten und kuriosesten Exemplare der Mediceischen Sammlung, in weiches Licht getaucht, in einer geradezu theatralischen Anordnung abgebildet sind. In denselben Jahrzehnten um die Wende vom 17. zum 18. Jh. entstand eine exotische Präsentation von Muscheln mit einem Papagei und einem Paradiesvogel auf dem Hintergrund eines düsteren Seebildes (Abb. 17). Die noch unsichere Zuordnung des Werkes an einen anonymen niederländischen oder italienischen Maler bestätigt die Geschmacksvorliebe der Zeit für diese Art von Sujets, wie auch den lebhaften Austausch zwischen nordischen und italienischen Malern, der offenbar auch am Florentiner Hof selbst stattfand.

Ende des 18. Jhs. war die Muschelkunde in ganz Europa zum Modeereignis geworden. Die Veröffentlichung bedeutender illustrierter Werke, vor allem jener unseres Autors Antoine-Joseph Dezallier d'Argenville, und eine deutliche Veränderung in den Geschmacksvorlieben der Sammler weckten das Interesse einer wachsenden Zahl von Angehörigen des europäischen Adels und des aufstrebenden Bürgertums. Selbst adlige Damen begeisterten sich nun für Naturkunde, wie das Bildnis der Marchesa Gentili Boccapaduli in ihrem Naturalienkabinett (Abb. 18) beweist. Obwohl die Rocaille, ein bis 1760 äußerst beliebtes Dekorelement, nun durch den neuen klassischen Stil ersetzt wurde, erwies sich das Muschelmotiv zumindest auf den Stillleben als anpassungsfähiges Sujet. Dem durchschlagenden Erfolg der ‚Muschelmanie' war mit der Entstehung der Moderne keineswegs ein endgültiges Ende beschieden. Auch auf zeitgenössische Sammler und Liebhaber üben diese extravaganten Artefakte der Natur nach wie vor eine unwiderstehliche Anziehungskraft aus. Die Passion für Muscheln scheint nie zu erlöschen.

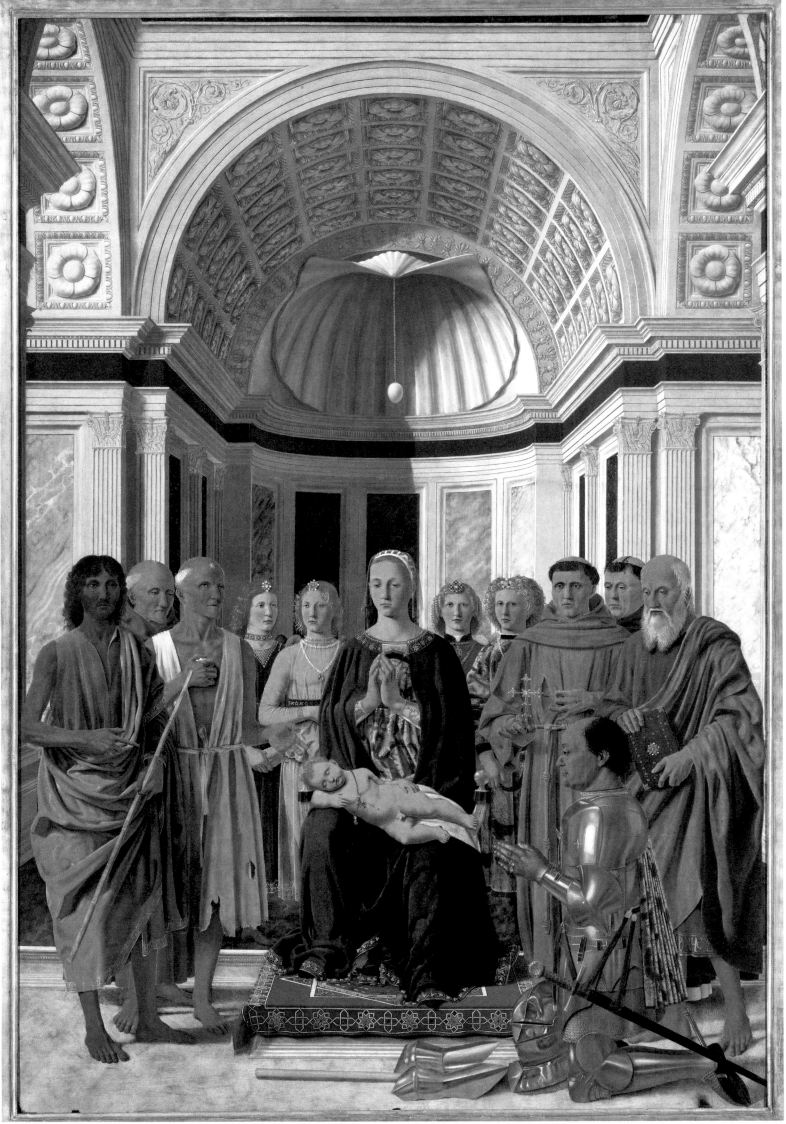

La passion des coquillages.
Parcours entre science et art autour de la *Conchyliologie* de Dezallier d'Argenville

Veronica Carpita

Antoine-Joseph Dezallier d'Argenville est l'un des intellectuels et des collectionneurs les plus fascinants du XVIII^e siècle français. Né à Paris en 1680, il est orienté tout d'abord vers des études littéraires, puis obtient une licence en droit à l'université de Paris. Ses parents, éditeurs et libraires de la rue Saint-Jacques, ayant le souci d'initier leur fils unique à tous les arts, l'éducation du jeune Dezallier d'Argenville se poursuivra sous l'égide des maîtres les plus prestigieux de son époque. La fréquentation de la rue Saint-Jacques, où se côtoyaient artistes, hommes de lettres et de sciences, ainsi que sa formation éclectique, tant littéraire que scientifique, firent d'Antoine-Joseph Dezallier d'Argenville un homme aux multiples talents, tout à la fois avocat, naturaliste, géomètre, jardinier, fin lettré, connaisseur des arts, collectionneur, mais aussi musicien et compositeur à ses heures. Il n'avait pas 30 ans lorsqu'il fit publier *La Théorie et la pratique du jardinage* (Paris, 1709), un ouvrage qui connut bien quatre éditions, deux traductions (en anglais et en allemand), de multiples rééditions et même quelques plagiats. Comme il sied à un héritier de la bonne société, Dezallier d'Argenville entama en 1713 son Grand Tour d'Italie, auquel il consacra plus de deux ans. Son séjour dans le *Bel Paese* affûta encore ses talents de fin connaisseur d'art et de lettré, au point qu'il fut élu à Rome, en 1714, membre de l'Accademia dell'Arcadia. De retour à Paris, il consacra son énergie à son avenir, s'assurant une brillante carrière de haut fonctionnaire public : il acheta ainsi une charge honorifique de Secrétaire du roi, qui s'assortissait d'un titre de noblesse, et devint avocat au Parlement. Il fut nommé ensuite *Maître des comptes* de Paris, mais son ascension sociale culmina en 1748, lorsqu'il fut investi du titre de *Conseiller du Roi et ses conseils*, qui lui garantissait une rente de la couronne. Ce privilège lui fut accordé autant pour ses bons et loyaux services en qualité de fonctionnaire que pour les nombreux ouvrages littéraires et scientifiques qu'il avait personnellement présentés au roi Louis XV (1710–1774) – œuvres qui firent sa renommée.

Les passions de Dezallier d'Argenville

Dans son élégant hôtel particulier de la rue du Temple, Dezallier d'Argenville avait constitué un véritable cabinet de curiosités, où il se retirait pour étudier et rédiger ses écrits. Outre une riche bibliothèque, il y avait réuni des objets appartenant aux mondes des arts et des sciences naturelles, les deux pôles du savoir qui catalysaient ses passions. A la mort de son père, il avait hérité d'une abondante collection de peintures, gravures, dessins, bronzes, médailles et coquillages. On n'y comptait guère plus d'une centaine de tableaux, contre plusieurs milliers d'estampes et de dessins, qui faisaient l'orgueil de leur propriétaire. Toutefois, Dezallier d'Argenville ne

vivait pas cloîtré dans son cabinet. Il y recevait au contraire de très bonne grâce les visiteurs désireux d'examiner sa collection, et entretenait des rapports épistolaires avec nombre d'érudits, de collectionneurs et autres intellectuels rencontrés lors de ses voyages en Europe. A l'issue de son long tour d'Italie, en 1728, il avait en effet séjourné quelques mois en Angleterre, visitant également, selon toute probabilité, la Hollande et l'Allemagne, où abondaient les collections de coquillages exotiques. L'amour de l'art le poussa non seulement à enrichir sa collection par des acquisitions fréquentes, mais aussi à mettre à profit son immense culture artistique pour publier un *Abrégé de la vie des plus fameux peintres* (1745). Plus tard, à un âge déjà avancé puisqu'il avait 65 ans, il remettra sur le métier cet ouvrage et en publiera deux autres éditions, corrigées et étoffées, en 1752 et 1762.

Le jardinage et l'hydraulique avaient cependant toujours été ses occupations de prédilection. Son œuvre de jeunesse, *La Théorie et la pratique du jardinage*, connut un succès international. Les planches de cet ouvrage furent gravées à partir de dessins fournis par Dezallier d'Argenville lui-même, ainsi que par son célèbre maître Jean-Baptiste Alexandre Le Blond (1679–1719) – à qui l'on attribua initialement l'œuvre entière, cette dernière ayant été publiée anonymement sous le pseudonyme de « M*** ». Ces divers mérites valurent à Dezallier d'Argenville d'être sollicité par Denis Diderot (1713–1784) et Jean Le Rond d'Alembert (1717–1783) pour collaborer à *l'Encyclopédie*, avec la rédaction de près de 600 articles sur le jardinage et l'hydraulique. Sa passion avait trouvé en outre une expression concrète dans la conception de jardins, bosquets, fontaines, labyrinthes et théâtres de verdure, pour l'embellissement de son domaine d'Argenville, puis pour celui de son ermitage de Bièvres, près de Versailles. Il avait également prodigué ses conseils à la comtesse de Fuligny Rochechouart, lui envoyant des dessins pour son jardin d'Agey, en Bourgogne. Dans une lettre à cette amie, il décrit d'ailleurs l'un des curieux banquets qu'il organisait à Bièvres : ayant à sa table quelques dames passionnées de fossiles et d'histoire naturelle, il leur avait fait servir de petites pâtisseries présentées à l'intérieur de coquillages.

La Conchyliologie

La passion pour les coquillages, les fossiles et les minéraux, qui animait Dezallier d'Argenville découlait de façon tout à fait naturelle de son intérêt pour l'hydraulique et le jardinage, mais aussi pour l'étude des méthodes d'organisation et de classification du savoir dans le cadre de son cabinet de curiosités. Il distinguait à ce titre les simples curieux des savants : les premiers disposaient les spécimens de façon à ce qu'ils procurent un

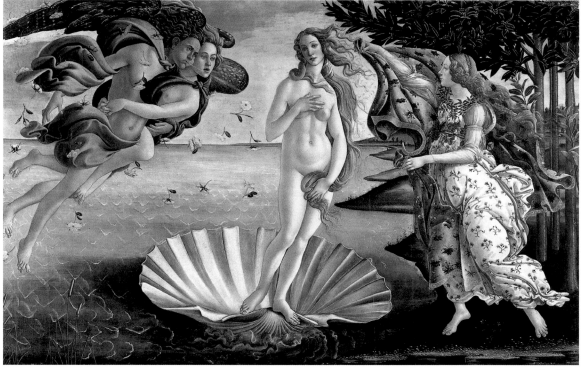

plaisir esthétique purement visuel; les seconds – au nombre desquels il se comptait – étudiaient les systèmes permettant de disposer les échantillons du monde naturel en opérant des distinctions de genres. Ayant visité des musées et des collections à travers toute l'Europe, et en possédant une lui-même, Dezallier d'Argenville avait publié dès 1727 une *Lettre sur le choix et l'arrangement d'un cabinet curieux*. On y apprend en passant qu'à l'époque, les médailles constituaient encore l'objet de curiosité par excellence. Le vent n'allait cependant pas tarder à tourner, précisément grâce aux études de Dezallier d'Argenville, mais aussi à l'activité du célèbre marchand d'art et collectionneur français Edme-François Gersaint (1694–1750). Installé à Paris, ce dernier y avait introduit la mode des ventes aux enchères accompagnées des premiers catalogues raisonnés. S'apercevant de l'intérêt croissant que suscitaient les coquillages exotiques, Gersaint partit en Hollande en 1733 afin de choisir les exemplaires les plus beaux et les plus rares en provenance des mers lointaines et, en 1736, il organisa à Paris la première vente aux enchères de coquillages et curiosités naturelles avec catalogue. L'immense succès de cette dernière, et des opérations suivantes menées par Gersaint, eut deux conséquences: il provoqua, d'une part, la croissance exponentielle des cabinets de coquillages et de *naturalia*, à Paris comme dans tout le royaume, et lança d'autre part la science conchyliologiste en France. Gersaint s'efforçait d'établir une classification et une nomenclature en s'inspirant d'ouvrages précédents, mais il admettait se débattre avec les dénominations latines et grecques, compliquées et intraduisibles, et appelait de ses vœux une étude générale en langue française sur les coquilles elles-mêmes et les animaux qui les habitaient, illustrée de dessins réalisés d'après nature. De fait, le célèbre botaniste Joseph Pitton de Tournefort (1656–1708), auteur des *Eléments de botanique* (1694) – un ouvrage fondamental dans lequel il classifiait les plantes par genres et espèces – avait lui-même amorcé des recherches sur les coquillages, dans une optique de classification, mais sa mort subite y avait hélas coupé court. Or, si la collection de coquilles de Tournefort était demeurée à Paris (Louis XIV l'adjoignit à la sienne), sa méthode de classification inédite ne fut pas publiée en France mais en Italie, en 1742, par Niccolò Gualtieri (1688–1744). Ce sera Dezallier d'Argenville qui, s'inspirant de la classification des plantes de Tournefort, publiera en cette même année 1742 le premier ouvrage de conchyliologie en France. Le catalogue de Gersaint paru en 1736 décrivait déjà, dans sa liste des cabinets les plus célèbres de France et de Hollande, la très riche collection de coquillages que possédait Dezallier d'Argenville. Il révélait en outre que ce dernier travaillait à une *Histoire des coquilles & des minéraux* qu'il ne tarderait pas à publier. En effet, comme l'énonce clairement le titre

L'Histoire naturelle éclaircie dans ses deux parties principales, la lithologie et la conchyliologie, le savant fit le choix d'examiner ensemble ces deux aspects contigus du règne naturel. Dédiée à la Société royale de Montpellier, dont Dezallier avait été élu membre en 1740, l'œuvre connut un succès si immédiat que la première édition fut épuisée en un temps record. Le frontispice de la page de garde, une invention merveilleuse de style rococo, fut commandé à François Boucher (1703–1770), dont la carrière fulgurante culminera en 1765 avec son titre de Premier Peintre du roi de France (p. 2). Dezallier d'Argenville dessina lui-même les coquillages les plus beaux et les plus rares de son cabinet, en grandeur nature et à l'aide d'un miroir, afin qu'ils apparaissent dans le bon sens sur les 32 superbes planches gravées à l'eau-forte par Pierre-Quentin Chédel (1705–1763). Cette luxueuse publication fut financée par de nombreux savants et amateurs, à chacun desquels est dédiée une planche de l'*Histoire* (ill. 6). En plus d'opérer une distinction entre coquillages marins, terrestres et fluviaux (ces catégories se subdivisant elles-mêmes en classes, genres, espèces et variétés), Dezallier d'Argenville décrit en détail leur formation, les lieux et les techniques de récolte, les différents usages des coquillages, les diverses façons de les nettoyer et de les disposer dans un cabinet. Il fournit de surcroît un registre des plus célèbres collections d'histoire naturelle d'Europe, ainsi qu'un tableau réunissant environ 2000 termes latins et grecs, avec leurs équivalents ou explicitations en français. Le succès de ce livre, confirmé s'il en était besoin par l'admission de Dezallier d'Argenville à la Royal Society de Londres (1750), encouragea ce dernier à poursuivre ses recherches. En 1751, il publie ainsi un petit traité dédié aux fossiles retrouvés dans les diverses provinces de France, *Enumerationis fossilium, quae in omnibus Galliae provinciis reperiuntur, tentamina*. En 1755, il fait paraître une traduction française de son *Enumerationis*, ainsi qu'une version enrichie de sa *Lithologie*, déjà publiée avec la *Conchyliologie* en 1742 (*L'Histoire naturelle éclaircie dans une de ses parties principales, l'oryctologie, qui traite des terres, des pierres, des métaux, des minéraux et autres fossiles*, rééditée en 1760). Enfin, il publie en 1757 ce que l'on s'accorde à considérer comme la seconde édition de la *Conchyliologie*: à la section consacrée à la lithologie se substitue désormais une *Zoomorphose* ou étude des mollusques, comme l'appelait de ses vœux Gersaint dès 1736 (*L'Histoire naturelle éclaircie dans une de ses parties principales, la Conchyliologie, qui traite des coquillages de mer, de rivière et de terre… augmentée de la Zoomorphose*). L'ouvrage s'accompagne de 41 planches gravées à l'eau-forte, la plupart tirées des divers chapitres de la première édition de 1742. De nombreux exemplaires possèdent en outre un appendice, ainsi que trois nouvelles gravures figurant des coquillages rares. Cette seconde édition

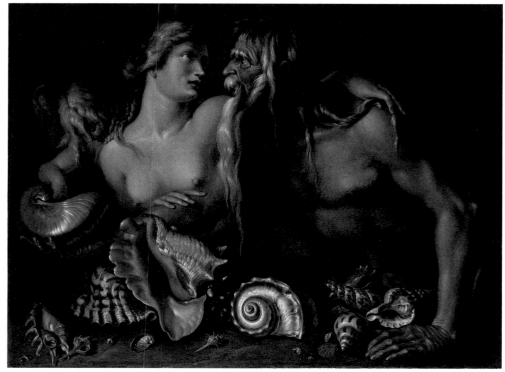

Ill. 14

de 1757 avait donc été enrichie dans son contenu – le nombre d'objets illustrés se montant désormais à 572 –, mais aussi corrigée et améliorée. Dezallier d'Argenville lui avait consacré plus de dix ans de travail, et s'était fait envoyer les dessins des mollusques depuis les Indes, ainsi que de nombreux pays d'Europe. Les illustrations de la *Zoomorphose* avaient le mérite de reproduire pour la première fois d'après modèle vivant les habitants des coquilles.

Le succès commercial de *L'Histoire naturelle* amena Dezallier d'Argenville et son éditeur Guillaume François de Bure à faire colorier les planches de certains exemplaires de la seconde édition, vendus en reliure cuir et dorés sur tranche. Le prix de ces volumes de luxe était de 240 livres françaises, soit environ cinq fois le coût d'un exemplaire ordinaire.

Dezallier d'Argenville mena ses recherches sur les coquillages jusqu'à la fin de ses jours. Il remit en effet à son éditeur, le libraire de Bure, des addenda ultérieurs à *L'Histoire naturelle*, mais la mort le faucha le 29 novembre 1765 sans lui laisser le temps de rééditer son œuvre. En mars 1766, son cabinet d'histoire naturelle et ses milliers de coquillages furent dispersés lors d'une vente aux enchères. Ses tableaux, sa collection de dessins et d'estampes connurent le même sort. Mais, à la différence des collections, la renommée de *L'Histoire naturelle* était destinée à survivre à son auteur. Jacques de Favanne de Montcervelle et son fils Guillaume, dessinateurs naturalistes au service de la couronne de France, et eux-mêmes collectionneurs passionnés de coquillages, résolurent en effet d'éditer pour la troisième fois l'ouvrage de Dezallier d'Argenville : *La Conchyliologie, ou Histoire naturelle des coquilles de mer, d'eau douce, terrestres et fossiles, avec un traité de la zoomorphose, ou représentation des animaux qui les habitent* parut donc en 1780, toujours chez l'éditeur de Bure. Le projet des de Favanne était des plus ambitieux : faire de *La Conchyliologie* l'œuvre exhaustive et la plus à jour existant en France sur le sujet. A cette fin, ils corrigèrent toutes les erreurs commises par Dezallier d'Argenville dans la classification des coquillages, étoffèrent considérablement les différents chapitres, enrichirent l'ouvrage d'un portrait de Dezallier d'Argenville peint par Hyacinthe Rigaud (1659–1743 ; p. 4) et d'une série de 83 planches dessinées par leurs soins et nouvellement gravées. De fait, *La Conchyliologie* de 1780 parut en deux volumes : le premier s'ouvre sur deux frontispices, tout d'abord celui composé par Boucher, puis un paysage marin, prétexte à présenter les différentes techniques de pêche aux coquillages (p. 44) ; le second volume propose quant à lui une vue de l'île d'Aix (p. 206). Sur les 80 planches restantes, deux (pl. LXXVII et LXXVIII) reproduisent respectivement les anatomies de certains mollusques, tirées de l'œuvre de Martin Lister

(1639–1712), et un paysage peuplé d'animaux en train de se nourrir de coquillages. Les autres figurent quelque 2008 espèces ou variétés de testacés, nombre d'entre elles jusqu'alors inédites. Jacques et Guillaume de Favanne conservèrent dans cette troisième édition tous les coquillages présentés par Dezallier d'Argenville, exception faite de ceux constitués en séries. Ceux qu'ils y adjoignirent étaient tirés d'auteurs précédents ou avaient été dessinés dans des cabinets du monde entier. Ayant réuni cette masse impressionnante de matériel, les de Favanne préparèrent eux-mêmes les dessins en couleur des diverses planches, afin qu'elles soient gravées à l'eau-forte avec toute la précision requise. Soucieux d'accélérer la réalisation de l'ouvrage, ils mobilisèrent une équipe de douze graveurs, parmi lesquels Vincent Vangelisty. Pour cette édition, toutefois, l'éditeur n'avait pas prévu de faire colorier les planches de certains exemplaires. Les rares copies en couleur en circulation doivent donc être considérées comme des ouvrages de luxe, coloriés sur la demande expresse de leurs acquéreurs ou propriétaires. Il en résulte une qualité très variable des enluminures, certains volumes ayant été coloriés avec le plus grand soin et une remarquable habileté, à l'image de l'exemplaire reproduit ici, d'autres par une main négligente et malhabile. L'absence d'un modèle de référence a en outre entraîné des différences substantielles et des infidélités dans la coloration des coquillages. Elle explique également le choix de certains propriétaires qui firent relier les planches coloriées séparément, en un troisième volume. Pour toutes ces raisons, les prix de marché de l'ouvrage oscillaient déjà considérablement à la fin du XVIIIᵉ siècle : selon la qualité du travail à l'aquarelle et la préciosité de la reliure, ils pouvaient atteindre 500 à 600 livres françaises.

Si Dezallier d'Argenville avait voulu faire de son *Histoire naturelle* un produit artistique, au-delà même de sa portée scientifique, Jacques et Guillaume de Favanne accentuèrent au contraire la dimension de livre d'agrément de *La Conchyliologie*, surchargeant les planches de coquillages aux formes décoratives et symétriques inspirées du *Thesaurus* d'Albert Seba (1665–1736). En tant que contributions à la malacologie, les travaux de Dezallier d'Argenville et des de Favanne furent supplantés assez vite par des publications plus modestes sur le plan éditorial, mais scientifiquement plus à jour. Cependant, ils jouèrent un rôle fondamental dans la diffusion des connaissances naturalistes. Car la passion pour l'histoire naturelle, et pour les coquillages en particulier, s'était répandue en France au point de supplanter l'attrait pour les antiquités. Au XVIIIᵉ siècle, les cabinets d'histoire naturelle se multiplièrent : Dezallier d'Argenville en dénombrait 17 à Paris en 1742, 20 en 1757 ; en 1780, les de Favanne de Montcervelle en répertoriaient 135.

ILL. 15
Filippo Napoletano
Two shells, early 17th century
Zwei Muscheln, Anfang 17. Jh.
Deux coquillages, début XVIIᵉ siècle
Oil on canvas, 39 x 59 cm (15.4 x 23.2 in.)
FLORENCE, GALLERIA PALATINA
DI PALAZZO PITTI

Conchyliologie et conchyliomanie.
Livres et collections de coquillages des temps modernes

À l'heure où paraissait *La Conchyliologie*, en 1780, la tradition des études dans ce domaine avait déjà près de deux siècles et demi. C'est en 1553 que Pierre Belon (1517–1564), médecin et spécialiste des simples, publie à Paris son *De aquatilibus, Libro duo*, dédié aux animaux aquatiques – un ouvrage qui fait date, puisqu'on y trouve la première description de nombreux coquillages, enrichie de 30 illustrations xylographiques de Pierre Gourdelle. Belon avait observé et copié des mollusques et autres animaux lors de ses voyages sur la côte méditerranéenne et la côte atlantique. Son œuvre anticipe d'un an à peine la parution des *Libri Piscibus Marinis*, du médecin et professeur de Montpellier Guillaume Rondelet (1507–1566) – un précieux volume in-folio contenant des centaines de xylographies d'habitants des mers, gravées par les soins de Georges Reverdy. Dans la seconde partie de son ouvrage, *Universae aquatilum Historiae pars altera*, parue en 1555, Rondelet consacrait un chapitre entier aux coquillages, observés avec plus de précision et reproduits de façon plus exacte que ceux de Belon. Les œuvres de ces deux pionniers français furent intégralement compilées par le Suisse Konrad Gesner (1516–1565) dans son *Historiae Animalium Liber III*, avec un matériel de plus de 700 illustrations xylographiques (1558). Ce volume ne représentait qu'une bribe de la grandiose entreprise encyclopédique menée par Gesner, qui visait à réunir tout le savoir humain en une œuvre unique : les *Libri historiae animalium* (1551–1558) pour le monde animal et la *Bibliotheca universalis* (1545) pour la culture littéraire. Bien que ponctuées d'observations personnelles, les publications de ces médecins et zoologues du XVIᵉ siècle se présentaient essentiellement comme de colossales compilations de textes antiques. Aristote (384–322 av. J.C.) et Pline l'Ancien (23–79) en constituaient l'incontournable point de départ. Le premier de ces auteurs avait, dans *De animalibus*, différencié les coquillages terrestres des coquillages marins, et subdivisé ces derniers en univalves et bivalves. Le second, dans *Naturalis historiae*, avait distingué trois genres : mollusques, crustacés et testacés. Néanmoins, identifier les espèces à partir des auteurs anciens se révélait dans certains cas une entreprise ardue, tant pour l'ambiguïté des descriptions littéraires que pour les variantes de nomenclatures. D'autre part, l'autorité indiscutable des Anciens amenait encore à inclure dans ces répertoires des animaux fantasmagoriques et monstrueux, tels le poisson-moine et l'hydre. Pour autant, à partir du milieu du XVIᵉ siècle, l'image scientifique entendue comme reproduction à l'identique, par le biais du dessin et de la gravure, joua un rôle documentaire et didactique irremplaçable dans l'observation et la classification de la réalité animale et végétale. Le succès des traités et des images naturalistes qui caractérisa le siècle ne se cantonna pas à un cercle restreint de personnes éclairées, mais fut au contraire alimenté par des collectionneurs « virtuoses » et des princes qui tissèrent des rapports érudits non seulement entre eux, mais aussi avec des savants et des artistes spécialistes du genre naturaliste. Les premières collections de coquillages dont nous ayons connaissance se sont constituées aux Pays-Bas. Érasme de Rotterdam (1467–1536) en possédait une, et Albrecht Dürer (1471–1528) en vit de nombreuses durant son voyage à Anvers. L'irrésistible expansion coloniale hollandaise en Asie, en Indonésie, en Afrique du Sud et en Australie, sur les voies ouvertes par la Compagnie des Indes orientales, créée en 1602, et la Compagnie des Indes occidentales (1616), garantit aux Provinces-Unies la plus forte concentration de collections malacologiques de toute l'Europe moderne. On pense que même la compagnie pétrolière Shell ne dédaignait pas à l'origine le commerce de coquillages. La découverte de l'Amérique, et l'intensification consécutive des voyages et du commerce avec les Indes et l'Extrême-Orient, avaient en réalité porté à la connaissance des Européens nombre d'espèces animales et végétales jamais vues auparavant. Précieuses marchandises, les coquillages arrivaient de terres lointaines et exotiques dans les ports des principales puissances maritimes européennes, où collectionneurs et naturalistes se les arrachaient.

Dans la seconde moitié du XVIᵉ siècle, les cours des souverains italiens et allemands les plus éclairés représentèrent des foyers de recherche très actifs sur les coquillages et sur le monde naturel en général. Ces princes rassemblaient en effet des collections considérables de *naturalia* et *artificialia*, et comptaient parmi leurs protégés des scientifiques et artistes spécialisés. Parmi les cas les plus célèbres, citons la collaboration qui s'instaura à la cour de l'archiduc Ferdinand II du Tyrol (1529–1595), au château d'Ambras, entre le médecin de Sienne Pietro Andrea Mattioli (1500–1577) et le peintre Giorgio Liberale (vers 1527–1579/80), né à Udine. De 1562 à 1576, Liberale enlumina pour l'archiduc un manuscrit sur parchemin de cent feuillets avec des animaux marins de la mer Adriatique (ill. 2). Il s'agit là du premier et du plus vaste échantillonnage de faune marine locale, et ce riche matériel inspira en partie les xylographies de Mattioli dans le commentaire qu'il publia sur la *Materia medica* (1564) du Grec Dioscoride (Iᵉʳ siècle). Les grandes planches à l'aquarelle de Giorgio Liberale reproduisent avec finesse et précision les créatures des mers, mais constituent en outre autant de trompe-l'œil d'un grand raffinement, dans lesquels l'analyse scientifique ne le cède en rien au langage esthétique et ornemental. À cette même époque, le Milanais Giuseppe Arcimboldo (1526–1593) travaillait comme illustra-

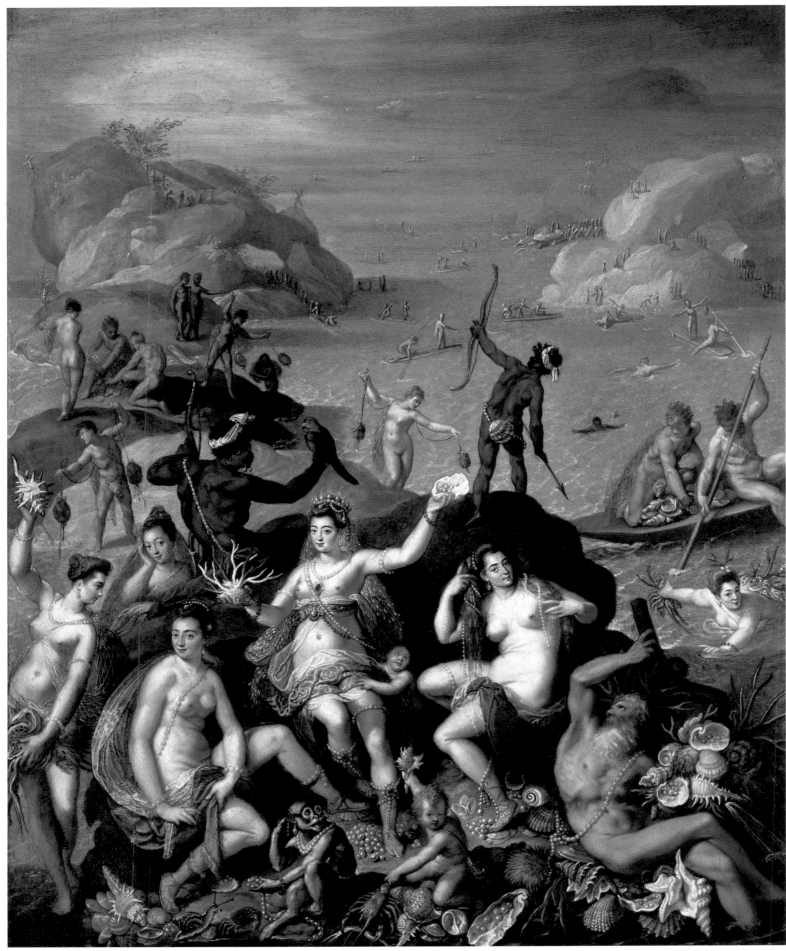

teur scientifique à Vienne et à Prague pour les empereurs de la maison de Habsbourg. Sa maestria dans le genre naturaliste s'exprime aussi bien dans ses études d'animaux d'après nature que dans ses extravagantes « têtes composées », portraits anthropomorphiques formés des éléments les plus variés (objets, fruits, légumes ou animaux). Parmi ces nombreuses têtes, il réalisa pour Maximilien II (1527–1576) une *Allégorie de l'eau*, composé de 62 genres différents de poissons, crustacés, coquillages et mollusques (ill. 1).

Héritier d'une famille de peintres et de ciseleurs au service des Habsbourg depuis des générations, le peintre Jacopo Ligozzi (vers 1547–1627), originaire de Vérone, enlumina à Prague pour Rodolphe II un manuscrit sur parchemin qu'il orna de 20 planches s'inspirant de créatures marines. Devenu sans tarder l'enlumineur naturaliste le plus célèbre et le plus jalousé, Ligozzi entra au service du grand-duc François Ier de Médicis (1541–1587), lequel, en digne successeur de son père Cosme Ier, fondateur des jardins botaniques de Pise et de Florence, devint un collectionneur passionné de *naturalia* et un expérimentateur enthousiaste dans le domaine des sciences et de l'alchimie. C'est à partir de 1570 que François avait entrepris de rassembler dans le Studiolo du Palazzo Vecchio toutes les pièces rares et précieuses qui firent sa célébrité. Un mur entier de ce Petit Cabinet était dédié à l'eau, l'un des quatre éléments choisis comme critères d'organisation de la collection du grand-duc. Alignées le long de ce mur se trouvaient diverses armoires dont les portes peintes étaient ornées, comme de juste, d'allégories et de mythes marins et qui recelaient des nautiles, des coquillages, des éponges, des coraux, des perles et d'autres fossiles aquatiques. Les significations astrologiques complexes et les mystérieuses allégories cosmiques contenues dans les décorations du Studiolo de François Ier se virent encore amplifiées dans la superbe Tribune des Offices, qu'il fit construire en 1584. Le grand-duc y transféra ses précieuses collections d'art antique et moderne, ainsi que ses raretés naturelles, assignant à l'élément aqueux un rôle des plus spectaculaires : la haute coupole octogonale fut entièrement incrustée de scintillantes coquilles d'huîtres couvertes de nacre, et Ligozzi peignit une frise aujourd'hui perdue, composée de poissons et de coquillages et courant sur l'ensemble des huit murs, juste au-dessus de la plinthe.

Très demandées, les représentations d'animaux et de plantes réalisées par Ligozzi et Arcimboldo passèrent de main en main, et quelques-unes parvinrent entre les mains du célèbre médecin et naturaliste bolognais Ulisse Aldrovandi (1522–1605). Celui-ci rassembla, à ses propres frais, une équipe d'enlumineurs et de graveurs afin d'illustrer sa très conséquente œuvre encyclopédique sur le monde naturel. L'éclatant corpus graphique ainsi constitué, comprenant plus de 2900 planches enluminées et conservé au-

jourd'hui à la Bibliothèque universitaire de Bologne, inclut entre autres une centaine de coquillages, qui furent publiés dans le *De reliquis animalibus exanguinibus*, imprimé à Bologne en 1606 avec un matériel illustratif de quelque 650 xylographies.

Sans doute, au XVIe siècle et jusqu'au milieu du XVIIe, l'approche cognitive du monde naturel telle que la pratiquaient médecins et naturalistes était encore nettement caractérisée par une attirance pour le rare et le merveilleux, et par une adhésion à un projet d'investigation encyclopédique et universelle. Mais il est tout aussi indiscutable que ces « dilettantes » privés avaient constitué des collections toujours plus spécialisées dans le domaine de la recherche scientifique, et que leurs musées-laboratoires, quelque taxonomie que suivît leur organisation, commençaient à perdre les connotations d'éclectisme chaotique et hédoniste attachées aux *Wunderkammern* d'Europe du Nord. La première représentation d'un de ces cabinets scientifiques est une xylographie de 1599, figurant le pharmacien napolitain Ferrante Imperato (1550–1625 ; ill. 3) en train de faire visiter à quelques gentilshommes son musée privé débordant de livres et de curiosités naturelles, en particulier des dizaines de coquillages et crustacés.

Au début du XVIIe siècle, les recherches menées en Italie au sein de l'académie des Lynx, et en particulier les découvertes de Galilée (1564–1642), Lynx lui-même depuis 1611, grâce au télescope et au microscope amplifièrent les possibilités d'exploration du monde naturel. Le sens de la vue s'en trouva dès lors promu au rang de premier instrument de la raison et de la connaissance. On verra un exemple de ce nouveau climat dans les études menées par Fabio Colonna (1567–1640), juriste napolitain passionné de recherches naturalistes et membre lui aussi de l'académie des Lynx. S'appuyant sur une comparaison entre les coquillages fossiles et vivants, il affirma l'origine organique (et non végétative) de ces animaux, et ses études devinrent fondamentales pour les recherches qui suivirent sur le sujet.

Il eut pour successeur le peintre et savant Agostino Scilla (1629–1700) qui, dans son ouvrage très court *La vana speculazione disingannata dal senso* (la vaine spéculation détrompée par le bon sens, 1670), illustré de superbes eaux-fortes de Pietro Santi Bartoli (1635–1700), démontra en s'appuyant sur une série de dissections l'origine organique des coquillages fossiles. Quelques années plus tard, en 1675, Johann Daniel Major (1634–1693), un médecin de Kiel, fit paraître une nouvelle édition de l'*Opusculum de purpura* de Colonna, la toute première tentative de classification des coquillages vivants. Les subdivisions établies par Major – *univalves*, *bivalves* et *turbinata* – furent également adoptées par le père jésuite Filippo Buonanni (1638–1725) dans sa *Ricreatione dell'occhio e della mente*

nell'observation' delle Chiocciole (distraction de l'œil et de l'esprit par l'observation des escargots, 1681 ; l'édition latine, datée de 1684, fut remise à jour en 1691 et réimprimée dans le *Musaeum Kircherianum* en 1709). Dans cette publication enrichie de belles gravures à l'eau-forte (ill. 4), Buonanni défendait la thèse aristotélicienne de la génération spontanée des fossiles par le biais d'une hypothétique *vis plastica* (une sorte de « pouvoir modelant ») qu'auraient possédée les pierres. Au musée du Collège romain, fondé par le jésuite Athanase Kircher (1602–1680), dont Buonanni allait devenir conservateur en 1698, ce dernier avait observé au microscope des centaines de coquillages. Son étude par dissection – qui portait sur les couleurs autant que sur l'anatomie des coquillages – ne lui ôta nullement l'idée que la nature créait d'elle-même de véritables mines de « pierres figuratives » reproduisant la morphologie d'animaux ou de végétaux. La conviction aveugle que la nature se prêtait à des « plaisanteries » de cette espèce poussa Buonanni à accréditer la légende du « limaçon sarmatique » qui se trouve reproduit sur l'une des planches de la *Ricreatione*.

Les expériences sur la reproduction des mollusques menées à la même période par Francesco Redi (1626–1697), Antonio Felice Marsili (1649–1710) et, plus tard, par René-Antoine de Réaumur (1683–1757) anéantirent définitivement la croyance en la génération spontanée. Néanmoins, ces théories révolutionnaires – et périlleuses – avaient bien du mal à s'imposer : de fait, on devait bien admettre que certains fossiles témoignaient de l'existence sur Terre d'espèces éteintes, ce qui mettait à mal le dogme de la perfection éternelle de la Création divine. Dans la seconde moitié du XVII^e siècle, la découverte de coquillages et d'autres restes fossiles décidèrent certains naturalistes à étudier la Terre autrement que sous son aspect présent. On commençait enfin à voir en la nature le fruit d'une évolution qui se perdait dans la nuit des temps. Cependant, embrasser cette conception évolutionniste était loin d'être simple, comme le démontre bien le cas du médecin anglais Martin Lister (vers 1638–1712). Bien que sa méthodologie de recherche sur les coquillages et les mollusques fût fondée sur une observation minutieuse, il n'en soutenait pas moins l'existence de germes contenus dans la terre et capables de générer, selon les conditions environnementales, diverses espèces d'êtres vivants. Dans son *Historia animalium Angliae* (1678), et surtout dans les cinq livres de son *Historia Conchyliorum* (1685–1692), il propose pourtant un nouveau système de classification couvrant plus de mille coquillages observés dans sa propre collection, dans celle de William Courten alias Charlton (1572–1636) et au musée Ashmolean d'Oxford. En outre, à l'inverse des premières publications, les coquillages de Lister sont représentés pour la première fois du côté correct et non à l'envers, reproduisant fidèlement la position de détails importants comme le *stoma* (la bouche) des gastéropodes.

Dans la Hollande de ce début de XVII^e siècle, tandis que se répandait la « tulipomanie » qui conduirait au crack financier de 1637, il était également de bon ton de posséder et d'exhiber des coquillages rares et exotiques, qui se vendaient à des prix ahurissants. Témoin de cette véritable « conchyliomanie », le marchand et poète Roemer Visscher (1547–1620) exprime à ce propos son sentiment : sous une gravure représentant des coquillages sur une plage, il appose la légende « Il est écœurant de voir ce que peut faire un fou de son argent » (*Sinnepoppen*, 1614). La Bruyère lui-même (1645–1696), toujours prompt à fustiger avec brio les mœurs de son époque, ne se prive pas d'ironiser sur les collectionneurs – et les spéculateurs – qui attribuaient aux coquillages les noms les plus improbables : « Devineriez-vous, à entendre parler celui-ci de son *léopard*, de sa *plume*, de sa *musique*, les vanter comme ce qu'il y a sur la terre de plus singulier et de plus merveilleux, qu'il veut vendre ses coquilles ? Pourquoi non, s'il les achète au poids de l'or ? » A travers toute l'Europe, les collections de coquillages se multiplient : on se rappellera, parmi les plus célèbres, celle de John Tradescant (vers 1570–1638), enrichie par John Tradescant fils (1608–1662) et réunie par la suite au musée Ashmolean d'Oxford ; celle, londonienne, du pharmacien James Petiver (1658–1718) ; la collection de coquillages jamaïcains du président de la Royal Society, Sir Hans Sloane (1660–1753), récupérée ensuite par le British Museum ; le musée constitué à Copenhague par Ole Worm (1588–1654) ; à Paris, le musée du monastère Sainte-Geneviève et les cabinets du cardinal Mazarin (1602–1661), de Nicolas Boucot († 1699) et de Joseph Pitton de Tournefort (1656–1708), enfin celui de Gaston d'Orléans (1608–1660) ; en Italie, on citera le musée vénitien d'Andrea Vendramin (1554–1629), transféré après sa mort à Amsterdam, celui de Ludovico Moscardo (vers 1611–1681) à Vérone, la collection de Manfredo Settala (1600–1680) à Milan, enfin l'éclatante collection de coquilles rassemblée à Florence par le grand-duc Cosme III de Médicis (1642–1723) qui, en 1682, avait acquis celle du célèbre naturaliste hollandais Georg Eberhard Rumpf (1627–1702). En 1683, une part importante de la collection de Rumpf fut cédée par Cosme III au marchand Ferdinando Cospi de Bologne, lequel fit dessiner en couleur les coquillages (on en dénombrait bien quatre cents !) par Jacopo Tosi, dans un volume conservé aujourd'hui à la bibliothèque universitaire de Bologne. A son tour, le musée Cospiano fut cédé par son fondateur Ferdinando Cospi au sénat bolognais, qui le transféra tout d'abord à l'hôtel de ville, puis à l'institut des Arts et des Sciences, où il rejoignit les collections du musée Aldrovandi (1742).

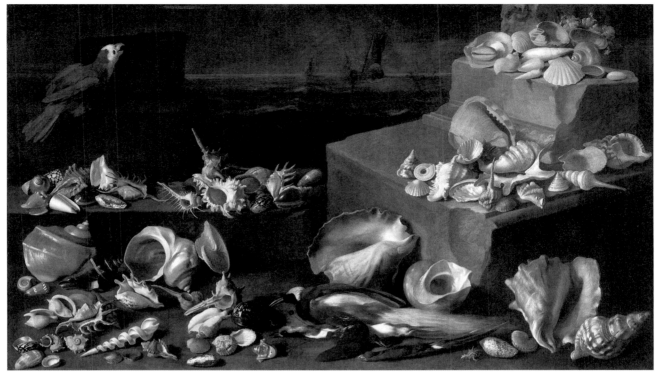

Agent de la Compagnie des Indes à Amboine, en Indonésie, Rumpf avait mené de longues recherches sur les animaux marins qui peuplaient l'océan Indien et l'océan Pacifique. Cette entreprise exceptionnelle fut néanmoins entravée par une série de contretemps malheureux. Rumpf perdit la vue à 40 ans à peine, et l'incendie d'Amboine, en 1687, détruisit les illustrations réalisées par son fils, déjà prêtes pour l'impression. Les 60 planches re-gravées et le texte manuscrit finirent par parvenir en Hollande, où ils furent publiés en allemand en 1705 (*D'Amboinsche Rariteitkamer*). Cette œuvre représente une contribution fondamentale à la conchyliologie tropicale et aux recherches sur la biologie des animaux dans leur habitat. La traduction latine *Thesaurus cochlearum* (ill. 5), datée de 1711, fut suivie de rééditions ultérieures dans d'autres langues et assura à ce « Pline des Indes » une renommée européenne. Certains coquillages de la collection de Rumpf échurent également au naturaliste Niccolò Gualtieri. En partie intégrés aux collections scientifiques de l'université de Pise, ils furent reproduits et publiés par Gualtieri sur les 110 magnifiques planches de son *Index Testarum Conchyliorum* (1742). En cette même année paraissait à Paris *L'Histoire naturelle* de Dezallier d'Argenville. Bien que notre auteur condamnât les curieux qui collectionnaient les bizarreries de la nature, et les coquillages en particulier, en sacrifiant l'ordre méthodique au plaisir des yeux, les collections et les musées d'histoire naturelle allaient s'obstiner, au moins jusqu'au XIXᵉ siècle, à privilégier les installations et dispositions captivantes, capables de générer émerveillement et stupeur (ill. 6). Certaines sont bien connues, par exemple les compositions ornementales et anthropomorphiques de coquillages réalisées par le pharmacien Albert Seba, et publiées dans le troisième volume de son *Thesaurus* (1758) : il s'agit là de l'un des premiers exemples de représentation en couleurs de mollusques (1734–1765 ; ill. 7). Cependant, bien des entreprises ambitieuses tournèrent court, en raison de difficultés financières. Citons par exemple le *Choix de coquillages et crustacés* (*Auserlesene Schnecken, Muscheln*, ouvrage bilingue de 1758), de Franz Michael Regenfuss (vers 1712–1780), graveur attitré de Frédéric V, roi du Danemark et de Norvège. Des trois somptueux volumes in-folio projetés initialement ne parut que le premier, agrémenté de merveilleuses planches à l'aquarelle (ill. 8) : bien qu'on n'en compte que 12, les illustrations si raffinées de Regenfuss témoignent d'une exquise habileté, dans la technique comme dans l'orchestration de la composition, et demeurèrent un modèle pour toutes les œuvres successives jusqu'au XIXᵉ siècle. Aussi fascinantes et virtuoses qu'elles fussent, ces illustrations sont toutefois à mille lieues des recherches avancées que menait à cette même période Carl Linné (1707–1778). Ce botaniste suédois développa, dans son *Systema natu-rae* (1735–1767), un système de classification des êtres vivants – en usage encore aujourd'hui – fondé sur les organes reproducteurs. Ayant discerné initialement huit genres de coquillages, il se ravisa dans sa dernière édition, posant les bases d'une classification correcte et définitive en distinguant 35 genres et 807 espèces.

A partir du milieu du XVIIIᵉ siècle, le système linnéen devint un point de départ incontournable pour les chercheurs naturalistes, parmi lesquels on citera F. H.W. Martini et J. H. Chemnitz, auteurs d'un ouvrage en onze volumes illustré de planches à l'aquarelle (*Neues systematisches Conchylien-Cabinet*, 1769–1786), ainsi qu'Ignace de Born (1742–1791), qui reproduisit et publia les coquillages du couple impérial François et Marie-Thérèse d'Autriche (*Testacea Musei Caesarei Vindobonensis*, 1780), avec 18 planches en couleur des plus raffinées. Le rythme exponentiel auquel les recherches étaient menées avait fini par rendre nécessaire la publication de traités aptes à synthétiser sous une forme abordable tout le développement de la malacologie jusqu'aux découvertes les plus récentes. En 1775 parut à Paris le *Dictionnaire* de l'abbé Christophe Elizabeth Favart d'Herbigny (1725–1793) ; l'année suivante, Mendez da Costa (1717–1791) fit publier à Londres les *Elements of Conchology*. L'éditeur londonien de Mendez, Benjamin White, imprima en 1776 le quatrième volume de la *British Zoology* de Thomas Pennant (1726–1798), dédié aux *Crustacea, Mullusca, Testacea*, et accompagné d'une centaine de petites planches à l'eau-forte. En 1803, George Montagu (1753–1815) reprit l'étude de la faune locale de Pennant dans l'ouvrage *Testacea Britannica*, illustré de 16 planches plutôt modestes. Le marché éditorial anglais, décidément florissant en cette fin du XVIIIᵉ siècle, produisit une autre œuvre fondamentale sur la malacologie : en 1784 parut en effet *The Universal Conchologist*, de Thomas Martyn (1735–1825), une édition in-folio en quatre volumes enrichie de 120 planches à l'aquarelle qui, avec celles d'Ignace de Born, devinrent une référence essentielle et durable en matière de représentation de coquillages. Les recherches des Français Jean-Guillaume Bruguière (1750–1798) et Jean-Baptiste-Pierre de Monet de Lamarque (1744–1829) acquirent elles aussi une réputation internationale, et leurs méthodes de classification furent adoptées par l'Anglais George Perry (vers 1780–1859) pour sa *Conchology or the Natural History of Shells* (1811), laquelle s'accompagnait de 61 planches enluminées par John Clarke. La dernière œuvre d'importance en matière de malacologie parue au XVIIIᵉ siècle nous vient d'Italie : il s'agit du *Testacea Utriusque Siciliae* de 1791, signé de Giuseppe Saverio Poli (1746–1825), médecin italien de grand renom, membre de la Royal Society.

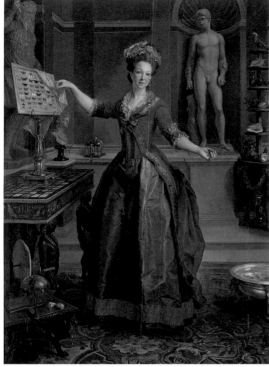

Ill. 18
Laurent Pécheux
*Portrait of the Marquise Gentili Boccapaduli
in her cabinet of natural curiosities*, 1777
*Bildnis der Marchesa Gentili Boccapaduli
in ihrem Naturalienkabinett*
*Portrait de la marquise Gentili Boccapaduli
dans son cabinet d'histoire naturelle*
Oil on canvas, 98 x 75 cm (38.6 x 29.5 in.)
ROME, PRIVATE COLLECTION

La fascination pour les coquillages dans l'art pictural

De tout temps, les coquillages ont été considérés comme des « artifices de la nature » et, en cela, comme un reflet tangible de la splendeur et de la perfection de la Création. Dans son introduction à la *Natural History of Shells*, George Perry affirmait que ces êtres vivants à l'architecture incroyablement complexe, fondée sur une spirale logarithmique, invitent à la contemplation de l'excellence divine. Une des premières représentations de coquillages liées à cette acception théologique peut être admirée dans le magnifique *Livre d'heures* de Catherine de Clèves (1417–1479), enluminé par un maître anonyme d'Utrecht vers 1440 (ill. 9). Peints aux marges du texte avec une précision hyperréaliste, en manière de trompe-l'œil d'une grande virtuosité, les moules et le crabe encadrent saint Ambroise. En effet, afin de glorifier le dessein parfait de la Création, Ambroise avait raconté la fable du crabe qui réussit à manger l'huître en insérant astucieusement un petit caillou entre ses deux valves.

On vit longtemps ces créatures marines comme la « récréation de l'œil et de l'esprit » – pour reprendre les termes de Buonanni. Le concept était certes ancien, puisqu'il remontait à Cicéron (106–43 av. J.-C.), mais n'en jouissait pas moins d'une considérable faveur dans la littérature et dans les cercles humanistes de toute l'Europe. Dans son *De Oratore*, Cicéron exaltait les valeurs de l'*otium* (loisir) et de l'*amicitia* (amitié), cultivées par deux amis qui employaient leur temps libre à recueillir des coquillages. Dans la devise *conchas legere* (collectionner les coquillages) conçue par Erasme (1466–1536) se reconnaissaient donc tous les hommes de culture qui, à travers la contemplation de ces curiosités naturelles, recherchaient la méditation spirituelle et le repos de l'esprit. C'est en ce sens que doivent s'interpréter les portraits de collectionneurs qui choisissaient de poser en exhibant leurs coquillages, tels ceux (au nombre de deux) à l'effigie de Jan Govertsz van der Aar (ill. 10) : le premier exécuté en 1603 par Hendrick Goltzius (1558–1617), le second, de forme allégorique, peint en 1607 par Cornelis van Haarlem. Il en va de même des natures mortes et des « vanités » aux coquillages qui, au XVIIe siècle, connurent une vogue sans précédent aux Pays-Bas. Les plus demandées étaient celles de Pieter Brueghel l'Ancien (1568–1625), d'Ambrosius Bosschaert (1573–1621), de son beau-frère Balthasar van der Ast (vers 1593–1657 ; ill. 11) et de Jan van Kessel (1626–1679). Mais si l'on attribuait à la beauté des coquillages la double capacité d'élever l'esprit et d'amuser les sens, on leur prêtait également une troisième faculté : celle d'affiner le goût et la créativité des artistes. Les innombrables formes des coquillages, la variété de leurs matières et de leurs nuances, du blanc pur aux tons les plus criards, ont en réalité inspiré tous les peuples, tous les domaines de production artisanale et artistique – de la peinture à l'orfèvrerie, de l'architecture à la production textile, de la sculpture à l'ameublement, des armes à la scénographie. Déjà, dans la numismatique et dans certaines peintures pompéiennes, le coquillage apparaît lié à l'iconographie de la naissance de Vénus. De même, dans le célébrissime tableau de Botticelli (1445–1510 ; ill. 13) ou dans une œuvre plus récente de William Adolphe Bouguereau (1825–1905), datée de 1879, on retrouve la déesse Aphrodite abordant l'île de Chypre sur une énorme valve de coquillage. Cette image constitue une transposition édulcorée du mythe de la naissance de la déesse, sortie des parties génitales d'Uranus, qui avaient été coupées et jetées à la mer par Chronos. Générée par l'eau, origine de la vie, et elle-même coque protectrice d'un être vivant, la coquille a été de tout temps et par les plus antiques civilisations associée à la sphère sémantique de la fécondité, de la procréation et de l'amour, à laquelle la rattache également sa morphologie utérine. La croyance, encore répandue, en un pouvoir aphrodisiaque des huîtres dérive précisément de cette symbolique ancestrale.

Dans le monde chrétien, le coquillage qui produit la perle sans qu'il soit besoin de fécondation masculine est devenu symbole de l'Immaculée Conception. La *Sainte Conversation* de Piero della Francesca (vers 1420–1492) nous en fournit d'ailleurs un exemple admirable : la niche à coquille derrière les personnages, blanche et lisse comme la porcelaine, est plus qu'un simple décor à l'antique – il faut y voir une référence au mystère de la conception virginale de Marie (ill. 12). Cette fonction symbolique, soulignée encore par la présence, pendu au plafond, de cet œuf d'autruche que les mystiques médiévaux pensaient fécondé par les rayons du soleil, était tout à fait familière aux spectateurs de l'époque. On en retrouve un écho sur la porte centrale en bronze du dôme de Pise (1596–1603) où, au-dessus du panneau figurant l'Annonciation, est représentée une huître perlière ouverte recueillant la rosée fécondatrice. Dans l'iconographie chrétienne, la coquille est en outre un attribut de l'apôtre saint Jacques, dont la dépouille repose en Espagne, à Saint-Jacques de Compostelle. On ignore les motifs de cette association, mais il se trouve que le nom du saint désigne le coquillage *Pecten jacobaeus*, devenu un signe de reconnaissance pour tous les pèlerins chrétiens.

Liés par nature à l'élément aqueux, les coquillages décorent par ailleurs d'innombrables nymphées, jardins et fontaines – ou en ont inspiré les formes architectoniques. Parmi les exemples les plus célèbres, citons la Fontaine au Triton de Rome, œuvre de Gianlorenzo Bernini (1598–1680), où le dieu, soufflant dans sa conque, fait naître les tempêtes. Des coquillages aux formes diverses figurent souvent dans les représentations de divini-

tés marines, comme dans le célèbre *Triomphe de Galatée* (1511) de Raphaël (1483–1520) à la Villa Farnèse de Rome, ou le *Neptune et Amphitrite* (1515) du Hollandais Jan Gossaert (1478–1532). Ce même couple de divinités marines se retrouve également sur un tableau du peintre néerlandais Jacob de Gheyn le Jeune (1565–1629 ; ill. 14). La virtuosité picturale de l'artiste, admirable déjà dans le rendu de l'épiderme ruisselant de ce couple d'amants à peine émergés des flots, culmine dans la nacre scintillante des coquillages. Prémices offertes en gage d'amour par le vieux Neptune à sa jeune épouse, les coquillages vidés de leur mollusque furent sans nul doute copiés par de Gheyn dans l'une des très nombreuses collections d'Amsterdam.

C'est un vibrant hommage aux extravagants coquillages, aux perles précieuses, aux coraux arrachés aux Indes lointaines pour parer la collection de Ferdinand I^er de Médicis (1549–1609) que rend la petite huile sur toile de Jacopo Zucchi (vers 1541–1596) figurant *Le Royaume d'Amphitrite* (ill. 16). Dans cette nymphe maîtresse des mers, il faut reconnaître, pense-t-on, les traits de Clélia Farnèse, qui fut la maîtresse de Ferdinand avant son mariage avec Christine de Lorraine (1565–1636), en 1589. C'est à Cosme II, héritier de Ferdinand, que l'on doit la commande au peintre naturaliste Filippo Napoletano (1587/1591–1629) d'un tableau représentant deux extraordinaires gastéropodes des Indes orientales (ill. 15). Au cours du XVII^e siècle, la célèbre « Chambre aux coquillages » des Offices (aujourd'hui disparue) inspira également de nombreuses natures mortes à l'illustratrice Giovanna Garzoni (1600–1670) ou à Bartolomeo Bimbi (1648–1725). A la demande du prince-héritier Ferdinand (1663–1713), Bimbi réalisa deux toiles sur lesquelles il reproduisait d'après nature les exemplaires les plus beaux et les plus insolites du musée des Médicis, les disposant selon une chorégraphie quasi théâtrale, dans une lumière douce et diffuse. C'est à ces mêmes décennies (fin du XVII^e – début du XVIII^e siècle) que remonte une autre toile, étalage exotique de coquillages avec perroquet et paradisier, dans une marine sombre (ill. 17). Son attribution encore incertaine à un anonyme hollandais ou italien atteste l'engouement de l'époque pour ce genre de peinture, et suggère bien la fréquence des contacts – par exemple à cette même cour florentine – entre peintres nordistes et italiens.

Au milieu du XVIII^e siècle, la mode de la conchyliologie faisait rage dans toute l'Europe. Avec la publication d'importantes œuvres illustrées, au premier plan desquelles celles d'Antoine-Joseph Dezallier d'Argenville, cette nouvelle fascination des collectionneurs pour les coquillages gagnait également un nombre croissant de dilettantes, issus aussi bien de l'aristocratie que d'une bourgeoisie européenne alors émergente. Ces dames de la bonne société se prirent au jeu elles aussi, et les sciences naturelles ne tar-

dèrent pas à devenir une de leurs distractions favorites, comme le démontre clairement le portrait de la marquise Gentili Boccapaduli dans son cabinet d'histoire naturelle (ill. 18). Et si la mode rocaille, qui avait fait fureur jusqu'en 1760, cédait graduellement le pas au nouveau style néoclassique, la nature morte aux coquillages en tant que genre pictural se révéla capable de s'adapter au nouveau climat. Cependant, la conchyliomanie a-t-elle survécu à l'avènement de l'ère contemporaine ? Il serait faux de croire le contraire : ces fantasques artifices de la nature continuent à exercer une fascination indiscutable sur les collectionneurs et les amateurs, et la passion des coquillages ne donne aucun signe de déclin.

The scientific importance
of Dezallier d'Argenville's
Conchyliologie

Rainer Willmann

In the mid-18th century, the sciences, especially biology, underwent a sharp upturn because unknown flora and fauna were being brought back from expeditions to the far corners of the earth to be recorded. Public and private collections as well as the first natural history museums were founded. France played a paramount role in all this activity. Georges-Louis Leclerc de Buffon (1707–1788) was appointed professor at the Jardin du Roi and embarked on writing a compendious work on everything known about nature at that time. During his lifetime 36 volumes were published, followed by eight more posthumously. In Sweden, Carolus Linnaeus (1707–1778: Carl von Linné after a knighthood was conferred on him), alongside Buffon, the most important natural scientist of the 18th century, catalogued all species of plants and animals then known. The sources available to those scientists were accounts of travels, hundreds of descriptions as well as pictures of animals and plants and numerous early attempts at dealing scientifically with biodiversity – a treasure trove of writings on natural history going back to Aristotle. The *Conchyliologie* of Dezallier d'Argenville was one of those early works, a magnificently sweeping opus devoted to animals with hard exoskeletons. "Conchylia" was the term then applied to virtually all fauna with a rigid calcareous exoskeleton – a shell. The category included all moluscs, softbodied animals gastropods including gastropods, bivalves, cephalopods and tusk shells or scaphopods, but also corals, tube worms and some echinoderms such as sea urchins. Dezallier d'Argenville left out other groups such as the sea stars or starfish, which are close relatives of the sea urchin. Consistent classification of those relationships on the basis of overall structure was left to later naturalists. Many of Dezallier d'Argenville's descriptions are scientifically important. After all, Linnaeus referred constantly to Dezallier d'Argenville's work and his illustrations when writing his own survey of all then known organisms, the *Systema naturae*. The Dezallier d'Argenville compendium is rightly regarded as one of the pillars of the *Systema naturae*, which was so crucial to the development of biology as a science (see appendix).

Dezallier d'Argenville was, of course, unaware of the significance of much of the data that would be expected today in any description of a new species because much of that information was unavailable to him. He did point out repeatedly that many of the species he presented were extremely rare but that is on the whole no longer of biological significance, and many organisms would later prove to be quite common. Other data would have been far more important; this is especially true of the provenance of specimens. Only rarely was Dezallier d'Argenville able to list the place where a specimen was found, which is, however, of great importance in identifying

it. In view of the close similarity of so many species and, on the other hand, the considerable genetic variability within numerous species, it is often difficult today to ascertain precisely what organisms were actually meant. Cone gastropod species especially often resemble each other very closely but also tend to be variable in the extreme. Without data on provenance, it is virtually impossible to identify a specimen. Indeed, it is certainly misleading of Dezallier d'Argenville to deduce West Indian origins from the sheen of some shells. Many organisms are depicted in Dezallier d'Argenville either upside down or in an oblique view, which makes it much more difficult to compare species. Some illustrations are not sufficiently detailed. In other cases, specimens are shown on much too small a scale or the colouring is not accurately reproduced, which often makes it almost impossible to identify them.

Hence meticulous scientific classification is important. Since there are so many species, this is an ambitious undertaking. Just consider that, to the present state of our knowledge, roughly 38,000 species of gastropods have been recorded – of which about 16,000 belong to the order of pulmonates – and it is assumed that some 20,000 species have yet to be discovered. There are fewer species of bivalves: about 8,000 species have been described but just as many again may be awaiting discovery and scientific description. However, processing new finds will be much easier to manage in the near future: freely accessible online databases are being built up by several institutions. Recorded organisms are filed in these databases with a picture, a description, an historical overview of research conducted on them and references for further study. The Department of Morphology, Systems and Evolutionary Biology at Göttingen University and the Göttingen Zoological Museum have compiled and annotated earlier zoological descriptions under the name AnimalBase. At the same time, the entire body of relevant early zoological writings has been made accessible online free of charge by the Göttingen University jointly with the Göttingen State and University Library through the Ezoolo research project (Early zoological literature online).

In many respects, Dezallier d'Argenville's classification system has little to do with current ideas of how fauna should be classified – and not even much in common with Linnaeus's taxonomic system. Dezallier d'Argenville classified fauna as belonging to the same groups if they lived in multiple-plate shells, such as sea urchins, Goose Barnacles (sessile crustaceans) and chitons. He in fact united in one group organisms that are not related to one another at all: sea urchins are echinoderms, which are quite closely related to vertebrates; Goose Barnacles are arthropods and chitons

are marine molluscs, invertebrates that are closely related to bivalves, gastropods, scaphopods and cephalopods.

Dezallier d'Argenville realised that he was in many ways a pioneering natural scientist. This is particularly true of his *Zoomorphosis*. In that part of his work, which comprises a section in its own right, he presented various shelled animals in naturalistic poses as observed from live specimens. Even before his time, such representations had appeared sporadically. As Dezallier d'Argenville wrote, he had depended on the earlier writers and was able to have his drawings copied from their illustrations. However, he preferred to base his drawings directly on observations of fauna in its natural state. It was important to him that these creatures, too, should be viewed as living organisms and not merely as beautiful curiosities, collector's items that were also aesthetically appealing. He politely pointed out that his findings often differed considerably from those published by earlier writers. Unfortunately, we do not really know how Dezallier d'Argenville worked. Some of his works suggest that he collected specimens on his travels and made sketches after which his plates were engraved.

In plate 68, for instance, he recorded the Common Limpet in worm's-eye view, from below and from the side, describing its elongated body with the oral orifice, including lips and dentition as well as its two feelers. In another representation, he showed the Abalone, which then still occurred on the coasts of Brittany, and described how it excretes its waste through the holes in its shell. Dezallier d'Argenville did not always know the purpose of parts of a living organism, for instance when he showed the shells of sea worms with the live inhabitants peering out of them. He recorded an annelid worm that had delicate appendages about its oral orifice, which it withdrew along with its head into its tubular shell. Dezallier d'Argenville was unaware that the worm catches the finest particulate matter as its food with these bristles and also possesses respiratory organs – gills.

The meticulous accuracy with which he depicts the nacreous buoyant shell of the *Nautilus* is remarkable (plate 69). The *Nautilus* has an external shell, which means it is a living fossil since other cephalopods of this kind were extinct by the late Cretaceous. Dezallier d'Argenville showed *Nautilus* shells that were cut open from various sides to reveal the siphuncle extending as a strand of tissue from the soft living body into the inner chambers of the shell as well as the chambers themselves. Thus he was able to demonstrate that the *Nautilus* is similar to fossil ammonites. For comparison he showed the shell of a *Spirula*, a squid-like deep-water cephalopod, cut open longitudinally, as well as the shell of an Argonaut, also bisected, to demonstrate the basic difference between it and the *Nautilus* and *Spirula* – the lack of *camerae* or chambers. He represented the soft body of the Argonaut partly after an illustration by Ruysch and, therefore, only in part after a specimen of his own preserved in spirits. Dezallier d'Argenville regretted that he had been unable to see the fauna he wanted to or not soon enough. This was the case with the *Nautilus*, which, as he pointed out, was common in the seas around the Moluccas. He hoped that he would be able to make better drawings of it than earlier writers had. Unfortunately, the ships that he was expecting to bring some specimens to France had been detained, either by war, that enemy of the arts and sciences, while still others had sought refuge in unknown ports. These apologies show how important it was to him to be able to contribute substantially to knowledge of the fauna of distant seas or of organisms not native to Europe.

Plate 70 shows various marine gastropods. Dezallier d'Argenville described the function of the operculum or lid borne on the soft body of the gastropod, which closes the orifice if necessary. In some marine gastropods the long siphuncle is shown protruding from the shell next to the gastropod's head. Dezallier d'Argenville described the position of the eyes,

and, in order to show the soft parts more clearly, he had broken open part of the shell of a Common Whelk (plate 71). He showed several longitudinal sections of marine gastropod shells. Without having prepared his own specimens, Dezallier d'Argenville would never have been able to obtain such detailed insights into the structure of the various invertebrates. He even opened up dissected sea urchins (a delicacy in France) to be able to describe their entrails.

He also depicted the insides of bivalves, for the most part anatomically correctly, albeit very superficially measured by today's standards. In plate 72 an opened oyster is depicted with its gills. Dezallier d'Argenville also observed that only the upper shell of a living oyster can be moved; the lower shell is its immovable support. There is no hinge; its function – shutting the two halves of the shell – is assumed by a sinewy muscle. That Dezallier d'Argenville translated only part of his studies into pictures is shown by the comparisons he provides. He wrote that the *Spondylus* (the Thorny or Spiny Oyster) differs from the oyster only in the way it closes. And, whereas some bivalves – the oyster for one – live clinging to the sea bed, others can quickly dig themselves in with the aid of a foot.

Whenever possible, he went into the habits of his fauna. For instance, he wrote about the Purple Dye Murex that it feeds on flesh and small fish and, to capture them, hides in the sand and spears its prey with its very long tongue. On the long Noble Pen Shell, which is common in the Mediterranean, Dezallier d'Argenville reported that it clung to rocks and lived with its point stuck in the sand. Its filaments – byssus – were finer than those of the common Blue Mussel; stockings, gloves and other things were made of them.

He also described the habits of scaphopods (plate 68), a difficult to observe group of invertebrates with which many biologists are not all that familiar today. As far as is known, some 380 species exist throughout the world. He wrote that the Noble Pen Shell, widespread in the Mediterranean, tends to stand upright in the sand, where it anchors itself by means of its foot. Danger makes it withdraw its body deep into its shell.

Dezallier d'Argenville dealt with one important group of gastropods, terrestrial slugs, in the *Zoomorphosis* (plate 76). The reason for this "special treatment" is that they have reduced their shells so that much of their soft bodies is exposed. Many species have not even retained vestigial shells. Strictly speaking, therefore, they cannot be subsumed under the heading "Conchylia". Nevertheless, Dezallier d'Argenville realised that these forms of life were gastropods. He called gastropods with vestigial shells "slugs with shells" and those without "slugs without shells". In this simple but correct observation, he was further advanced than Linnaeus, who, as late as 1758, was still assigning these gastropod species to a different group altogether.

Dezallier d'Argenville was aware that even drawing on those species he was able to observe personally, sometimes at his very doorstep, he could not even begin to encompass faunal diversity. He did, however, point out that new discoveries would make constant revision of the fauna necessary, a conclusion that is just as valid today.

Die wissenschaftliche Bedeutung des Conchylien-Werkes von Dezallier d'Argenville

Rainer Willmann

In der Mitte des 18. Jhs. erlebten die Naturwissenschaften, insbesondere die Biologie einen enormen Aufschwung, denn von Forschungsreisen aus aller Welt wurden unbekannte Tiere und Pflanzen mitgebracht, die dokumentiert werden mussten. Öffentliche und private Sammlungen sowie die ersten Naturhistorischen Museen wurden gegründet. Frankreich spielte dabei eine dominierende Rolle. Georges Louis Leclerc de Buffon (1707–1788) erhielt eine Anstellung am Jardin du Roi und begab sich daran, eine monumentale Zusammenstellung all dessen zu schreiben, was über die Natur bekannt war, zu seinen Lebzeiten 39 Bände. In Schweden katalogisierte Carolus Linnaeus (1707–1778), später Carl Ritter von Linné, neben Buffon einer der bedeutendsten Naturwissenschaftler des 18. Jhs., alle damals bekannten Tier- und Pflanzenarten. Ihre Quellen waren Reiseberichte, hunderte von Beschreibungen und Abbildungen von Pflanzen und Tieren und zahlreiche frühere Versuche, die organismische Vielfalt zu erfassen – ein Schatz an naturgeschichtlicher Literatur, die bis zu Aristoteles zurückreichte. Die *Conchyliologie* von Dezallier d'Argenville gehörte als ein prachtvoll angelegtes, den Schalentieren gewidmetes Opus dazu. „Conchylien" waren praktisch alle Tiere, die ein starres Außenskelett aus Kalk – eine Schale – bildeten. Dazu zählten die Weichtiere, das heißt die Mollusken mit Schnecken, Muscheln, Kopf- und den Kahn- oder Grabfüßern, die Korallen, Röhrenwürmer und einige Stachelhäuter wie die Seeigel. Andere Gruppen ließ Dezallier d'Argenville außen vor, so die Seesterne als nahe Verwandte der Seeigel. Diese Beziehungen konsequent auf Grund ihres allgemeinen Baues zu berücksichtigen, blieb den späteren Naturwissenschaftlern vorbehalten. Zahlreiche Darstellungen von Dezallier d'Argenville sind wissenschaftshistorisch bedeutend, hatte doch Linné bei der Erstellung seiner Gesamtschau der damals bekannten Organismen, seiner *Systema naturae*, immer wieder auf das Werk von Dezallier d'Argenville Bezug genommen und auf dessen Abbildungen verwiesen. Zu Recht zählt es zu den tragenden Säulen der für die Entwicklung der Biologie so entscheidenden *Systema naturae* (s. Anhang).

Dezallier d'Argenville war sich der Bedeutung vieler Informationen, die man heute bei der Beschreibung neuer Arten erwarten würde, nicht bewusst, denn Vieles stand ihm nicht zur Verfügung. Zwar wies er immer wieder darauf hin, dass viele der von ihm dargestellten Arten äußerst selten seien, aber das ist heute im Allgemeinen nicht mehr von biologischem Interesse, und viele Formen erwiesen sich später als durchaus häufig. Andere Angaben wären viel wichtiger gewesen, das gilt insbesondere für die Herkunft und den Fundort der Stücke, die für die Bestimmung von großer Bedeutung sind. Bei der großen Ähnlichkeit mancher Arten, andererseits bei der erheblichen Variabilität, der viele Arten unterworfen sind, kommt es oft zu Problemen, wenn man heute genau ermitteln möchte, um welche Formen es sich tatsächlich handelt. Vor allem die Kegelschnecken-Arten sind einander oft extrem ähnlich, manchmal aber in höchstem Maße variabel. Ohne Fundortangabe ist dann eine Bestimmung kaum möglich. Da führt es eher in die Irre, wenn Dezallier d'Argenville vom Glanz mancher Gehäuse schließt, dass sie aus Westindien stammen. Viele Formen sind auf dem Kopf stehend oder in schräg orientierter Stellung abgebildet, was den Vergleich der Arten sehr erschwert. Manche Abbildungen sind nicht detailliert genug gezeichnet, andere Objekte sind viel zu klein abgebildet oder die Kolorierung ist nicht verbindlich, wodurch die Bestimmung häufig fast unmöglich ist.

Daher ist eine sorgsame wissenschaftliche Sichtung wichtig. Aufgrund der Artenfülle ist diese Aufgabe anspruchsvoll, bedenkt man, dass rund 38 000 Schneckenarten bisher bekannt sind – davon etwa 16 000 Lungenschnecken – und man davon ausgeht, dass ca. weitere 20 000 Arten noch nicht entdeckt worden sind. Die Muscheln sind weniger artenreich: Bisher wurden etwa 8000 Arten beschrieben, vielleicht harren noch einmal so viele ihrer Entdeckung und wissenschaftlichen Beschreibung. Allerdings wird eine solche Bearbeitung in naher Zukunft viel einfacher sein als heute: Von mehreren Institutionen aus werden per Internet verfügbare Datenbanken aufgebaut, in denen die bereits erfassten Organismen mit Bild, Beschreibung, einem Einblick in die Geschichte ihrer Erforschung und Literaturverweisen behandelt werden. Von Göttingen aus, in der Abteilung Morphologie, Systematik und Evolutionsbiologie der dortigen Universität sowie dem Göttinger Zoologischen Museum, werden unter dem Namen AnimalBase die älteren zoologischen Beschreibungen erfasst und kommentiert. Zugleich wird gemeinsam mit der Göttinger Staats- und Universitätsbibliothek im Forschungsprojekt Ezoolo (Early zoological literature online) die gesamte relevante alte Literatur zur Tierwelt für jedermann kostenlos zugänglich ins Internet gestellt.

In vieler Hinsicht hat Dezallier d'Argenvilles Klassifikation wenig mit heutigen Vorstellungen vom System der Tiere zu tun – und auch wenig mit der von Linné. So fasste er die Tiere zusammen, die in vielteiligen Gehäusen leben, darunter fielen zum Beispiel die Seeigel, Entenmuscheln (festsitzend lebende Krebse) und Käferschnecken. Er vereinigte also in ein und derselben Gruppe Organismen, die verwandtschaftlich überhaupt nichts miteinander zu tun haben: Die Seeigel gehören zu den Stachelhäutern (Echinodermata), die den Wirbeltieren relativ nahe stehen, die Entenmuscheln zu den Krebsen und damit zu den Gliederfüßern, und die

Käferschnecken sind eine Gruppe der Weichtiere (Mollusca) und sind somit mit den Muscheln, Schnecken, Kahnfüßern und Kopffüßern nahe verwandt.

Dezallier d'Argenville war sich im Klaren darüber, dass er in mancher Hinsicht mit zu den naturgeschichtlichen Pionieren gehörte. Das gilt insbesondere für seine *Zoomorphose*. In jenem Teil, der einen eigenen Abschnitt seines Werkes bildet, stellte er verschiedene Schalentiere lebend dar. Schon vor ihm hatte es vereinzelt solche Darstellungen gegeben, und Dezallier d'Argenville hätte sich, wie er selbst schrieb, auf die älteren Autoren verlassen und zum Teil deren Abbildungen nachzeichnen lassen können. Er zog es jedoch vor, seine Darstellungen unmittelbar auf die Beobachtungen der Tiere, wie sie sich in der Natur zeigen, zu stützen. Es war ihm wichtig, dass man auch diese Tiere als lebende Organismen verstand und nicht nur als Schönheiten, als Sammlungsgegenstände mit einem ästhetischen Reiz. Höflich wies er darauf hin, dass seine Erkenntnisse oft erheblich von dem abwichen, was andere Autoren vor ihm veröffentlicht hatten. Leider wissen wir nicht genau, wie Dezallier d'Argenville gearbeitet hat. Manche Darstellungen lassen darauf schließen, dass er selbst auf Reisen gesammelt und Skizzen angefertigt hat, nach denen seine Tafeln gestochen wurden.

Er beschrieb auf Tafel 68 z. B. die Meeres-Napfschnecke von oben, von unten und in ihrer Seitenansicht, beschrieb ihren länglichen Körper mit der Mundöffnung samt Lippen und Zähnchen sowie die beiden Fühler. In einer weiteren Darstellung zeigte er das Meerohr, wie man es in Frankreich nur an den Küsten der Bretagne finde und schrieb, dass es seine Abfallprodukte durch die Löcher seiner Schale ausscheide. Nicht immer wusste Dezallier d'Argenville, wozu die Teile des lebenden Organismus dienen, zum Beispiel, wenn er Gehäuse von Meereswürmern mit den herausschauenden lebenden Individuen zeigt. So beschrieb er einen gegliederten Wurm, der um seine Mundöffnung feine Fortsätze aufweise, die er samt Kopf bei Gefahr in seine Röhre zurückziehe. Dass er mit diesem Apparat kleinste Partikel fängt, die ihm als Nahrung dienen, und er damit zugleich Atemorgane – Kiemen – aufweist, war Dezallier d'Argenville nicht bekannt.

Bemerkenswert ist auch die Genauigkeit, mit der er auf das Perlboot einging, den *Nautilus* (Tafel 69), einen Kopffüßer mit äußerem Gehäuse und damit geradezu ein lebendes Fossil, denn derartige Kopffüßer lebten ansonsten nur bis zum Ende der Kreidezeit. Dezallier d'Argenville zeigte Gehäuse, die in verschiedenen Richtungen aufgeschnitten waren, womit der vom Weichkörper in das Innere ziehende Sipho als Strang sowie die Kammerung des Gehäuses sichtbar wurden. Damit konnte er verdeutlichen, dass der Nautilus den fossilen Ammoniten gleicht. Zum Vergleich zeigte er die Schale von *Spirula*, der Länge nach aufgeschnitten, sowie die Schale des Papierbootes *Argonauta*, ebenfalls in der Mittellinie aufgeschnitten, um den grundlegenden Unterschied zu *Nautilus* oder *Spirula* – das Fehlen der Kammerung – zu zeigen. Den Weichkörper des Papierbootes stellte er teilweise nach der Abbildung von Ruysch und nur zum Teil nach einem eigenen in Spiritus konservierten Exemplar dar. Er bedauerte sehr, dass er bisweilen nicht oder nicht rechtzeitig die erwünschten Tiere zu Gesicht bekommen hatte, wie beispielsweise beim Nautilus, der in den Meeren der Molukken nicht selten sei, und von denen er bessere Darstellungen als jene früherer Autoren zu gewinnen hoffte. Aber die Schiffe, mit welchen er deren Ankunft in Frankreich erwartete, seien durch den Krieg, dem Feind der Künste und Wissenschaften, zurückgehalten worden, andere seien in unbekannte Häfen verschlagen. Das belegt, wie wichtig es ihm war, einen wertvollen Beitrag zur Kenntnis der Fauna ferner Meere oder von im europäischen Raum nicht lebenden Organismen zu liefern.

Tafel 70 zeigt verschiedene Meeresschnecken, und Dezallier d'Argenville beschrieb die Funktion des Deckels, der auf dem Weichkörper getragen und notfalls vor die Mündung gezogen wird. Bei manchen ist der lange neben dem Kopf aus dem Gehäuse ragende Sipho auffällig. Er beschrieb die Position der Augen, und, um die Weichteile besser zeigen zu können, hatte er von einer Wellhornschnecke das Gehäuse zum Teil aufgebrochen (Tafel 71). Mehrfach hat er Längsschnitte durch Schneckengehäuse abgebildet. Ohne eigene Präparationen hätte Dezallier d'Argenville nie einen so detaillierten Einblick in den Bau der verschiedenen Weichtiere gewinnen können. Er öffnete und zerschnitt sogar Seeigel, um deren Inneres beschreiben zu können. Selbst das Innere von Muscheln stellte Dezallier d'Argenville anatomisch im wesentlichen korrekt dar, wenn auch, gemessen an heutigen Standards, noch sehr oberflächlich. Auf Tafel 72 findet sich eine geöffnete Auster mit ihrem Kiemenapparat. Dezallier d'Argenville ergänzte, beim lebenden Tier lasse sich nur die obere flache Klappe der beiden Gehäusehälften bewegen, die untere bilde für die obere das Widerlager. Ein Schloss fehle; dessen Funktion – also das Verschließen des Gehäuses – übernehme ein sehniger Muskel. Dass Dezallier d'Argenville nur einen Teil seiner Untersuchungen auch in Bildern umsetzte, zeigen seine Vergleiche: Er schrieb, dass *Spondylus*, der Eselshuf oder die Lazaruskappe, sich von der Auster außer durch ihr Schloss nicht unterscheide. Und während manche Muscheln – so die Auster – am Meeresboden haftend leben, könnten andere sich rasch mit Hilfe ihres Fußes eingraben.

Auf die Lebensweise ging er ein, wo immer möglich. Zum Beispiel zur Purpurschnecke (Stachelschnecke, *Bolinus brandaris*) schrieb er, sie ernähre sich gern von Fleisch und kleinen Fischen, und um sie zu erbeuten, verberge sie sich im Sand und spieße die Beute mit Hilfe ihrer sehr langen Zunge auf. Zu den lang ausgezogenen Steckmuscheln, wie sie im Mittelmeer nicht selten seien, wusste Dezallier d'Argenville zu berichten, dass sie an den Felsen festgeheftet und mit ihrer Spitze im Sand steckend leben. Ihre Haarfäden – der Byssus – seien feiner als die der Miesmuschel; aus ihnen stelle man Strümpfe, Handschuhe und anderes her. Er beschrieb auch die schwer zu beobachtende Gruppe der Kahn- oder Grabfüßer, der Scaphopoda (Elefantenzähne; Tafel 68), eine vielen Biologen eher unbekannte Gruppe von Weichtieren – weltweit gibt es nach derzeitiger Kenntnis rund 380 Arten. Er schrieb, sie steckten fast immer nahezu senkrecht im Sande und verankerten sich dort mit Hilfe ihres Fußes. Bei Gefahr zögen sie ihren Weichkörper tief in ihr Gehäuse zurück.

Auf eine wichtige Gruppe von Schnecken, die terrestrischen Nacktschnecken, konnte Dezallier d'Argenville erst in seiner *Zoomorphose* eingehen (Tafel 76). Der Grund für diese „Sonderbehandlung" liegt darin, dass sie ihr Gehäuse zurückgebildet haben, so dass der Großteil des Weichkörpers frei liegt, und viele Arten haben nicht einmal Reste der einstigen Schale. Sie fallen also streng genommen nicht unter den Begriff „Conchylien". Aber Dezallier d'Argenville war klar, dass diese Lebensformen Schnecken sind, und jene, die noch einen Gehäuserest aufweisen, nannte er „Limaces à coquilles", und jene ohne „Limaces sans coquilles". Damit war er weiter als Linné, der diese Arten noch 1758 in eine ganz andere Gruppe als die Schnecken gestellt hatte.

Dezallier d'Argenville war sich bewusst, dass er selbst bei jenen Arten, die er aus unmittelbarer Anschauung und sogar fast vor der eigenen Haustür beobachten konnte, die tatsächliche Artenvielfalt nicht vollständig erfassen konnte. Er wies darauf hin, dass neue Entdeckungen eine immer wieder neue Bearbeitung der Tierwelt erfordern würden, was sich bis heute bewahrheitet hat.

L'importance scientifique
de la *Conchyliologie*
de Dezallier d'Argenville

Rainer Willmann

Les sciences naturelles, et la biologie en particulier, connurent un essor colossal au milieu du XVIIIᵉ siècle car des plantes et des animaux, dont on ignorait jusque-là l'existence, étaient rapportés de voyages dans le monde entier et leur existence devait être consignée. On assista à la fondation de collections publiques et privées et des premiers musées de sciences naturelles, la France jouant ici un rôle prépondérant. Devenu intendant du Jardin du Roi, Georges Louis Leclerc de Buffon (1707–1788) entreprit de rédiger un inventaire complet du savoir de son époque dans le domaine des sciences naturelles – de son vivant, un ouvrage de trente-neuf volumes. Pendant ce temps en Suède, Carolus Linnaeus (1707–1778), plus tard Carl chevalier von Linné, le plus important naturaliste du XVIIIᵉ siècle à côté de Buffon, cataloguait toutes les espèces d'animaux et de plantes connues. Leurs sources étaient des comptes rendus de voyages, des centaines de descriptions et de représentations de plantes et d'animaux ainsi que de nombreuses tentatives précoces pour répertorier la diversité organismique – un véritable trésor remontant à Aristote. Une de ces sources est la *Conchyliologie* de Dezallier d'Argenville, un ouvrage superbement agencé consacré aux coquillages. Les conchyles étaient pratiquement tous les animaux possédant un squelette externe en calcaire, une coquille. En font partie les mollusques – les coquillages bivalves et univalves, les gastéropodes, les céphalopodes et les scaphopodes, les coraux, les annélides et quelques échinodermes comme l'oursin. Dezallier d'Argenville ignora toutefois d'autres groupes, par exemple celui des étoiles de mer parentes des oursins. C'est aux naturalistes ultérieurs qu'il revint de prendre méthodiquement en compte ces relations, en raison de leur structure générale. De nombreuses descriptions de Dezallier d'Argenville jouent un rôle important dans l'histoire des sciences, car Linné n'a cessé de se référer à son œuvre et de renvoyer à ses illustrations en élaborant sa *Systema naturae*, vue d'ensemble des organismes alors connus. On peut dire qu'elle fait partie à juste titre des piliers de la *Systema naturae* qui a été déterminante pour le développement de la biologie (v. annexe).

Cependant Dezallier d'Argenville, dont la documentation était lacunaire, n'était pas conscient de l'importance de nombreuses informations que l'on s'attendrait à trouver aujourd'hui dans la description de nouvelles espèces. Et s'il faisait sans cesse remarquer que bien des espèces représentées par ses soins étaient extrêmement rares, ceci ne présente en général pas d'intérêt aujourd'hui biologiquement parlant – d'ailleurs de nombreuses formes se révélèrent plus tard assez courantes. D'autres données auraient été plus importantes, en particulier l'origine des animaux en question. Dezalier d'Argenville ne pouvait nommer que de temps en temps l'endroit d'où ils venaient, alors que cette donnée aurait été capitale pour

la détermination. Certaines espèces étant très semblables, et vu la grande variabilité à laquelle sont soumises de nombreuses espèces, on rencontre souvent des problèmes aujourd'hui quand on veut définir avec précision de quelles formes il s'agit vraiment. Les espèces de cônes, en particulier, se ressemblent souvent énormément mais elles peuvent aussi être extrêmement variables. Déterminer l'espèce sans connaître l'endroit où elle a été découverte est alors pratiquement impossible. Et lorsque Dezallier d'Argenville déduit de l'éclat de certaines coquilles qu'elles pourraient provenir des Antilles, ceci tendrait plutôt à égarer le lecteur. De nombreuses formes sont représentées la tête en bas ou de biais, ce qui complique encore beaucoup la comparaison des espèces. Certains dessins ne sont pas assez détaillés, d'autres objets sont représentés trop petits ou la coloration est incertaine, ce qui rend souvent la détermination presqu'impossible. Une classification scientifique soigneuse est donc essentielle. On mesure la difficulté de la tâche quand on sait que nous connaissons à ce jour environ trente-huit mille espèces de gastéropodes – dont environ seize mille gastéropodes pulmonés – et que l'on part du principe que vingt mille autres espèces n'ont pas encore été découvertes. Les espèces de coquillages sont moins nombreuses : huit mille environ ont été décrites jusqu'ici, peut-être sont-elles tout aussi nombreuses à attendre d'êtres découvertes et décrites scientifiquement.

En tout cas ce genre de travail sera beaucoup plus facile dans un avenir proche : plusieurs institutions ont mis en ligne des banques de données dans lesquelles on trouve l'image et la description des organismes déjà répertoriés, avec un aperçu de l'histoire de leur étude et des références bibliographiques. Sous le nom d'AnimalBase, les descriptions zoologiques anciennes ont été saisies et commentées par le département Morphologie, Systématique et Biologie évolutive de l'université de Göttingen ainsi que par le Musée zoologique de Göttingen. En même temps, dans le cadre du projet Ezoolo (Early zoological literature online), en collaboration avec la Bibliothèque universitaire de Göttingen, l'intégralité de l'ancienne littérature pertinente traitant de la faune est mise en ligne et est accessible gratuitement par tout un chacun.

La classification de Dezallier d'Argenville diffère à de nombreux égard de notre conception actuelle de la systématique zoologique – et de celle de Linné. Il rassemble ainsi des animaux dont la coquille est compartimentée, par exemple l'oursin, le pouce-pied (un crabe à pédoncule) et le chiton (un polyplacophore), réunissant en un seul et même groupe des organismes qui n'ont absolument rien de commun : les oursins font partie des échinodermes, relativement proches des vertébrés ; le pouce-pied est un

crustacé qui fait donc partie des arthropodes et les chitons sont des mollusques et donc étroitement apparentés aux coquillages, aux gastéropodes, aux scaphopodes et aux céphalopodes.

Dezallier d'Argenville avait conscience d'être à bien des égards l'un des pionniers de l'histoire naturelle, ce qui vaut particulièrement pour sa *Zoomorphose*, une section autonome de son ouvrage dans laquelle il représente divers coquillages d'après nature. Ceci avait déjà été fait avant lui et Dezallier d'Argenville aurait pu, ainsi qu'il l'écrit d'ailleurs lui-même, se fier aux auteurs anciens et reprendre en partie leurs illustrations. Il préféra cependant baser ses descriptions sur l'observation des animaux tels qu'ils se montrent dans la nature. Il lui importait que l'on considérât aussi ces animaux comme des organismes vivants et pas seulement comme des pièces de collection offrant des attraits d'ordre esthétique. Il remarque poliment que ses connaissances divergeaient souvent considérablement de ce que d'autres auteurs avaient publié avant lui. Nous ne savons malheureusement pas exactement comment il a travaillé. Certaines descriptions semblent indiquer qu'il a lui-même collectionné des pièces au cours de ses voyages et fait des croquis d'après lesquels ses planches ont été gravées.

Il montre ainsi sur la planche 68 la bernique ou patelle commune vue d'en haut, d'en bas et de côté, décrit son long corps avec sa bouche, ses lèvres et ses petites dents ainsi que ses deux tentacules. Dans une autre description il montre l'ormeau, ou oreille de mer, tel qu'on ne le trouve en France que sur les côtes bretonnes et écrit qu'il évacue ses excréments par des trous de sa coquille.

Dezallier ne savait pas toujours à quoi servaient certaines parties de l'organisme vivant, on le remarque dans le cas des annélides tubicoles. Il montre des tubes d'où dépassent des animaux vivants, décrivant ainsi un ver segmenté dont la bouche montre de fins prolongements qu'il rétracte avec sa tête dans son tube s'il se sent menacé. Dezallier d'Argenville ignorait qu'il attrape avec ces filaments les très fines particules dont il se nourrit et qu'il montre ainsi en même temps qu'il possède des organes de respiration, des branchies.

Il traite aussi avec une exactitude remarquable le nautile (planche 69), un céphalopode à coquille externe et donc pour ainsi dire un fossile vivant, car ce genre de céphalopode n'a vécu sur la terre que jusqu'à la fin du crétacé. Dezallier d'Argenville montre des coupes des coquilles, pratiquées dans diverses directions, ce qui fait que les divers compartiments et le siphon, un long cordon creux qui traverse ceux-ci, sont visibles. Il peut ainsi établir que le nautile est semblable aux ammonites fossiles. Il montre en guise de comparaison une coupe longitudinale de la coquille de spirule et de la coquille de l'argonaute pour mettre en évidence la différence fondamentale entre le nautile et la spirule – l'absence de compartimentation. Pour représenter le corps mou de l'argonaute, il utilise l'illustration de Ruysch et seulement en partie l'exemplaire qu'il a conservé dans de l'alcool. Son grand regret était de n'avoir pu, ou trop tard, observer certains animaux, par exemple le nautile qui n'est pas rare dans la mer des Moluques et qu'il espérait représenter mieux que les auteurs anciens. Mais les navires qui devaient lui rapporter les spécimens en France auraient été retenus par la guerre, « ennemie du progrès des arts et des sciences », d'autres étant « relégués dans quelque port inconnu ». Ceci prouve combien il tenait à livrer une contribution précieuse à la connaissance de la faune des mers lointaines ou des organismes ne vivant pas dans l'espace européen.

La planche 70 montre divers gastéropodes et Dezallier d'Argenville décrit la fonction de l'opercule qui se trouve sur le corps mou et qui sert au besoin à clore la coquille. On remarque chez certains animaux le siphon sortant de la coquille près de la tête. Il décrit la position des yeux et, pour mieux examiner les parties molles, il ouvre en partie la coquille d'un buccin

(planche 71). Il a représenté plusieurs fois des sections longitudinales de coquilles de gastéropodes. Sans ses préparations personnelles Dezallier n'aurait jamais pu avoir un aperçu aussi détaillé de l'intérieur des divers mollusques. Il a même ouvert et découpé des oursins pour pouvoir décrire leur structure interne. L'appareil interne du mollusque tel que le représente Dezallier d'Argenville est pour l'essentiel anatomiquement correct même si son traitement reste très superficiel comparé aux standards actuels. Sur la planche 72 nous contemplons une huître avec son appareil branchial. Dezallier d'Argenville ajoute que seule la valve supérieure est mobile chez l'animal vivant, la valve inférieure servant de point de résistance. Les deux écailles seraient dépourvues de charnière, un muscle tendineux remplaçant celle-ci pour fermer la coquille. Les comparaisons de Dezallier montrent qu'il n'a illustré qu'une partie de ses recherches : il écrit que le spondyle, ou pied-d'âne, ne se différencie de l'huître que par sa charnière. Et tandis que d'autres coquillages, dont l'huître, vivent accrochés au sol marin, d'autres pourraient s'enfouir rapidement à l'aide de leur pied.

Dans la mesure du possible il aborde le mode de vie, écrivant par exemple à propos de la pourpre (murex, *Bolinus brandaris*) qu'elle se nourrit de chair et de petits poissons, se cachant dans le sable pour les attraper avec sa très longue langue. Il rapporte de la pinne marine (grande nacre, *Pinna nobilis*), courante en Méditerranée, qu'elle est attachée au rocher et vit avec sa pointe fichée dans le sable. Les filaments soyeux qu'elle secrète, le byssus, seraient plus fins et abondants que ceux de la moule et serviraient à la fabrication de bas, de gants et d'étoffes.

Il décrit aussi le mode de vie des scaphopodes (dentales ; planche 68), un groupe de mollusques difficiles à observer et très peu connus même de nombreux biologistes – selon leurs connaissances actuelles il en existe aujourd'hui 380 espèces de par le monde. Il écrit qu'ils sont presque toujours fichés verticalement dans le sable dans lequel ils sont ancrés à l'aide de leur pied. Lorsqu'ils sont menacés, ils se rétractent au fond de leur coquille.

Dezallier d'Argenville n'aborde un groupe important de gastéropodes, les gastéropodes terrestres, que dans sa *Zoomorphose* (planche 76). La raison de ce traitement particulier est que leur coquille a régressé, si bien que la plus grande partie du mollusque est découvert, et de nombreuses espèces n'ont même pas de vestiges de leur coquille. Ces limaces et escargots ne sont donc pas, strictement parlant, des « conchyles ». Mais Dezallier d'Argenville était conscient du fait qu'ils faisaient tous partie « de la famille du limaçon », les uns avec coquille, les autres sans. Il voit ainsi plus loin que Linné qui, en 1758, classe encore ces espèces dans un tout autre groupe que les gastéropodes.

Dezallier d'Argenville savait qu'il ne pouvait répertorier complètement l'effective diversité des espèces, même celles qu'il pouvait examiner directement et presque observer devant sa porte. Il a fait remarquer que la découverte de nouvelles espèces exigerait toujours un remaniement de la description de la faune, une observation dont la véracité ne s'est pas démentie.

Jac. De Favanne Pinx.

Jac. Mesnil Sculp.

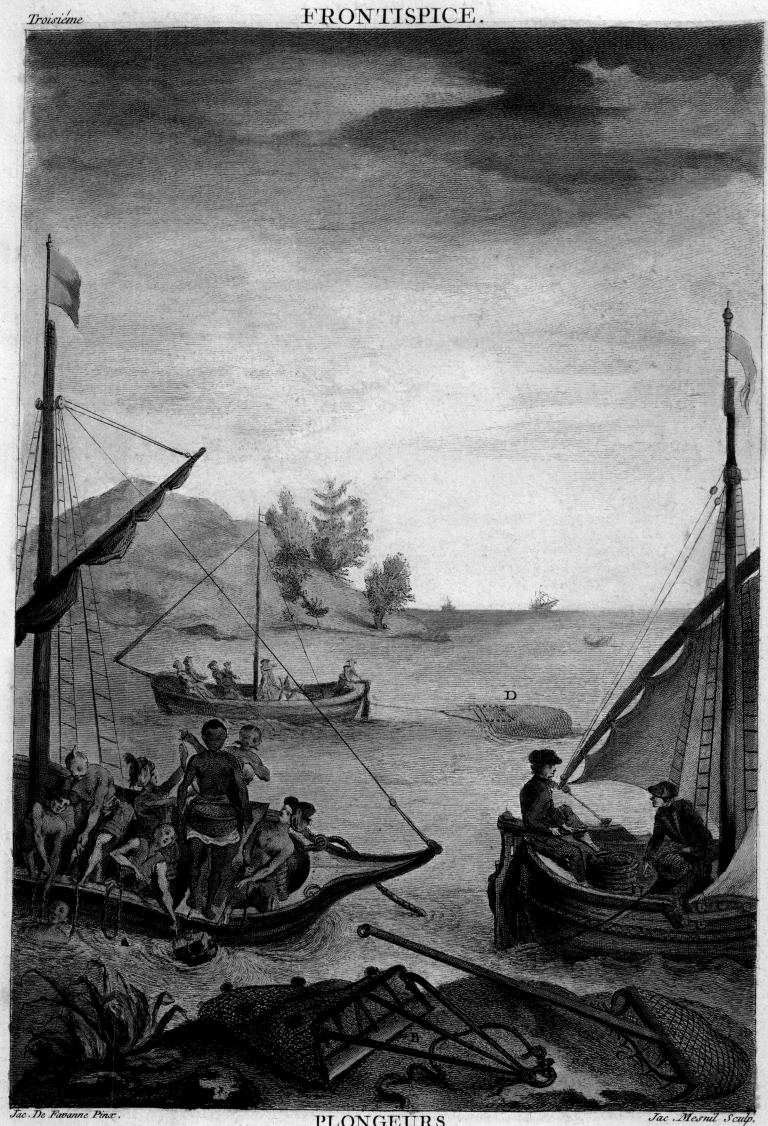

PLONGEURS

(A), Pour les Huîtres à Perles à l'Isle de Ceylan, tom. 1. pag. 156. (B), la Drague, pag. 156.
(C), le Rateau, pag. 156. (D), le Gangui, pag. 157.

RAINER & SOPHIA WILLMANN

Plates with identification of species
Tafelteil mit der Bestimmung der Arten
Planches indiquant
la détermination des espèces

LOTTIIDAE, PATELLIDAE

———————

True Limpets
Napfschnecken, Echte Napfschnecken
Acmées et Patelles

C *Nacella* sp.? F, K, N *Nacella* sp. Q1 cf. *Cellana testudinaria* (L., 1758) Common Turtle Limpet |
Schildkrötenschnecke | – Q2 *Lottia stanfordiana, Collisella pelta* or | oder | ou
Testudinalia testudinalis (Müller, 1776) Plate or Shield Limpet | Schildkrötenschnecke | –

PATELLIDAE

————

True Limpets
Echte Napfschnecken
Patelles

B1 *Patella granularis* L., 1758 Granulated Limpet | Gekörnelte Napfschnecke | Patelle granuleuse
B4 *Patella granatina* L., 1758? Sandpaper Limpet | – | –
D1 *Patella* sp. D2 *Patella* cf. *aspera* Röding, 1798? European China Limpet or | oder | ou
cf. *ferruginea* Gmelin, 1791? Ribbed Mediterranean Limpet | Gerippte Mittelmeer-Napfschnecke | –
F1–F3 *Patella* cf. *chapmani* Tenison-Woods, 1876 Chapman's Limpet | – | Patelle de Chapman
G2 *Patella* sp. N Patellina indet.

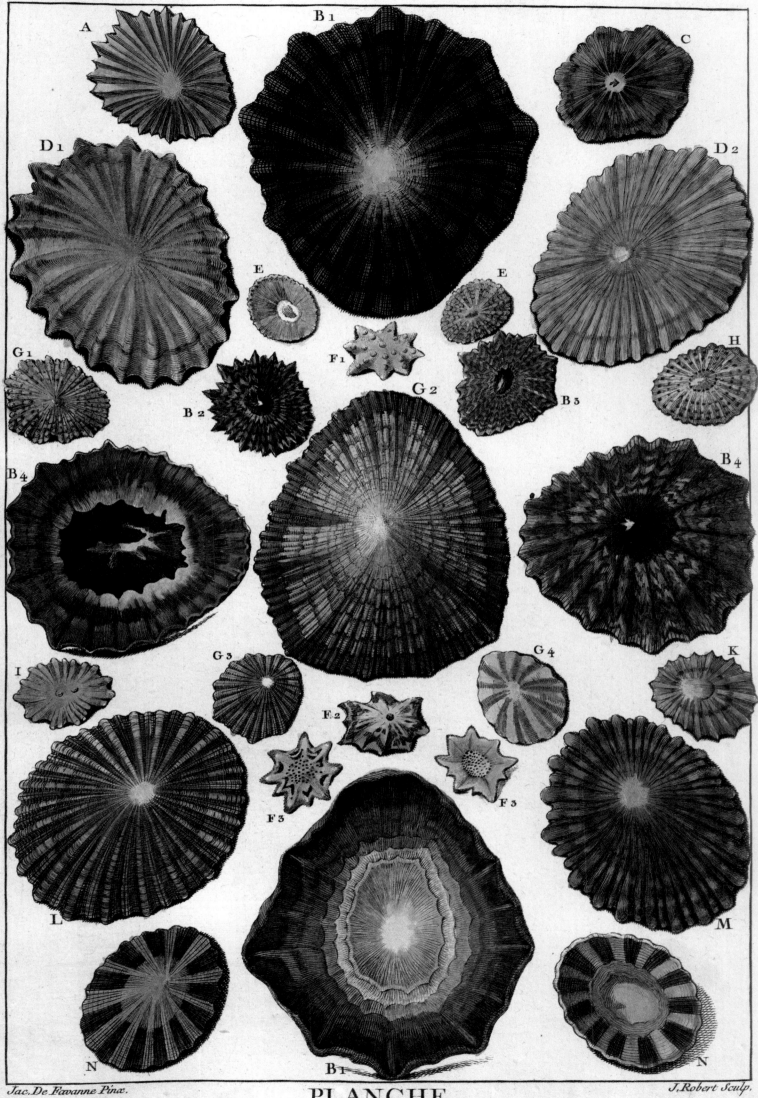

FISSURELLIDAE

─────────

Keyhole Limpets
Lochschnecken
Fissurelles

PATELLIDAE: *PATELLA, NACELLA*

─────────

True Limpets
Echte Napfschnecken
Patelles

A **Patellidae** True Limpets | Echte Napfschnecken | Patelles
A1–E **Fissurellidae** Keyhole Limpets | Lochschnecken | Fissurelles
A3 *Diodora* sp. A4 cf. *Fissurella picta* (Gmelin, 1791) Painted Keyhole Limpet | Farbige Lochnapfschnecke | –
B2 *Nacella mytilina* (Helbling, 1779)? B3 *Patella compressa* L., 1758?
D?, F **Fissurellidae:** *Diodora* sp. Keyhole Limpets | Lochschnecken | Fissurelles

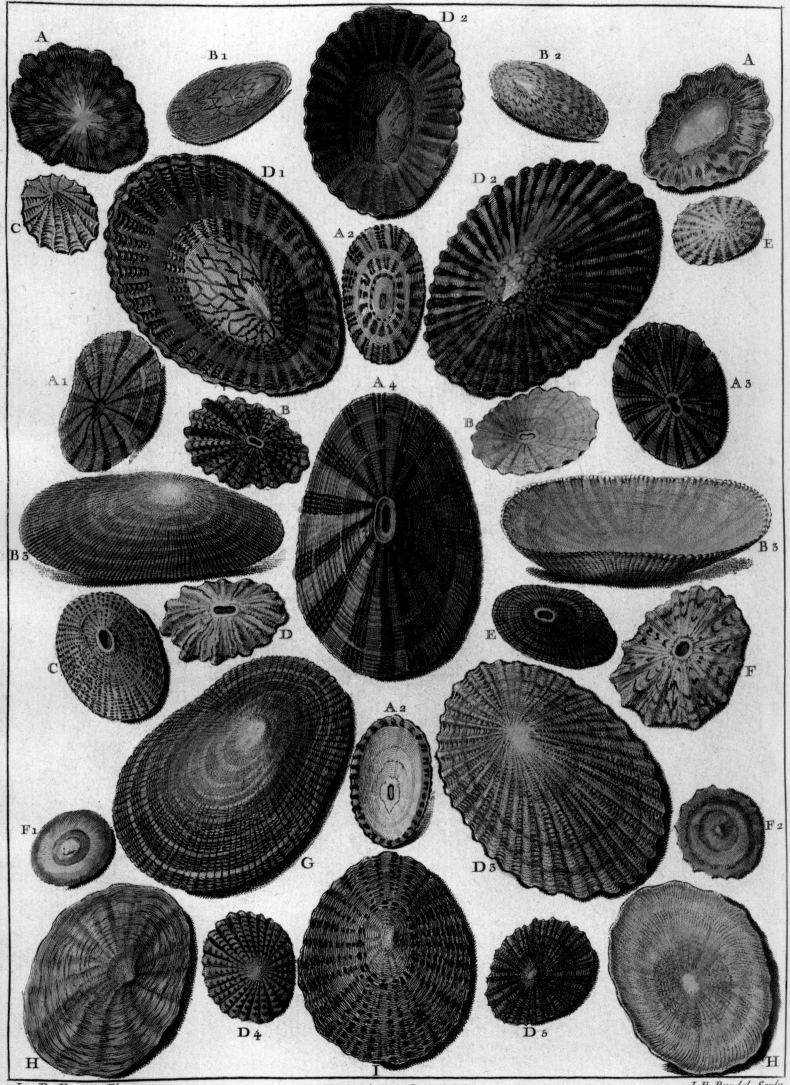

Jac. De Favanne Pinx.

J. B. Bradel Sculp.

CREPIDULIDAE

———

Slipper Shells, Cup-and-saucer Shells
Pantoffel- oder Haubenschnecken
Crépidules: *Calyptraea, Crucibulum, Capulus, Crepidula*

NERITIDAE

———

Nerites
Schwimmschnecken
Nérites

MURICIDAE

———

Rock Shells or Purpuras
Purpurschnecken und Verwandte
Muricidés ou Pourpres

A1–A3 *Calyptraea* (*Trochita*) *trochiformis* (Born 1778) Trochita Shell | – | –
B2–B3 *Crucibulum spinosum* (Sowerby 1824) Spiny Cup-and-saucer | – | –
C2–C3 *Calyptraea chinensis* (L., 1758) Chinese Cup-and-saucer | – | – E1 Neritidae: *Clypeolum?*
E2 *Capulus ungaricus* (L., 1767) Fool's Cap | Kappenschnecke | –
F2 *Crepidula aculeata* Gmelin, 1791 Spiny Slipper Shell | Stachelige Pantoffelschnecke | Crépidule épineuse
G1 *Crepidula?* Slipper Shell | Pantoffelschnecke | Crépidule
G3 Neritidae Nerite | Schwimmschnecke | Nérite
H2 Muricidae *Concholepas concholepas* (Bruguière, 1792) Barnacle Rock-Shell | – | –
M2 Fissurellidae *Emarginula* sp. Keyhole Limpet | Lochschnecke | Fissurelle, Emarginule

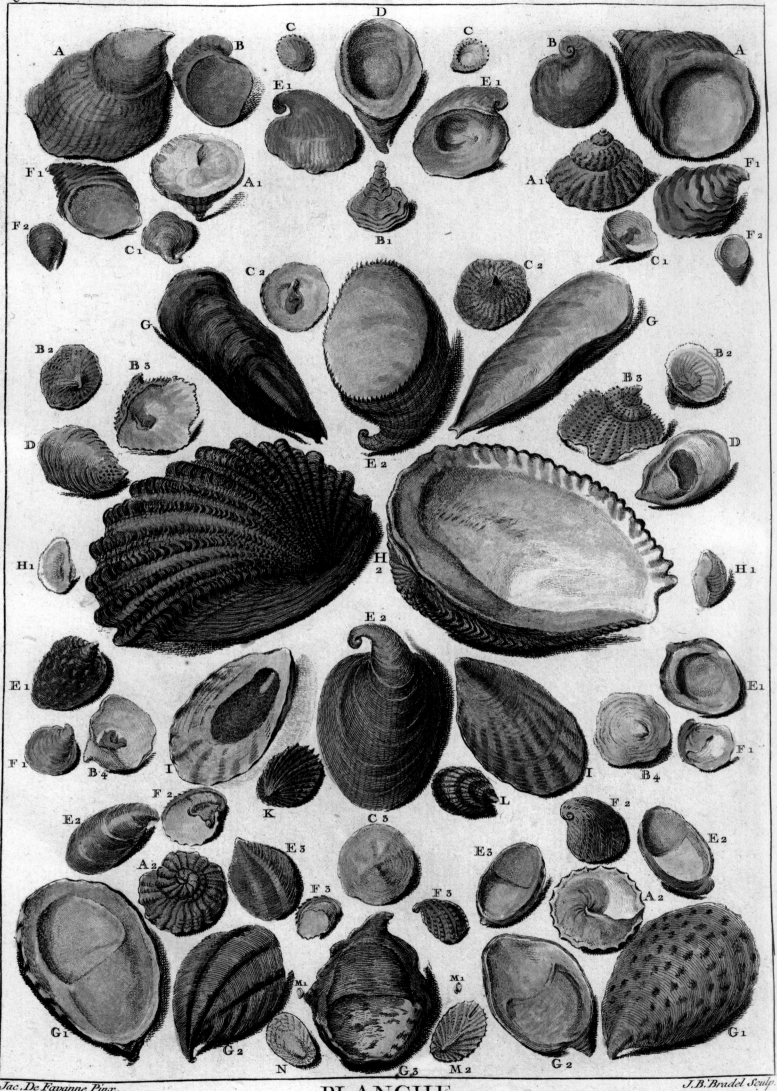

Jac. De Favanne Pinx. J. B. Bradel Sculp.

PLANCHE
IV.

Above / oben / en haut:

HALIOTIDAE

————

Abalones, Ormers
Meerohren
Oreilles de Mer, Ormeaux

A1–A3 *Haliotis* **sp.** Abalone | Meerohr | Oreille de Mer
A4 *Haliotis asinina* L., 1758 Donkey's Ear Abalone | Esels-Meerohr | Oreille d'âne
B *Haliotis midae* L., 1758? Midas's Abalone, Perlemoen | Midas-Meerohr | Ormeau de Midas
D *Haliotis scalaris* Leach, 1814? Staircase Abalone | – | –

Below / unten / en bas:

EPITONIIDAE

————

Wentletraps
Wendeltreppen
Scalaires

CLAVAGELLIDAE,
SCAPHOPODA ET AL.

————

Scaphopods
Kahnfüßer
Dentales, Scaphopodes

A *Epitonium scalare* L., 1758? Precious Wentletrap | Echte Wendeltreppe | Scalaire précieuse
B **Clavagellidae** Watering Pot Clams | – | –
Brechitis (*Penicillus*) *penis* (L., 1758) Common Watering Pot | – | –
E1–E6 **Scaphopoda** Scaphopods | Kahnfüßer | Dentales

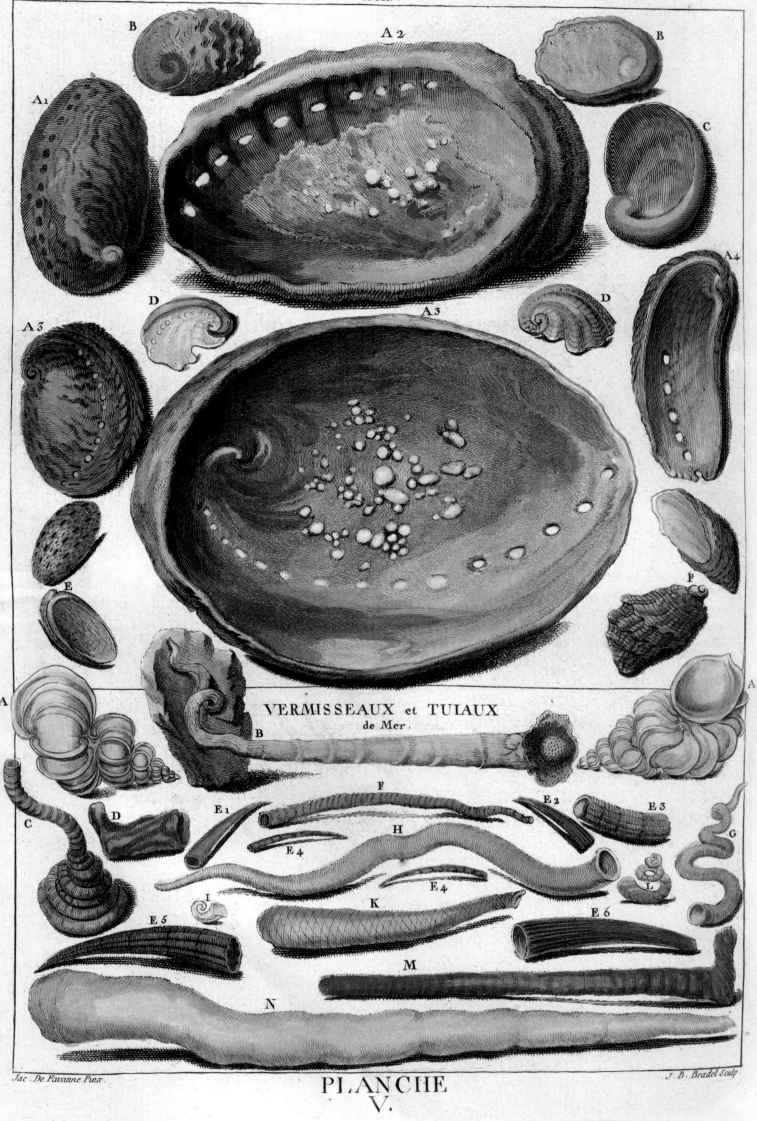

VERMISSEAUX et TUIAUX
de Mer.

Jac. De Favanne Pinx. J. B. Bradel Sculp.

PLANCHE
V.

ANNELIDA: SERPULIDAE ET AL.

———

—

Röhrenwürmer

—

GASTROPODA: VERMETIDAE

———

Worm-Shells
Wurmschnecken
Vermets
(*Vermetus, Serpulorbis, Petaloconchus* et al.)

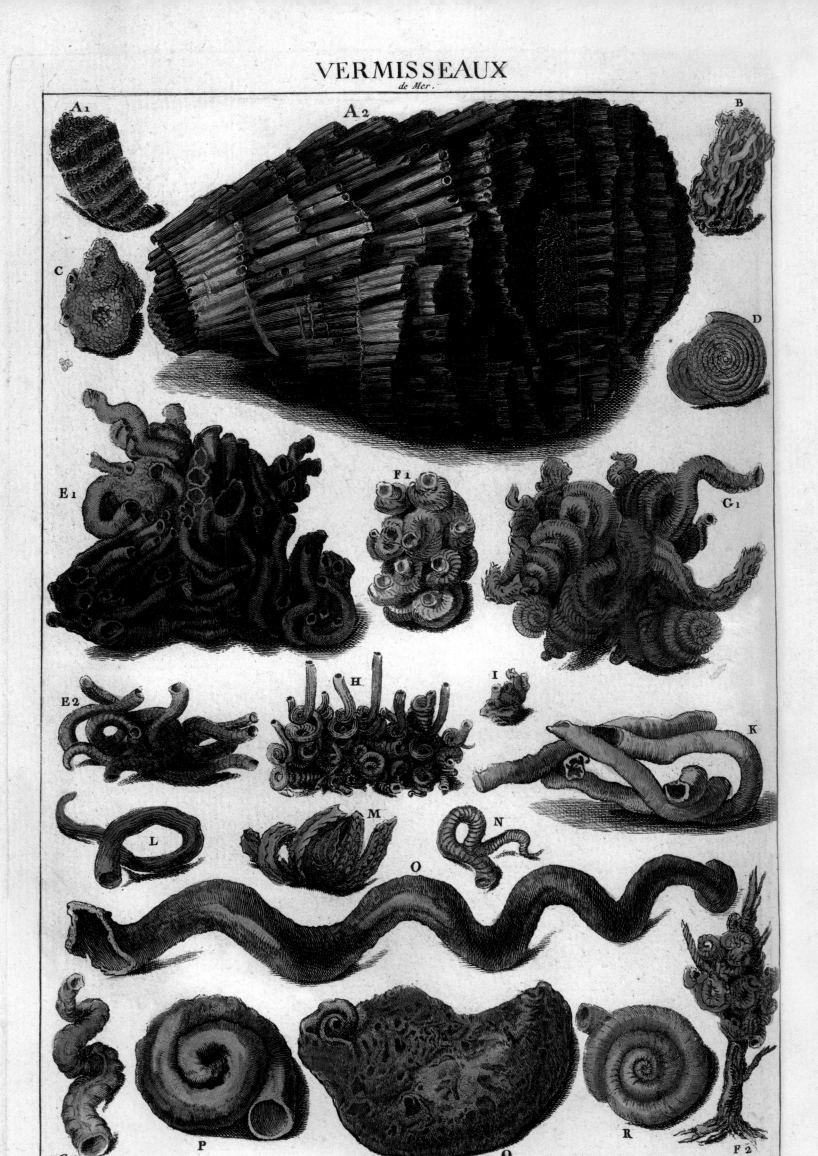

CEPHALOPODA: NAUTILIDA

———

Chambered Nautilus
Perlboot
Nautille

ARGONAUTA

———

Paper Nautilus
Papierboot
Argonaute

SPIRULA

———

Spirula
Posthörnchen
Spirule

A2, A8, A10 *Argonauta argo* L., 1758 Paper Nautilus | Papierboot | Argonaute voilier
A5 *Argonauta hians?* Brown Paper Nautilus | – | –
A6 *Argonauta hians* Lightfoot 1786 Brown Paper Nautilus | – | –
A7 *Argonauta nodosa* Lightfoot 1786 Nodose Paper Nautilus | – | –
A9 *Argonauta* sp. B1–B4 Foraminifera gen. et sp. indet.
C2 *Carinaria cristata* L., 1767 Glassy Nautilus | – | –
D2 *Nautilus pompilius* L., 1758 Chambered Nautilus | Perlboot | –
D3 *Nautilus* sp. E *Spirula spirula* L., 1758
Common Spirula | Posthörnchen | Spirule commune

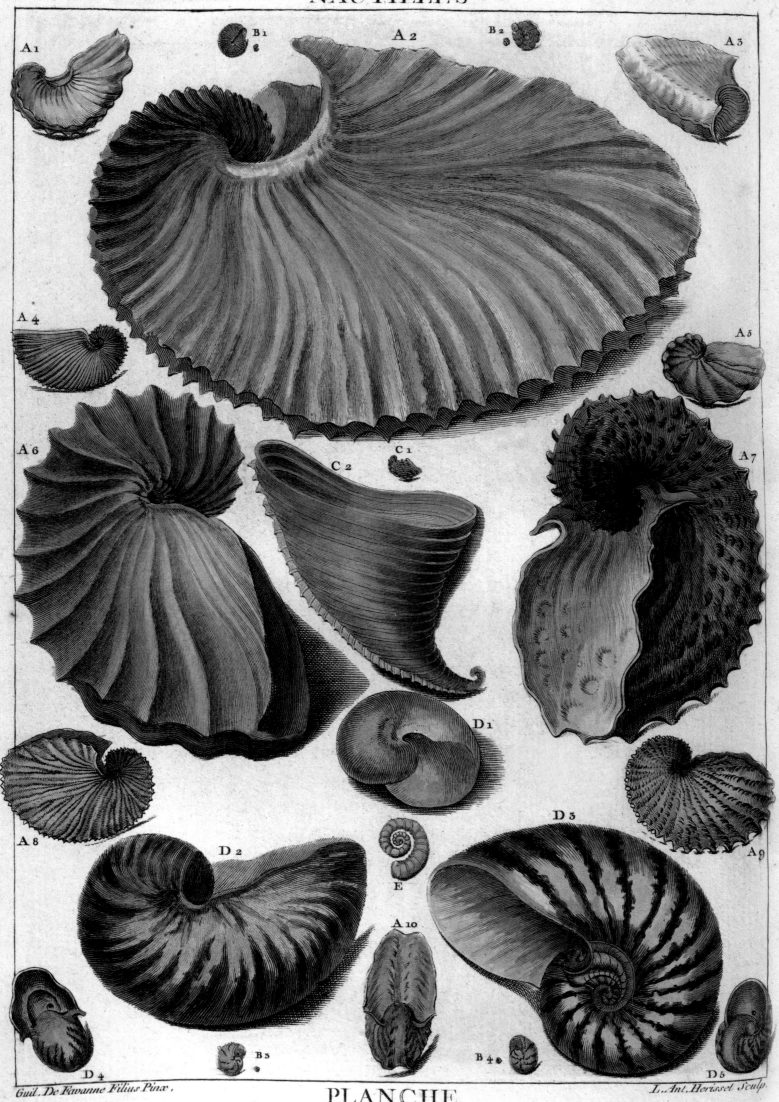

A 1
B 1
A 2
B 2
A 3
A 4
A 5
A 6
C 2
C 1
A 7
D 1
A 8
D 2
E
D 3
A 9
A 10
D 4
B 3
B 4
D 5

Guil. De Favanne Filius Pinx.

L. Ant. Herisset Sculp.

TROCHIDAE

————————

Top Shells
Spitzkreiselschnecken
Troques

TURBINIDAE

————————

Turban Shells
Kreiselschnecken
Turbos

C1 Skeneidae? C2 cf. *Trochea*, cf. *Gibbula rosea*
G1 *Turbo* (*Marmarostoma*) *argyrostomus* L., 1758 Silver Mouth Turban Shell | Silbermund-Turbanschnecke | –
G4 *Turbo* (*Marmarostoma*) *pulcher* Reeve 1842 (= *intercostalis* Menke, 1843)
Beautiful Turban | Schöne Turbanschnecke | Beau Turbo
I Trochidae Top Shell | Kreiselschnecke | Troque
I4 Trochidae *Gibbula* sp. K2 *Atlanta peroni* Lesueur 1817? Peron's Sea Butterfly | – | –

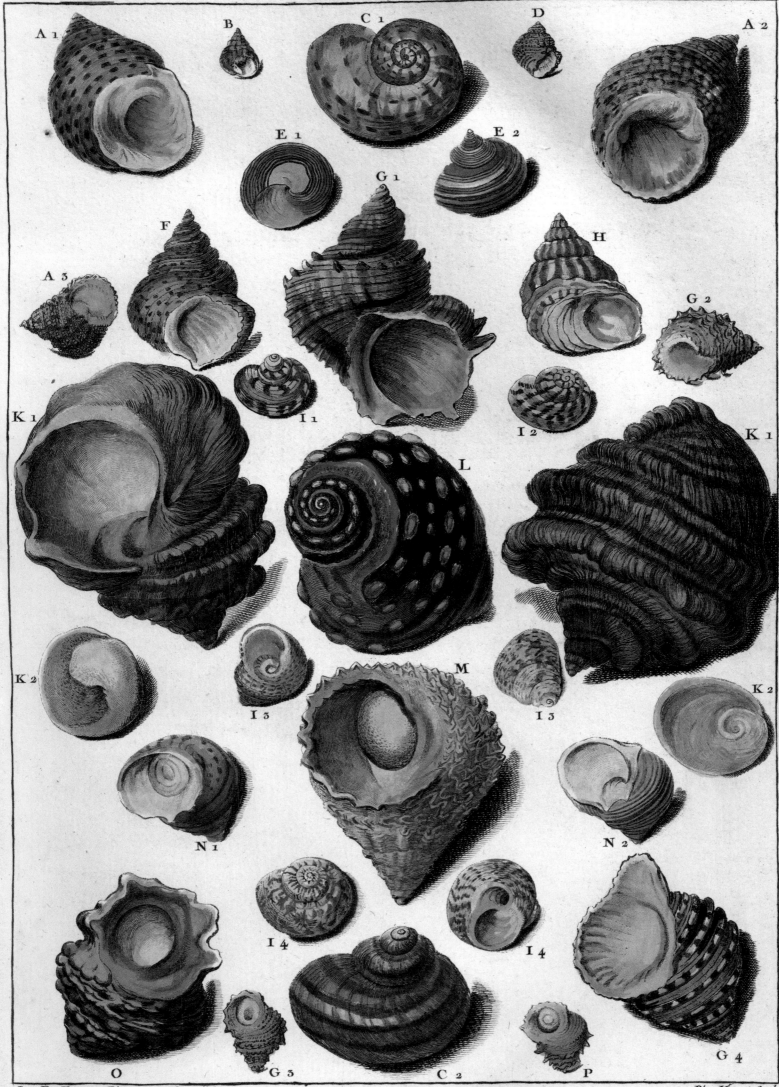

TURBINIDAE

———

Turban Shells
Kreiselschnecken
Turbos

TROCHIDAE

———

Top Shells
Spitzkreiselschnecken
Troques

LITTORINIDAE ET AL.

———

Periwinkles
Strandschnecken, Uferschnecken
Littorines ou Bigorneaux

A1–A3 *Turbo setosus* Gmelin, 1791 Rough Turban | – | – C *Astraea* sp.? cf. *Tectarius rusticus* (Philippi, 1846)
D1–D4, F2 *Turbo petholatus* L., 1758 Tapestry Turban | – | –
G1–G5 *Angaria* cf. *delphinus* (L., 1758) Delphinula | Delphinschnecke | Delphinule
N cf. *Littorina squalida* O–P Littorinidae?

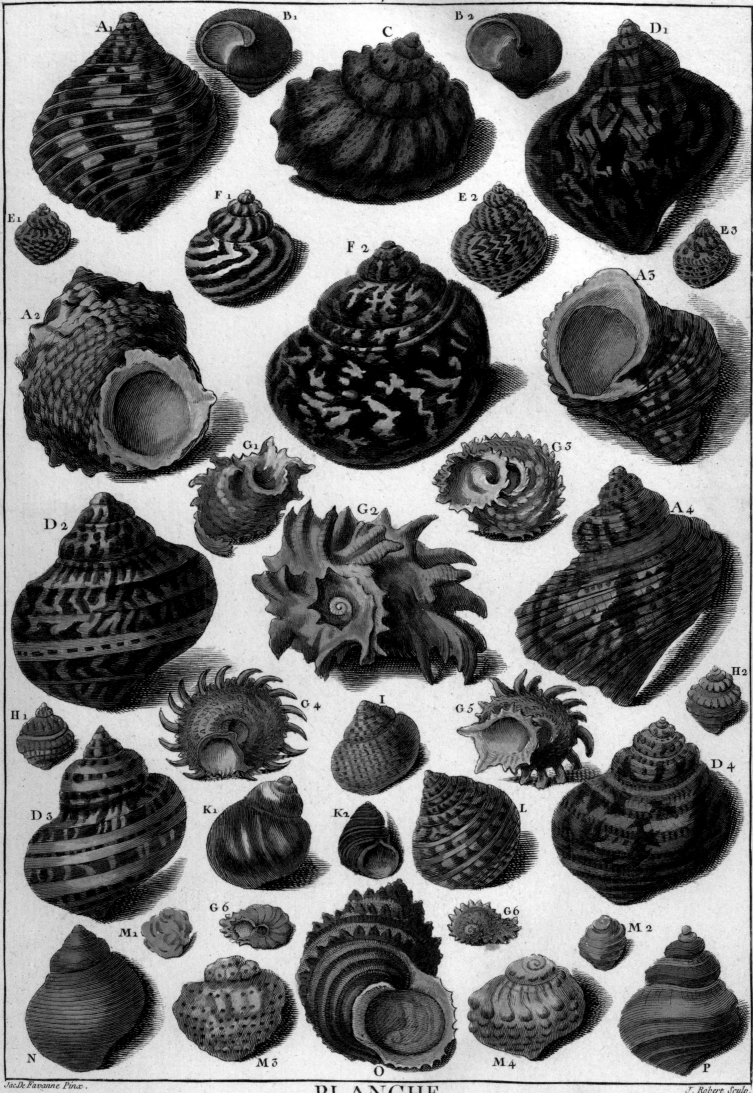

NERITIDAE

———

Nerites
Schwimmschnecken
Nérites

B *Neritodryas dubia* (**Gmelin, 1791**) Dubious Nerite | – | Nérite douteuse
C *Nerita tesselata* **Gmelin, 1791** Tessellate Nerite | – | – E, I, **Z** *Nerita* Nerite | Schwimmschnecke | Nérite
Q3 Neritidae? Nerite | Schwimmschnecke | Nérite R *Nerita* cf. *costata* **Gmelin, 1791** Costate Nerite | – | –
(vel *N. exuvia* L., 1758? Snake skin Nerite | – | –)
T *Neritina communis* (**Quoy & Gaimard, 1832**) Zigzag Nerite | – | Néritine commune

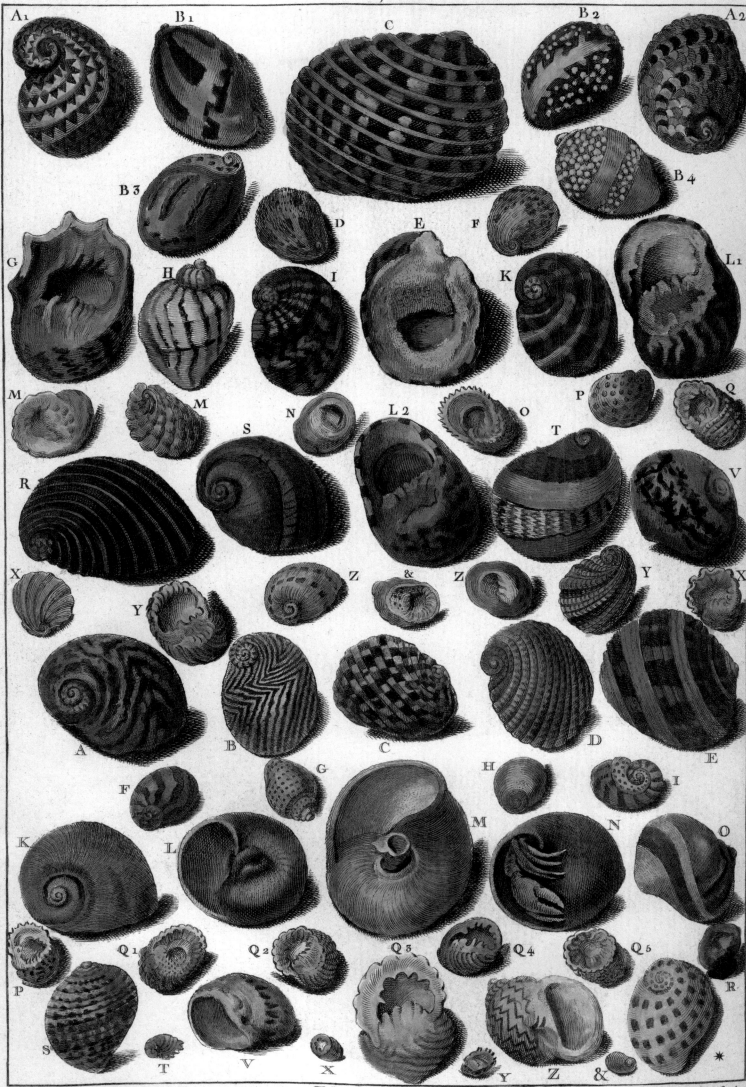

NERITIDAE

Nerites
Schwimmschnecken
Nérites

NATICIDAE

Moon Shells
Nabelschnecken
Natices

D1 Naticidae F *Nerita ascensionis* Gmelin, 1791? Ascension Nerite | – | –
Nerita cf. *textilis* Gmelin, 1791? Textile Nerite | – | Nérite textile

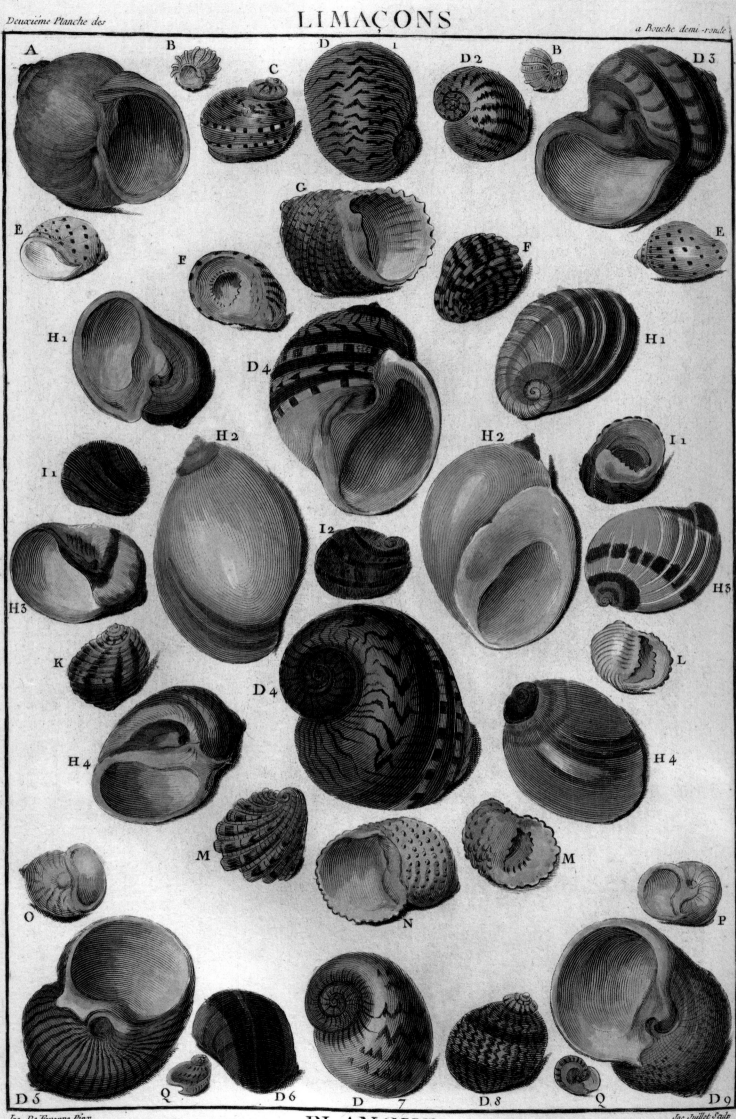

.

TROCHIDAE, XENOPHORIDAE

————

Carrier Shells
Lastenträgerschnecken
Coquillages collectioneurs
ou Xénophores

ARCHITECTONICIDAE

————

Sundials
Perspektiv- oder Sonnenuhrschnecken
Solariums ou Architectonicidés

A cf. *Echinius cumingii* B1 *Trochus niloticus* L., 1767 Commercial Trochus | – | Troque commercial
B2 *Tegula* sp. ? C2 *Xenophora* Carrier Shell | Trägerschnecke, Lastenträgerschnecke |
Coquillage collectioneur E1 *Astraea?* Star Shell | – | Astrée
K *Architectonica perspectiva* (L., 1758) Clear Sundial | Perspektivschnecke | –
O cf. *Tectus* or | oder | ou *Trochus*

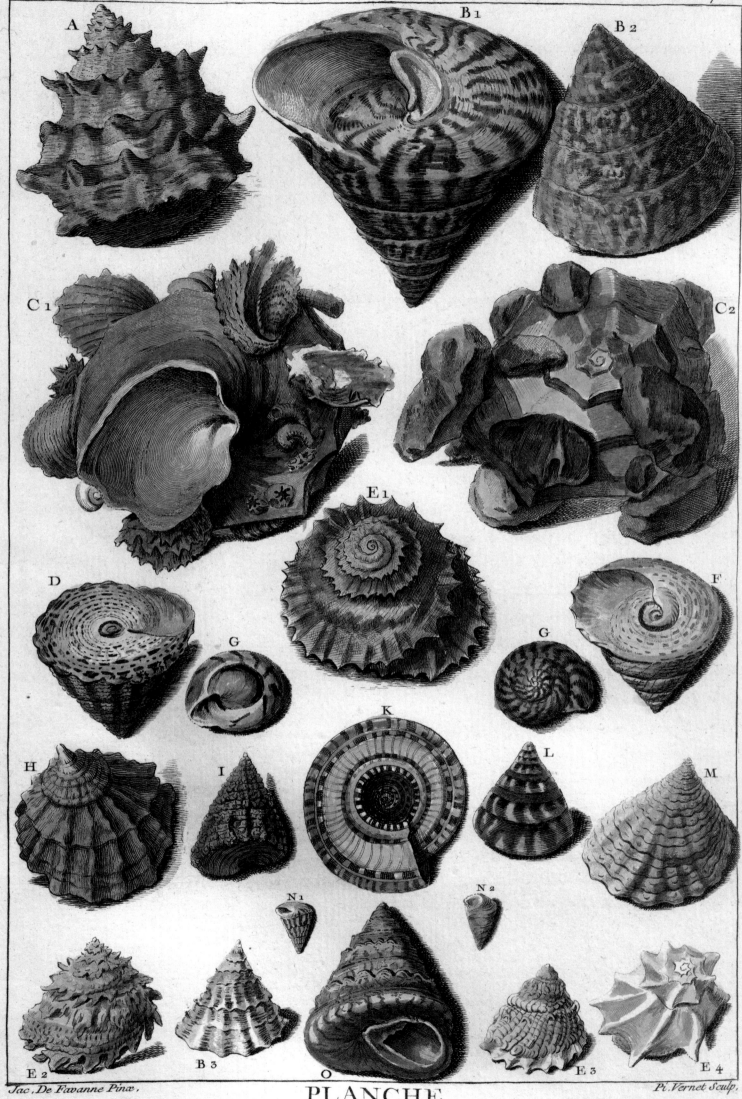

Jac. De Favanne Pinx, *Pi. Vernet Sculp.*

PLANCHE
XII.

A *Tectus?* B, D *Astraea tecta* (**Lightfoot, 1786**)? Imbricate Star Shell | – | Astrée imbriquée
C1 *Stellaria solaris* (**L., 1767**) Sunburst Carrier Shell | Sonnenlastenträgerschnecke |
Coquillage collectionneur ou Stellaria solaire ou Coquillage-soleil
C2 *Astraea* **sp.** Star Shell | – | Astrée **C4, C5** *Astralium haemotragum* (**Menke, 1829**) Pacific Star Shell | – | –
P *Tectus dentatus* (**Forskål, 1775**) or | oder | ou
Tectus pyramis **f.** *noduliferus* **Lamarck, 1822,** *Tectus* = Top Shell,
Tectus pyramis **f.** *noduliferus* Noded Pyramid Top Shell | – | –
V1 *Nerita?* & *Tectus triserialis* (**Lamarck, 1822**)?

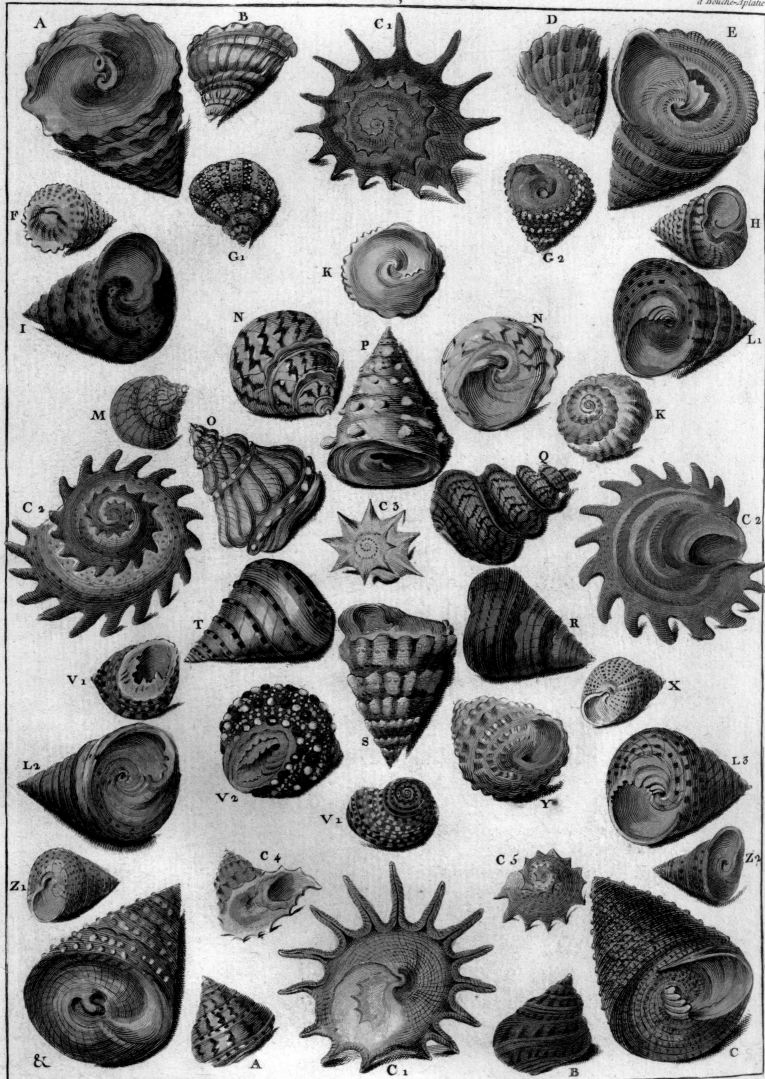

CONIDAE

———

Cones
Kegelschnecken
Cônes

A3 *Conus imperialis* L., 1758 Imperial Cone | – | Cône impérial
B1 *Conus chaldeus* (Röding, 1798)? B2 *Conus ebraeus* L., 1758 Hebrew Cone | – | –
B3 *Conus chaldeus* (Röding, 1798)? Vermiculate Cone | – | –
E4 *Conus marmoreus* L., 1758 Marble Cone | Marmorierte Kegelschnecke | Cône marmoré
I1 *Conus* cf. *genuanus* L., 1758 Garter Cone | – | – I2 *Conus spurius* Gmelin, 1791? Alphabet Cone | – | –
K1 *Conus spectrum* L., 1758 or | oder | ou *Conus princeps* L., 1758
Specter Cone | – | – or | oder | ou Prince Cone | – | Cône princier

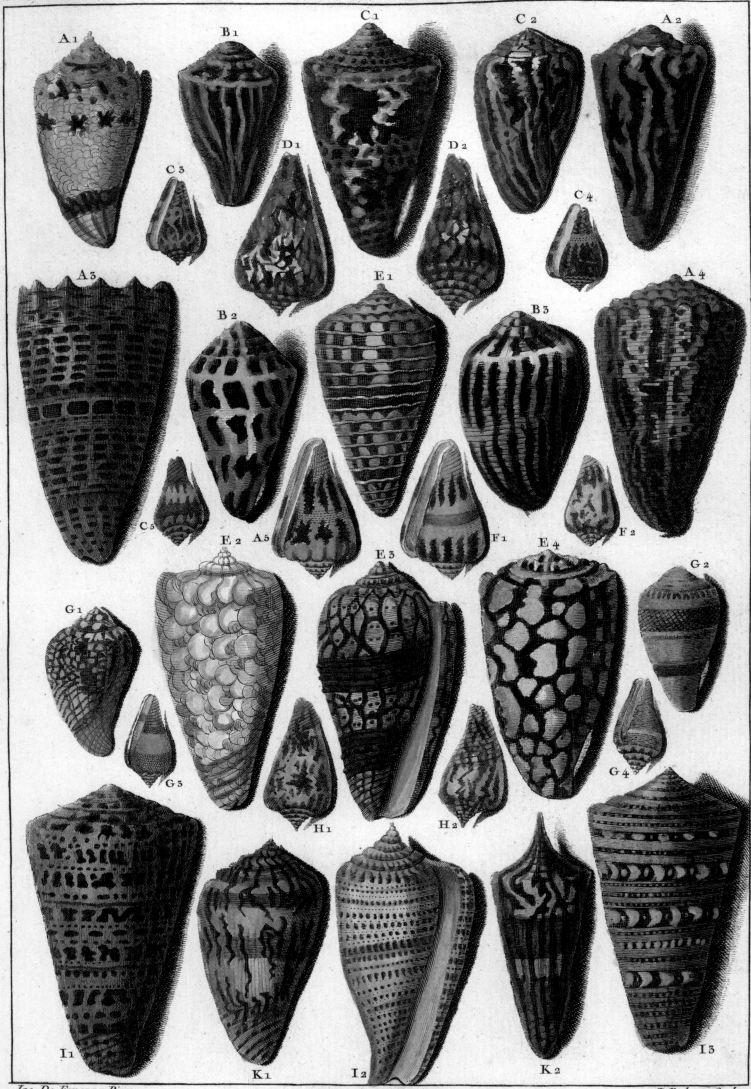

A1 B1 C1 C2 A2
C3 D1 D2 C4
A3 B2 E1 B3 A4
C5 E2 A5 F1 F2
G1 E3 E4 G2
G5 H1 H2 G4
I1 K1 I2 K2 I3

Jac. De Favanne Pinx.

PLANCHE XIV.

J. Robert Sculp.

CONIDAE

———

Cones
Kegelschnecken
Cônes

D1 *Conus figulinus* L., 1758 Fig Cone | Feigen-Kegelschnecke | –
D3 *Conus figulinus* L., 1758? *C. reductaspiralis* Walls, 1979? or | oder | ou *quercinus* Lightfoot, 1796
F4 *Conus stercusmuscarum* L., 1758 Fly-specked Cone | – | –
F5 *Conus pulicarius* Hwass, 1792 Flea-bite Cone | – | –
O cf. *Conus tenuilineatus* P *Conus mindanus* Hwass, 1792?
Bermuda Cone | Bermuda-Kegelschnecke | Cône pline d'Argent

Deuxième Planche des

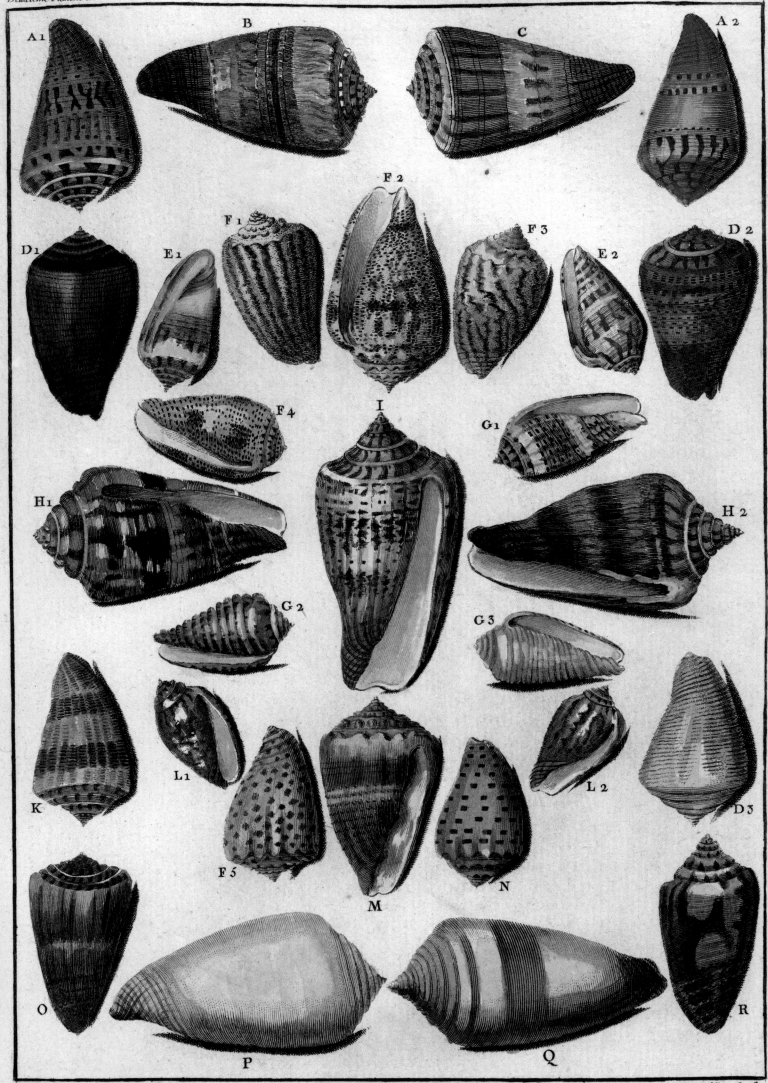

A 1
B
C
A 2
F 2
F 1
D 1
E 1
F 3
E 2
D 2
F 4
I
G 1
H 1
H 2
G 2
G 3
K
L 1
L 2
D 3
F 5
M
N
O
P
Q
R

Jac. De Favanne Pinx

Jac. Juillet Sculp

CONIDAE

———

Cones
Kegelschnecken
Cônes

L1 *Conus genuanus* L., 1758? Garter Cone | – | –

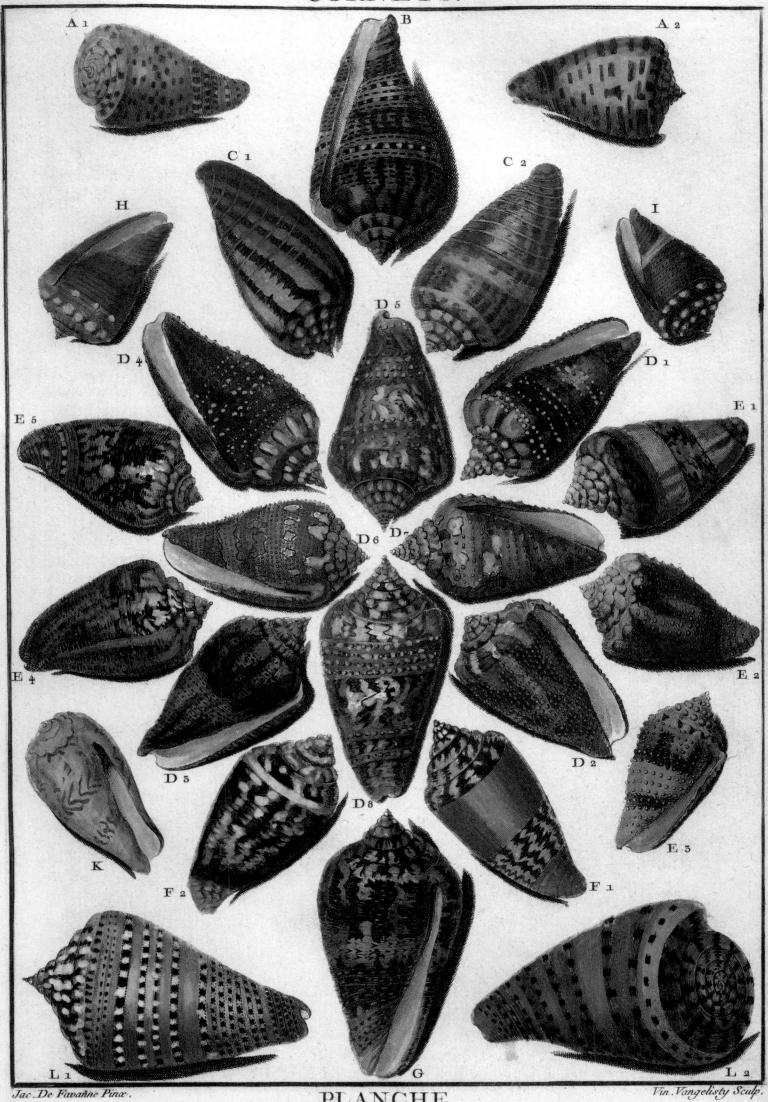

A 1 B A 2
C 1 C 2
H I
D 5
D 4 D 1
E 5 E 1
D 6 D 7
E 4 E 2
D 3 D 2
K D 8 E 3
F 2 F 1
L 1 G L 2

Jac. De Favanne Pinx . Vin. Vangelisty Sculp .

PLANCHE
XVI.

CONIDAE

———

Cones
Kegelschnecken
Cônes

A1 *Conus pictus* Reeve, 1843? *Conus* cf. *pseudocedonulli* Blainville, 1818?
Conus cf. *mindanus* Hwass, 1792? Bermuda Cone | Bermuda-Kegelschnecke | Cône pline d'Argent
B *Conus princeps* L., 1758? Prince Cone | – | – I1–I6 cf. *Conus ammiralis* L., 1758
P *Conus* cf. *textile* L., 1758 Textile Cone | Textil-Kegelschnecke, Netzkegel | Cône textile

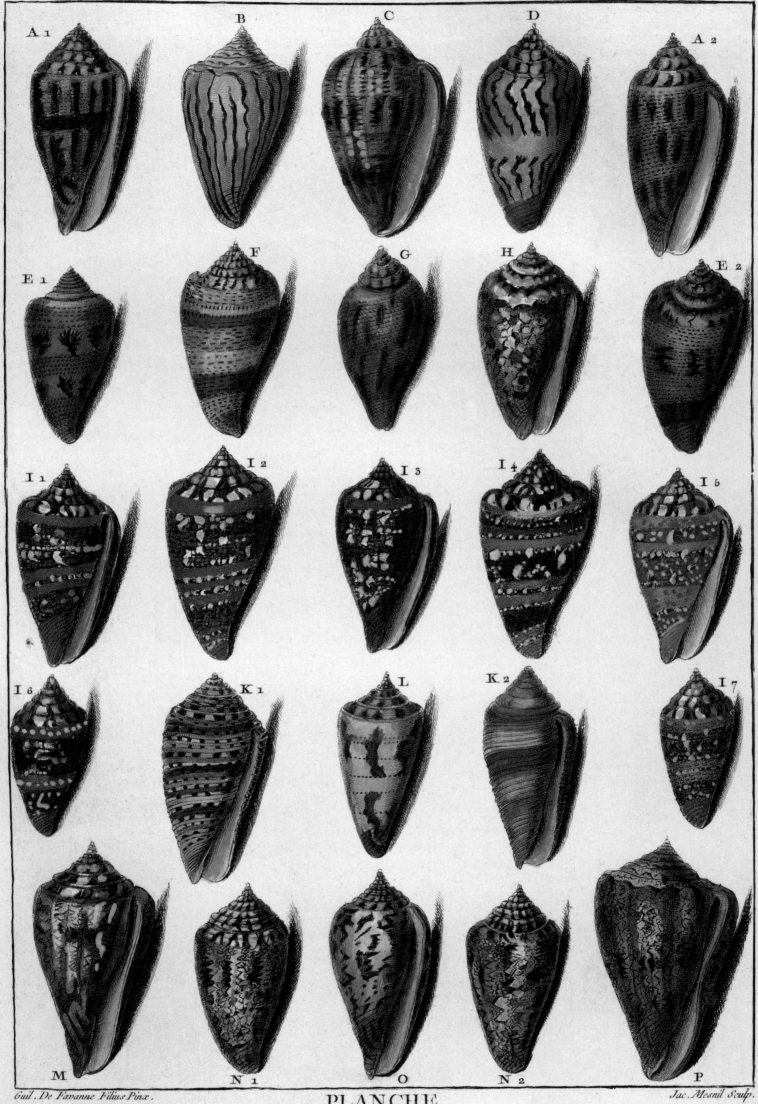

CONIDAE

———

Cones
Kegelschnecken
Cônes

CORNETS

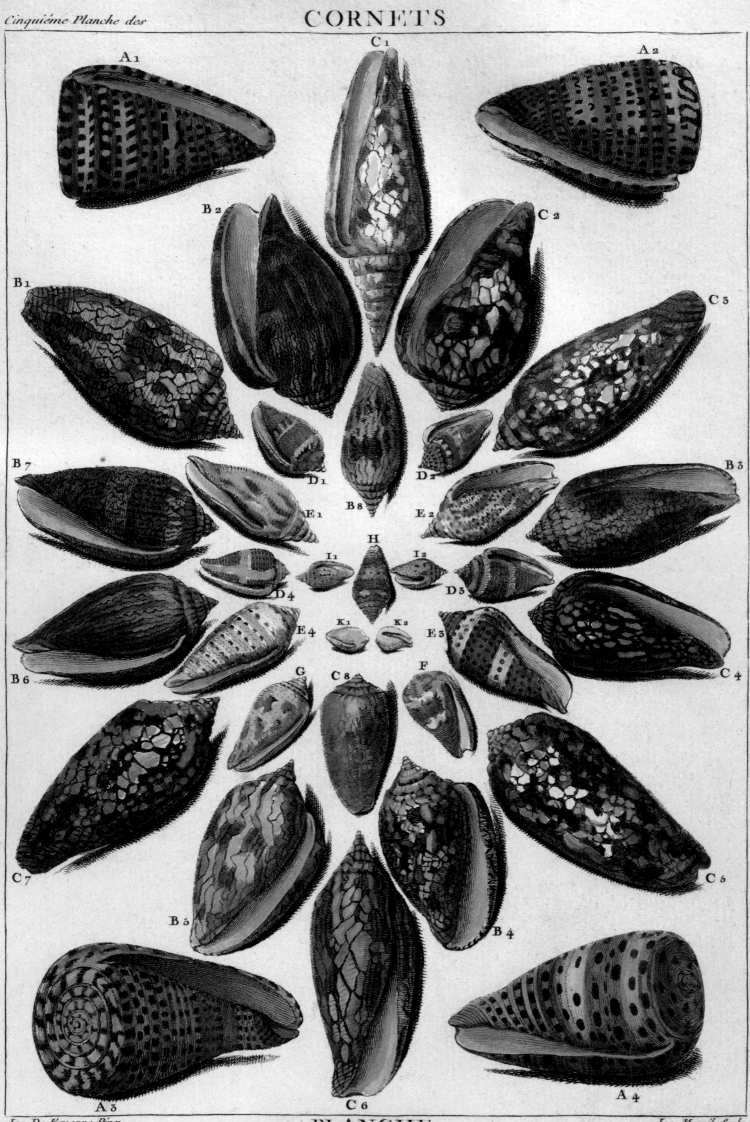

Jac. De Favanne Pinx.

Jac. Mesnil Sculp.

PLANCHE XVIII.

CONIDAE

———

Cones
Kegelschnecken
Cônes

OLIVIDAE

———

Olives
Olivenschnecken
Olives

STROMBIDAE

———

True Conch
Flügelschnecke
Strombe

D *Terebellum terebellum* L., 1758 Terebellum Conch | – | –
L1 *Conus geographus* L., 1758?
Geography Cone | Landkarten-Kegelschnecke | Cône géographe

L 1 M 1 M 2 M 3 N M 4 L 2

OLIVES

A B 1 C 1 C 2 B 2 D

B 3 E 1 E 2 F B 4

G 1 G 2 H 1 H 2 I 1 I 2

K L 1 E 3 L 2 M

B 5 N B 6

O P Q R

Jac. De Favanne Pinx. Jac. Juillet Sculp.

PLANCHE
XIX.

STROMBIDAE

─────────

True Conchs
Flügelschnecken
Strombes

A1 *Mirabilistrombus listeri* (Gray, 1852) Lister's Conch | – | Strombe de Lister
A3 **Strombidae** True Conch | Flügelschnecke | Strombe A8 *Doxander* **sp.?**
C1 *Aliger gigas* (L., 1758) Pink Conch | Riesen-Flügelschnecke | Strombe géant

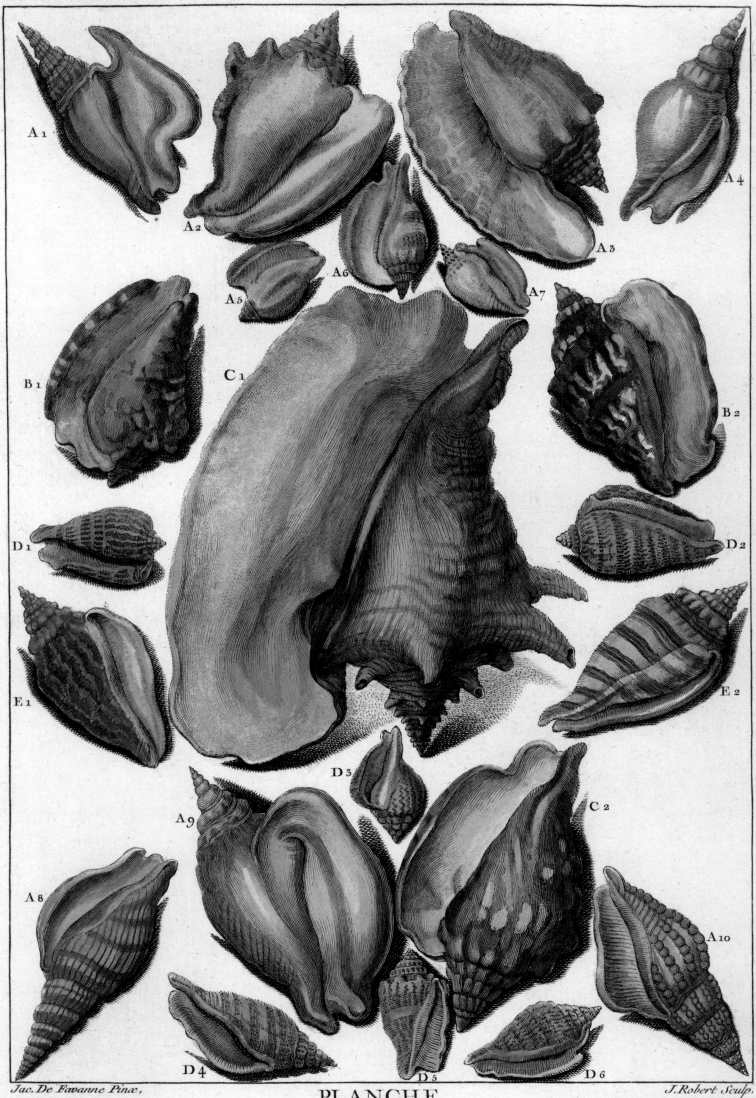

STROMBIDAE

———

True Conchs and Spider Conchs
Flügelschnecken
Strombes et Lambis

A1 *Aliger gallus* (**L., 1758**) Rooster-tail Conch | – | –
A4 *Aliger* **cf.** *raninus* (**Gmelin, 1791**) Hawk-wing Conch | – | –
C2 *Lambis chiragra* **L., 1758** Chiragra Spider Conch | – | Lambis chiragra
E3 *Lambis lambis* (**L., 1758**) Common Spider Conch |
Gemeine Spinnenschnecke, Kleine Teufelskralle |
Coquillage araignée, Lambis commun

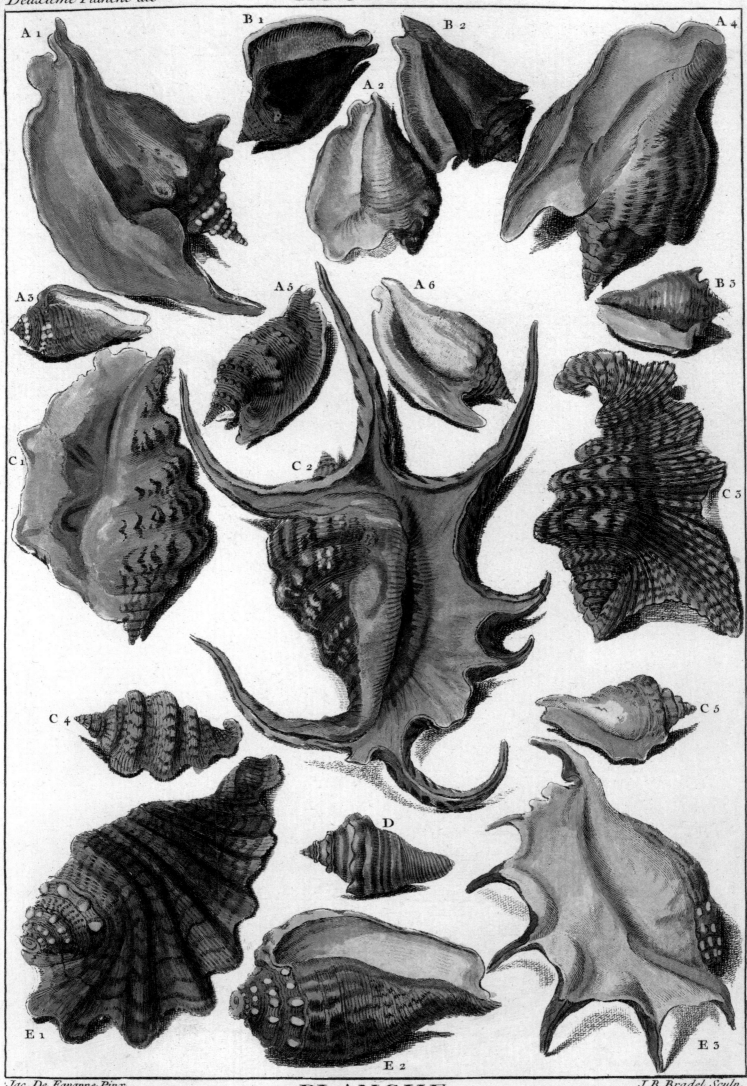

Jac. De Favanne Pinx. J.B. Bradel Sculp.

PLANCHE
XXI.

STROMBIDAE

——————

True Conchs, Spider Conchs
Flügelschnecken, Fingerschnecken
Strombes, Lambis

APORRHAIDAE

——————

Pelican's Foot Shells
Pelikanfüße
Pieds de pélican

A1 *Strombus* cf. *urceus* L., 1758 Little Bear Conch | – | Strombe Petit Ours
A2 cf. *Tricornis sinuatus* (Humphrey, 1786), juvenilis
A3 *Lambis* cf. *truncata* (Humphrey, 1786)?, juvenilis Seba's Spider Conch or
Giant Spider Conch | – | Lambis tronqué ou Lambis géant
A4 *Lambis lambis* (L., 1758) Common Spider Conch | Gemeine Spinnenschnecke,
Kleine Teufelskralle | Coquillage araignée ou Lambis commun
A6 *Lambis millipeda* (L., 1758) Milleped Spider Conch | Tausendfüßerschnecke | –
B *Lambis scorpius* (L., 1758) Scorpion Conch | Skorpionschnecke | Lambis Scorpion
D1 *Aporrhais?* D2 *Aporrhais* sp. Pelican's Foot | Pelikanfuß |
Pied de pélican G *Strombus?*

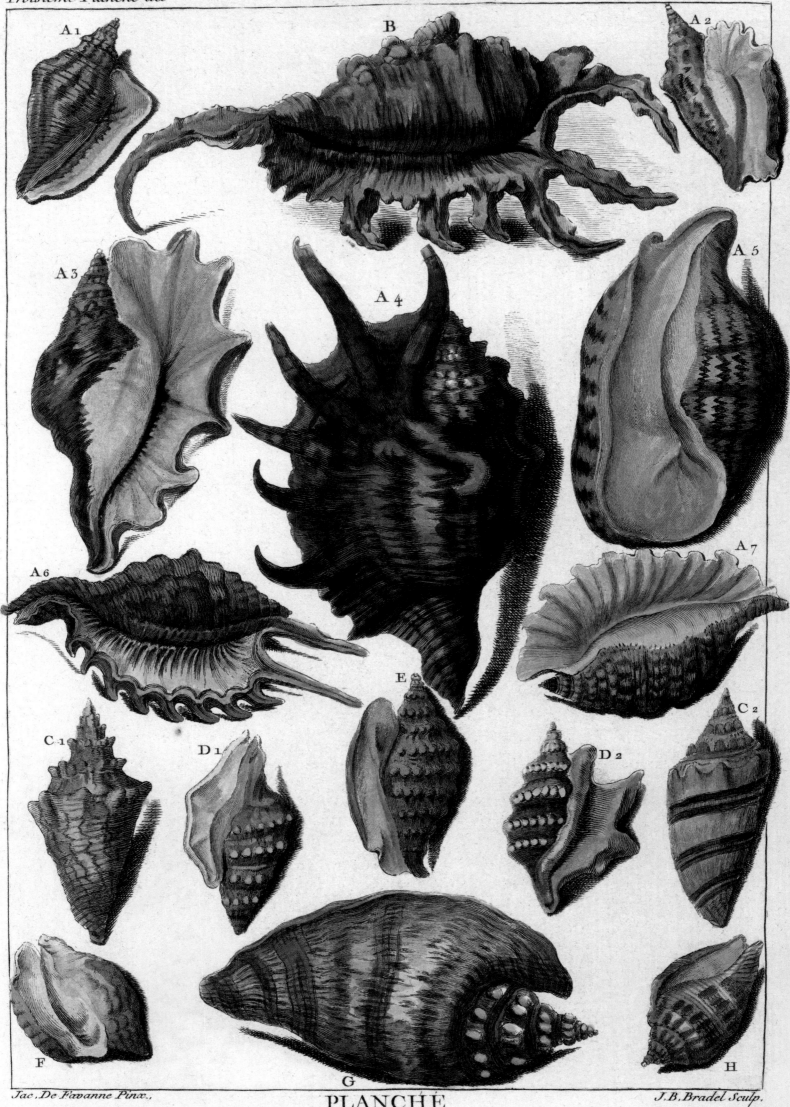

VOLUTIDAE

———

Volutes
Walzenschnecken
Volutes

MELONGENIDAE

———

Swamp Conchs, Crown Conchs,
Giant Whelks, Stair Shells, Melon Conchs
Kronenschnecken, Riesen- oder
Treppenschnecken
Mélongènes

MURICIDAE

———

Murex Shells
Purpurschnecken, Stachelschnecken
Murex, Pourpres

FICIDAE, ET AL.

———

A1–A2 *Voluta? Aulica?* B *Voluta* sp. G 1 *Voluta ebraea* L., 1758 Hebrew Volute | – | –
C–D *Bursa* sp. Frog-Shell | Froschschnecke | Ranelle
F2 *Morula?* G5 *Voluta* sp. H *Busycon* different species | verschiedene Arten | espèces diverses
H2 *Busycon contrarium* (Conrad, 1840)? H 5 *Ficus sp.* I1 *Tonnidae?*

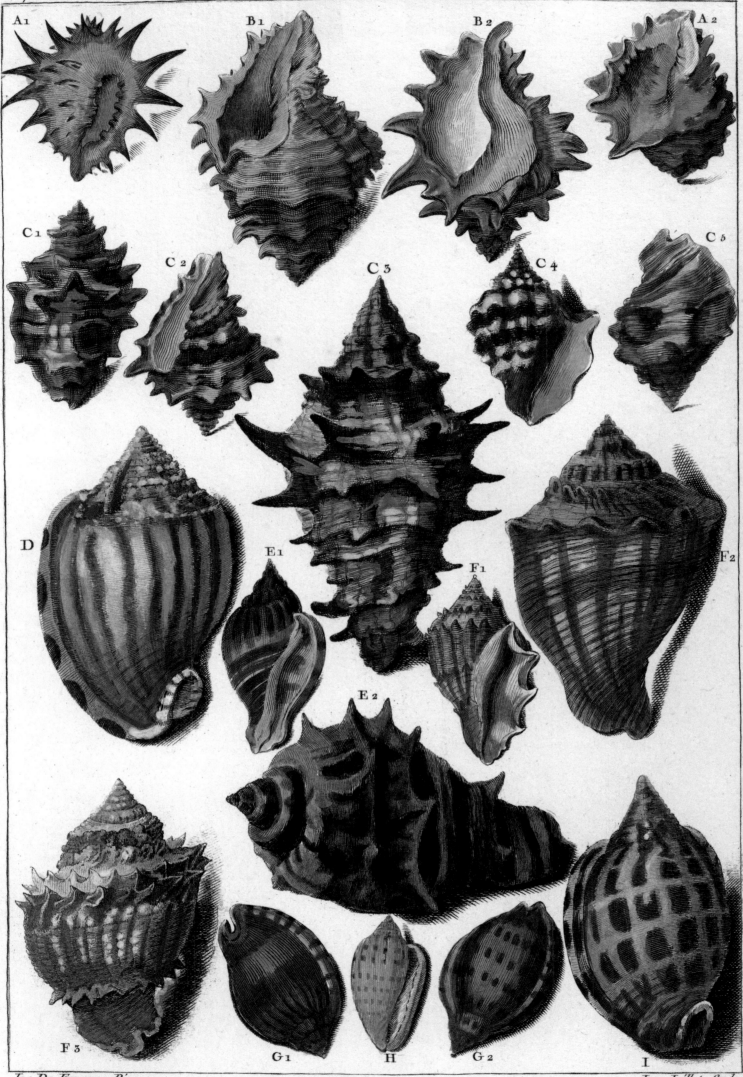

Cinquiéme Planche des

A 1 B 1 B 2 A 2

C 1 C 2 C 3 C 4 C 5

D E 1 F 1 F 2

E 2

F 3 G 1 H G 2 I

Jac. De Favanne Pinx. Jac. Juillet Sculp.

CASSIDAE

———————

Helmet Shells
Helmschnecken
Casques

A3 *Galeodea echinophora* (L., 1758) Spiny Bonnet | Knotige Helmschnecke |
Cassidaire échinophore B2 *Cassis tuberosa* (L., 1758)
Horned Helmet or King Helmet | Gehörnte Helmschnecke | Casque Roi
D4 *Phalium glaucum* (L., 1758)? Gray Bonnet | Graugrüne Helmschnecke | Casque gris

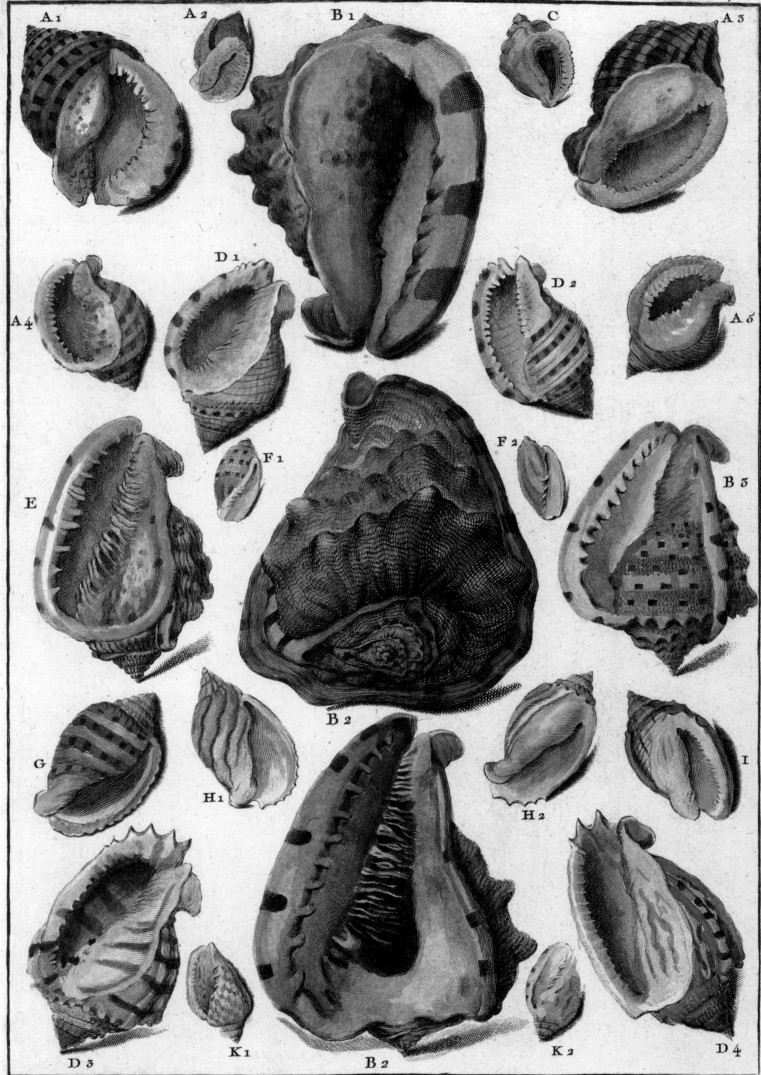

CASSIDAE

———

Helmet Shells
Helmschnecken
Casques

A1 *Cassis madagascariensis* **Lamarck, 1822?** Clench's Helmet or Emperor Helmet | – |
Casque de Madagascar A2 *Cypraecassis rufa* **(L., 1758)?** Bullmouth Helmet | – | Casque rouge
B2 cf. *Cypraecassis coarctata* **(Sowerby, 1825)** Contracted Cowrie-helmet | – | –

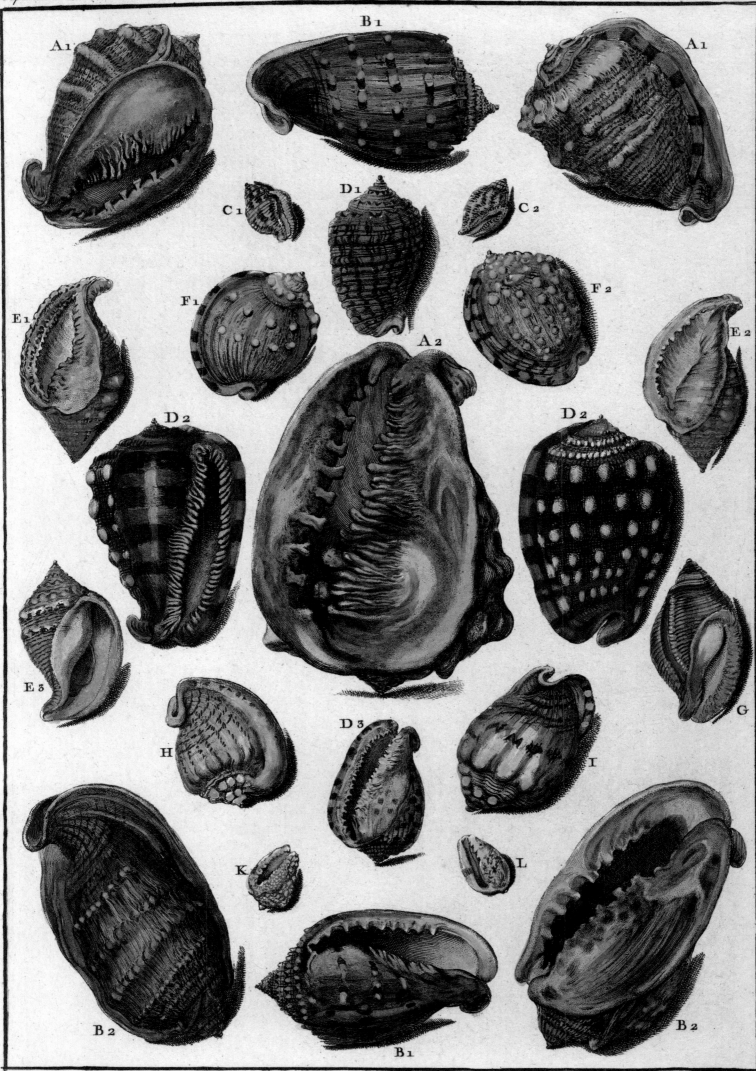

Jac. De Favanne Pinx.　　J.B. Germain Sculp.

PLANCHE
XXVI.

TONNIDAE

———

Tun Shells
Tonnenschnecken
Tonnes

BULLIDAE

———

Bubble Shells
Blasenschnecken
Bulles

A2 *Tonna* cf. *perdix* (L., 1758) Pacific Partridge Tun | – | –
B1 *Tonna* sp. (*luteostoma* Küster, 1857? or cf. *galea* (L., 1758)? Giant Tun | – |
Tonne géante C1 *Tonna* sp. F6 *Bulla ampulla* L., 1758? Ampulle Bulla | – | –
F9 *Atys naucum* (L., 1758)? White Pacific Atys | – | –

TONNES

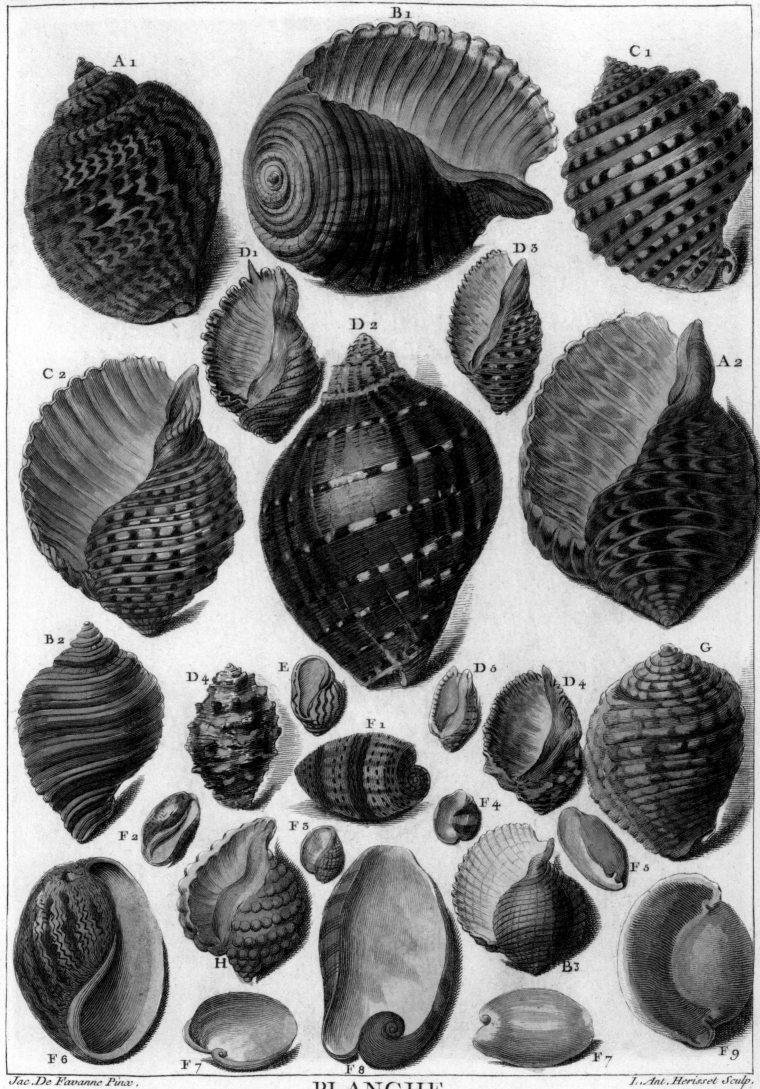

HARPIDAE

———

Harp Shells
Harfenschnecken
Morums

VOLUTIDAE:
MELO, AMORIA, CYMBIOLA

———

Volutes
Walzenschnecken
Volutes

A1–A3 *Harpa* sp. A4 *Harpa costata* (L., 1758) Imperial Harp | – | –
B3–B4 *Melo* sp. D *Cymbiola?* E *Amoria* sp. cf. *ellioti* (Sowerby, 1864) Elliot's Volute |
Elliots Walzenschnecke | Volute d'Elliot or | oder | ou
cf. *turneri* (Griffith & Pidgeon, 1834)? Turner's Volute | – | Volute de Turner
F *Melo melo* (Lightfoot, 1786) Indian Volute | Indische Walzenschnecke | Volute des Indes

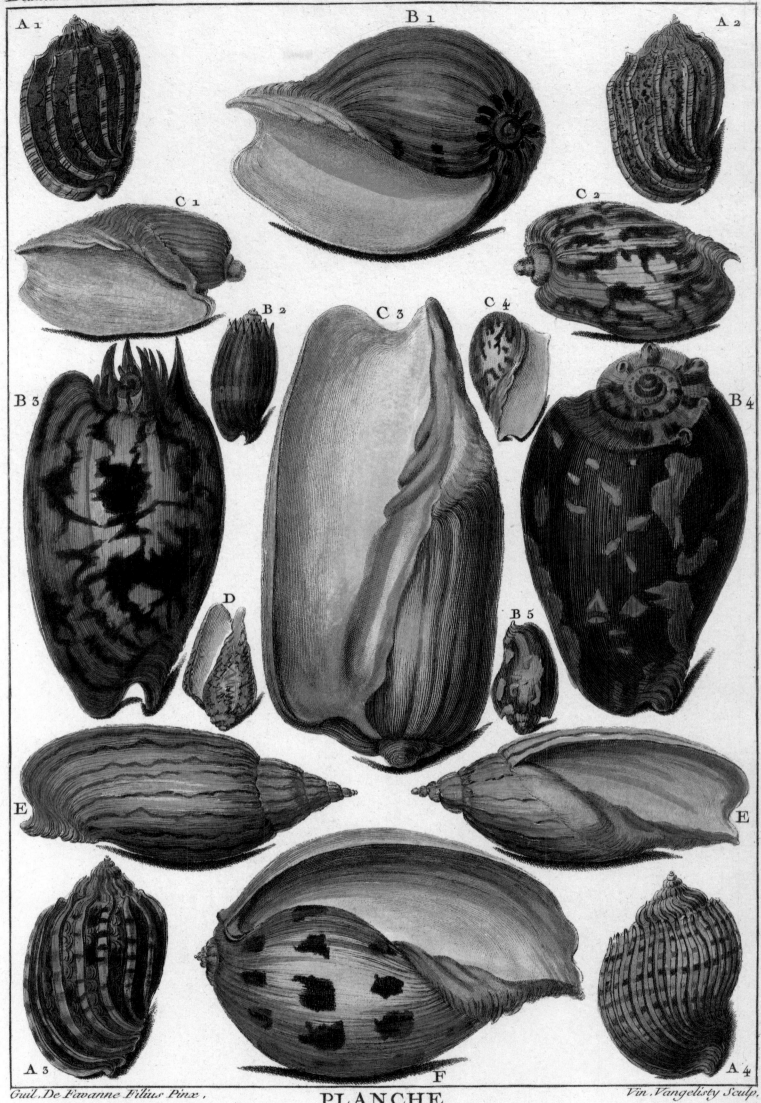

CYPRAEIDAE

———

Cowries
Porzellanschnecken, Kaurischnecken
Porcelaines

TRIVIIDAE: *TRIVIA*

———

Bean Cowries
Scheidewegschnecken
Grains de Café

OLIVIDAE

———

Olives
Olivenschnecken
Olives

A2 *Lyncina lynx* (L., 1758)? Lynx Cowrie | – | –
A3 *Leporicypraea mappa* (L., 1758) Map Cowrie | Landkartenschnecke | –
B1 *Macrocypraea* cf. *cervus* L., 1771 Atlantic Deer Cowrie | – | –
B2 *Lyncina (Arestiodes) argus* (L., 1758) Eyed Cowrie | Argusaugen-Kauri | –
B6 cf. *Erosaria ocellata* (L., 1758) C1 *Talparia talpa* (L. 1758)? Mole Coline | – | –
C5 *Cypraea ovum* Gmelin, 1791? Golden Mouth Cowrie | – | –
D2 *Olivia?* G *Monetaria moneta* (L., 1758) Money Cowrie | Geld-Kauri | Porcelaine Monnaie
E **Marginellidae** or | oder | ou **Cysticidae?**
H1 *Niveria?* H3 *Trivia* Bean Cowrie | Kaffeebohnenschnecke | Grain de Café
I *Palmadusta ziczac*(L., 1758)? Zigzag Cowrie | – | –
Q1 *Staphylaea nucleus* (L., 1758) Q2 *Trivia* or | oder | ou *Cypraea?*

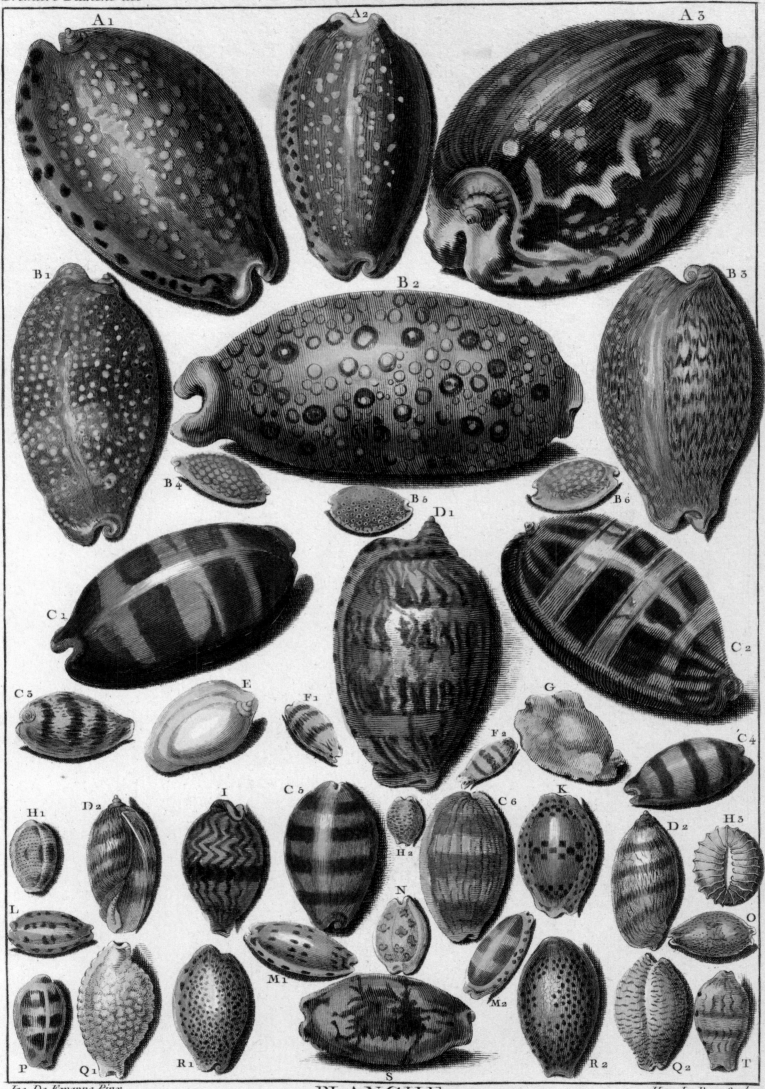

CYPRAEIDAE

———

Cowries
Porzellanschnecken, Kaurischnecken
Porcelaines

OVULIDAE

———

Egg-shells
Eischnecken
Ovules

F1 *Erosaria caputserpentis caputserpentis* (L., 1758)
Snake head Cowrie | Schlangenkopfschnecke | Porcelaine tête-de-serpent
F2 *Cypraea* (*Mauritia*) *mauritiana* L., 1758
Humpback Cowrie | Mauritius-Kauri | Porcelaine de l'Île de France
F3 *Cypraea* (*Mauritia*) *mauritiana* L., 1758 G1 *Cyphoma gibbosum* (L., 1758)
Flamingo Tongue | Flamingozunge | Monnaie Caraïbe à ocelles
G2 *Calpurnus verrucosus* (L., 1758) Umbilical Ovula | – | –
K1 *Phenacovolva birostris* (L., 1767) Double-snouted Volva | – | –
K2 *Volva volva* (L., 1758) Shuttlecock Volva | – | –
L2 *Cypraea tigris* L., 1758 Tiger Cowrie | Tigerschnecke | Porcelaine Tigre
N *Ovula* sp. cf. *ovum* (L., 1758) Egg Cowrie | Ei-Kauri, Eischnecke | Ovule

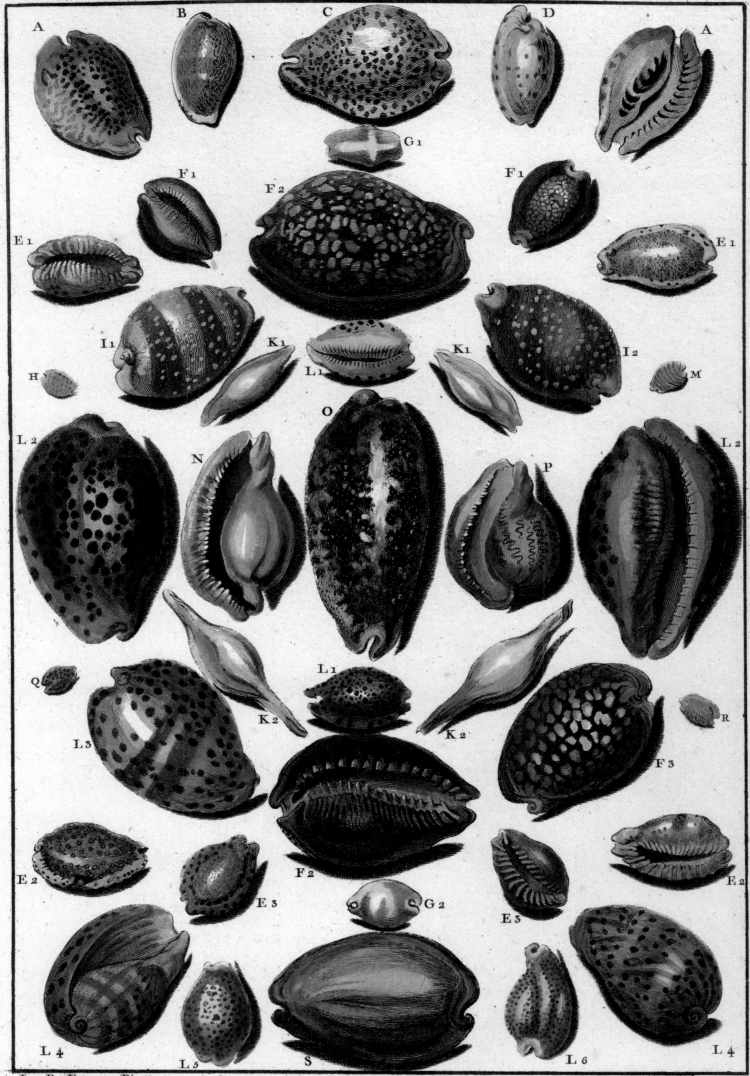

Jac. De Favanne Pinx.
Hip. Le Roy Sculp.

PLANCHE
XXX.

MITRIDAE

———

Miters, Miter Shells
Mitraschnecken | Mitres

COSTELLARIIDAE

———

Ribbed Miters | Gerippte Mitraschnecken | Mitres à côtes axiales

BURSIDAE

———

Frog Shells | Froschschnecken | Bourses

RANELLIDAE ET AL.

———

Distorsios

A3 *Amoria* (Volutidae)? or | oder | ou *Marginella* (Marginellidae)? C1–C2, D2 Mitridae
C2 *Mitra mitra* (L., 1758) Episcopal Miter | Echte Mitraschnecke | Mitre épiscopale
D2 *Mitra papalis* (L., 1758)? Papal Miter | – | Mitre papale
H1–H2 *Distorsio* sp. I4 Costellariidae: *Vexillum* sp.
I5–I6 *Vexillum* sp. J7 *Vexillum rugosum* (Gmelin, 1791) Rugose Miter | – | –

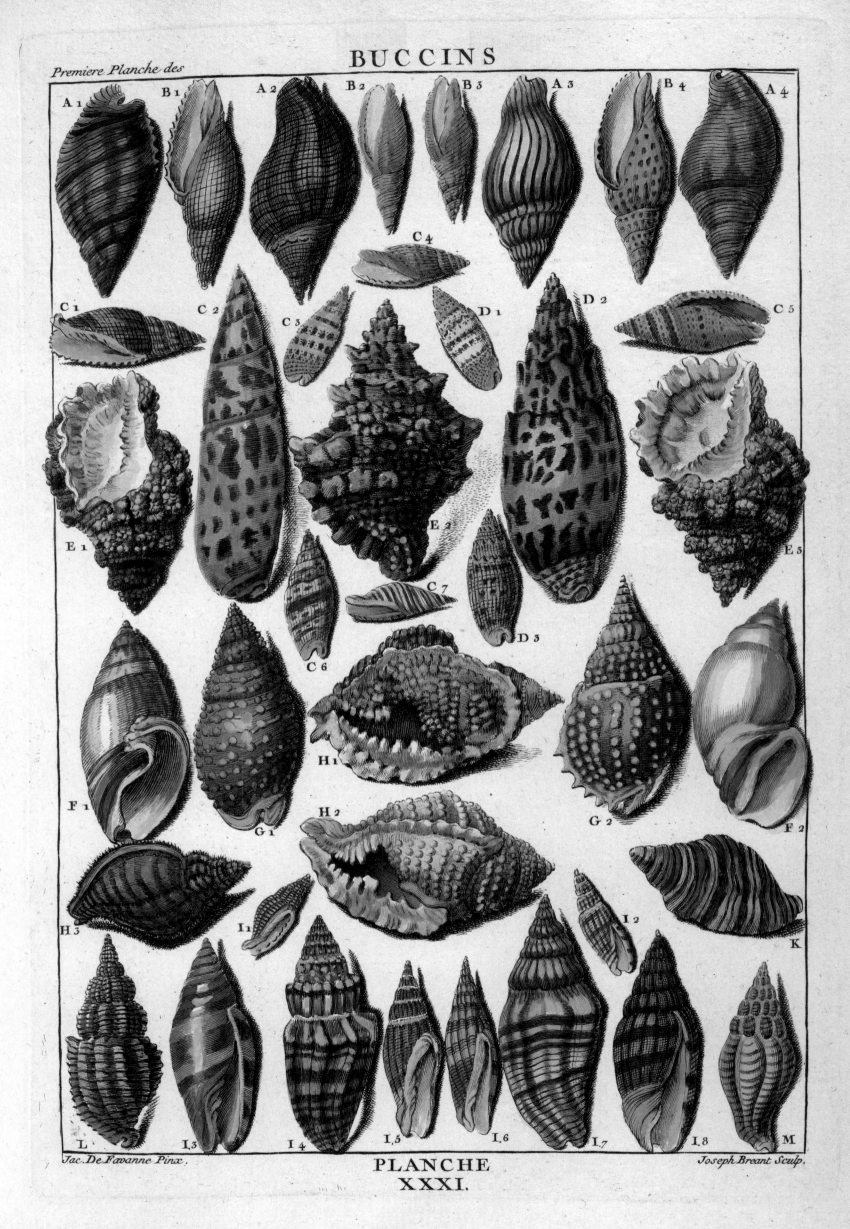

BUCCINIDAE

Whelks and allies
Wellhornschnecken und Verwandte
Buccins

BURSIDAE

Frog Shells
Froschschnecken
Bourses, Ranelles

A *Neptunea contraria* L., 1771? Left-handed Neptune | – | –
B1, B3–B6 *Bursa* spp. Frog Shells | Froschschnecken | Bourses
B2 *Bufonaria echinata* (Link, 1807)? Spiny Frog Shell | Stachelige Froschschnecke |
Bourse épineuse C Buccinidae D *Buccinum undatum* L., 1758 Common Northern Buccinum |
Wellhornschnecke | Buccin commun F cf. *Cantharus* Goblet | – | –
G1–G2 *Charonia lampas* (L., 1758) Trumpet Triton | – | –
H *Neptunea* cf. *lyrata* (Gmelin, 1791) New England Neptune | – | –
N Volutidae? M *Neptunea* cf. *antiqua* (L., 1758) Ancient Neptune | Spindelschnecke | –
or | oder | ou *Neoberingius turtoni* (Bean, 1834)

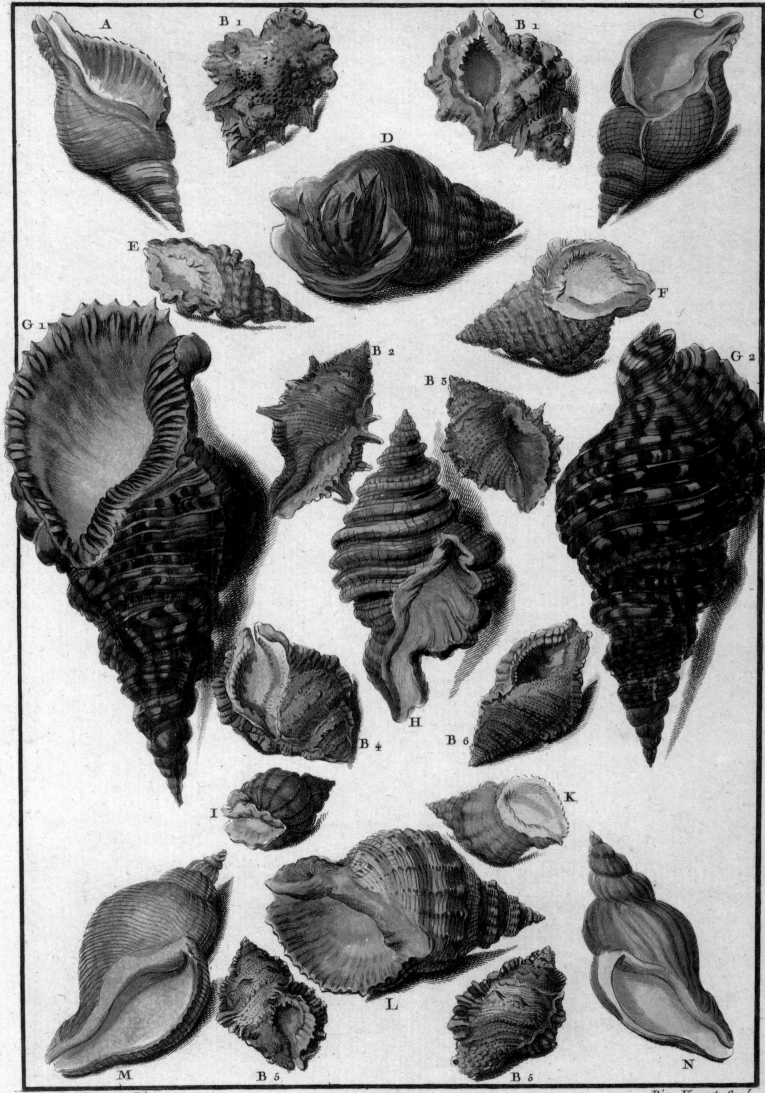

FASCIOLARIIDAE

———

Tulips and Spindles
Spindelschnecken
Fasciolaires

NASSARIIDAE

———

Mud Shells, Dog Shells, Basket Shells
Netzreusenschnecken, Sandschnecken
Nasses

COLUBRARIIDAE ET AL.

———

C1–C2 Fasciolariidae *Fusinus* sp. Spindle | – | –
C3 *Fusinus* cf. *gracillimus* (Sowerby, 1880)
C4, C6 *Fusinus* sp. E1–E2 Babyloniidae: *Babylonia* cf. *spirata* (L., 1758)
G Mitridae Miter | – | – L *Nassarius glans* (L., 1758) Glans Nassa | – | –
X2 Colubrariidae

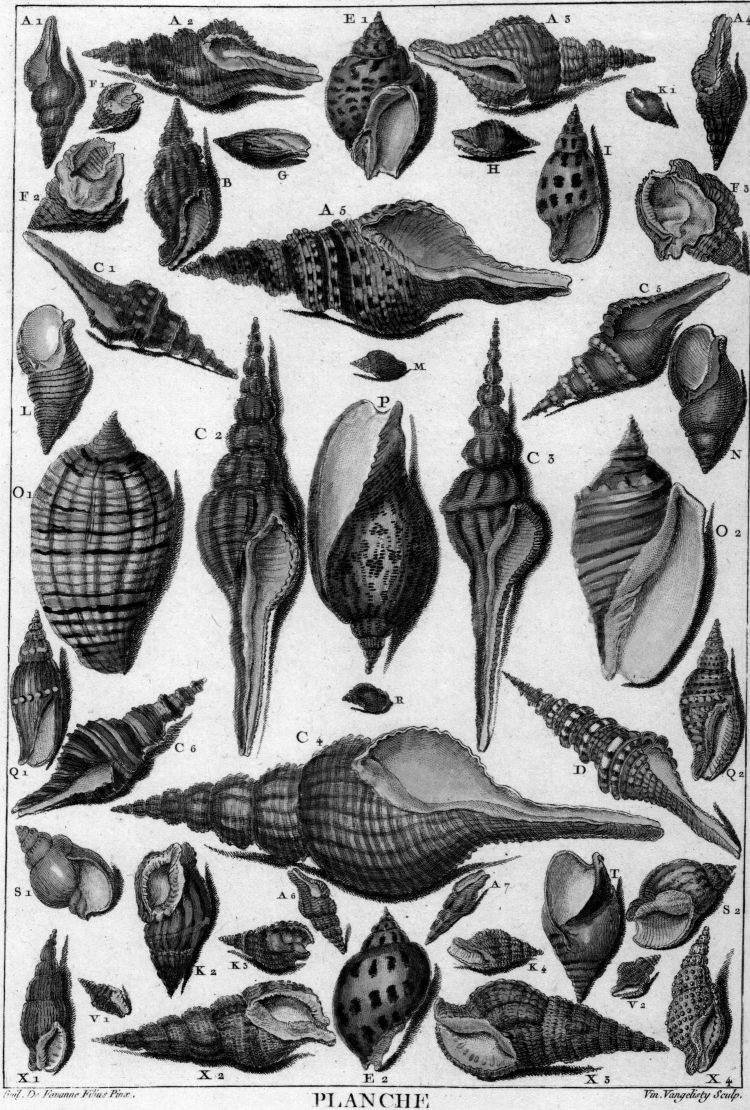

Guil. De Favanne Filius Pinx. Vin. Vangelisty Sculp.

**PLANCHE
XXXIII.**

STROMBIDAE

———

True Conchs
Flügelschnecken
Strombes

CORALLIOPHILIDAE, RANELLIDAE

———

FASCIOLARIIDAE ET AL.

———

Tulips and Spindles
Spindelschnecken
Fasciolaires
et al.

A2 *Ranularia gutturnium* (Röding, 1798)? Long-neck Triton | – | –
vel *R. monilifera* (Adams & Reeve, 1850)?
A3 *Lotoria* cf. *lotoria* (L., 1758) Black-spotted Triton | Schwarzgefleckte Tritonschnecke | –
A4 Ranellidae B3 Strombidae *Tibia fusus* (L., 1758) E *Mipus gyratus* (Hinds, 1844)?
F *Latiaxis mawae* (Griffith & Pidgeon, 1834) G1, 2, 3 *Monoplex* spp.?
H *Pleuroploca* sp.

BUCCINS.

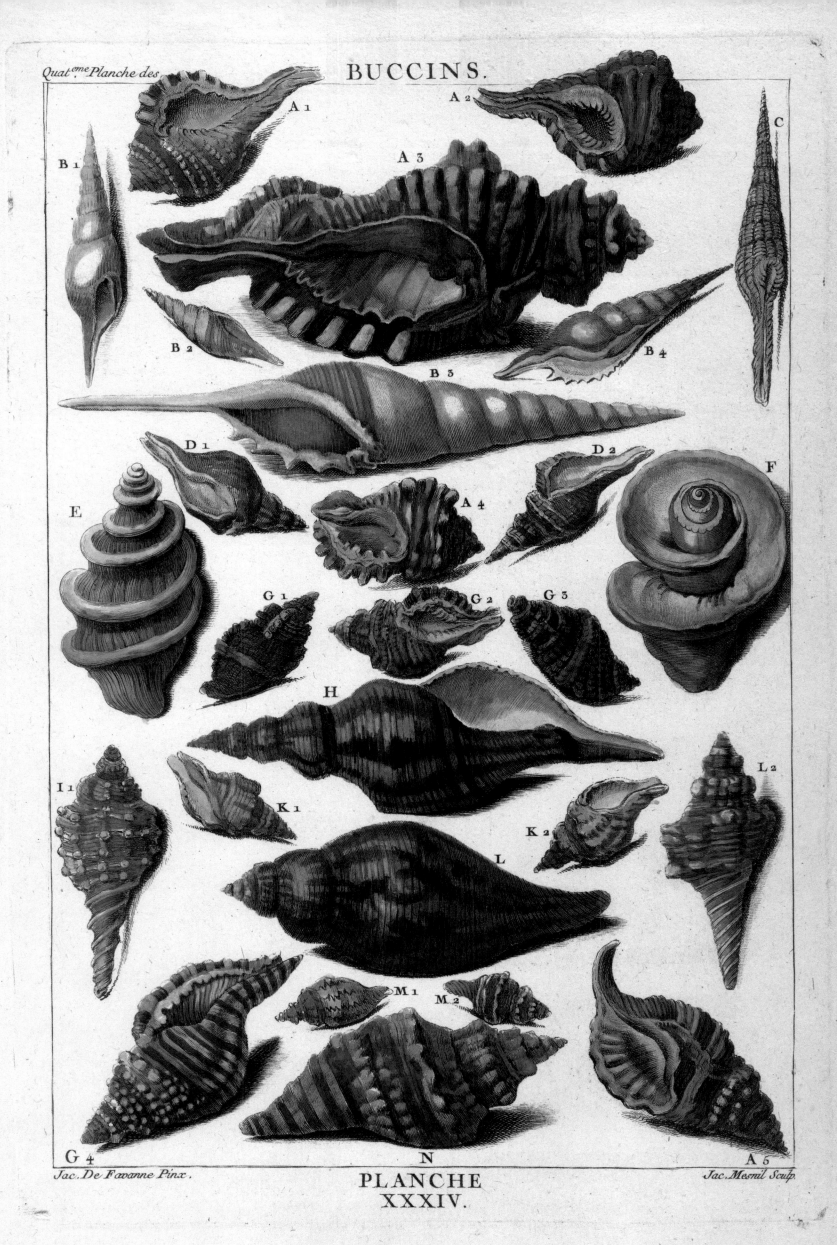

PLANCHE
XXXIV.

MELONGENIDAE

———

Swamp Conchs, Crown Conchs,
Giant Whelks, Stair Shells,
Melon Conchs
Kronenschnecken,
Riesen- oder Treppenschnecken
Mélongènes

FASCIOLARIIDAE ET AL.

———

Spindles
Spindelschnecken
Fasciolaires
et al.

B1 *Pugilina morio* (L., 1758) Giant Hairy Melongena | Große Kronenschnecke |
Grande Mélongène chevelue
B3–B4 Fasciolariidae: *Pleuroploca* sp. C3 *Cantharus*? Goblet | – | –
D *Neptunea* or | oder | ou **Fasciolariidae**

BUCCINS

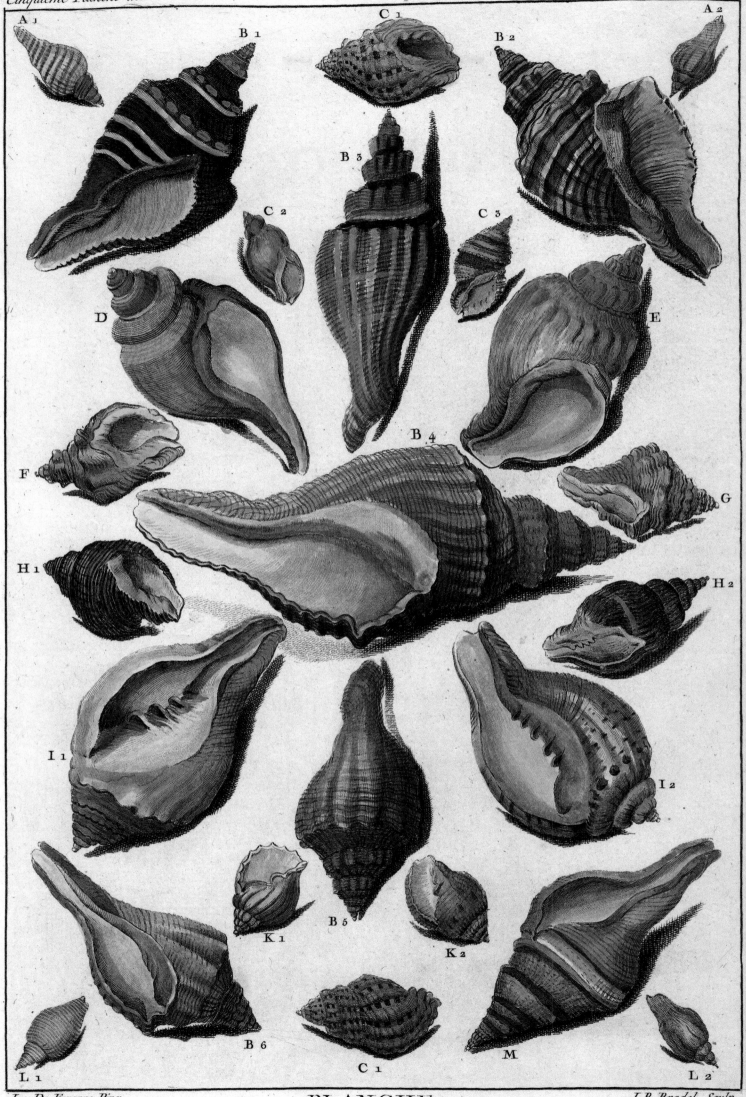

Jac. De Favanne Pinx.

J.B. Bradel Sculp.

PLANCHE
XXXV.

MURICIDAE
also / auch / aussi CORALLIOPHILIDAE?

———————

Murex Shells
Purpurschnecken
Murex, Pourpres

also / auch / aussi

Coral Shells
Korallenschnecken

—

C1 cf. *Babelomurex fearnleyi* (Emerson & D'Attilio, 1965)
D *Chicoreus ramosus* (L., 1758)? F *Chicoreus* sp.
G4 *Chicoreus* cf. *axicornis* (Lamarck, 1822) Axicornis Murex | – | –
I1–2 *Chicoreus* cf. *brunneus* (Link, 1807)

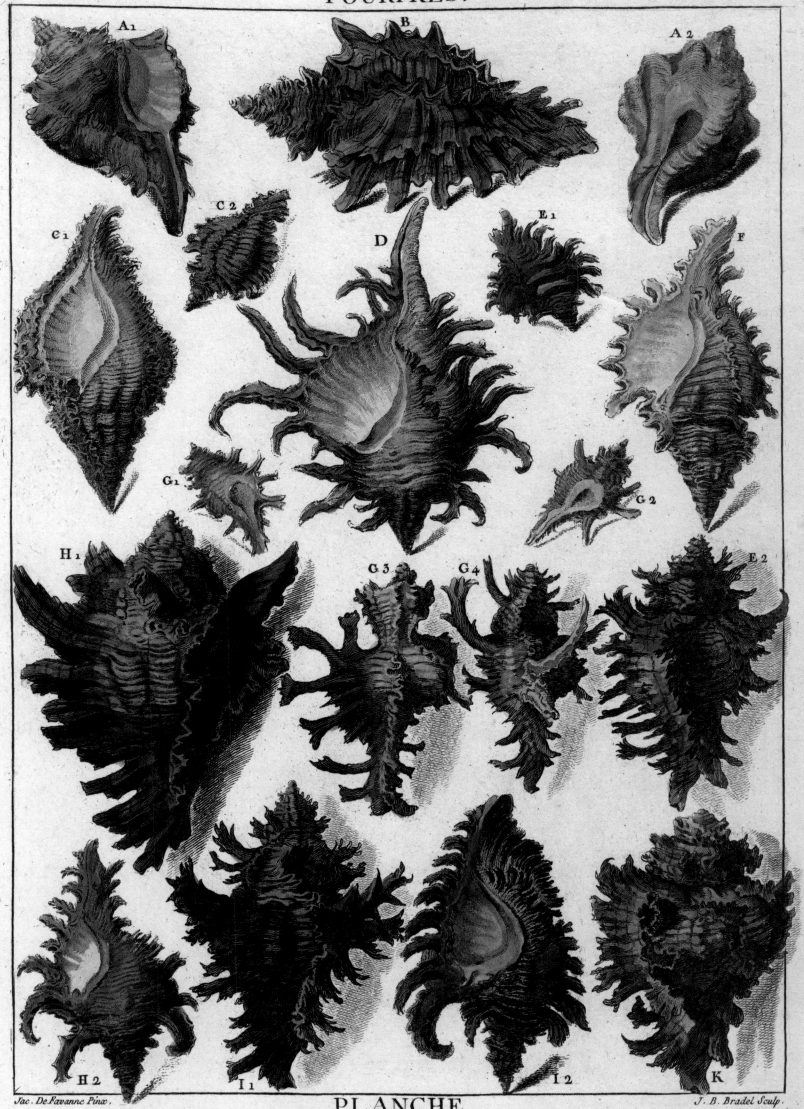

Jac. De Favanne Pinx.

J. B. Bradel Sculp.

MURICIDAE

———

Murex Shells
Purpurschnecken, Stachelschnecken
Murex, Pourpres

A, B1 *Chicoreus* D *Hexaplex* cf. *radix* (Gmelin, 1791)
Root Murex, Radish Murex | Wurzelschnecke | –
H1 *Trophon* sp. Trophon | Trophonschnecke | –

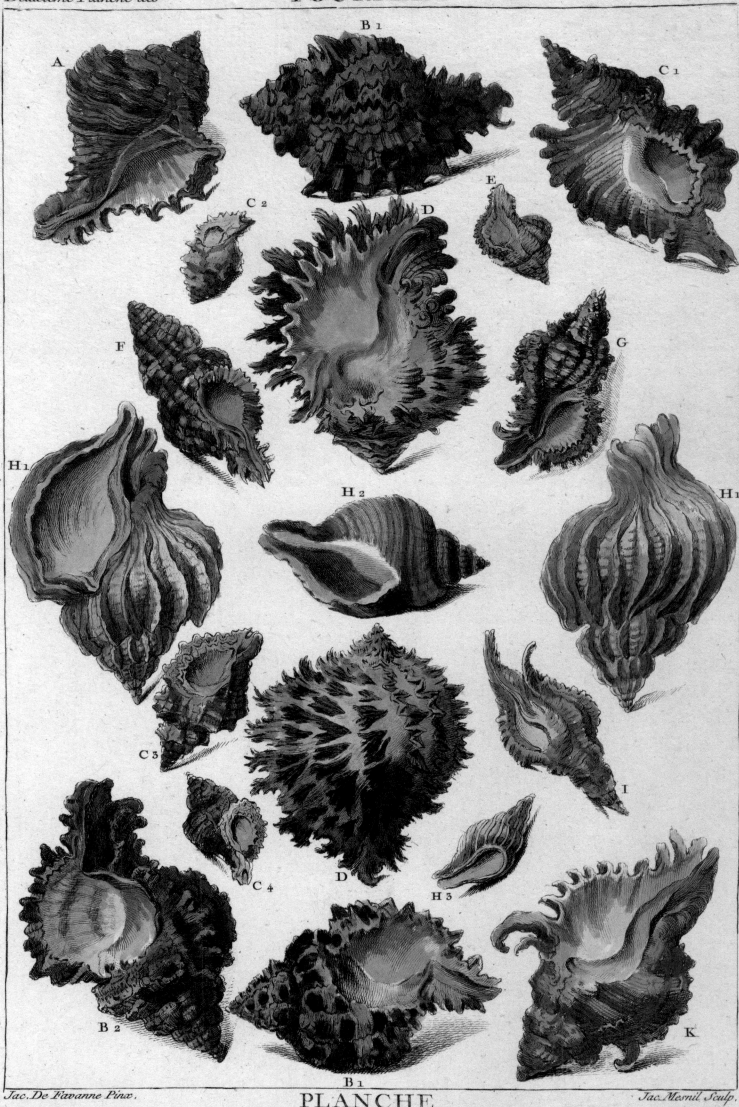

MURICIDAE

————

Murex Shells
Purpurschnecken
Murex, Pourpres

A1–A2 *Murex pecten* Lightfoot, 1786 (or | oder | ou *Murex troscheli* Lischke, 1868)
Venus Comb Murex | Venuskamm, Skelettspindel | –
B1–B2 *Haustellum haustellum* (L., 1758) D *Siratus* sp.?
E1–E2 *Bolinus brandaris* (L., 1758)?
Purple Dye Murex | Brandhorn, Herkuleskeule | Rocher massue

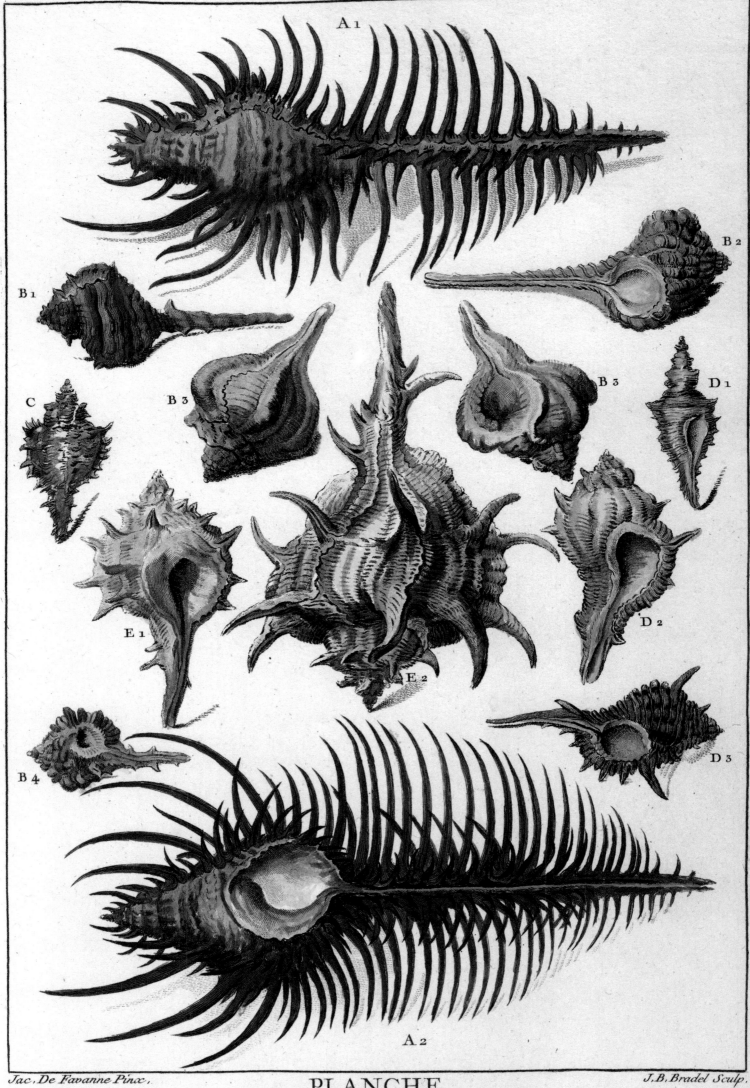

TURRITELLIDAE

—————

Turret Shells | Turmschnecken | Turritelles

EPITONIIDAE

—————

Wentletraps | Wendeltreppen | Scalaires

CERITHIIDAE

—————

Ceriths | – | Cérithes

TEREBRIDAE

—————

Auger shells | – | Térèbres

POTAMIDIDAE

—————

Horn Snails | – | –

A *Acus maculata* (L., 1758)? Marlinspike | – | Térèbre tacheté
B2 *Telescopium telescopium* (L., 1758) Telescope snail | Teleskopschnecke | –
C4 **Fasciolariidae** C5 *Cerithium nodulosum* (Bruguière, 1792) Giant Knobbed Cerith | – | Cérithe noduleux
C10 *Rhinoclavis* sp. E *Turritella communis* Risso, 1826 Common European Turritella |
Gemeine Turmschnecke | Turritelle commune
I *Terebra* sp. M1–M2 *Epitonium* sp. Wentletrap | Wendeltreppe | Scalaire

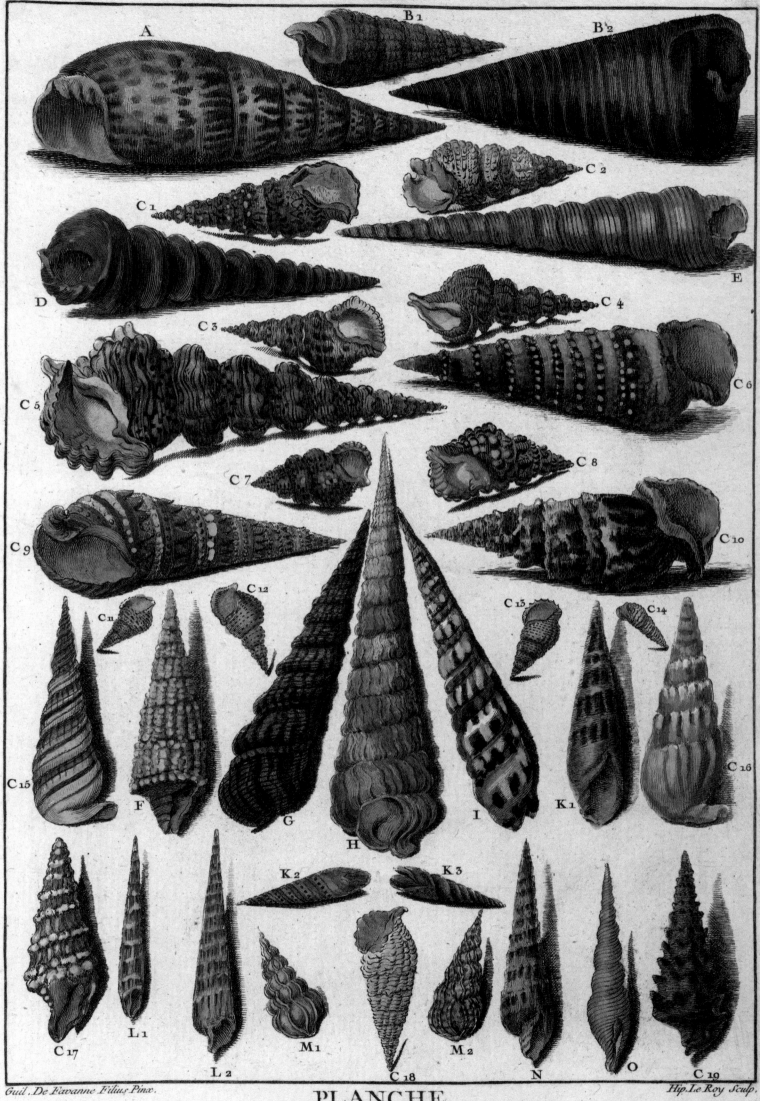

PLANCHE
XXXIX.

TEREBRIDAE

———

Auger Shells
Bohrerschnecken, Schraubenschnecken
Térèbres

TURRITELLIDAE

———

Turret Shells, Screw Shells
Turmschnecken, Schraubenschnecken
Turritelles

POTAMIDIDAE

———

Horn Snails, Mud Whelks, Mud Creepers
Schlammschnecken, Schlammkriecher
Cérithes

A1 *Terebra crenulata* (L., 1758) Crenulate Auger | – | Térèbre crénelé
A3 Potamididae D *Terebra subulata* (L., 1767) Subulate Auger | – | –
H, L2 Terebridae J1, J3, N Turritellidae O cf. *Terenolla pygmaea* Hinds, 1844
Y *Terebra* cf. *dimidiata* (L., 1758) Dimidiate Auger | – | – Z *Terebra* sp.

Below / unten / au-dessous:
A1 *Terebralia palustris* (L., 1767) Mud creeper | Große Schlammschnecke | –

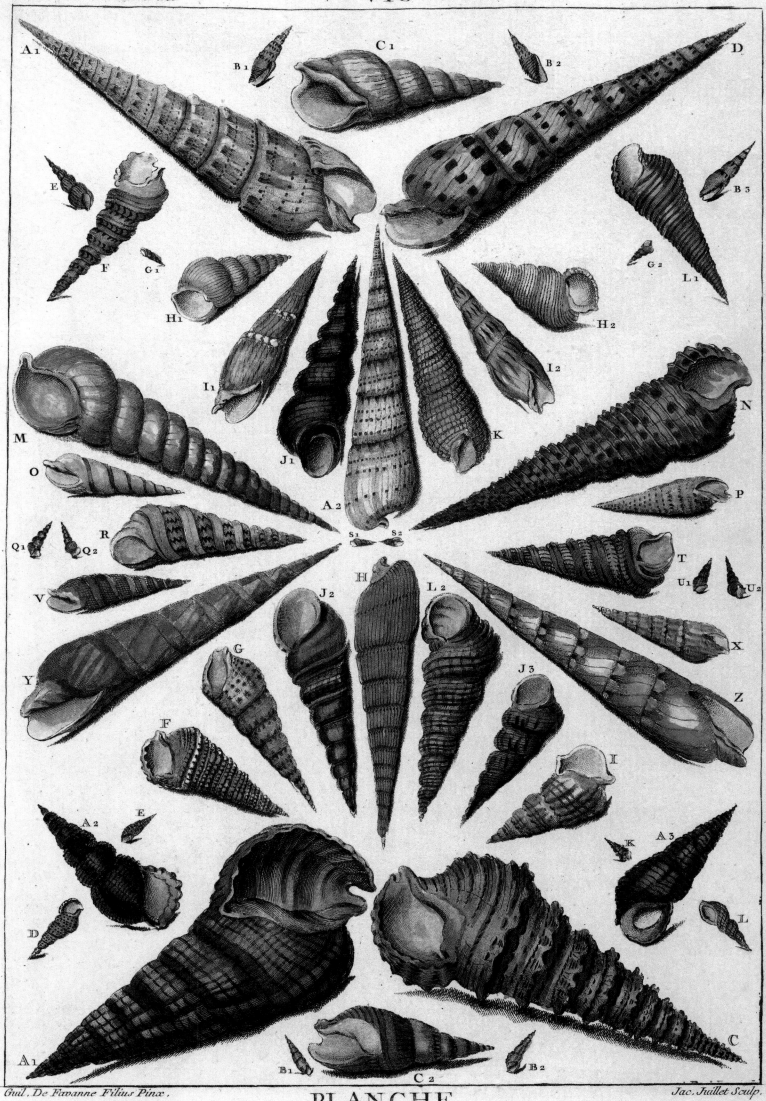

Guil. De Favanne Filius Pinx.

Jac. Juillet Sculp.

BRACHIOPODA

Brachiopods | Armfüßer | Brachiopodes

BIVALVIA

Bivalve Shells | Muscheln | Lamellibranches

ANOMIIDAE

Jingle Shells | Zwiebelmuscheln | Anomies

OSTREIDAE

Oysters | Austern | Huîtres

PTERIIDAE

Pearl Oysters and Winged Oysters
Flügelmuscheln | Huîtres ailées

A1–A5 Brachiopoda B *Anomia ephippium* L., 1758 European Jingle Shell |
Sattelmuschel, Europäische Zwiebelmuschel | Anomie commune d'Europe
C1, C6 *Ostrea edulis* L., 1758 European Oyster | Europäische Auster, Essbare Auster | Huître plate d'Europe
C2 *Lithophaga?* E1, E4 *Pinctada* cf. *margaritifera* Pearl Oyster | Perlauster | Huître perlière

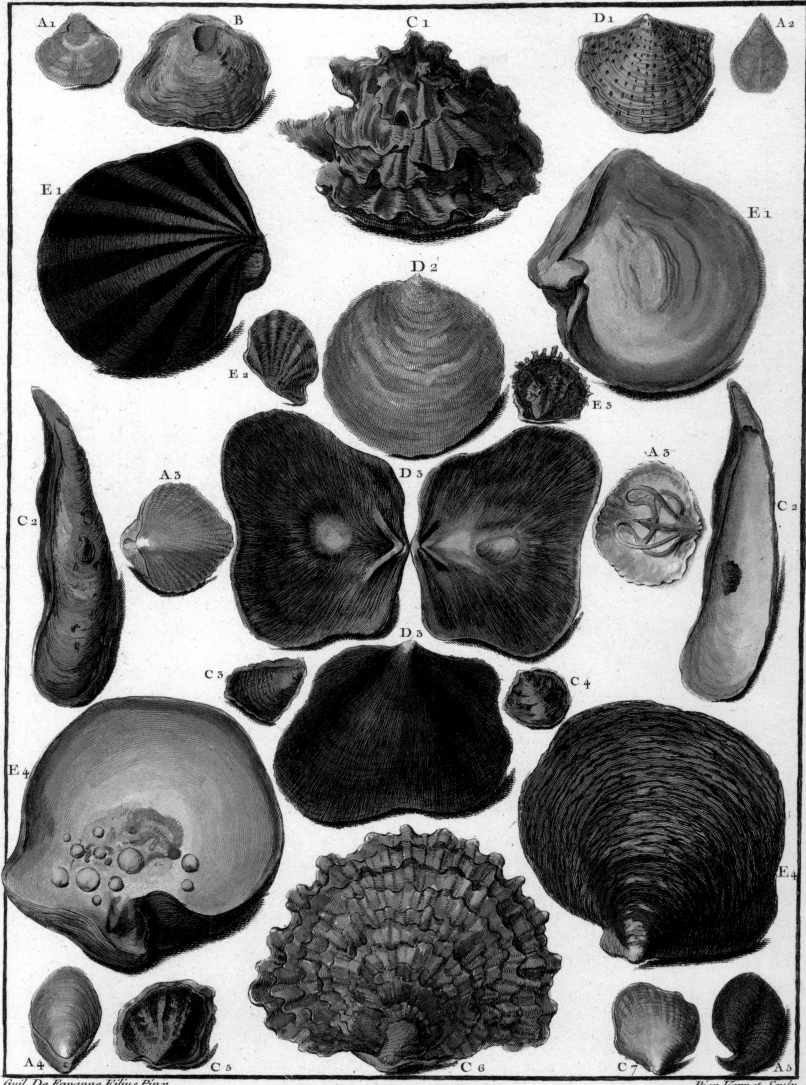

PTERIIDAE

———

Pearl Oysters and Winged Oysters

—

—

MALLEIDAE

———

Hammer Oysters
Hammeraustern
Malleus

SPONDYLIDAE

———

Thorny Oysters
Stachelaustern
Spondyles

A1 *Malleus malleus* (L., 1758) Common Hammer Oyster, Black Hammer Oyster |
Schwarze Hammerauster oder –muschel | Malleus commun
B3 *Pteria avicula* (Holten, 1802)? Black Wing Oyster | Schwarze Flügelmuschel | Huître ailée noire
C1 *Pteria penguin* (Röding, 1798)? Penguin Wing Oyster | – | –
D, E *Spondylus* sp. F *Spondylus* (*gaederopus* L., 1758?)
Thorny Oyster | Eselshuf, Stachelauster oder -muschel | Pied d'âne, Jardon

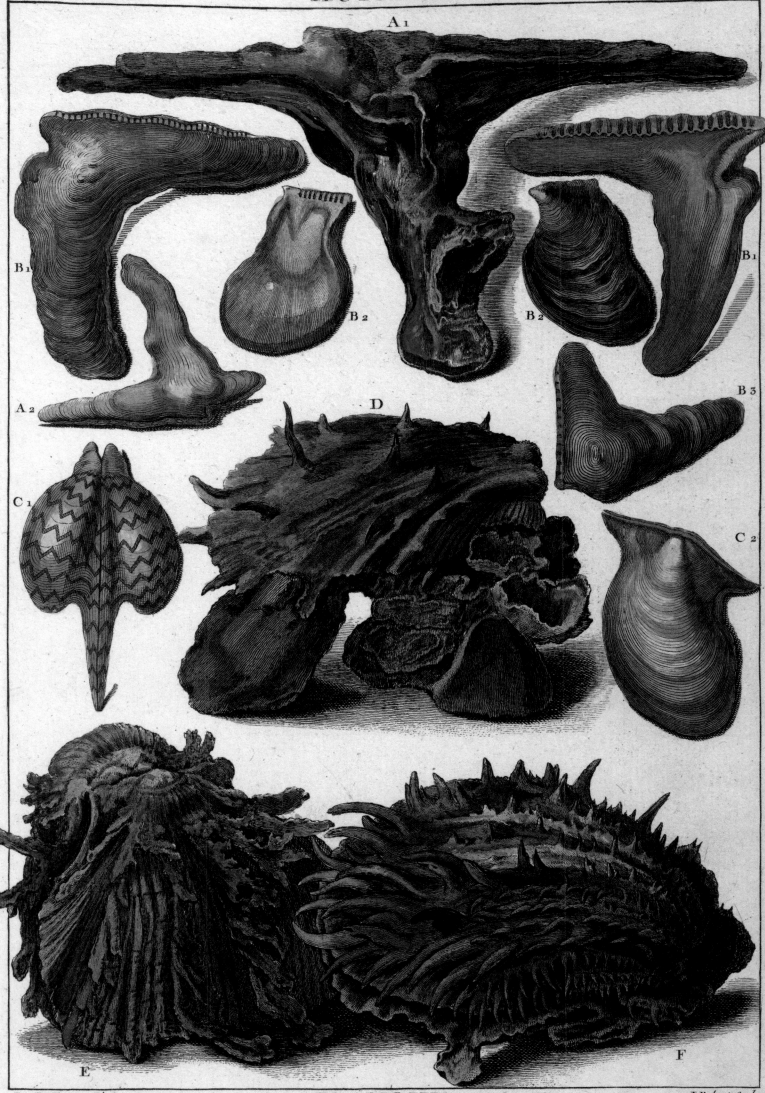

A 1

B 1 B 2 B 1

B 2

A 2 D B 3

C 1 C 2

E F

Jac. De Favanne Pinx.

J. Robert Sculp.

PLANCHE
XLII.

SPONDYLIDAE

———

Thorny Oysters
Stachelaustern
Spondyles

E *Spondylus americanus* Hermann, 1781 or | oder | ou *Spondylus regius* (L., 1758)
American Thorny Oyster | Amerikanische Stachelauster | Spondyle américain or | oder | ou
Regal Thorny Oyster | Königliche Stachelauster | Spondyle Roi

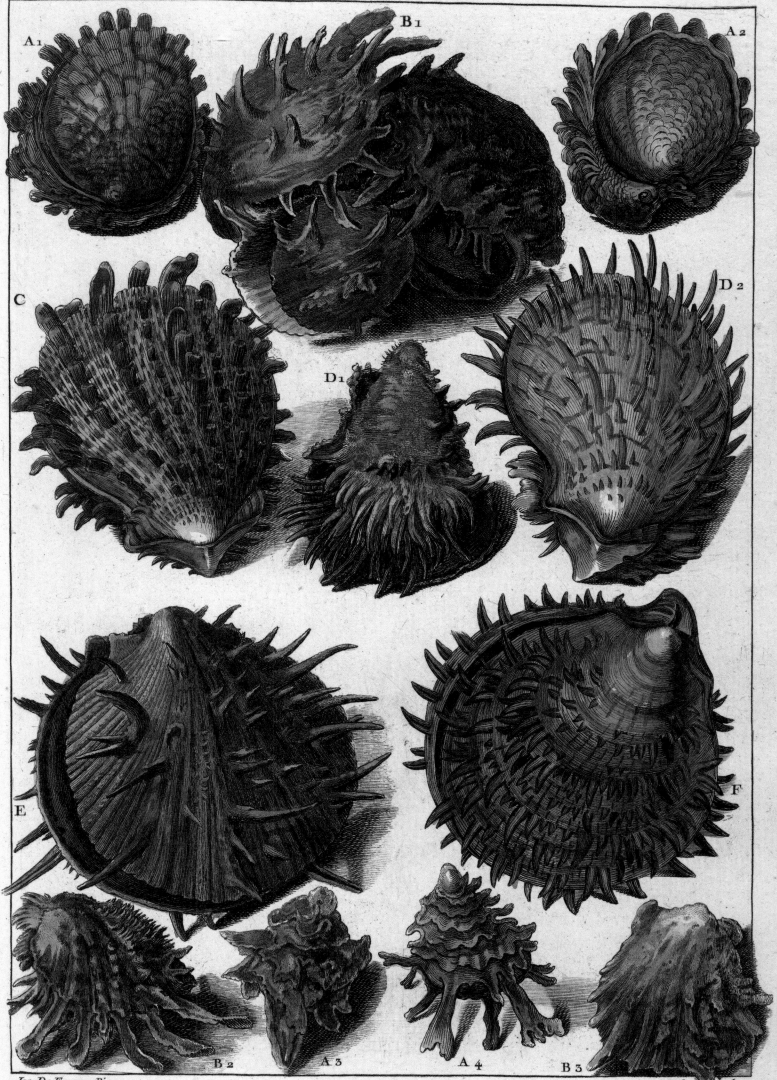

SPONDYLIDAE

———

Thorny Oysters
Stachelaustern
Spondyles

I *Spondylus sinensis* Chinese Thorny Oyster |
Chinesische Stachelauster | Spondyle chinois

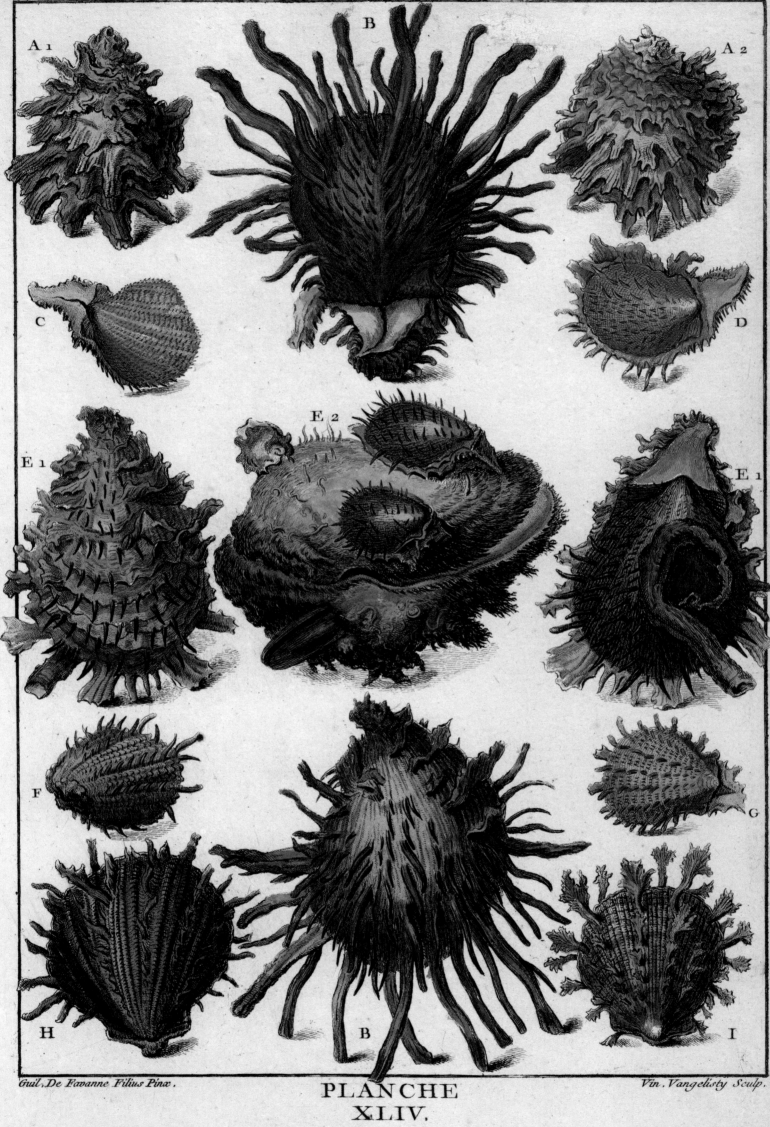

Guil. De Favanne Filius Pinx.

Vin. Vangelisty Sculp.

OSTREIDAE

————

True Oysters
Austern
Huîtres

GRYPHAEIDAE (*HYOTISSA*)

————

C cf. *Lopha cristagalli* (L., 1758)? Cock's-comb Oyster | – | –
D1, D3 *Hyotissa hyotis* (L., 1758) Honeycomb Oyster | – | –

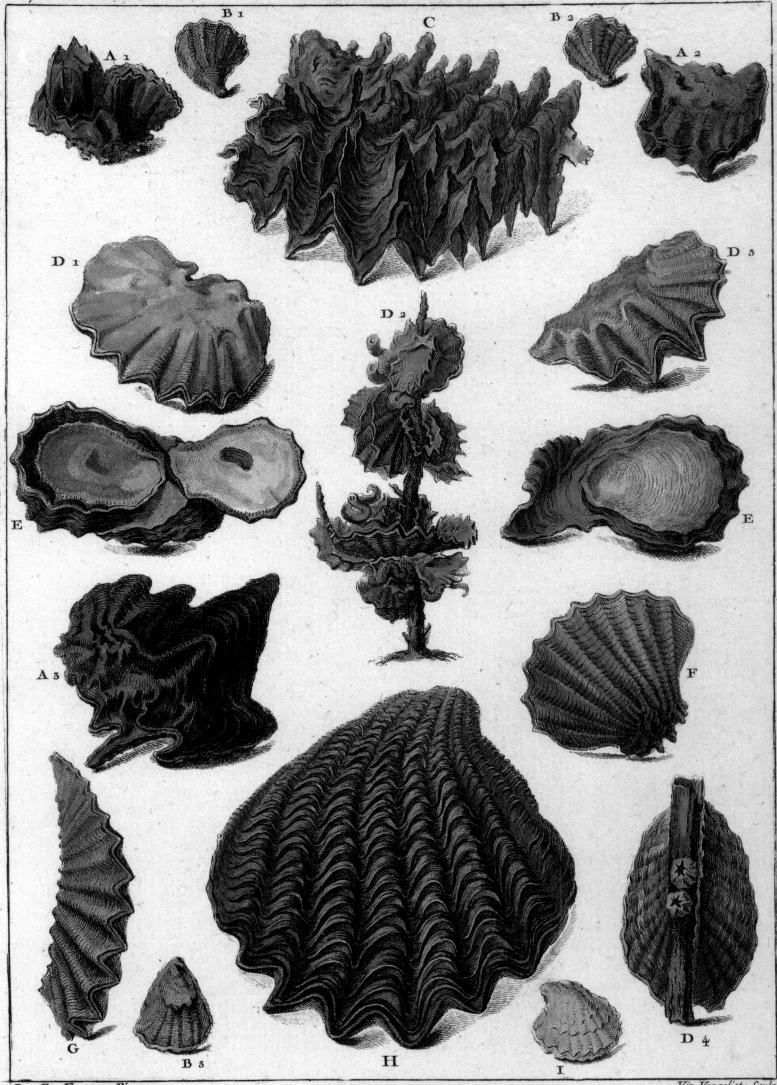

LUCINIDAE

———

Lucina Clams

–

Lucines

VENERIDAE

———

Venus Clams
Venusmuscheln
Praires

ARCTICIDAE

———

Arctica Clams
Islandmuscheln

–

A *Tivela* sp. B1 *Venerupis pullastra* (Montagu, 1803)? – | Teppichmuschel | –
or | oder | ou *Fimbria* sp. or | oder | ou *Humilaria* sp.
B2 Lucinidae: *Fimbria* sp.? Basket Lucina | – | – B5 *Chione*? B6 cf. *Venus verrucosa* (L., 1758)?
D *Chamelea striatula* (da Costa, 1778) Striated Venus | Strahlige Venusmuschel | Praire striée
F1 cf. *Macrocallista maculata* (L., 1758) F2 *Callista* sp. (cf. *lilacina* (Lamarck, 1818))
G Lucinidae: *Divaricella dentata* (Wood, 1815)? Toothed Cross-hatched Lucina | – | Lucine dentée
O *Arctica islandica* (L., 1767) Ocean Quahog | Islandmuschel | –

Premiere Planche des

A

B 1

A

C 1

C 2

B 2

D

B 2

B 3

E 1

E 2

B 4

G

F 1

F 2

H

L

I

K

M 1

N

M 1

M 2

B 5

O

B 6

O

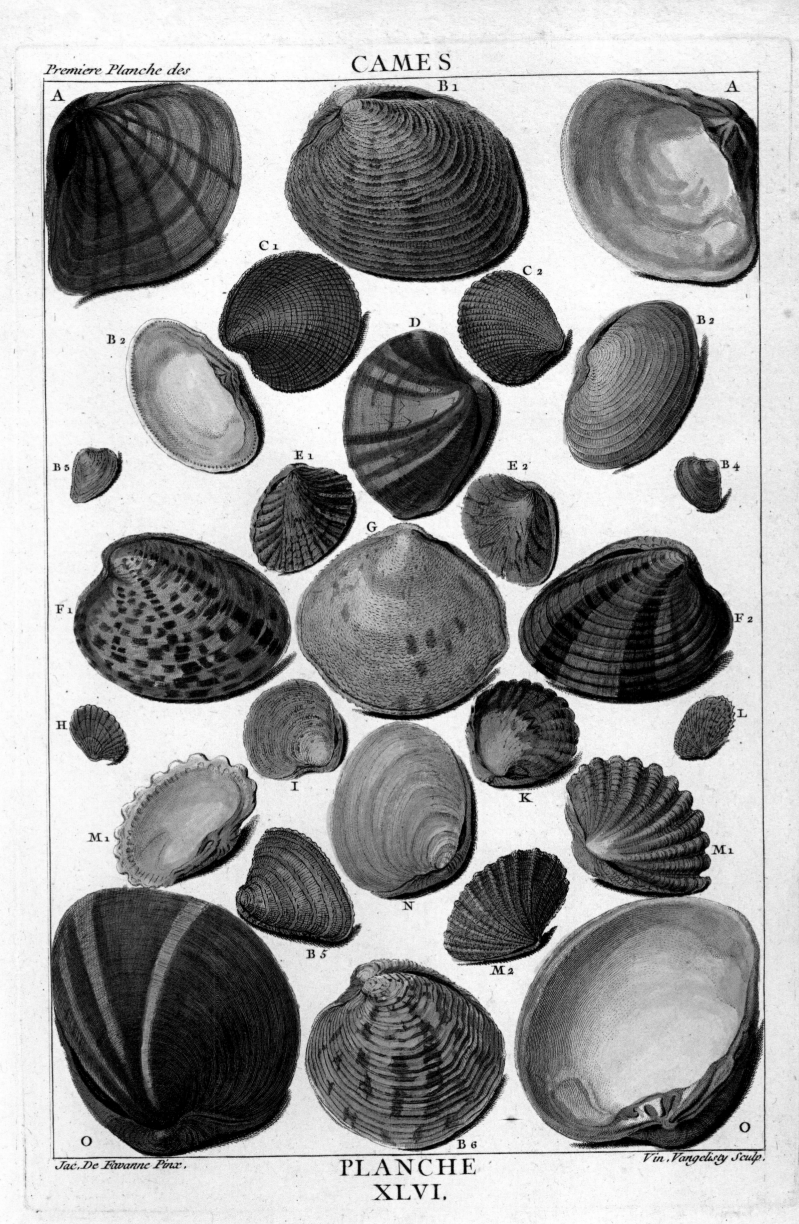

Jac. De Favanne Pinx.

Vin. Vangelisty Sculp.

VENERIDAE

———

Venus Clams
Venusmuscheln
Praires

ASTARTIDAE

———

Astarte Clams
et al.

—

—

A1 *Tapes literatus* (L., 1758) C *Timoclea ovata* (Pennant, 1777)
or | oder | ou *Gafrarium* sp.? D1 Semelidae Semele Clam | – | –
E3 *Pitar dione* (L., 1758) Royal Comb Venus | – | –
E7 *Irus* cf. *macrophylla* (Deshayes, 1853)? E8 *Astarte* cf. *sulcata* (da Costa, 1778)?
E9 *Venus verrucosa* (L., 1758) Warty Venus | Warzige Venusmuschel | –
H *Circe scripta* (L., 1758)? Script Venus | – | –

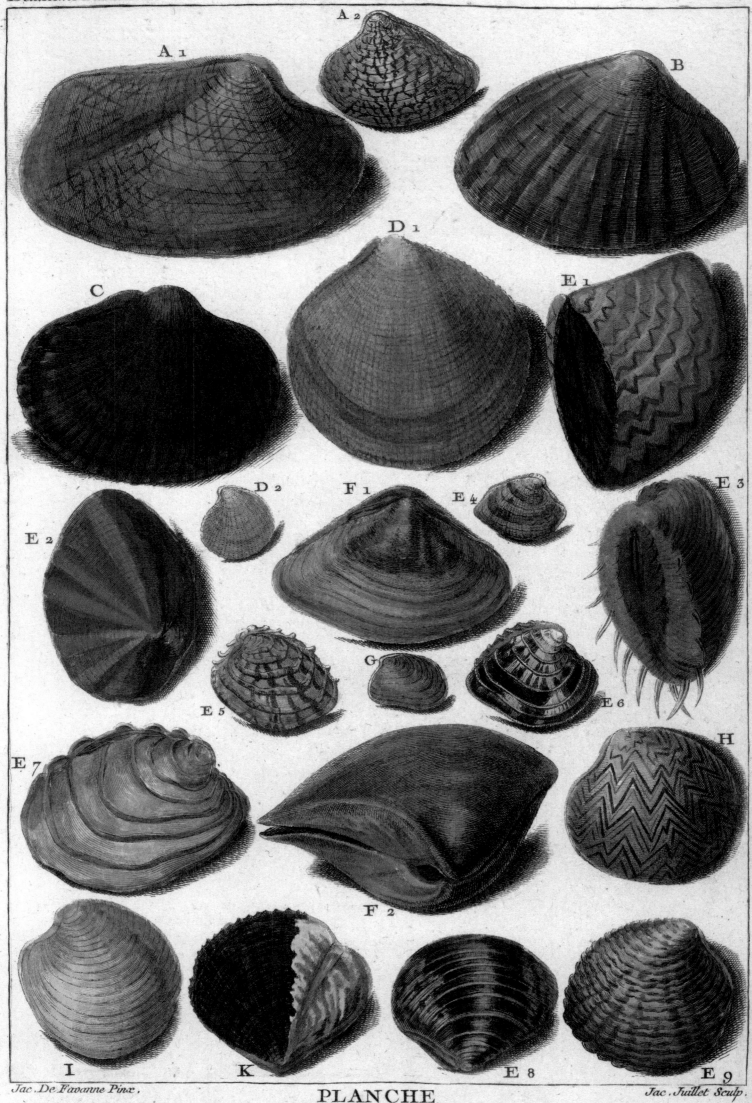

Jac. De Favanne Pinx. Jac. Juillet Sculp.

PLANCHE
XLVII.

VENERIDAE

———

Venus Clams
Venusmuscheln
Praires

MACTRIDAE

———

Mactras

—

Mactres

C cf. *Mactrellona alata* (Spengler, 1802) F3 *Dosinia* sp.
K4 *Lioconcha castrensis* (L., 1758) Camp Pitar Venus | – | –
M1 *Mactra* sp.

CAMES

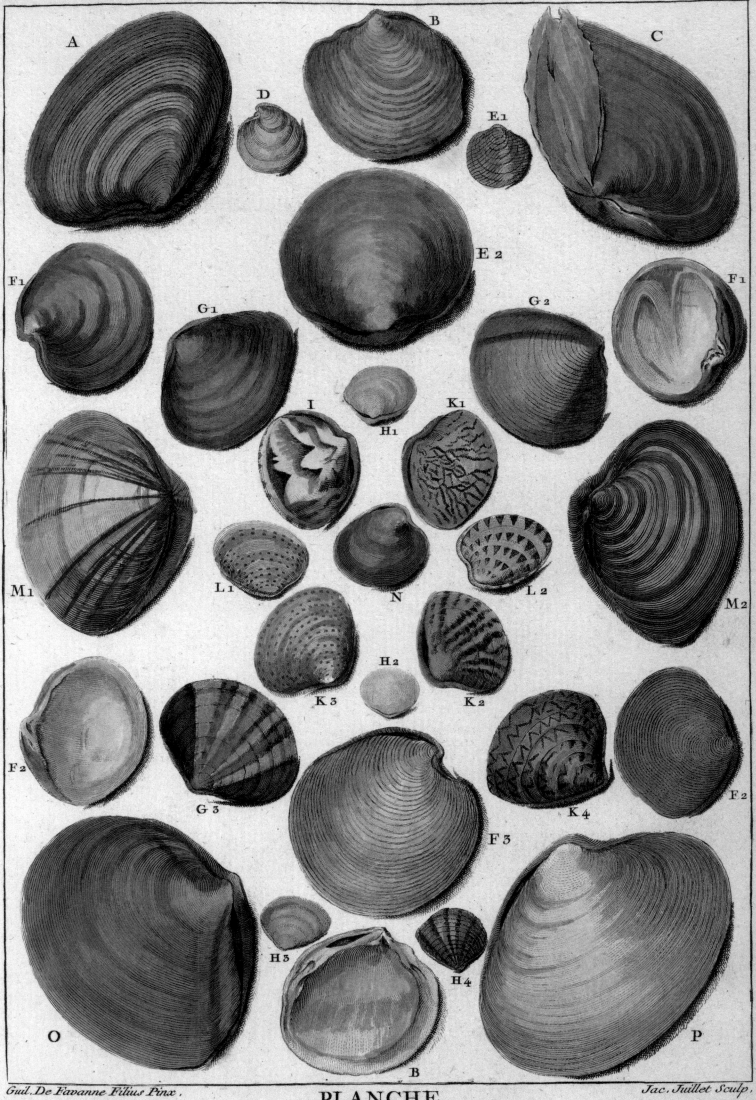

Gui. De Favanne Filius Pinx. Jac. Juillet Sculp.

PLANCHE
XLVIII.

VENERIDAE

———

Venus Clams | Venusmuscheln | Praires

TELLINIDAE

———

Tellins | Tellmuscheln | Tellines

DONACIDAE

———

Donax Clams and Bean Clams
Dreiecksmuscheln | Donax

SOLECURTIDAE

———

Solecurtus Clams | – | –

A *Tellina* sp. D1 cf. *Solecurtus strigillatus* (L., 1758) E2 *Donax* sp.
G1–G2 *Tellina* sp. I1 *Paphia* sp.,
I2 *Paphia* cf. *textile* (Gmelin, 1791) Textile Venus | – | –
I3 *Paphia* cf. *euglypta* (Philippi, 1847) Well-carved Venus clan | – | –

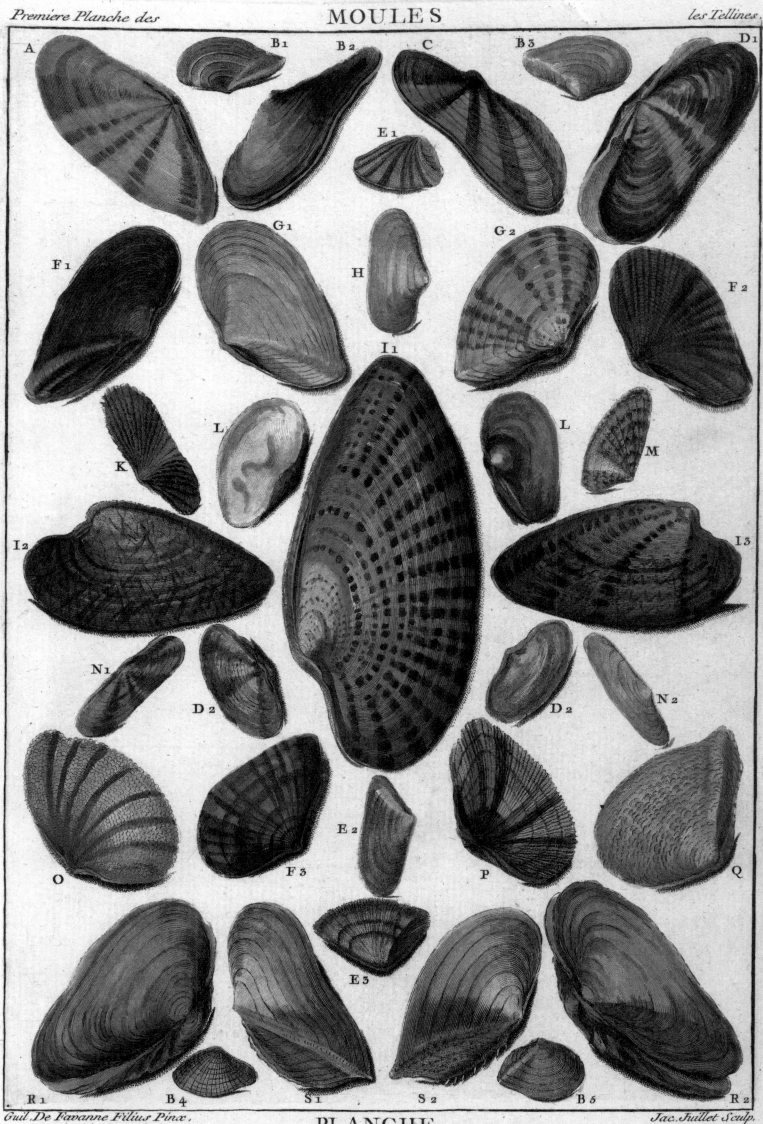

PINNIDAE

———

Pen Shells
Steckmuscheln
Pinnes

MYTILIDAE

———

Sea Mussels
Miesmuscheln
Moules

A1 *Pinna nobilis* L., 1758 A4 *Atrina* cf. *tuberculosa* (Sowerby, 1835)?
or | oder | ou *Atrina* cf. *seminuda* Lamarck, 1819? – | – | Atrine
B, E1 *Modiolus* sp. Mussels | Große Miesmuscheln | Modioles
C2, M cf. *Septifer* sp. ou *Brachidontes* sp.?
E2 cf. *Geukensia* sp.? O1 cf. *Perna perna* (L., 1758) Perna Mussel | – | –
O2 *Mytilus* sp. *edulis* L., 1758 (?) Common Blue Mussel |
Gemeine Miesmuschel | Moule commune
R1–R2 cf. *Aulacomya*

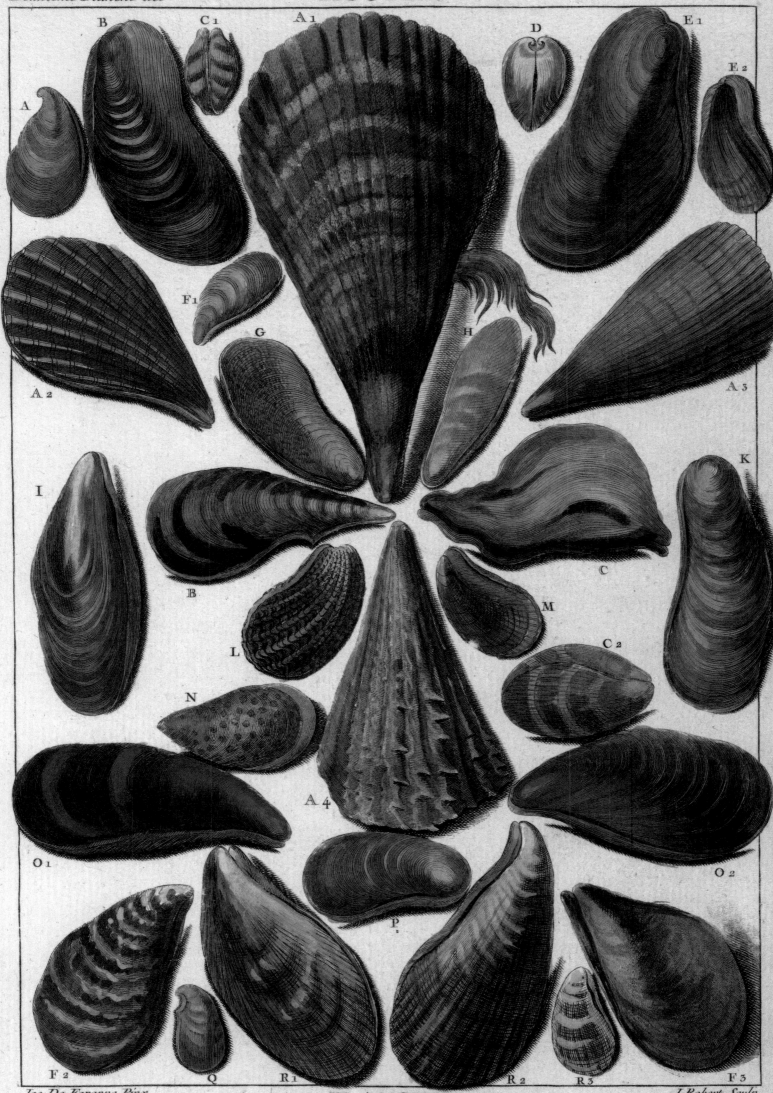

Jac. De Favanne Pinx.

J. Robert Sculp.

ARCIDAE

———

Arcs
Archenmuscheln
Arches

CARDIIDAE

———

Cockles
Herzmuscheln
Coques, Cœurs
et al.

C1 *Anadara granosa* (L., 1758) Granular Arc | Warzige Archenmuschel | –
E1, E2 *Corculum cardissa* (L., 1758) True Heart Cockle | Herzmuschel | –

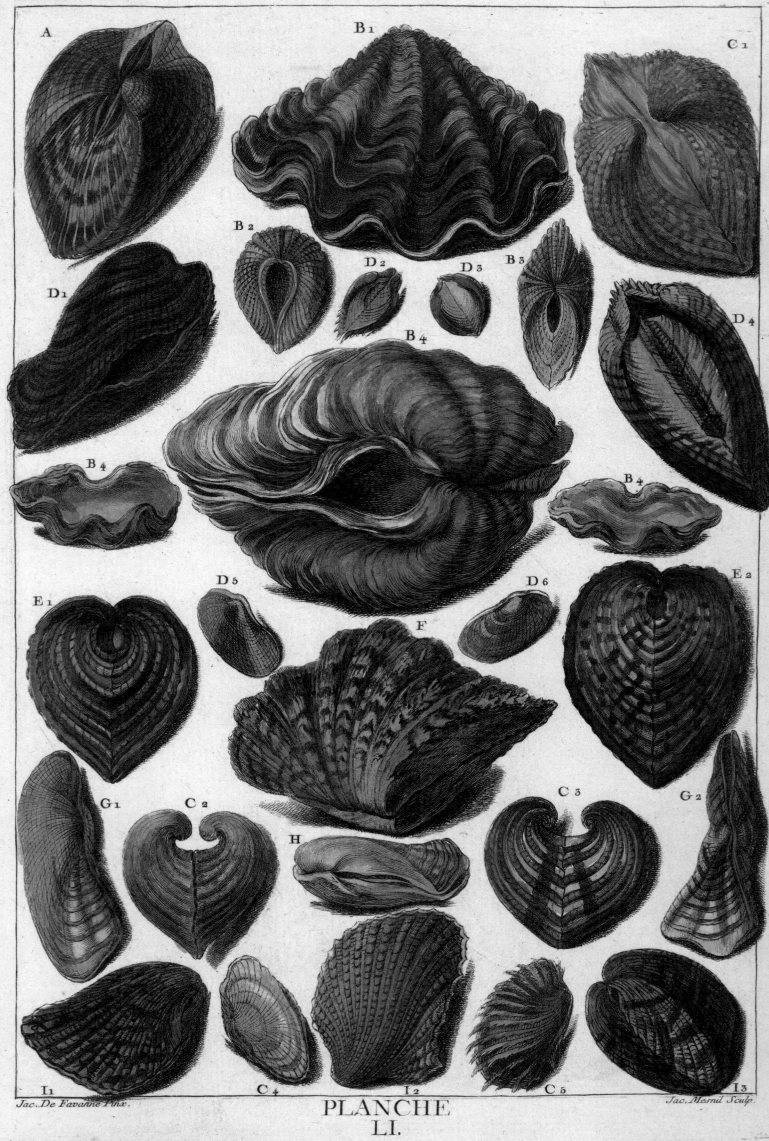

CARDIIDAE

Cockles
Herzmuscheln
Coques, Cœurs

A1 *Frigidocardium exasperatum* (Sowerby, 1841)?
A4 *Acanthocaria tuberculata* (L., 1758) Tuberculate Cockle | – | –
B *Cardium costatum* L., 1758 Great Ribbed Cockle | – | –
C2 *Acanthocardia echinata* (L., 1758)? European Prickly Cockle |
Stachelige Herzmuschel | Coque épineuse
F *Ringicardium hians* (Brocchi, 1814)? Hians Cockle | – | –

GLYCIMERIDAE

———

Bittersweet Clams

–

Amandes de Mer

CARDIIDAE

———

Cockles
Herzmuscheln
Coques, Cœurs
et al.

D1 Glycimeridae D2, D5–D6 *Glycimeris* Bittersweet Clam | – |
Amande de Mer L1 *Trachycardium*

Guil. De Favanne Filius Pinx. Jac. Mesnil Sculp.

PLANCHE
LIII.

PECTINIDAE

———

Scallops
Kammmuscheln
Pectens

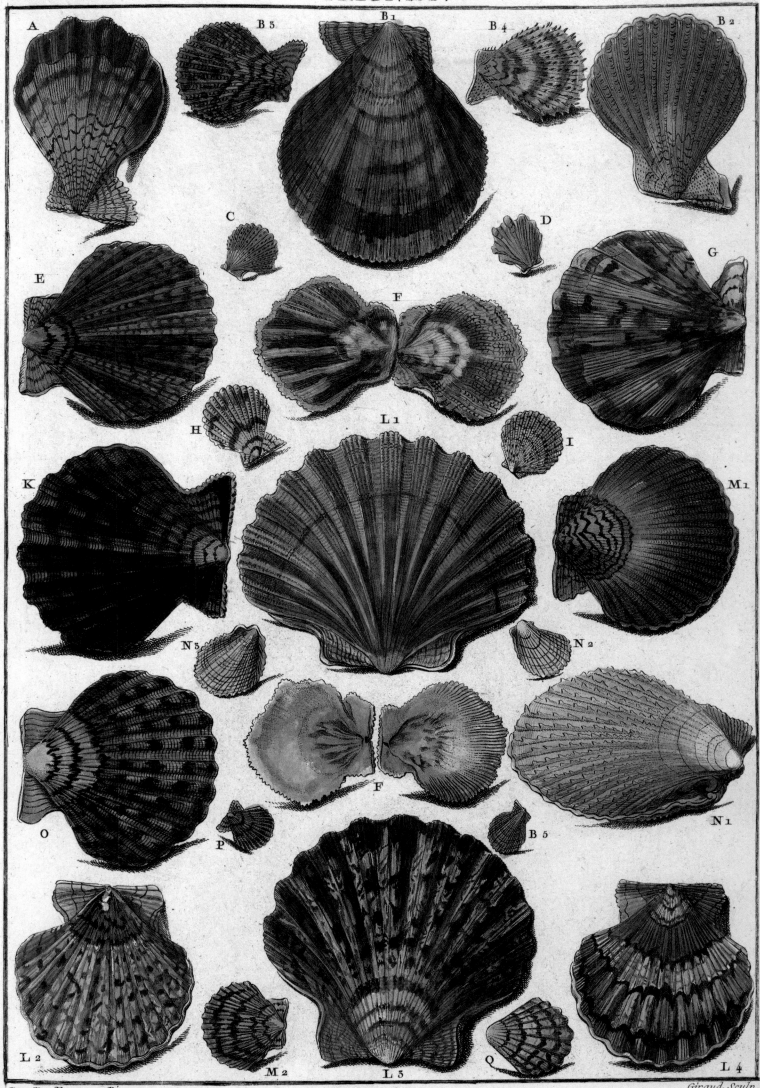

Jac. De Favanne Pinx. Giraud Sculp.

PLANCHE
LIV.

Above / oben / en haut:

PECTINIDAE

————————

Scallops
Kammmuscheln
Pectens

A2 *Decatopecten noduliferus?*

Below / unten / en bas:

SOLENIDAE

————————

Razor Clams
Schwert- oder Scheidenmuscheln
Couteaux

Deuxième Planche des

A 1 A 2 B A 3 A 4

A 5 A 6

C A 7 D

A 8 A 9

E 2

E 1 E 3

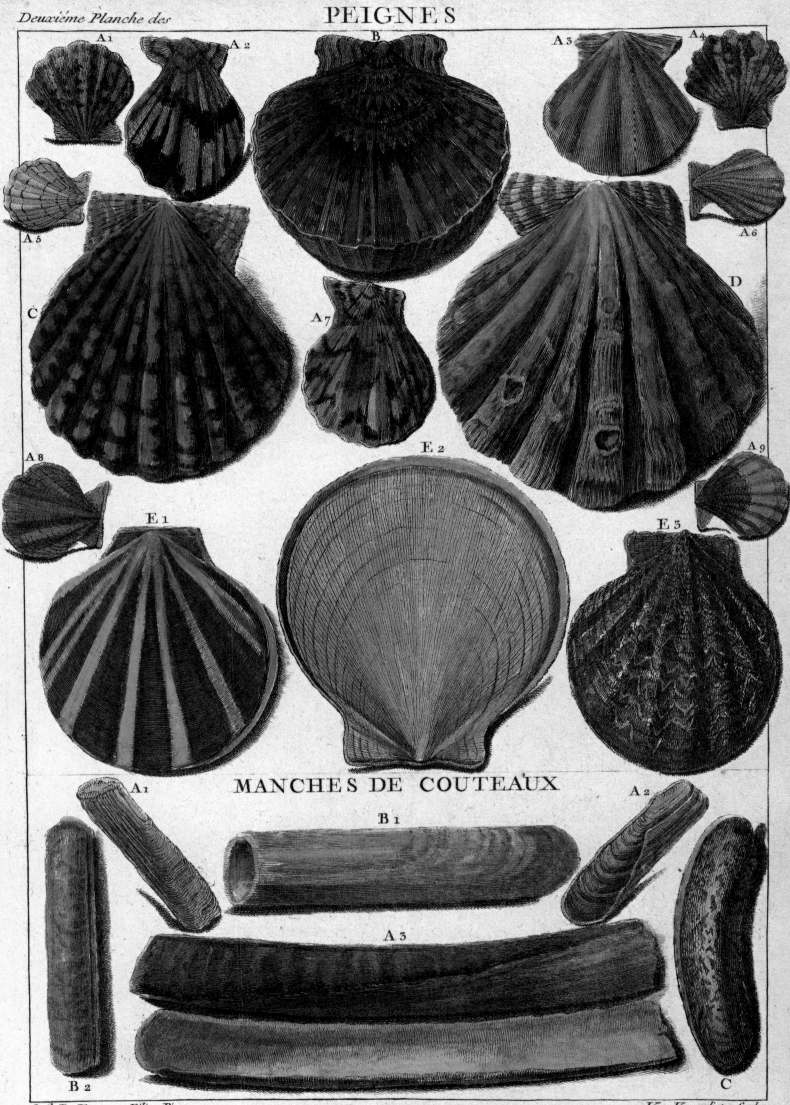

MANCHES DE COUTEAUX

A 1 A 2

B 1

A 3

B 2 C

Guil. De Favanne Filius Pinx.

Vin. Vangelisty Sculp.

PLANCHE
LV.

POLYPLACOPHORA

———

Chitons
Käferschnecken
Placophores, Polyplacophora

ECHINOIDEA

———

Sea Urchins
Seeigel
Oursins

Premiere Planche des

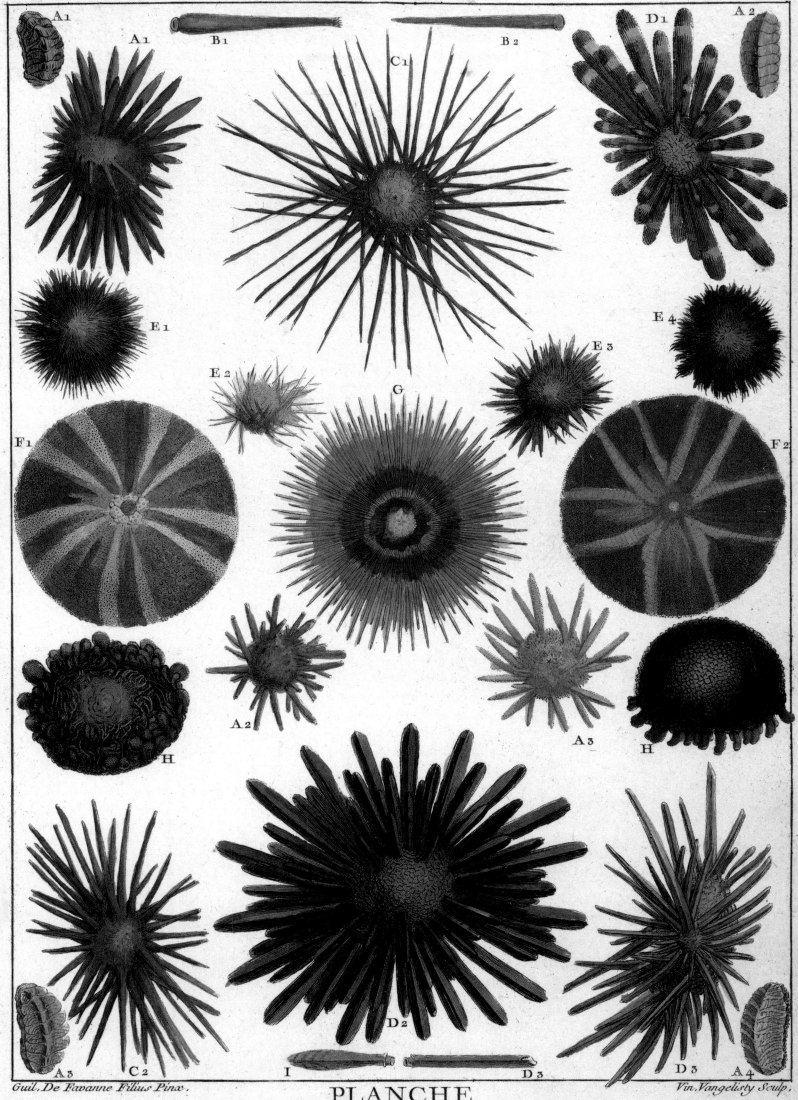

Guil. De Fawanne Filius Pinx.

Vin. Vangelisty Sculp.

ECHINOIDEA

———

Sea Urchins
Seeigel
Oursins

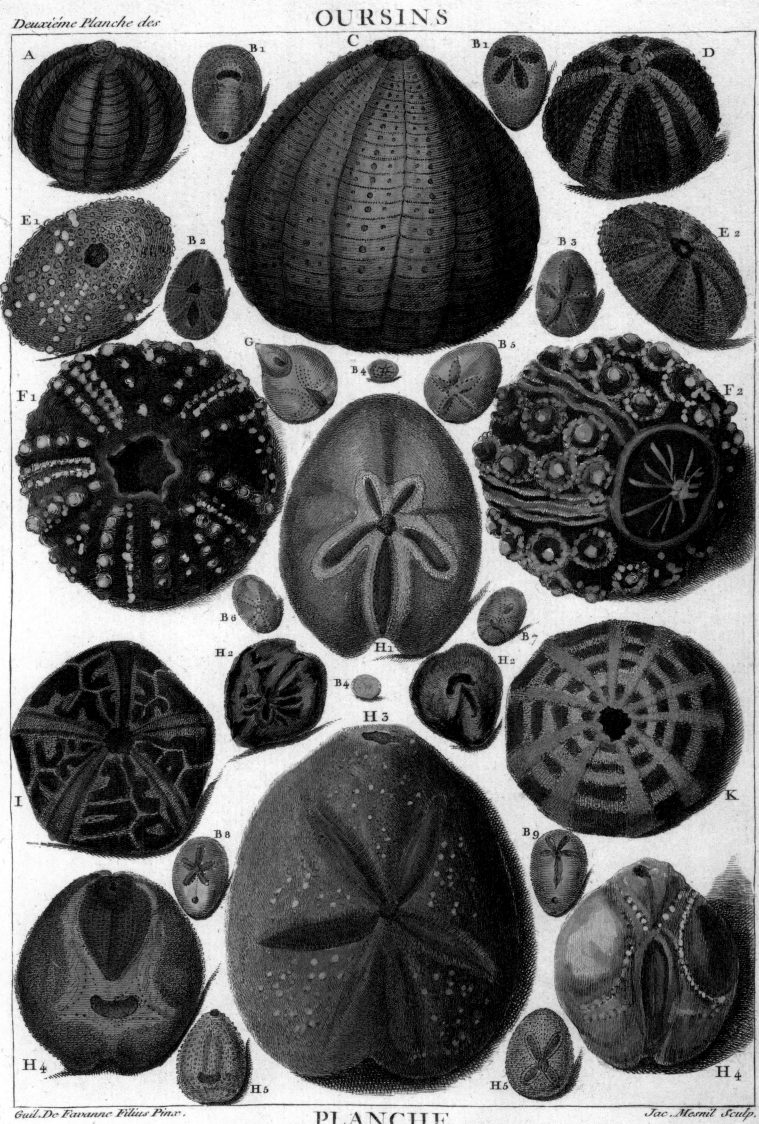

Guil. De Favanne Filius Pinx. Jac. Mesnil Sculp.

PLANCHE LVII.

ECHINOIDEA

———

Sea Urchins
Seeigel
Oursins

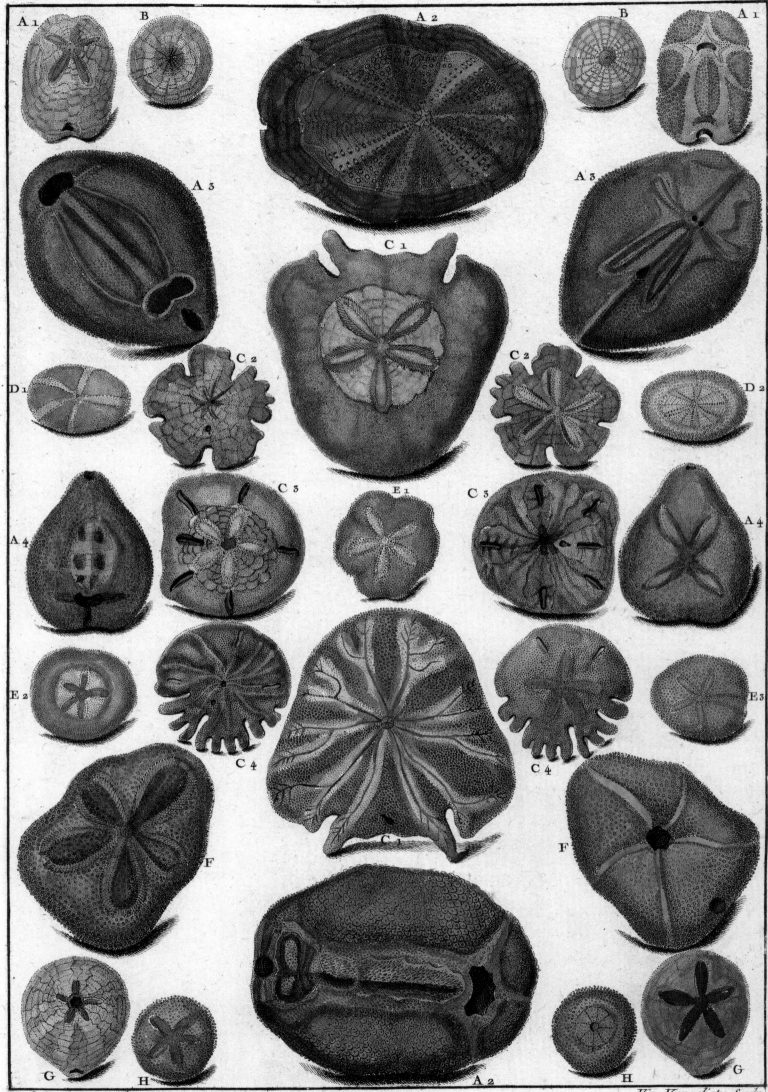

Guil .De Favanne Filius Pinx . *Vin .Vangelisty Sculp .*

A **Cirripedia, Balanomorpha** Barnacle, Acorn Barnacle | Seepocken | Cirripèdes
B **Cirripedia, Lepadomorpha** Goose barnacles | Entenmuscheln | Cirripèdes
C **Brachiopoda: Lingulida**

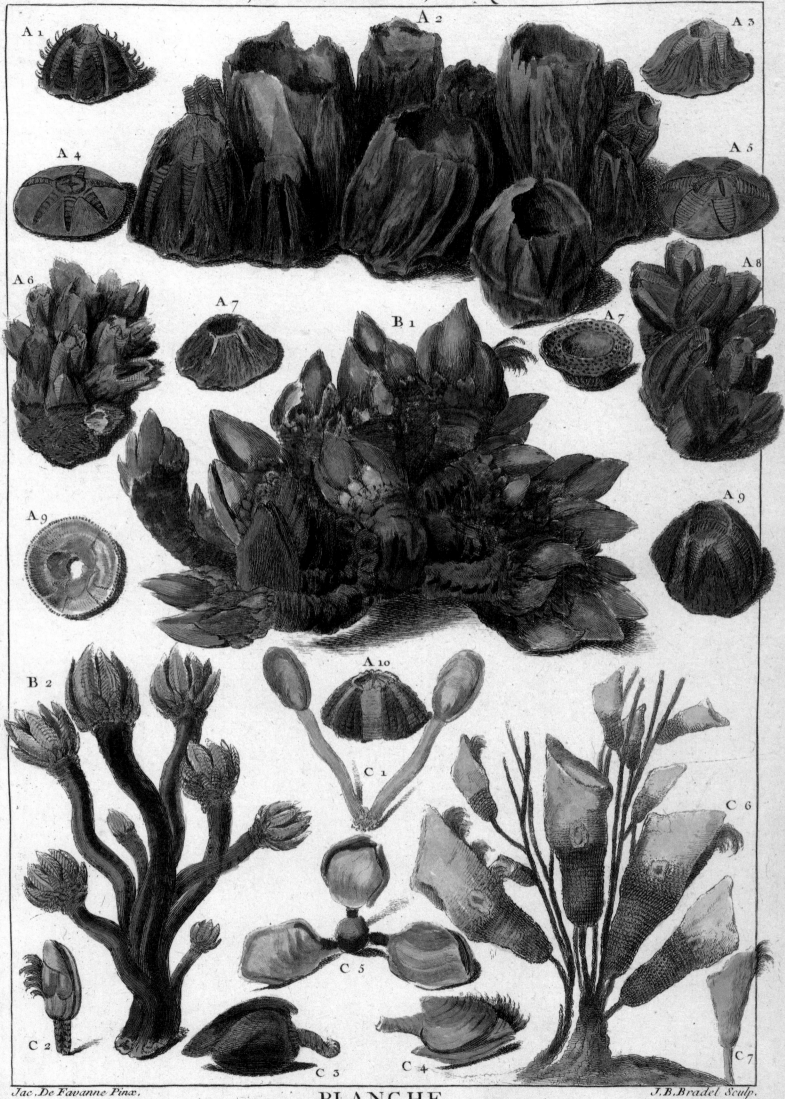

PHOLADIDAE

———

Pholads and Piddocks
Bohrmuscheln
Pholades

B *Pholas dactylus* L., 1758 European Piddock | – | –
C *Cyrtopleura?* Angel Wing | – | –

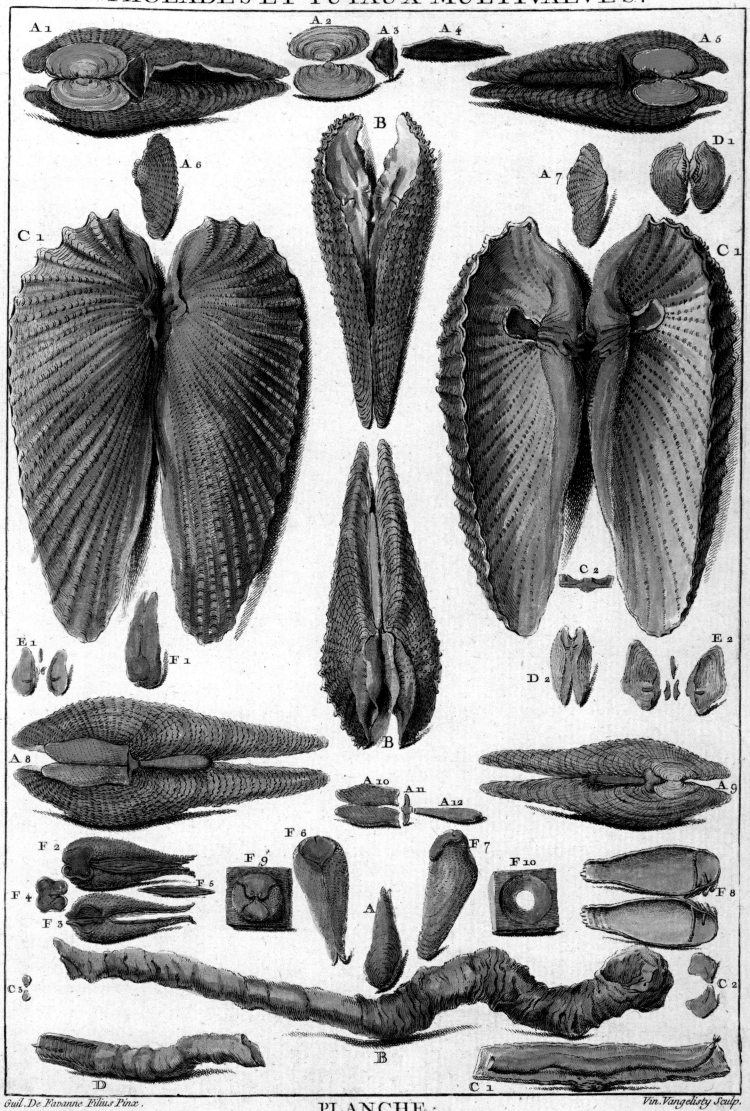

PLANCHE
LX.

GASTROPODA

———————

Freshwater Snails
Süßwasserschnecken
Coquilles d'eau douce

A1–A2 *Ancylus fluviatilis* **Müller** Freshwater Limpet | Flussnapfschnecke | –
B1–B2 *Planorbarius?* – | Große Posthornschnecke | –
B3–B6 *Planorbis* sp. – | Posthörnchen | –
C10 *Viviparus* sp. River Snail | Sumpfdeckelschnecke | Paludine vivipare
D1–D3 Neritidae: *Theodoxus* sp. D7 *Theodoxus coronatus* Leach, 1815?
D9, D11 Viviparidae: *Viviparus, V. contectus* Müller? E3 Lymnaeidae: *Radix auricularia* L.?
E10–E11 *Radix* sp., *R. auricularia* L.,? Bigear Radix | Ohrschlammschnecke | –
F2–3, F6–7, F9–10, F13, 17, 23 Lymnaeidae F14 Bythiniidae: *Bythinia* sp.
F16 *Lymnaea stagnalis* (L., 1758) Great Pond Snail | Spitzschlammschnecke | Petite Limnée
H *Melanoides tuberculata* (Müller, 1774)

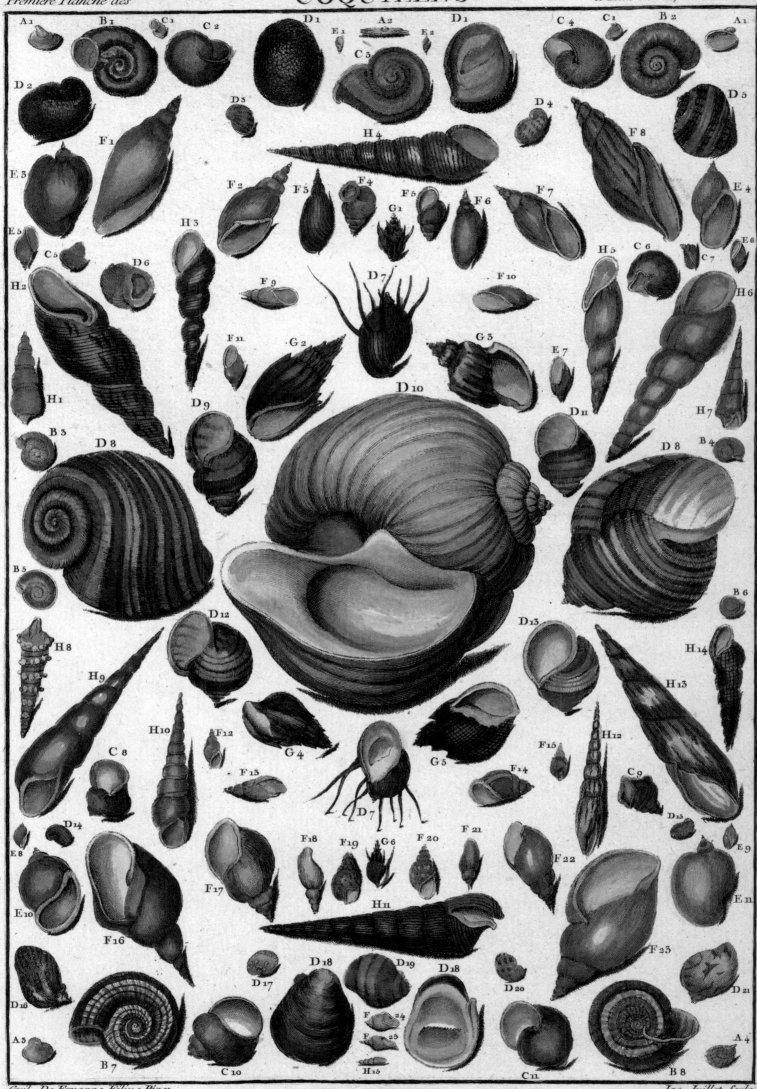

Guil. De Favanne Filius Pinx. Jac. Juillet Sculp.

PLANCHE
LXI.

UNIONIDAE, SPHAERIIDAE

——————

Freshwater Shells
Süßwassermuscheln
Coquilles d'eau douce

A1–A2 *Anodonta cygnaea* L., Swan Mussel | Schwanenmuschel | Moule d'eau douce
B5 *Pisidium* sp. E *Anodonta anatina* L., – | Teichmuschel, Entenmuschel | –
G1 *Unio pictorum* L., Painter's Mussel | Malermuschel | Moule d'eau douce

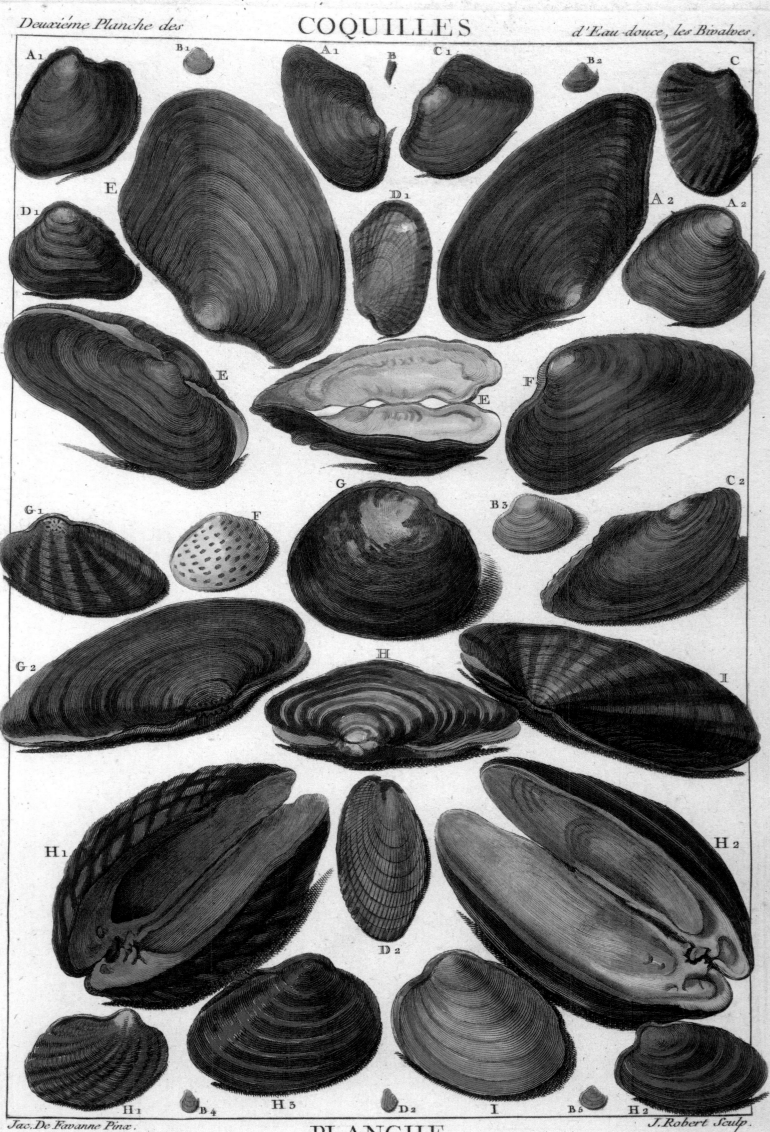

PULMONATA

Terrestrial Snails
Lungen-Landschnecken
Coquilles terrestres

D3 *Cernuella virgata?*

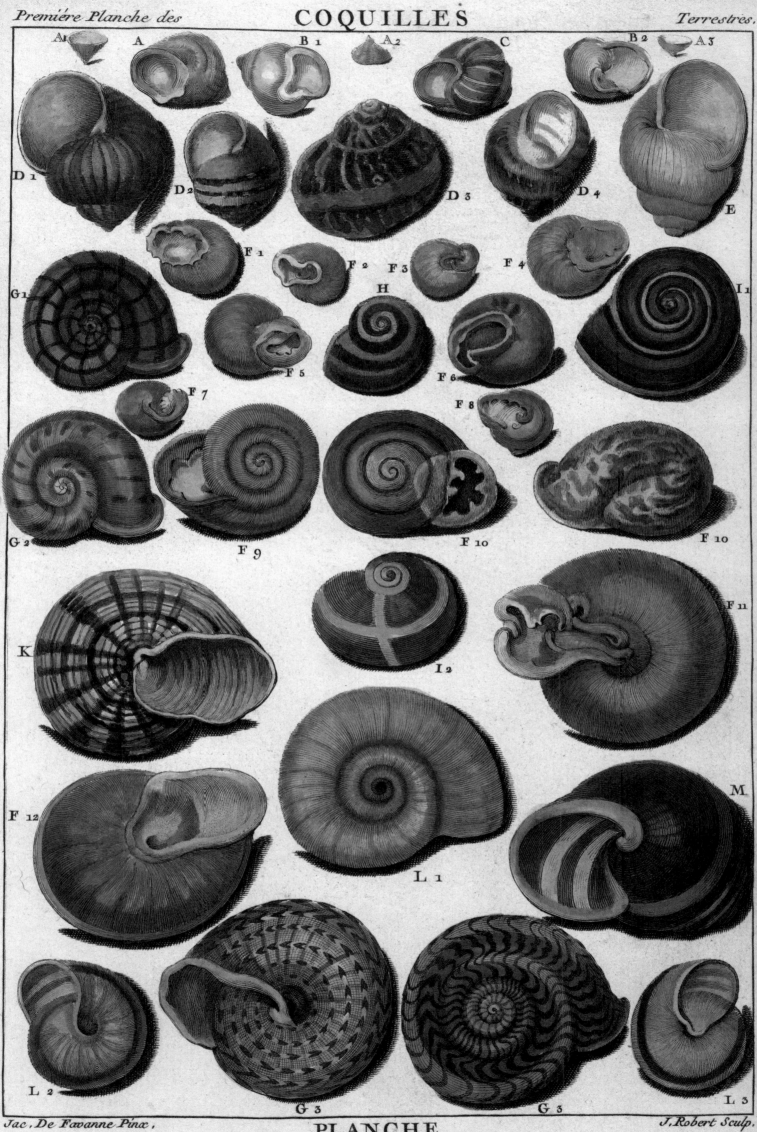

PULMONATA

———

Land Snails
Landschnecken
Coquilles terrestres

H5 *Pomatias elegans?* – | Schöne Landdeckelschnecke | –
I *Vallonia costata?* – | Gerippte Grasschnecke | –

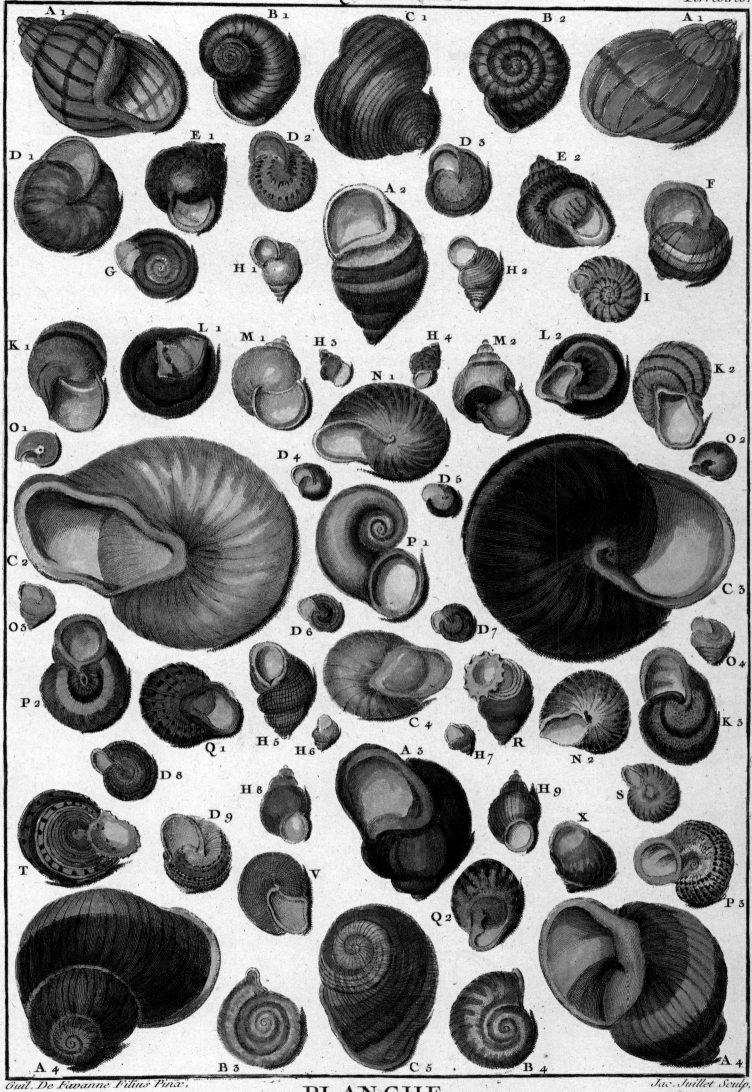

Guil. De Favanne Filius Pinx. *Jac. Juillet Sculp.*

PLANCHE
LXIV.

PULMONATA

———

Land Snails
Landschnecken
Coquilles terrestres

E4, E9 Clausiliidae? – | Schließmundschnecken | –
G *Achatinella* sp. M *Achatina* sp. – | Achatschnecke | –

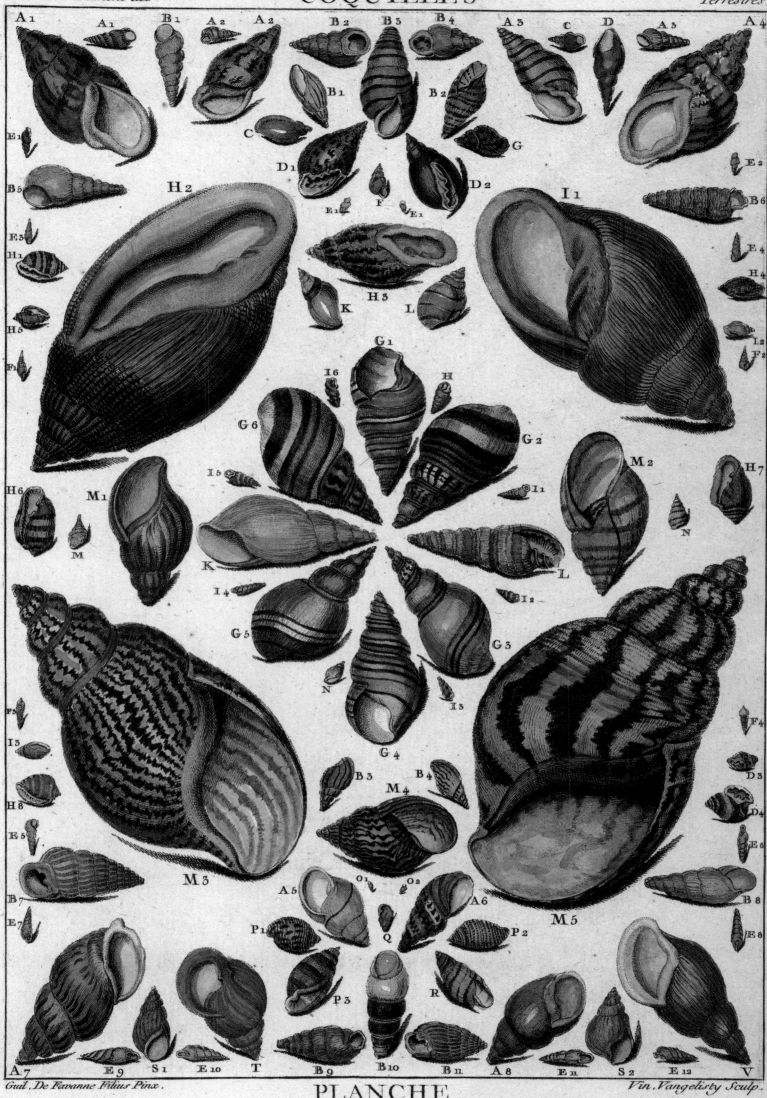

Guil. De Favanne Filius Pinx. Vin. Vangelisty Sculp.

PLANCHE
LXV.

MOLLUSCA FOSSILES

Fossil Molluscs
Fossile Mollusken
Mollusques fossiles

A2 Gastropoda: Fissurellidae B1 Scaphopoda? B5 Scaphopoda
C3–4 Cephalopoda: Nautilida D1 Ammonoidea: *Pavlovia pallasioides* (Neaverson)?
D10, 13 Cephalopoda: Ammonoidea
D5 Cephalopoda, Ammonoidea: *Macrocephalites macrocephalus* (Schlotheim)?
D8 Cephalopoda: Ammonoidea: *Dactylioceras commune* (Sowerby)?
D11 Cephalopoda: Ammonoidea, *Schloenbachia* sp.?
D14 Cephalopoda, Ammonoidea: *Creniceras renggeri* (Oppel)
D20 Cephalopoda: Ammonoidea: *Uptonia jamesoni* (Sowerby)
F1 Gastropoda: *Xenophora* sp. G Gastropoda: Conidae I Gastropoda: *Athleta* sp.
K3 Gastropoda: *Ficus* sp.? M3, 6, 7 Gastropoda: Fusinidae
O4, O7 Gastropoda: Cerithiidae

Guil. De Favanne Filius Pinx. *L. Ant. Herisset Sculp.*

PLANCHE
LXVI.

FOSSILIA: BRACHIOPODA,
MOLLUSCA, ECHINODERMATA
ET CRUSTACEA

———

Fossil Brachiopods, Molluscs, Cnidarians, Echinoderms and Crustaceans
Fossile Armfüßer, Weichtiere, Cnidaria, Stachelhäuter und Krebse
Brachiopodes, Mollusques, Cnidaires, Échinodermes et Crustacés fossiles

1. **Brachiopoda** Brachiopods / Armfüßer / Brachiopodes
Bivalvia Lamellibranchs, Bivalves | Muscheln | Lamellibranches
A1–4 Brachiopoda, A3 Rhynchonellida
C Ostreidae: *Ctenostreon?* **E2–3** *Gryphaea arcuata* Lamarck

2. **Echinoidea** Sea Urchins | Seeigel | Oursins **Anthozoa** Corales | Korallen | Coraliers
Cirripedia Barnacles | Rankenfüßer | Cirripède
A–K Echinoidea Sea-Urchins | Seeigel | Oursins, Échinides
A2, B Echinoidea – | Seeigelstacheln | – **K** *Micraster*
L Anthozoa Coral | Einzelkoralle | Coralier
M Cirripedia, Balanomorpha Barnacle, Acorn Barnacles |
Seepocke | Cirripède **&1–3: Lamellibranchia: Pectinacea**

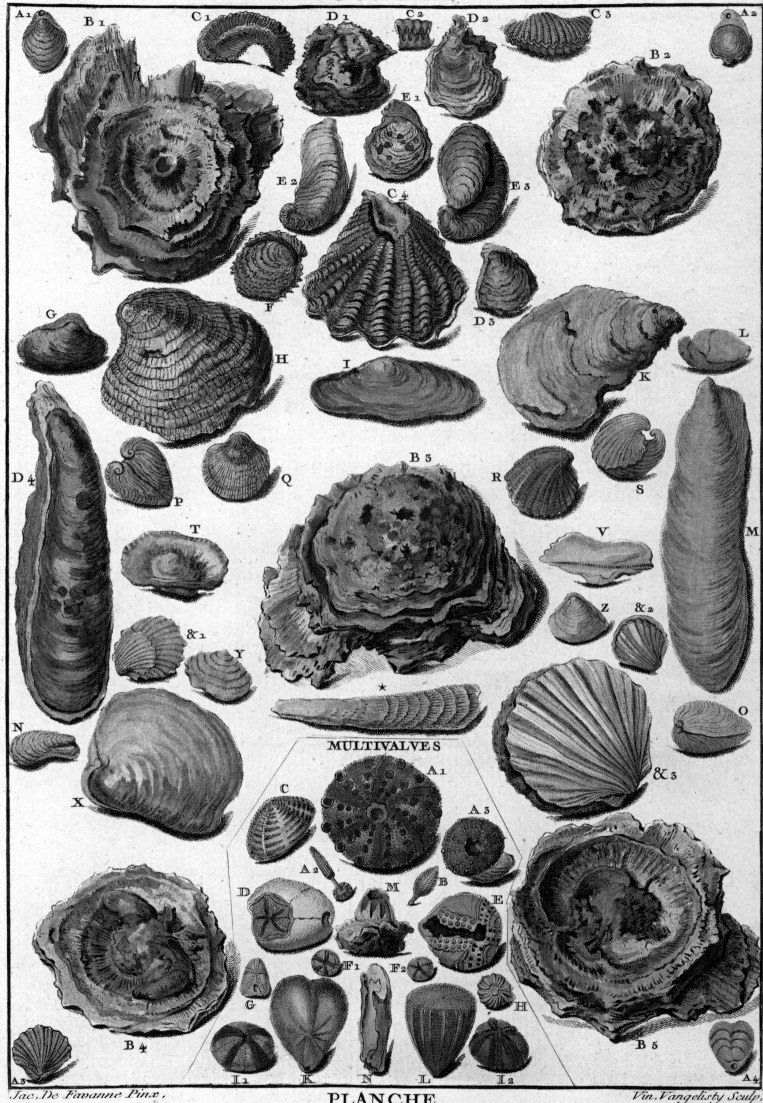

MULTIVALVES

Jac. De Favanne Pinx. *Vin. Vangelisty Sculp.*

MOLLUSCA ET ARTICULATA

———————

Molluscs and articulated animals
Weichtiere und Gliedertiere
Mollusques et Articulés

A–C *Patella vulgaris* Common European Limpet | Napfschnecke | Patelle commune
D **Patellidae** True Limpet | Napfschnecke | Patelle
E **Fissurellidae** Keyhole Limpets | Lochnapfschnecken | Fissurelles
F 1–2 *Haliotis* **sp.** (*rufescens?*) Abalone | Gemeines Meerohr | Ormeau rouge
I **Scaphopoda** Scaphopod | Elephantenzahn | Scaphopode, Dentale
H **Serpulidae** – | Gehäuse von Meereswürmern | –
L, M **Annelida** Annelids | Ringelwürmer | Annélides

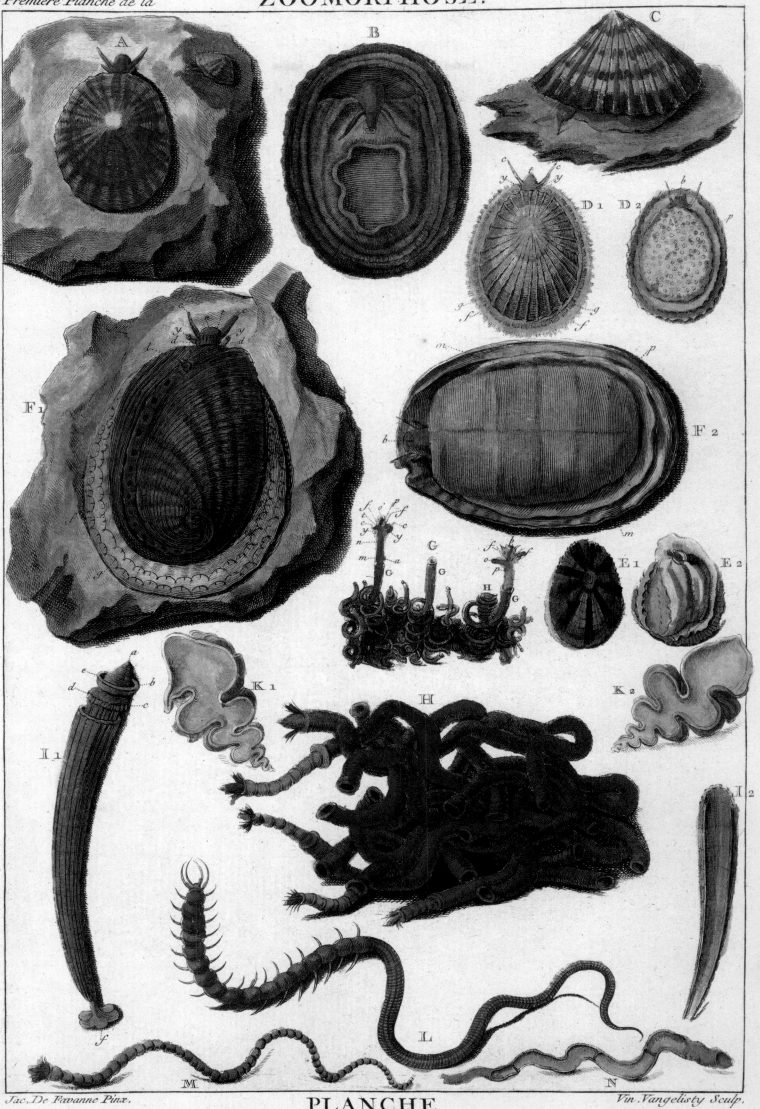

CEPHALOPODA

———

Cephalopods
Kopffüßer
Céphalopodes

A1–4 *Nautilus* Nautilus: Shell | Schiffsboot: Gehäuse | Nautile: Coquille
A5 *Nautilus* Soft body | Weichkörper | Corps doux
B *Spirula* C1–C4 *Argonauta* Paper Nautilus | Papierboot | Argonaute
D **Ammonoidea** Ammonites | Ammoniten | Ammonites

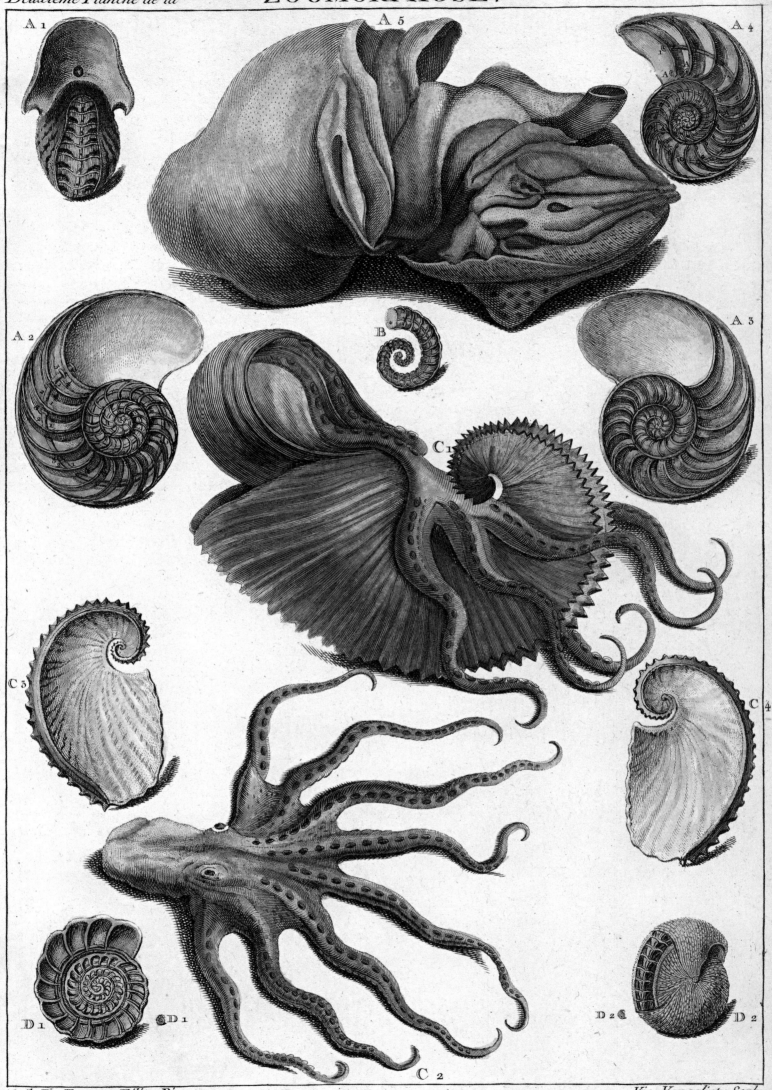

A 1
A 5
A 4
A 2
B
A 3
C 1
C 3
C 4
D 1
D 1
C 2
D 2
D 2

Guil. De Favanne Filius Pinx.

**PLANCHE
LXIX.**

Vin. Vangelisty Sculp.

GASTROPODA MARINA

———

Marine Snails
Meeresschnecken
Gastéropodes marins

C *Natica?* E Neritidae
H *Calliostoma zizyphinus* (L., 1758) European Painted Top | Europäische Kreiselschnecke | –
K *Conidae* Cone | Kegelschnecke | Cône
P Tonnidae S **Cypraeidae** Cowrie | Porzellanschnecke | Porcelaine
V **Cypraeidae vel Triviidae** Cowrie | Porzellanschnecke | Porcelaine

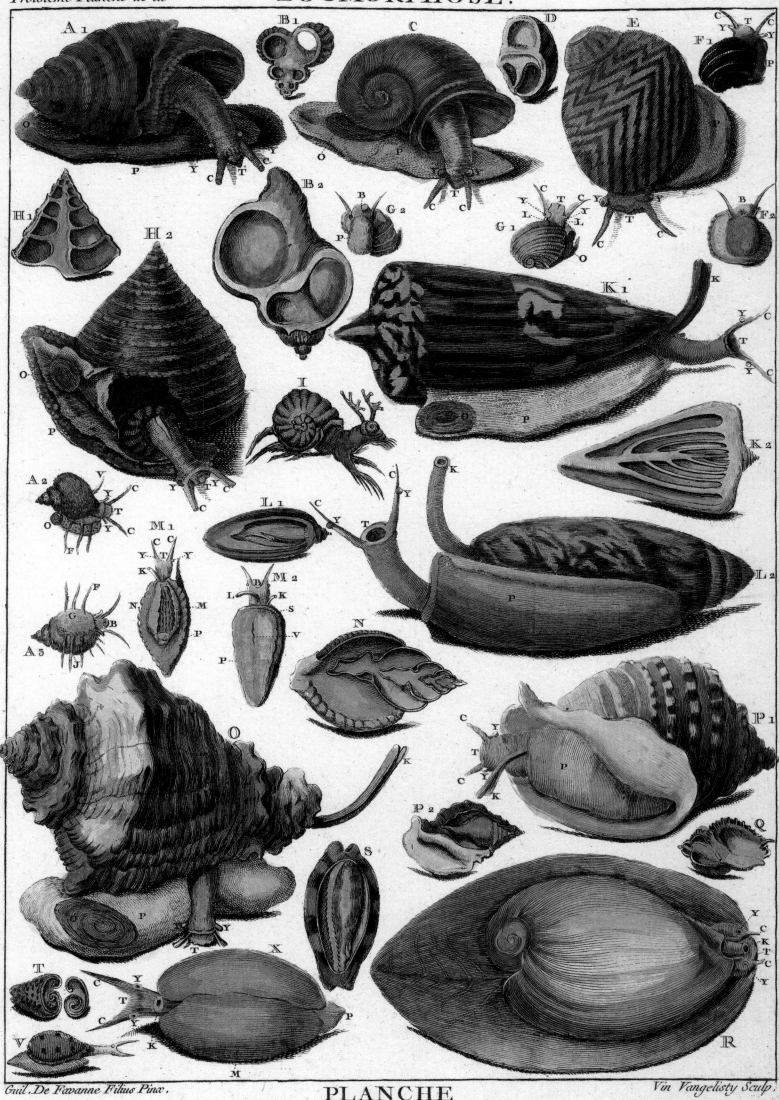

GASTROPODA MARINA

Marine Snails
Meeresschnecken
Gastéropodes marins

B–C *Buccinum undatum* L., 1758 Common Northern Whelk |
Wellhornschnecke | Buccin commun, Bulot, Calicoco, Torion
N1–N2 *Bolinus brandaris* (L., 1758) Purple Dye Murex | Purpurschnecke, Stachelschnecke, Brandhorn |
Pourpre de Méditerranée E, G, L, M, Q Various Gastropod Shells cut open |
diverse Schneckengehäuse, aufgeschnitten | Coupes de différentes coquilles L *Nassarius?*
Q *Epitonium* Wentletrap | Wendeltreppe | Scalaire

BIVALVIA

Bivalves
Muscheln
Bivalves

A *Ostrea* Oyster | Auster | Huître
M *Pinna nobilis* L., 1758 Pen Shell | Steckmuschel |
Grande Nacre de Méditerranée
P, P1 *Mytilus edulis* L., 1758 Mussel | Miesmuschel | Moule

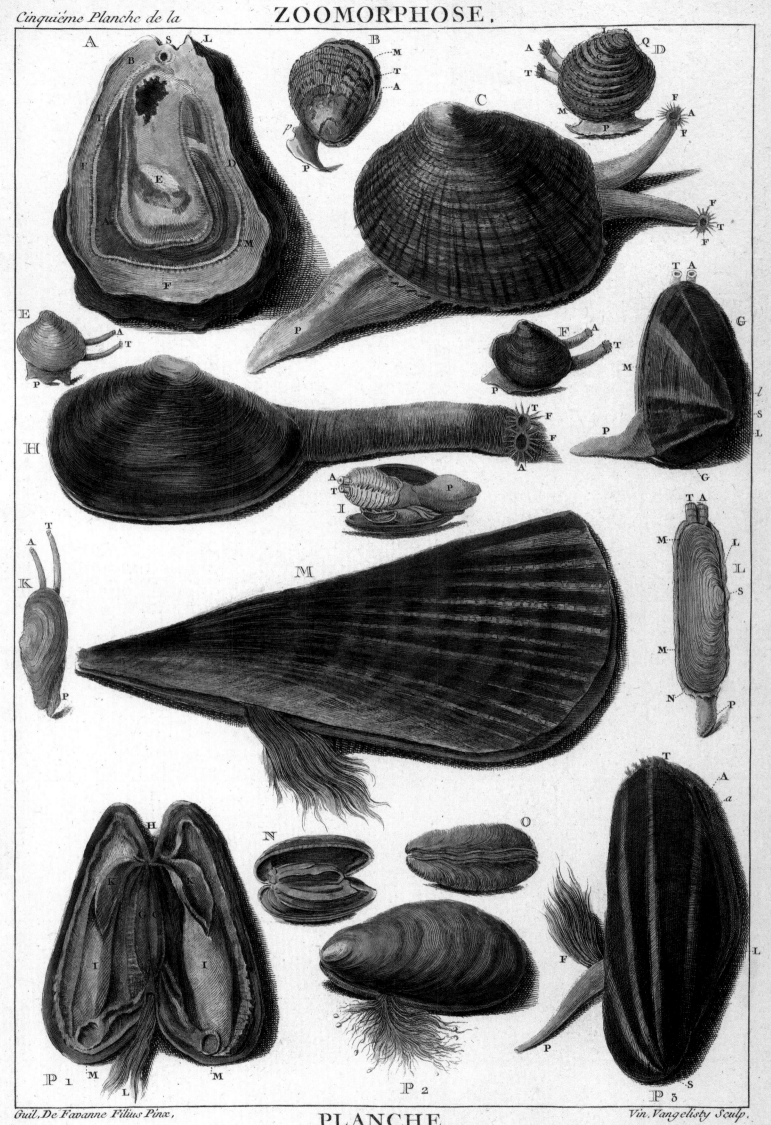

Guil. De Favanne Filius Pinx. Vin. Vangelisty Sculp.

PLANCHE
LXXII.

BIVALVIA MARINA

———————

Marine Bivalves
Meeresmuscheln
Bivalves marins

A, G, H **Pectinidae** Scallops | Kammmuscheln | Pectens
B, C, D, E **Cardiidae** Cockles | Herzmuscheln | Coeurs, Coques
E *Cerastoderma edule* L., 1758 Edible Cockle | Essbare Herzmuschel | Coque commune
I1–I2 **Solenidae** Razor Clams | Scheidenmuscheln, Messerscheiden | Couteaux

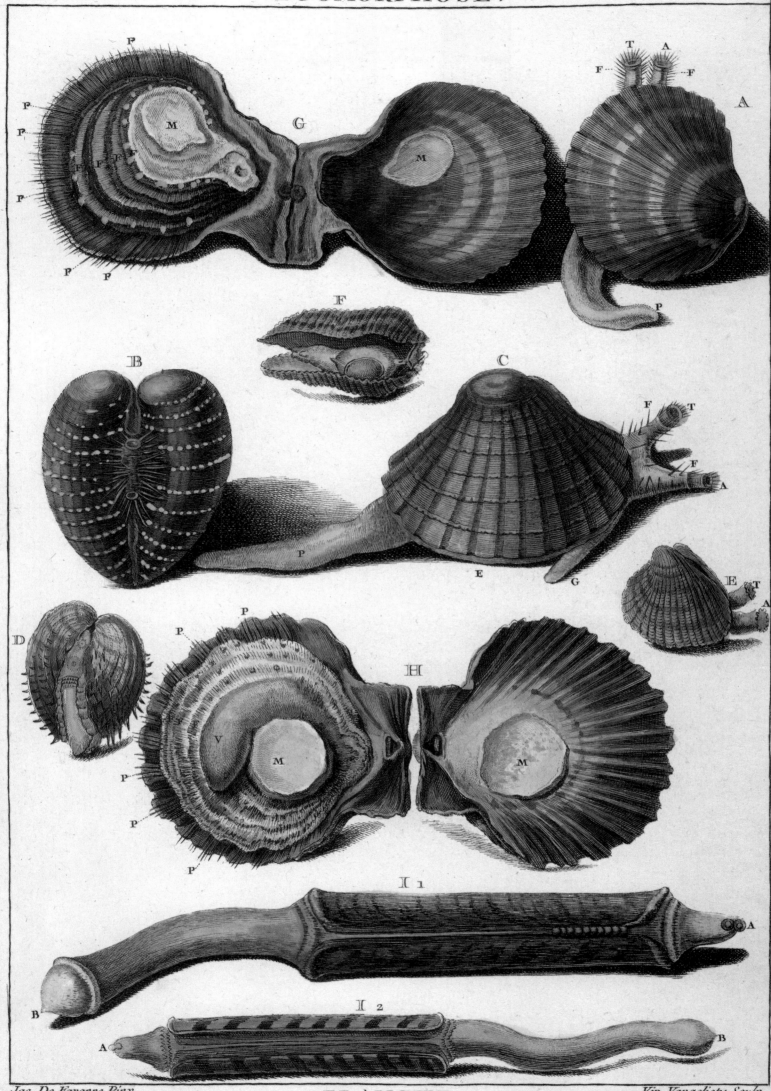

Jac. De Favanne Pinx.

PLANCHE
LXXIII.

Vin. Vangelisty Sculp.

MOLLUSCA, ECHINOIDEA ET CRUSTACEA

———

Molluscs, Sea Urchins and Crustaceans
Weichtiere, Seeigel und Krebstiere
Mollusques, oursins et écrevisses

A **Polyplacophora** Chiton | Käferschnecke | Polyplacophore
B–D **Echinoidea** Sea Urchins | Seeigel | Oursins
E **Cirripedia, Balanomorpha** Barnacles | Seepocken | Balanes
F1–F6, G1 **Cirripedia, Lepadomorpha** Goose barnacles, physique, parts of the shell |
Entenmuscheln, Körperbau, Elemente des Gehäuses |
Cirripèdes, Constitution, Éléments de coquille
H **Pholadidae** Pholads, Piddocks | Bohrmuscheln | Pholades
K *Zirfaea crispata* (L., 1767) – | Krause Bohrmuschel, Rauhe Bohrmuschel | –
M *Teredo* sp. – | Bohrwurm | –

ZOOMORPHOSE.

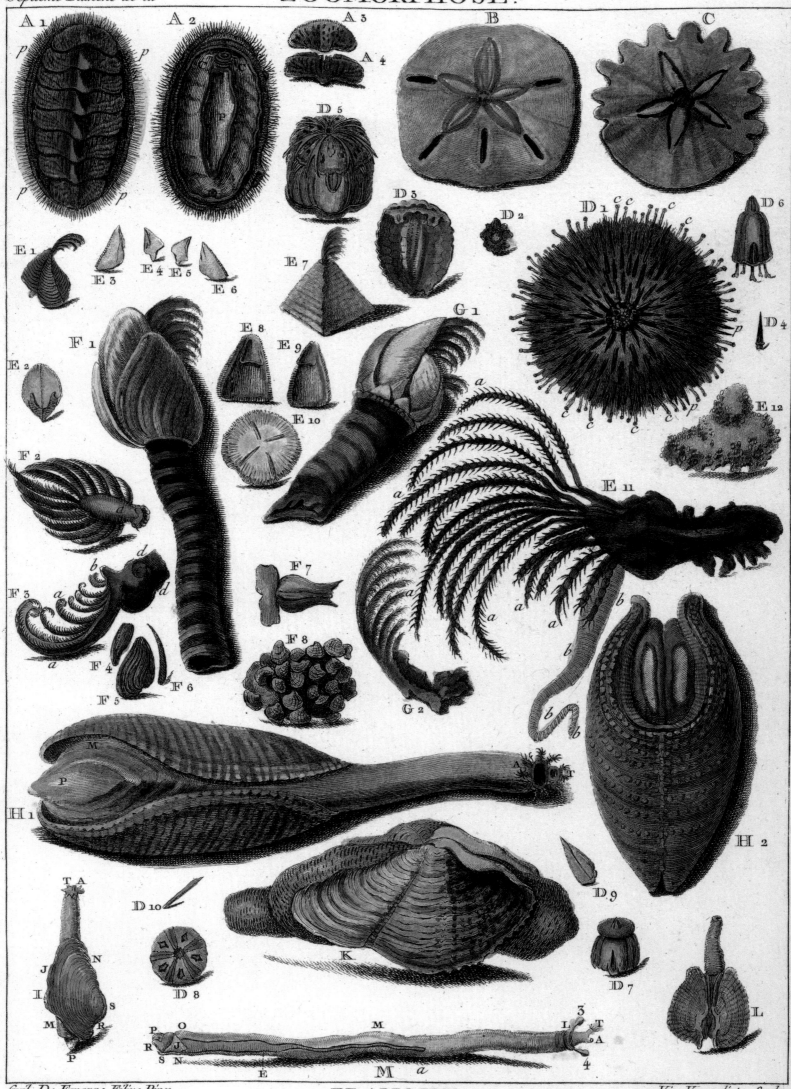

Guil. De Favanne Filius Pinx.

PLANCHE
LXXIV.

Vin. Vangelisty Sculp.

GASTROPODA ET BIVALVIA

Freshwater Gastropods and Bivalves, Freshwater Snails and Shells
Süßwasserschnecken und –muscheln
Gastéropodes et bivalves d'eau douce

Above / oben / en haut:

GASTROPODA

Snails | Schnecken | Gastéropodes

A *Ancylus fluviatilis* L. – | Flussnapfschnecke | –
B *Viviparus* sp. River Snail | Sumpfdeckelschnecke | Paludine vivipare
F *Succinea putris* (L., 1758)? Amber Snail, European Ambersnail |
Bernsteinschnecke | Ambrette commune
G *Galba palustris?* D *Planorbarius corneus* (L., 1767) Great Ramshorn |
(Große) Posthornschnecke | Planorbe rouge

Below / unten / en bas:

BIVALVIA

Bivalves | Muscheln
Lamellibranches, Bivalves

A Sphaeriidae? D 1–2 Unionidae Freshwater Shells |
Teichmuscheln | Moules d'eau douce

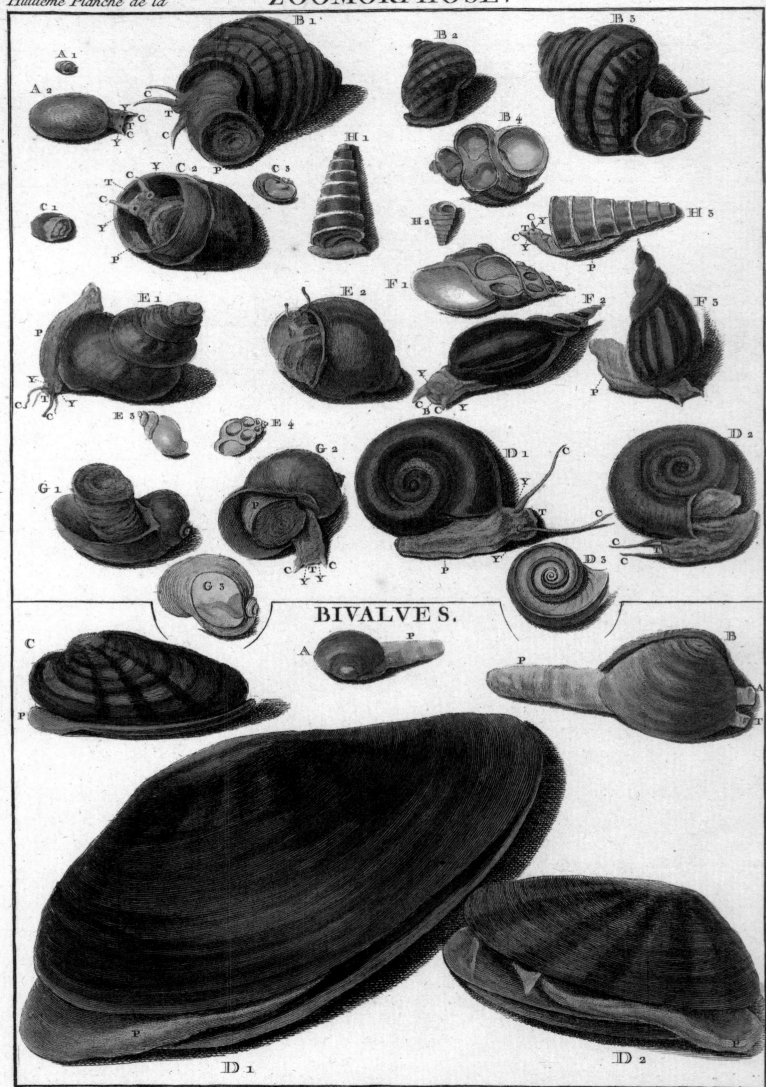

BIVALVES.

PULMONATA

———

Terrestrial Snails belonging
to various families
Lungenschnecken, Landschnecken
verschiedener Familien
Coquilles terrestres de
diverses familles

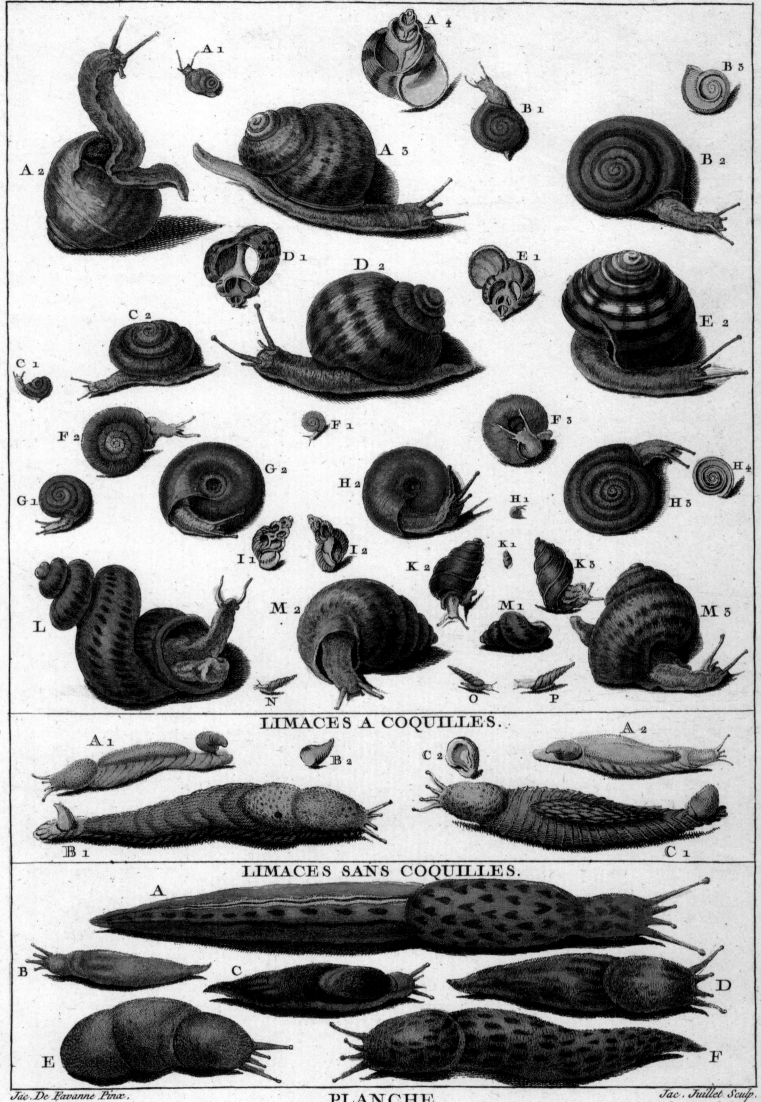

LIMACES A COQUILLES.

LIMACES SANS COQUILLES.

Jac. De Favanne Pinx. *Jac. Juillet Sculp.*

BIVALVIA ET GASTROPODA

————

Anatomical studies of various gastropods and bivalves
Anatomie von Schnecken und Muscheln
Gastéropodes et Bivalves, Anatomie

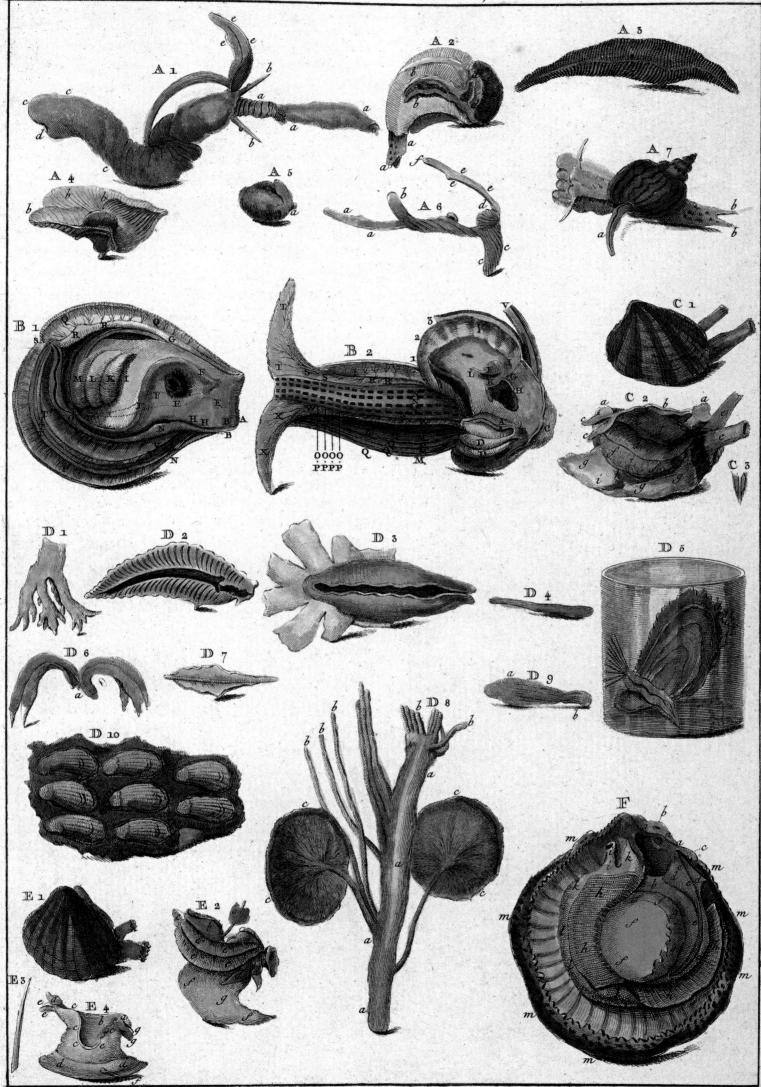

Above / oben / en haut:

BIVALVIA ET GASTROPODA

————

Anatomical studies of gastropods and bivalves
Anatomie von Schnecken und Muscheln
Gastéropodes et Bivalves, Anatomie

Below / unten / en bas:

MOLLUSCA

————

Molluscs and their predators
Fressfeinde von Mollusken
Mollusques et leurs prédateurs

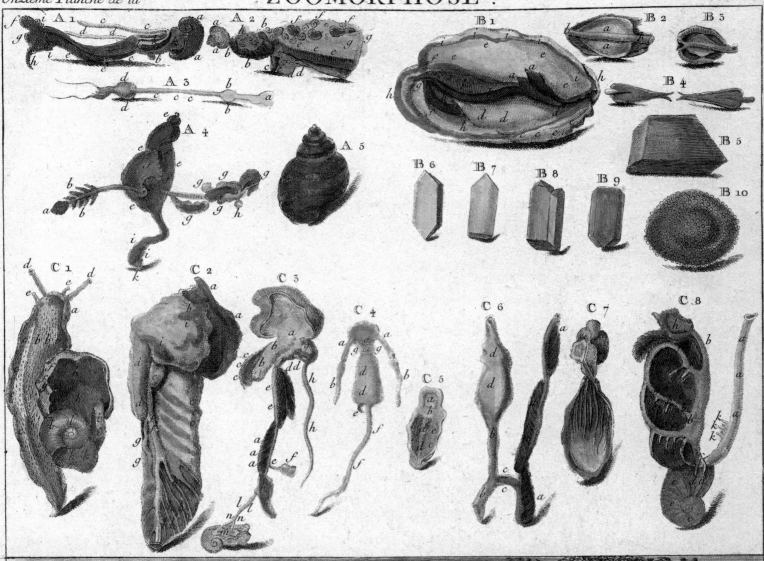

Guil. De Favanne Filius Pinx . *Vin. Vangelisty Sculp .*

PLANCHE
Différens Animaux qui **LXXVIII.** *mangent des Coquillages .*

GASTROPODA

———

Snails
Schnecken
Gastéropodes

BIVALVIA

———

Bivalve
Muschel
Bivalve

Above / oben / en haut:
A Fissurellidae D *Haliotis* sp. Abalone | Meerohr | Oreille
E *Brechites* sp.,
G Muricidae L–O Conidae, Y *Tibia* sp.

Below / unten / en bas:
H *Latirus* sp. I *Trophon* sp.
N *Cerithium* cf. *nodulosum* Brugière, 1792
Giant Knobbed Cerith | – | –

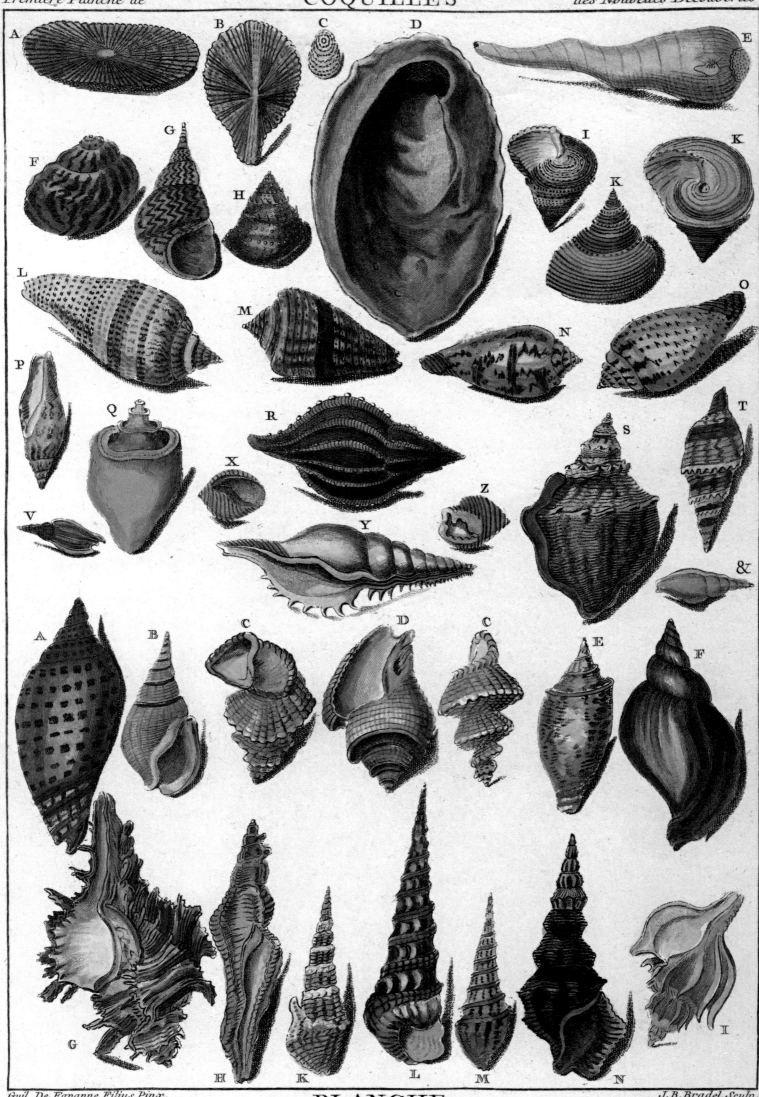

Guil. De Favanne Filius Pinx. J.B.Bradel Sculp.

MOLLUSCA

———

Molluscs of different groups
Weichtiere aus unterschiedlichen Gruppen
Mollusques de différents groupes

Brachiopoda? (K) Brachiopod | Armfüßer | Brachiopode
C Ostreidae H *Arca* **sp.** Arc | Archenmuschel | Arche
Q Cephalopoda, Belemnnoida: Fossil belemnite | fossiler Belemnit | Bélemnite fossile
S Bivalvia: *Diceras* **sp.** Jurassic bivalve |
Fossile Muschel aus dem Jura | Bivalve jurassique

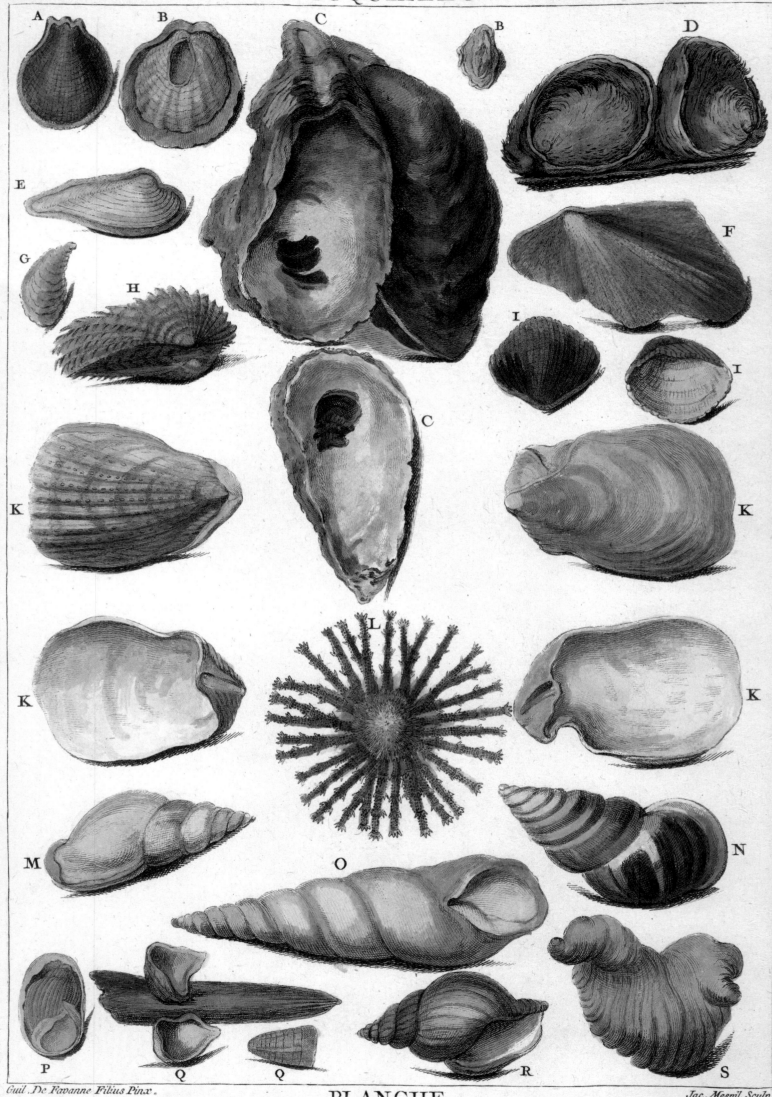

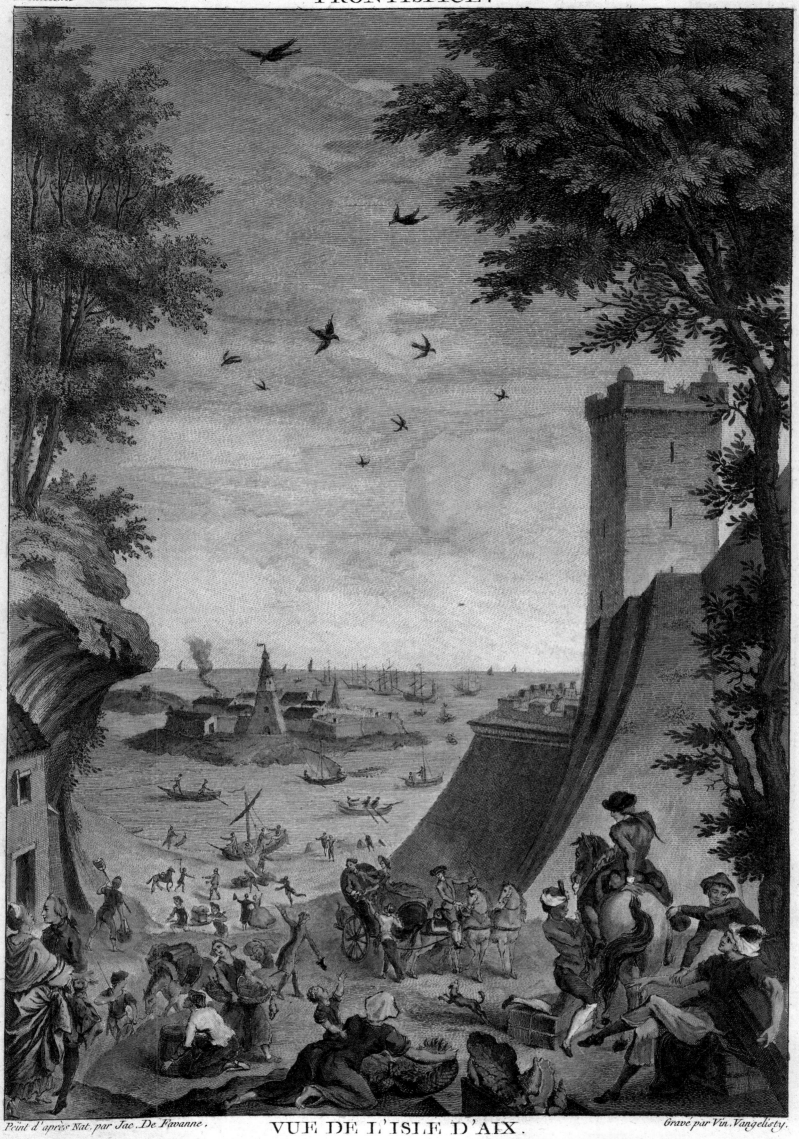

Peint d'après Nat. par Jac. De Favanne. VUE DE L'ISLE D'AIX. *Gravé par Vin. Vangelisty.*

Prise aux environs de la Tour de Fouras, telle qu'elle existoit jusqu'en l'année 1756.

RAINER WILLMANN

———

Zoological nomenclature in
Dezallier d'Argenville and Linnaeus

Die Benennung der Arten bei
Dezallier d'Argenville und Carl von Linné

La désignation des espèces chez
Dezallier d'Argenville et Carl von Linné

Zoological nomenclature in Dezallier d'Argenville and Linnaeus

Rainer Willmann

The route to today's biological taxonomy

In Dezallier d'Argenville's day, flora and fauna that attracted the interest, either for aesthetic reasons or because of curiosity aroused by what had never been seen before, of educated laymen and scholars alike were brought to Europe from the four corners of the earth. Dezallier d'Argenville depicted numerous species that had never been represented and described in scholarly publications. At the same time, publication of his works in the editions of 1742 and 1757 coincided with an era in which there was no universally valid, standardised convention for naming flora and fauna. Today scientific names consist of two parts, a "first name" (genus name) and, lower in the taxonomical hierarchy, a more precise second name (species name within a genus). Such names had been in sporadic use before Linnaeus yet it was not until his overview of all organisms known to him in the tenth edition of his *Systema naturae* (1753 flora, 1758 fauna) that this system for classifying species became the recognised convention, ultimately attaining virtually the force of law in biology. Today newly discovered species must be classified according to this prescribed system; that is, they must be given two Latin, Greek or Latinate or Graecised names. A biological name is called binomial or binary because it consists of two parts. To avoid confusion, the species name is followed by the name of the first person to describe the animal or plant in question. To take an example, the complete scientific name of the European Blue Mussel is *Mytilus edulis* Linnaeus, 1758.

Without the numerous works written by others on the diversity of life among organisms, Linnaeus would never have been able to provide what amounted to an overview of the then known flora and fauna species. Assessing the true importance of Dezallier d'Argenville's work presupposes familiarity with the Linnaean method. After sorting organisms by group, Linnaeus listed one species after another by giving each a binary name and added a brief description of each. Of couse he was unable to examine personally all the species he described in the *Systema naturae* although he had managed to familiarise himself with a great many of them through personal observation and had dispatched his pupils all over the world to bring back to him specimens of unknown organisms. Linnaeus knew most of the species he dealt with from scholarly publications: he evaluated innumerable such works and quoted them when naming each species so that the source of his knowledge of those species was clearly indicated. It was also clear how the species Linnaeus had listed looked. After all, Linnaeus' work contained no illustrations – unlike the reference works he consulted, which often boasted magnificent representations of flora and fauna from all corners of the earth.

Dezallier d'Argenville's compendious work was something special indeed because it was so highly specialised, devoted entirely to crustaceans, animals with hard shells or exoskeletons. Dezallier d'Argenville was a specialist in that field. The advantage for Linnaeus of being able to draw on such a specialised work written by a specialist in almost the modern sense was that it amounted to a reference work that he could rely on because the diverse gastropod and bivalve species had already been meticulously pre-grouped in it. Hence what Dezallier d'Argenville had so carefully prepared constantly shines through in Linnaeus' work. One of the great strengths of Dezallier d'Argenville's work, apart from the wide range of species presented in it, is, of course, the superlative quality of the illustrations.

Linnaeus could not have known that many life forms that closely resembled each other actually belonged to entirely different species. When Linnaeus listed a species, described it and pointed out the reference works available, several species may actually have been concealed behind the one he was dealing with at any given point. A biological species is not necessarily something that is easily distinguishable from others; it is rather a group of natural populations that are capable of reproducing within the group but are genetically isolated from other groups of this kind. This isolation – not to be confused with spatial separation – is upheld by mechanisms that are anchored in the organism itself: for instance, different courtship behaviour so that mating cannot take place; genital incompatibility; incompatibility of egg and semen cells (so that no embryo can develop) or the sterility of hybrids – when things even develop to that point, which is rare. What causes isolation is, therefore, not always recognisable in the animal itself. Different species may even look virtually identical. On the other hand, it is a recognised fact no two individuals within a species are entirely identical. Species are in fact variable and the more two populations of the same species are spatially separated, the greater the differences between them as a rule. No wonder then that errors in the classification by species of so many invididuals creep into the first attempts to describe biological species. Linnaeus' work, pioneering as it was, was understandably affected to a considerable extent by such errors. It would be left to later writers to clarify classification into species. With the advance of knowledge, the earlier works continued to be assiduously studied so that those who consulted them might ascertain whether they contained data on species of whose existence no one had previously had the slightest suspicion.

In the meantime, even though Linnaeus can be credited with having introduced so many biological names, many of those he used have been changed. One reason for this is that Linnaeus introduced relatively few genus names. As awareness of the stupendous scale of biodiversity grew, more precise differentiation became a priority of necessity with the result that more genus names were introduced. The many species that Linnaeus classified in 1758 as *Ostrea* (oysters), for instance, are today distributed among numerous genera, including *Pteria, Malleus, Pecten* and *Chlamys*. Whenever a species is linked nowadays with a genus name different to the one used by the first person to describe a species, the name of the earlier writer is added in parentheses.

Another reason for changing biological names is that some species have been described and named more than once and by different scientists. Those names were then synonymous. However, only one of those names is valid, almost invariably (albeit with some exceptions) the name that was first published.

Vernacular names

Many bivalves, gastropods, scaphopods and echinoderms have long had common names in the various languages. Names of this kind usually exist when the species are well known in areas where a particular language is spoken, for instance, because the

flora or fauna thus named are of economic importance – such as the edible Common Cockle or the oyster. What makes Dezallier d'Argenville's work so special, however, is the fact that he showed exotic species. Of course there were no English, French, German or Italian common names for them. However, common names were often artificially created. In some English-language compendia of molluscs, common names for all species shown were made up almost compulsively whether it made scientific sense to do so or not. In some cases those names came from collectors who might have published an illustrated volume on gastropods, for instance. In the present book, no new common names have been created if there are no firmly established German, French or English common names. Anyone who is seriously interested in studying invertebrates will of course deal with the scientific nomenclature because only through it is unambiguous comprehension – especially at the international level – possible at all. It should be borne in mind that many particularly avid collectors of gastropods and bivalves today maintain contact beyond national borders, exchanging information and specimens, and often even contributing substantially to enlarging our knowledge of species diversity or the habits of individual species. The boundaries between science and enthusiastic amateurs have blurred in many fields. The use of unambiguous species names is indispensable to benefit on both sides from delight in the beauty of natural forms.

In the present new edition of the Dezallier d'Argenville *Conchyliologie*, the modern names will be given for the best-known species. That has been successful in many cases. Moreover, the identity of a particular specimen can often be resolved or at least satisfactorily narrowed down. There has been neither time nor space to engage in further determination. Particularly characteristic species have been easy to identify. Nevertheless, many a striking form has proved impossible to identify so that it took lengthy research to ascertain that a specimen reproduced defied classification. The illustrations are frequently too inaccurate for reliable species identification. Indeed, they are often so imprecise that it was better to eschew any attempt at classification. On the other hand, there are presumably many very accurately reproduced specimens that may still be problematic. Hence conducting in-depth research on them would certainly be worthwhile. It is highly likely that even today some gastropods and bivalves lurking in Dezallier d'Argenville's illustrations may conceal scientific surprises.

The *Conchyliologie* as a source work for the tenth edition of the *System of Nature* (*Systema naturae*, 1758) of Carolus Linnaeus

In collating the faunal species known in his day for his *Systema naturae* (1758), Linnaeus drew on a great many reference works. Among those he referred to was d'Argenville's 1742 publication and many of the specimens reproduced in it. Quite a few of those reference specimens were also reproduced in the later edition of Dezallier d'Argenville's *Conchyliologie*. Since Linnaeus merely named and described the species but did not use any illustrations, this new edition has made them available to a broader public in pictures as well.

In the following, the specimens Linnaeus chose as reference examples have been listed as they appear in the 1780 *Conchyliologie*. The plate and number of the illustration are named, followed by the scientific name Linnaeus used in 1758. It should be emphasised that in each case only one of several examples to which Linnaeus referred is shown; in the *Systema naturae* he also used references to other publications for each species. Further, it must be pointed out – see the chapter on the origins of modern taxonomy – that many of Linnaeus' names have in the meantime been changed. For example, Plate 9 A2–A3 is *Turbo radiatus* Gmelin, 1791; Linnaeus had called this specimen *Turbo chrysostomus*.

PLATE 1: Q1 *Patella testudinaria* in Linnaeus.
PLATE 4: B4 Probably an example of a reference for *Patella equestris* in Linnaeus; cf. Dezallier d'Argenville 1742
PLATE 6: Figure K.
PLATE 5: A1 *Haliotis marmorata* in Linnaeus. A4 *Haliotis asinina* in Linnaeus. H *Dentalium elephantinum* in Linnaeus. K *Dentalium entalis* in Linnaeus.
PLATE 6: A2 *Tubipora musica* in Linnaeus. E1 *Serpula glomerata* in Linnaeus. P *Serpula anguina* in Linnaeus.
PLATE 7: A2 *Argonauta argo* in Linnaeus. D2 *Nautilus pompilius* in Linnaeus.

PLATE 9: A2–A3 *Turbo chrysostomus* in Linnaeus. A4 *Turbo cochlus* in Linnaeus. D3 *Turbo petholatus* in Linnaeus. H *Turbo delphinus* in Linnaeus. L *Trochus labio* in Linnaeus.
PLATE 10: C *Nerita chamaeleon* in Linnaeus. K *Nerita albume* in Linnaeus. S *Nerita polita* in Linnaeus.
PLATE 12: A *Turbo pagodus* in Linnaeus. B2 *Trochus maculatus* in Linnaeus. K *Architectonica perspectiva* (L., 1758). *Trochus perspectivus* in Linnaeus.
PLATE 14: A3 *Conus imperialis* in Linnaeus. B1 *Conus ebraeus* in Linnaeus. E4 *Conus marmoreus* in Linnaeus. G2 *Conus rusticus* in Linnaeus. I1 *Conus litteratus* in Linnaeus.
PLATE 19: L1 *Conus geographus* in Linnaeus. M2 *Conus tulipa* in Linnaeus. N *Conus striatus* in Linnaeus. P *Conus nussatella* in Linnaeus. Q *Voluta oliva* in Linnaeus.
PLATE 22: A4 *Strombus lambis* in Linnaeus. B *Strombus scorpius* in Linnaeus. D2 *Strombus pes pelecani* in Linnaeus.
PLATE 24: C3 *Murex ceramicus* in Linnaeus. D *Buccinum plicatum* in Linnaeus. E2 *Murex melongena* in Linnaeus. I *Phalium areola* (L., 1758). *Buccinum areola* in Linnaeus.
PLATE 27: A1 *Buccinum perdix* in Linnaeus. C1 *Buccinumn dolium* in Linnaeus. D2 *Buccinum perscum* in Linnaeus. D4 *Buccinum patulum* in Linnaeus. F1 *Bulla physis* in Linnaeus. G *Buccinum pomum* in Linnaeus. N *Buccinum crenulatum* in Linnaeus.
PLATE 29: A3 *Cypraea mappa* in Linnaeus. B2 *Cypraea argus* in Linnaeus. K *Cypraea moneta* in Linnaeus. P *Cypraea asellus* in Linnaeus. Y *Cypraea stolida* in Linnaeus.
PLATE 34: A3 *Murex femorale* in Linnaeus. B3 *Murex fusus* in Linnaeus. H *Murex trapezium* in Linnaeus. L *Murex tulipa* in Linnaeus. L2 *Murex syracusanus* in Linnaeus.
PLATE 36: E2 *Murex saxatilis* in Linnaeus. G3 *Murex scorpio* in Linnaeus. G4 *Murex ramosus* in Linnaeus.
PLATE 38: A1 *Murex haustellum* in Linnaeus.
PLATE 39: B *Trochus telescopium* in Linnaeus. D *Turbo duplicatus* in Linnaeus. E *Turbo terebra* in Linnaeus. H *Murex aluco* in Linnaeus. K *Murex granulatus* in Linnaeus. R Probably *Buccinum strigilatum* in Linnaeus; cf. Dezallier d'Argenville 1742 PLATE 14: Figure R.
PLATE 41: B *Anomia ephippium* in Linnaeus. E1 *Pinctada? Mytiolus margaritiferus* in Linnaeus.
PLATE 42: A1 *Ostrea malleus* in Linnaeus.
PLATE 43: E *Spondylus regius* in Linnaeus. B2 *Chama lazarus* in Linnaeus.
PLATE 47: A1 *Venus literata* in Linnaeus. B *Venus chione* in Linnaeus. E3 *Venus dione* in Linnaeus. F2 *Venus scortum* in Linnaeus. H *Venus scripta* in Linnaeus.
PLATE 50: A1 *Pinna nobilis* in Linnaeus. B1 Probably *Chama gigas* in Linnaeus; cf. Dezallier d'Argenville 1742
PLATE 26: Figure E. F3 *Mytilus ruber* in Linnaeus.
PLATE 51: C1 *Arca granosa* in Linnaeus. E2 *Cardium cardissa* in Linnaeus, Heart Shell (Linnaeus: Cor veneris). F *Chama hippopus* in Linnaeus.
PLATE 55: A3 *Ostrea plica* in Linnaeus. D *Ostrea nodosa* in Linnaeus. E1 *Ostrea pleuronectes* in Linnaeus. B1 *Solen vagina* in Linnaeus. B2 *Solen siliqua* in Linnaeus. L *Solen ensis* in Linnaeus.
PLATE 57: F1 *Echinus mamillatus* in Linnaeus. F2 *Echinus cidaris* in Linnaeus.
PLATE 59: A *Lepas tintinabulum* in Linnaeus. B1 *Lepas Mitella* in Linnaeus.

Die Benennung der Arten bei Dezallier d'Argenville und Carl von Linné

Rainer Willmann

Der Weg zur heutigen Benennung der Arten

Zu Dezallier d'Argenvilles Zeit wurden in Europa Pflanzen und Tiere aus allen Teilen der Welt zusammengetragen, die das Interesse der gebildeten Laien und Wissenschaftler auf sich zogen – sei es auch aus ästhetischen Gründen oder aus Neugier auf nie zuvor Gesehenes. Dezallier d'Argenville bildete zahlreiche Arten ab, die noch nie zuvor in der Literatur dargestellt und beschrieben worden waren. Zugleich fiel die Veröffentlichung seines Werkes von 1742 bzw. von 1757 in eine Zeit, in der es noch keine allgemein gültige und einheitliche wissenschaftliche Bezeichnung der Tier- und Pflanzenarten gab. Heute bestehen solche Artbezeichnungen aus zwei Namen, dem „Vornamen" (Name der Gattung) und einem genauer bezeichnenden zweiten Namen (Name der Art innerhalb einer Gattung). Solche Bezeichnungen wurden zwar vereinzelt schon vor Carl von Linné benutzt, doch erst mit dessen Gesamtschau aller ihm bekannten Organismen in der zehnten Auflage seiner *Systema naturae* (1753 für die Pflanzen, 1758 für die Tiere) gewann diese Form der Benennung der Arten Anerkennung als Regel und schließlich geradezu gesetzliche Kraft. Heute sind neu entdeckte Arten nach diesen Vorgaben zu beschreiben, das heißt, sie müssen aus zwei lateinischen, griechischen oder latinisierten bzw. graecisierten Bezeichnungen bestehen. Eine solche aus zwei Teilen bestehende biologische Bezeichnung wird als binominal oder binär bezeichnet. Um jede Verwechslung auszuschließen, folgt dem Artnamen der Name des Erstbeschreibers. Der vollständige wissenschaftliche Name der europäischen Miesmuschel lautet daher *Mytilus edulis* Linné, 1758.

Ohne die zahlreichen Werke über die organismische Vielfalt durch andere Autoren wäre es Linné niemals möglich gewesen, so etwas wie einen Überblick der damals bekannten Tier- und Pflanzenarten zu liefern. Um die Bedeutung des Werkes von Dezallier d'Argenville ermessen zu können, muss man sich die Vorgehensweise von Linné vor Augen führen. Sortiert nach Organismengruppen, listete Linné eine Art nach der anderen unter Vergabe eines binären Namens auf und gab zu jeder eine Kurzbeschreibung. Natürlich konnte er nicht alle Arten, die er in der *Systema naturae* beschrieb, selbst untersuchen, auch wenn er sehr viele aus eigener Anschauung kannte und seine Schüler in alle Teile der Welt entsandte, damit sie ihm bislang unbekannte Organismen mitbrachten. Die meisten kannte er aus der Literatur: Er wertete unzählige Publikationen aus und zitierte diese bei der Nennung einer jeden Art, so dass erkennbar war, woher er seine Kenntnisse hatte. Auch konnte nachvollzogen werden, wie die von Linné aufgelisteten Arten aussehen. Denn Linnés Werk enthielt keinerlei Abbildungen – ganz im Gegensatz zu seinen Referenzwerken, die oft prachtvolle Darstellungen von Pflanzen und Tieren aus aller Herren Länder enthielten.

Dezallier d'Argenvilles Werk war insofern eine Besonderheit, als es sich ausschließlich auf die Conchylien bezog, Tiere mit harten Schalen oder Gehäusen. Auf diesem Gebiet war Dezallier d'Argenville Fachmann. Das hatte für Linné den Vorteil, dass hier ein Werk vorlag, auf das er in vieler Hinsicht vertrauensvoll zurückgreifen konnte, denn die Vielfalt an Schnecken und Muscheln war darin bereits sorgfältig vorgruppiert. Auf diese Weise schimmert in Linnés Werk immer wieder durch, was Dezallier d'Argenville vorbereitet hatte. Zu dessen Stärken gehörte neben der dargestellten Artenfülle auch die Qualität der Abbildungen.

Linné konnte nicht wissen, dass viele einander sehr ähnliche Formen zu verschiedenen Arten gehören können. Wenn Linné eine Art auflistete, beschrieb und auf die Literatur verwies, dann verbargen sich in Wirklichkeit möglicherweise mehrere Arten dahinter. Eine biologische Art ist nicht etwas, was sich von anderen Arten leicht erkennbar unterscheidet, sondern sie ist eine Gruppe natürlicher Populationen, die untereinander fortpflanzungsfähig und von anderen solchen Gruppen genetisch isoliert sind. Diese Isolation – nicht zu verwechseln mit der Separation, der räumlichen Trennung – wird durch Mechanismen aufrecht erhalten, die im Organismus selbst verankert sind, wie beispielsweise unterschiedliches Balzverhalten, das eine Verpaarung ausschließt, Inkompatibilität der Fortpflanzungsorgane, Unverträglichkeit der Ei- und Samenzelle (so dass sich gar kein Embryo entwickelt) oder die Unfruchtbarkeit von Hybriden – wenn es denn überhaupt zu einer so weiten Entwicklung kommt. Was diese Isolation bewirkt, ist also am Tier selbst nicht unbedingt erkennbar. Es kann durchaus sein, dass verschiedene Arten sich äußerlich nahezu gleichen. Andererseits gibt es keine zwei Individuen, die einander völlig gleichen. Arten sind also variabel, und je stärker zwei Populationen ein und derselben Art getrennt sind, desto größer sind in der Regel die Unterschiede. So ist es kein Wunder, dass bei den ersten Untersuchungsschritten an biologischen Arten Irrtümer zur Einschätzung der Artzugehörigkeit vieler Individuen entstehen können. Linnés Pionierarbeit war davon verständlicherweise stark betroffen. Es war späteren Autoren vorbehalten, die Artzugehörigkeiten zu klären. Mit fortschreitenden Kenntnissen wurden die älteren Werke immer wieder darauf hin durchgesehen, ob sie Angaben zu Arten enthielten, von deren Existenz man ursprünglich gar nichts ahnte.

Nun haben sich, obwohl Linné viele Namen eingeführt hatte, inzwischen zahlreiche der von ihm benutzten Bezeichnungen geändert. Ein Grund dafür liegt darin, dass er relativ wenige Gattungsnamen eingeführt hatte. Mit zunehmender Kenntnis des Artenreichtums wurde genauer differenziert, woraufhin weitere Gattungsnamen eingeführt wurden. Die vielen Arten, die Linné 1758 als *Ostrea* (Auster) bezeichnete, verteilen sich heute auf zahlreiche Gattungen, darunter beispielsweise *Pteria, Malleus, Pecten* und *Chlamys*. Immer wenn eine Art heute mit einem anderen Gattungsnamen verknüpft wird, als es der Erstbeschreiber einer Art getan hat, wird der Name des alten Autors in Klammern gesetzt.

Ein weiterer Grund für Namensänderungen liegt darin begründet, dass manche Arten mehrmals, und zwar von verschiedenen Wissenschaftlern, beschrieben und benannt worden sind. Diese Namen heißen Synonyme. Gültig ist dann nur einer dieser Namen, und zwar (mit einigen Ausnahmen) jener, der zuerst veröffentlicht worden war.

Trivialnamen

Viele Muscheln, Schnecken, Grab- bzw. Kahnfüßer und Stachelhäuter haben in den verschiedenen Sprachen seit langer Zeit Trivialnamen. Solche Namen existieren in der Regel dann, wenn die Arten im jeweiligen Sprachraum gut bekannt sind,

zum Beispiel, weil sie eine wirtschaftliche Bedeutung haben – wie bei der Essbaren Herzmuschel oder der Auster. Aber die Besonderheit von Dezallier d'Argenvilles Werk liegt darin, dass er Exoten dargestellt hat. Für sie gab es natürlich keine englischen, französischen, deutschen oder italienischen Bezeichnungen. Oft wurden allerdings künstliche Trivialnamen eingeführt. So wurde in manchen englischsprachigen Zusammenstellungen von Weichtieren geradezu zwanghaft für sämtliche abgebildeten Formen Trivialnamen geschaffen, ob sie sinnvoll waren oder nicht. In einigen Fällen stammen diese Namen von Sammlern, die einen Bildband über Schnecken veröffentlicht hatten. In der vorliegenden Publikation wurden, wenn es keine fest etablierten deutschen oder französischen Namen gibt, auch keine Trivialnamen genannt und auch keine neuen kreiert. Wer ernsthaft an der Weichtierkunde interessiert ist, der setzt sich ganz selbstverständlich mit den wissenschaftlichen Namen auseinander, denn nur über sie ist eine eindeutige – insbesondere internationale – Verständigung möglich. Man darf nicht vergessen, dass viele der besonders engagierten Sammler von Schnecken und Muscheln heute über die Ländergrenzen hinweg Kontakte pflegen, Informationen und Fundstücke austauschen und sogar sehr oft dazu beitragen, unsere Kenntnisse über die Artenvielfalt oder die Lebensweise der Tiere zu erweitern. Die Grenzen zwischen Wissenschaft und begeisterten Sammlern verschwimmen in vielen Bereichen. Für einen wechselseitigen Gewinn aus der Freude an den Formschönheiten der Natur ist die Verwendung eindeutiger Artnamen unabdingbare Voraussetzung.

In der vorliegenden Neuausgabe der *Conchyliologie* von Dezallier d'Argenville sollten für die bekanntesten Arten die heutigen Namen angegeben werden. Das ist in vielen Fällen gelungen. Darüber hinaus lässt sich die Identität häufig zumindest mit einer gewissen Wahrscheinlichkeit angeben oder eingrenzen. Aus Zeitgründen waren der weitergehenden Bestimmung Grenzen gesetzt. Besonders charakteristische Arten ließen sich rasch identifizieren. Jedoch erwies sich manch auffällige Form als nicht identifizierbar, so kam es vor, dass man lange recherchierte, um feststellen zu müssen, dass sich eine Abbildung jeder Bestimmung entzog. Des Öfteren sind die Abbildungen nicht so akkurat, dass man sich der Identität der Arten sicher sein könnte. Häufig sind sie sogar so ungenau, dass man besser auf den Versuch einer Bestimmung verzichtet. Andererseits gibt es viele vermutlich sehr präzise Abbildungen, deren Bestimmung größte Schwierigkeiten mit sich bringt, daher würde es sich durchaus lohnen, der Identität der dargestellten Formen durch aufwendige Forschung auf den Grund zu gehen. Bis heute können manche der Schnecken und Muscheln auf Dezallier d'Argenvilles Tafeln wissenschaftliche Überraschungen bergen.

Die *Conchyliologie* als Quellenwerk für die zehnte Auflage des *Systems der Natur* (*Systema naturae*, 1758) von Carl von Linné

Linné hatte bei der Zusammenstellung der zu seiner Zeit bekannten Tierarten für seine *Systema naturae* von 1758 eine Fülle von Literatur berücksichtigt. Unter anderem hatte er auf d'Argenvilles Werk von 1742 und viele der darin abgebildeten Exemplare Bezug genommen. Viele dieser Referenzexemplare wurden auch in der späteren Ausgabe von d'Argenvilles *Conchyliologie* wiedergegeben. Da Linné die Arten lediglich benannt und beschrieben, nicht aber abgebildet hatte, wurden sie mit der Neuausgabe einem breiteren Interessentenkreis auch im Bild zugänglich.

Im Folgenden werden jene Exemplare, die Linné als Referenzexemplare ausgewählt hatte, aufgelistet, wie sie sich in der *Conchyliologie* von 1780 wiederfinden. Dazu werden die Tafel und die Nummer der Abbildung genannt, gefolgt von dem wissenschaftlichen Namen, den Linné 1758 benutzt hat. Es sei betont, dass es sich dabei immer nur um eines von mehreren Referenzexemplaren handelt, auf die Linné Bezug genommen hatte, denn zu jeder Art führte er in der *Systema naturae* auch Verweise auf andere Literatur auf. Ferner sei darauf hingewiesen – siehe das Kapitel über die Entstehung der heutigen Benennung der Arten –, dass sich viele von Linnés Namen inzwischen geändert haben. Beispiel: Tafel 9 A2–A3 ist *Turbo radiatus* Gmelin, 1791; dieses Exemplar hatte Linné als *Turbo chrysostomus* bezeichnet.

Tafel 1: Q1 *Patella testudinaria* bei Linné.
Tafel 4: B4 Wahrscheinlich ein Referenzexemplar zu *Patella equestris* bei Linné, vgl. Dezallier d'Argenville 1742 **Tafel 6** Figur K.
Tafel 5: A1 *Haliotis marmorata* bei Linné. A4 *Haliotis asinina* bei Linné. H *Dentalium elephantinum* bei Linné. K *Dentalium entalis* bei Linné.

Tafel 6: A2 *Tubipora musica* bei Linné. E1 *Serpula glomerata* bei Linné. P *Serpula anguina* bei Linné.

Tafel 7: A2 *Argonauta argo* bei Linné. D2 *Nautilus pompilius* bei Linné.

Tafel 9: A2, A3 *Turbo chrysostomus* bei Linné. A4 *Turbo cochlus* bei Linné. D3 *Turbo petholatus* bei Linné. H *Turbo delphinus* bei Linné. L *Trochus labio* bei Linné.

Tafel 10: C *Nerita chamaeleon* bei Linné. K *Nerita albume* bei Linné. S *Nerita polita* bei Linné.

Tafel 12: A *Turbo pagodus* bei Linné. B2 *Trochus maculatus* bei Linné. K *Architectonica perspectiva* (L., 1758). *Trochus perspectivus* bei Linné.

Tafel 14: A3 *Conus imperialis* bei Linné. B1 *Conus ebraeus* bei Linné. E4 *Conus marmoreus* bei Linné. G2 *Conus rusticus* bei Linné. I1 *Conus litteratus* bei Linné.

Tafel 19: L1 *Conus geographus* bei Linné. M2 *Conus tulipa* bei Linné. N *Conus striatus* bei Linné. P *Conus nussatella* bei Linné. Q *Voluta oliva* bei Linné.

Tafel 22: A4 *Strombus lambis* bei Linné. B *Strombus scorpius* bei Linné. D2 *Strombus pes pelecani* bei Linné.

Tafel 24: C3 *Murex ceramicus* bei Linné. D *Buccinum plicatum* bei Linné. E2 *Murex melongena* bei Linné. I *Phalium areola* (L., 1758). *Buccinum areola* bei Linné.

Tafel 27: A1 *Buccinum perdix* bei Linné. C1 *Buccinumn dolium* bei Linné. D2 *Buccinum perscum* bei Linné. D4 *Buccinum patulum* bei Linné. F1 *Bulla physis* bei Linné. G *Buccinum pomum* bei Linné. N *Buccinum crenulatum* bei Linné.

Tafel 29: A3 *Cypraea mappa* bei Linné. B2 *Cypraea argus* bei Linné. K *Cypraea moneta* bei Linné. P *Cypraea asellus* bei Linné. Y *Cypraea stolida* bei Linné.

Tafel 34: A3 *Murex femorale* bei Linné. B3 *Murex fusus* bei Linné. H *Murex trapezium* bei Linné. L *Murex tulipa* bei Linné. L2 *Murex syracusanus* bei Linné.

Tafel 36: E2 *Murex saxatilis* bei Linné. G3 *Murex scorpio* bei Linné. G4 *Murex ramosus* bei Linné.

Tafel 38: A1 *Murex haustellum* bei Linné.

Tafel 39: B *Trochus telescopium* bei Linné. D *Turbo duplicatus* bei Linné. E *Turbo terebra* bei Linné. H *Murex aluco* bei Linné. K *Murex granulatus* bei Linné. R Wahrscheinlich *Buccinum strigilatum* bei Linné; vgl. Dezallier d'Argenville 1742 **Tafel 14** Figur R.

Tafel 41: B *Anomia ephippium* bei Linné. E1 *Pinctada? Mytiolus margaritiferus* bei Linné.

Tafel 42: A1 *Ostrea malleus* bei Linné.

Tafel 43: E *Spondylus regius* bei Linné. B2 *Chama lazarus* bei Linné.

Tafel 47: A1 *Venus literata* bei Linné. B *Venus chione* bei Linné. E3 *Venus dione* bei Linné. F2 *Venus scortum* bei Linné. H *Venus scripta* bei Linné.

Tafel 50: A1 *Pinna nobilis* bei Linné. B1 Wahrscheinlich *Chama gigas* bei Linné; vgl. Dezallier d'Argenville 1742 **Tafel 26** Figur E. F3 *Mytilus ruber* bei Linné.

Tafel 51: C1 *Arca granosa* bei Linné. E2 *Cardium cardissa* bei Linné, Venusherz (Linné: Cor veneris). F *Chama hippopus* bei Linné.

Tafel 55: A3 *Ostrea plica* bei Linné. D *Ostrea nodosa* bei Linné. E1 *Ostrea pleuronectes* bei Linné. B1 *Solen vagina* bei Linné. B2 *Solen siliqua* bei Linné. L *Solen ensis* bei Linné.

Tafel 57: F1 *Echinus mamillatus* bei Linné. F2 *Echinus cidaris* bei Linné.

Tafel 59: A *Lepas tintinabulum* bei Linné. B1 *Lepas Mitella* bei Linné.

La désignation des espèces chez Dezallier d'Argenville et Carl von Linné

Rainer Willmann

Historique de la nomenclature des espèces

A l'époque de Dezallier, des plantes et des animaux apportés du monde entier étaient rassemblés en Europe, éveillant l'intérêt des amateurs éclairés et des scientifiques, pour des raisons d'ordre esthétique ou parce que ceux-ci étaient curieux d'apprendre. Dezallier d'Argenville représenta de nombreuses espèces qui n'avaient jamais été mentionnées et décrites dans les œuvres publiées jusque-là. En même temps, son ouvrage de 1742 ou de 1757 paraît à une époque où il n'existe pas encore de nomination scientifique unitaire et universellement valable des espèces animales et végétales.

Aujourd'hui, cette désignation spécifique est composée de deux termes, le nom du genre et un second nom ou épithète précisant l'espèce à l'intérieur du genre. De telles désignations étaient déjà utilisées sporadiquement par Carl von Linné, mais il a fallu attendre son inventaire complet de tous les organismes connus de lui dans la dixième édition de sa *Systema Naturae* (1753 pour les plantes, 1758 pour les animaux) pour que cette forme de nomination spécifique soit reconnue et ait finalement presque force de loi. De nos jours, il faut décrire les nouvelles espèces en respectant ces données, c'est-à-dire que leur nom doit être composé de deux termes latins, grecs ou latinisés et grécisés.

Cette combinaison est dite binominale ou binaire. Pour exclure toute confusion, le nom spécifique est suivi du nom de l'auteur de la première description de la plante ou de l'animal et de l'année de publication. Le nom scientifique complet de la moule commune est ainsi *Mytilus edulis* Linné, 1758.

Sans les nombreux ouvrages traitant de la diversité organismique écrits par d'autres auteurs, Linné n'aurait jamais pu mettre au point cette sorte d'inventaire des espèces animales et végétales connues à l'époque. Pour mesurer l'importance de l'ouvrage de Dezallier d'Argenville il faut se représenter la démarche de Linné. Après les avoir classées par groupes d'organismes, il fait la liste d'une espèce après l'autre, donnant à chacune un nom binominal et en faisant une courte description.

Il ne pouvait évidemment pas étudier lui-même toutes les espèces qu'il décrit dans la *Systema naturae* même s'il en connaissait beaucoup pour les avoir vues et même s'il envoyait ses élèves dans toutes les parties du monde pour qu'ils lui rapportent des organismes inconnus. Il avait vu la plupart d'entre eux dans des livres : il exploitait d'innombrables publications et les citait en nommant chaque espèce, si bien que l'on pouvait voir d'où il tirait ses connaissances. Cela permettait aussi de se faire une idée de l'apparence des espèces répertoriées par Linné. Son ouvrage ne comporte en effet aucune illustration, contrairement à ses ouvrages de référence qui contenaient souvent des représentations magnifiques de plantes et d'animaux de tous les pays.

La singularité de l'ouvrage de Dezallier d'Argenville réside dans le fait qu'il est consacré exclusivement aux conchyles, des animaux pourvus d'une coquille dure. Dezallier d'Argenville étant un spécialiste en ce domaine, Linné eut l'avantage de disposer d'un ouvrage en lequel il pouvait se fier à de nombreux points de vue, car les mollusques terrestres et marins, avec ou sans coquille, y étaient déjà minutieusement regroupés. Ainsi le travail préparatoire de Dezallier d'Argenville – la qualité de ses illustrations est l'un de ses points forts, à côté de la multitude d'espèces représentées – transparaît sans cesse dans l'œuvre de Linné.

Celui-ci ne pouvait pas savoir que des formes très semblables peuvent appartenir à des espèces différentes. Lorsqu'il répertoriait une espèce, la décrivait et renvoyait aux ouvrages publiés, cette espèce en dissimulait peut-être en réalité plusieurs.

Une espèce biologique n'est pas quelque chose qui se laisse facilement différencier d'autres espèces, il s'agit au contraire d'un groupe de populations naturelles interfécondes génétiquement isolées d'autres groupes équivalents. Cet isolement – qu'il ne faut pas confondre avec la séparation spatiale – est maintenu par des mécanismes ancrés dans l'organisme lui-même, par exemple une parade nuptiale différente qui exclut l'accouplement, l'incompatibilité des organes de reproduction, l'incompatibilité des gamètes mâles et femelles qui fait qu'un embryon ne se développe pas, ou la stérilité des hybrides – si le croisement a été possible.

Ce qui cause cet isolement n'est donc pas forcément reconnaissable chez l'animal, certaines espèces ont d'ailleurs pratiquement le même aspect. D'un autre côté, et ceci ne se voit pas non plus, il n'existe pas deux individus qui soient parfaitement semblables. Les espèces sont donc variables et plus deux populations d'une seule et même espèce sont séparées, plus les différences sont importantes en général. Rien d'étonnant donc si, au début des recherches concernant les espèces biologiques, les naturalistes aient pu commettre des erreurs en essayant de classer de nombreux individus. Ce qui s'applique, on le conçoit facilement, au travail pionnier de Linné. Il incomba aux auteurs ultérieurs de mettre de l'ordre dans ces classifications spécifiques. A mesure que les connaissances s'approfondissaient, on relisait sans cesse les anciens ouvrages, pour voir s'ils contenaient des renseignements sur des espèces dont on ignorait l'existence au départ.

De nombreuses désignations utilisées par Linné ont été modifiées entretemps, l'une des raisons étant qu'il a introduit relativement peu de noms de genres. Plus la connaissance de la richesse des espèces s'approfondissait, plus il était important de les différencier exactement, ce qui a amené l'introduction d'autres noms génériques. Les nombreuses espèces que Linné nommait *Ostrea* (huître) en 1758 sont aujourd'hui réparties en de nombreux genres, par exemple *Pteria, Malleus, Pecten* et *Chlamys*.

Aujourd'hui, chaque fois qu'une espèce est attachée à un autre nom générique que celui qu'avait décrit le premier auteur, le nom de celui-ci est placé entre parenthèses.

Il peut arriver aussi que certaines espèces aient été décrites et nommées par différents auteurs. Tous ces noms scientifiques sont des synonymes dont un seul est valable et, à quelques exceptions près, c'est celui qui a été le premier publié.

Noms vernaculaires

De nombreux coquillages, gastéropodes, scaphopodes et échinodermes possèdent depuis longtemps un nom commun dans diverses langues. De tels noms existent en général quand les espèces sont bien connues dans l'aire linguistique correspondante, par exemple à cause de leur importance économique – c'est le cas de la coque ou de l'huître. Mais l'ouvrage de Dezallier d'Argenville offre la particularité d'avoir représenté des animaux exotiques pour lesquels il n'existait évidemment pas de désignation anglaise, française, allemande ou italienne. Des noms communs artificiels ont alors souvent été introduits, et dans certains recueils anglophones présentant des mollus-

ques, on a créé de manière presque compulsive des noms communs, qu'ils aient un sens ou non, pour désigner toutes les formes illustrées. Dans certains cas ces noms proviennent de collectionneurs qui avaient publié un recueil illustré sur les gastéropodes.

Aucun nom commun n'est cité – ou créé – dans le présent ouvrage au cas où un nom français ou allemand établi n'existerait pas. Celui qui s'intéresse sérieusement à la malacologie prend tout naturellement en considération le nom scientifique des mollusques, le seul à permettre une compréhension, une communication claire, et ce particulièrement sur le plan international.

Il ne faut pas oublier que nombre de collectionneurs amateurs engagés ont aujourd'hui des contacts au-delà des frontières de leur pays, échangent des informations et des trouvailles et qu'ils contribuent même très souvent à élargir nos connaissances sur la diversité des espèces ou le mode de vie des mollusques. Les frontières entres les scientifiques et les malacologues passionnés s'estompent dans de nombreux domaines. Pour que le gain retiré de l'étude des beautés formelles de la nature soit réciproque, l'utilisation de noms spécifiques clairs est absolument nécessaire.

Les noms actuels des espèces les plus connues devaient être mentionnés dans cette nouvelle publication de la *Conchyliologie* de Dezallier d'Argenville et nous y sommes parvenus dans de nombreux cas. L'identité peut être souvent fournie ou cernée avec une certaine plausibilité, une détermination plus poussée n'étant pas toujours possible pour des raisons de temps. S'il a été rapidement possible de mettre un nom sur les espèces caractéristiques, plus d'une forme remarquable s'est avérée impossible à identifier et il est arrivé que de longues recherches nous amènent à constater qu'une illustration était impossible à déterminer. Souvent les illustrations ne sont pas assez explicites pour que l'on puisse être sûr de l'identité des espèces. Elles sont souvent mêmes si imprécises qu'il est préférable de renoncer à la tentative de détermination.

D'un autre côté, il y a beaucoup d'illustrations probablement très précises qu'il est très difficile de déterminer, il serait donc intéressant de faire des recherches pour aller au fond des choses et identifier les formes représentées. Certains mollusques terrestres et aquatiques que nous contemplons sur les planches de Dezallier d'Argenville pourraient encore dissimuler bien des surprises sur le plan scientifique.

La *Conchyliologie* en tant que source de la dixième édition du *Système de la nature* (*Systema naturae*, 1758) de Carl Linné

En faisant l'inventaire des espèces connues à son époque pour les intégrer dans son *Systema naturae* de 1758, Linné a examiné une multitude d'ouvrages. Il s'est référé, entre autres, à celui réalisé en 1742 par d'Argenville et aux nombreux spécimens qui y sont représentés. Nombre de ces spécimens de référence ont aussi été repris dans l'édition ultérieure de la *Conchyliologie* de d'Argenville. Linné s'étant contenté de nommer et de décrire les espèces sans les représenter, cette nouvelle édition les rend aussi accessibles visuellement à un cercle d'intéressés plus large.

Le lecteur trouvera ci-dessous une liste des spécimens que Linné a choisis comme spécimens de référence, tels qu'ils se trouvent dans la *Conchyliologie* de 1780. La planche et le numéro de l'illustration sont indiqués, suivis du nom scientifique utilisé par Linné en 1758. Il faut souligner qu'il ne s'agit ici toujours que de l'un de plusieurs spécimens de référence auxquels Linné s'est référé car, dans le *Systema naturae*, il indiquait aussi à propos de chaque espèce ses références bibliographiques.

Il faut aussi faire remarquer – voir le chapitre sur la genèse de la nomenclature actuelle des espèces – que de nombreux noms choisis par Linné ont été modifiés. Exemple : la planche 9 A2–A3 représente *Turbo radiatus* Gmelin, 1791 ; Linné avait nommé ce spécimen *Turbo chrysostomus*.

PLANCHE 1 : Q1 *Patella testudinaria* chez Linné.
PLANCHE 4 : B4 Probablement un spécimen de référence de *Patella equestris* chez Linné, cf. Dezallier d'Argenville 1742, PLANCHE 6, figure K.
PLANCHE 5 : A1 *Haliotis marmorata* chez Linné. A4 *Haliotis asinina* chez Linné. H *Dentalium elephantinum* chez Linné. K *Dentalium entalis* chez Linné.
PLANCHE 6 : A2 *Tubipora musica* chez Linné. E1 *Serpula glomerata* chez Linné. P *Serpula anguina* chez Linné.
PLANCHE 7 : A2 *Argonauta argo* chez Linné. D2 *Nautilus pompilius* chez Linné.
PLANCHE 9 : A2, A3 *Turbo chrysostomus* chez Linné. A4 *Turbo cochlus* chez Linné. D3 *Turbo petholatus* chez Linné. H *Turbo delphinus* chez Linné. L *Trochus labio* chez Linné.

PLANCHE 10 : C *Nerita chamaeleon* chez Linné. K *Nerita albume* chez Linné. S *Nerita polita* chez Linné.
PLANCHE 12 : A *Turbo pagodus* chez Linné. B2 *Trochus maculatus* chez Linné. K *Architectonica perspectiva* (L., 1758). *Trochus perspectivus* chez Linné.
PLANCHE 14 : A3 *Conus imperialis* chez Linné. B1 *Conus ebraeus* chez Linné. E4 *Conus marmoreus* chez Linné. G2 *Conus rusticus* chez Linné. I1 *Conus litteratus* chez Linné.
PLANCHE 19 : L1 *Conus geographus* chez Linné. M2 *Conus tulipa* chez Linné. N *Conus striatus* chez Linné. P *Conus nussatella* chez Linné. Q *Voluta oliva* chez Linné.
PLANCHE 22 : A4 *Strombus lambis* chez Linné. B *Strombus scorpius* chez Linné. D2 *Strombus pes pelecani* chez Linné.
PLANCHE 24 : C3 *Murex ceramicus* chez Linné. D *Buccinum plicatum* chez Linné. E2 *Murex melongena* chez Linné. I *Phalium areola* (L., 1758). *Buccinum areola* chez Linné.
PLANCHE 27 : A1 *Buccinum perdix* chez Linné. C1 *Buccinumn dolium* chez Linné. D2 *Buccinum perscum* chez Linné. D4 *Buccinum patulum* chez Linné. F1 *Bulla physis* chez Linné. G *Buccinum pomum* chez Linné. N *Buccinum crenulatum* chez Linné.
PLANCHE 29 : A3 *Cypraea mappa* chez Linné. B2 *Cypraea argus* chez Linné. K *Cypraea moneta* chez Linné. P *Cypraea asellus* chez Linné. Y *Cypraea stolida* chez Linné.
PLANCHE 34 : A3 *Murex femorale* chez Linné. B3 *Murex fusus* chez Linné. H *Murex trapezium* chez Linné. L *Murex tulipa* chez Linné. L2 *Murex syracusanus* chez Linné.
PLANCHE 36 : E2 *Murex saxatilis* chez Linné. G3 *Murex scorpio* chez Linné. G4 *Murex ramosus* chez Linné.
PLANCHE 38 : A1 *Murex haustellum* chez Linné.
PLANCHE 39 : B *Trochus telescopium* chez Linné. D *Turbo duplicatus* chez Linné. E *Turbo terebra* chez Linné. H *Murex aluco* chez Linné. K *Murex granulatus* chez Linné. R Probablement *Buccinum strigilatum* chez Linné ; cf. Dezallier d'Argenville 1742, PLANCHE 14, figure R.
PLANCHE 41 : B *Anomia ephippium* chez Linné. E1 *Pinctada? Mytiolus margaritiferus* chez Linné.
PLANCHE 42 : A1 *Ostrea malleus* chez Linné.
PLANCHE 43 : E *Spondylus regius* chez Linné. B2 *Chama lazarus* chez Linné.
PLANCHE 47 : A1 *Venus literata* chez Linné. B *Venus chione* chez Linné. E3 *Venus dione* chez Linné. F2 *Venus scortum* chez Linné. H *Venus scripta* chez Linné.
PLANCHE 50 : A1 *Pinna nobilis* chez Linné. B1 Probablement *Chama gigas* chez Linné ; cf. Dezallier d'Argenville 1742, PLANCHE 26, figure E. F3 *Mytilus ruber* chez Linné.
PLANCHE 51 : C1 *Arca granosa* chez Linné. E2 *Cardium cardissa* chez Linné, Bucarde cœur-de-Vénus (Linné : Cor veneris). F *Chama hippopus* chez Linné.
PLANCHE 55 : A3 *Ostrea plica* chez Linné. D *Ostrea nodosa* chez Linné. E1 *Ostrea pleuronectes* chez Linné. B1 *Solen vagina* chez Linné. B2 *Solen siliqua* chez Linné. L *Solen ensis* chez Linné.
PLANCHE 57 : F1 *Echinus mamillatus* chez Linné. F2 *Echinus cidaris* chez Linné.
PLANCHE 59 : A *Lepas tintinabulum* chez Linné. B1 *Lepas Mitella* chez Linné.

Main works of
Antoine-Joseph Dezallier d'Argenville

La Theorie et la pratique du jardinage. Ou l'on traite à fond des beaux jardins appellés communément les jardins de propreté, comme sont les parterres, les bosquets, les boulingrins, &c. Contenant plusieurs plans et dispositions generales de jardins; nouveaux desseins...& autres ornemens servant à la décoration & embélissement des jardins. Avec la manière de dresser un terrain. Paris, 1709.

*L'Histoire naturelle éclaircie dans deux de ses parties principales. La Lithologie et la Conchiliologie, dont l'une traite des pierres et l'autre des coquillages, ouvrage dans lequel on trouve une Nouvelle méthode & une notice critique des principaux Auteurs qui ont écrit sur ces matières. Enrichi de Figures dessinées d'après Nature. Par M*** de la Societé Royale des Sciences de Montpellier.* Paris, 1742.

*Abregé de la vie des plus fameux peintres, avec leurs portraits gravés en taille-douce, les indications de leurs principaux ouvrages, quelques réflexions sur leurs caractères, et la maniere de connoître les desseins des grands maîtres. Par M*** de l'Académie royale des sciences de Montpellier....* 3 vols. Paris, 1745–1752.

Enumerationis fossilium, quae in omnibus Galliae provinciis reperiuntur, tentamina, auctore A. J. D. Dargenville.... Paris, 1751.

*L'Histoire naturelle éclaircie dans une de ses parties principales, l'oryctologie, qui traite des terres, des pierres, des métaux, des minéraux et autres fossiles... Par M.***...* Paris, 1755.

*L'Histoire naturelle éclaircie dans une de ses parties principales, la conchyliologie, qui traite des coquillages de mer, de rivière et de terre... augmenté de la zoomorphose, ou représentation des animaux à coquilles... Nouvelle édition... Par M***....* Paris, 1757.

La Conchyliologie, ou Histoire naturelle des coquilles de mer, d'eau douce, terrestres et fossiles, avec un traité de la zoomorphose, ou représentation des animaux qui les habitent... Par M. Dézallier d'Argenville,... 3e édition dédiée au roi par MM. de Favanne de Montcervelle père et fils. Paris, 1780.

Resources

ADANSON, M.: *Histoire naturelle du Senegal: Coquillages, avec des figures.* Paris, 1757.

ALDROVANDI, U.: *De reliquis animalibus exsanguinibus libri quatuor, post mortem ejus editi: nempe de Mollibus, Crustaceis, Testaceis et Zoophytis.* Bologna, 1606.

BALDASSINI, F.: *Elementi di Coachiologia linneiana illustrati da XXVIII tavole in rame del sig. E. I. Burrow A. M. membro della Soc. Linn., della Società Reale e della Soc. Geologica di Londra. Opera volgarizzata sulla seconda edizione inglese dal nobile signor marchese Francesco Baldassini da pesaro coll'aggiunta di copiose ed erudite note.* Milan, 1828.

BELON, P.: *De aquatilibus, Libri duo: Cum eiconibus ad vivam ipsorum effigiem, quoad eius fieri potuit, expressis. Ad amplissimum Cardinalem Castillionaeum.* Paris, 1553.

BESLER, M. R.: *Gazophylacium rerum naturalium e regno vegetabili, animali et minerali.* Leipzig, 1642.

BORN, I. VON [VON BORNEDLER, I.]: *Testacea Musei Caesarei Vindobonensis quae jussu Mariae Theresiae Augustae disposuit et descripsit Ignatius a Born, equ. S. Caes. Reg. Apost. Majest. In re monetaria et metallica a consiliis aulicis. Academ. Scient. Imp. Nat. Curios. Petropolit. Londinens. Holmens. Göttingens. Tolosan. Upsaliens. Sienens. Monacensis &c. sodalis.* Vienna, 1780.

BROCCHI, G. B.: *Conchiologia fossile subappennina.* Milan, 1814.

BROOKES, S.: *An Introduction to the study of Conchology: including observations on the Linnaean Genera, and on the arrangement of M. Lamarck; a glossary and tables of English names. Illustrated with coloured plates.* London, 1815.

BRUGUIÈRE, J.-G.: *Tableau encyclopédique et méthodique des trois règnes de la nature....* Paris, 1791.

BUONANNI, F.: *Musaeum Kircherianum sive Museum a P. Athanasio Kirchero In Collegio Romano Societatis Jesu.* Rome, 1709.

——: *«Pars secunda seu Supplementum Recreationis Mentis et Oculi in observatione Testaceorum quorum aliqua exprimuntur non antea in lucem edita», in Observationes circa viventia, quae on rebus non viventibus reperiuntur. Cum Micrographia curiosa sive Rerum minutissimarum Observationibus, quae ope Microscopij recognitae ad vivuum exprimuntur. His accesserunt aliquot Animalium tetsceorum Icones non antea in lucem editae. Omnia Curiosorum Naturae Exploratorum Utilitati & Iucunditati expressa & oblata. Illustrissimo Domina D. Leoni Strozzae excellentissimi Ducis Strozzae filio. A Patre Philippo Bonanni Societ. Iesu sacerdote.* Rome, 1691.

——: *Ricreatione dell'occhio e della mente nell'Observation' delle Chiocciole, proposta a' Curiosi delle Opere della Natura dal P. Filippo Buonanni della Compagnia di Giesù. Con quattrocento, e cinquanta figure di Testacei diversi, sopra cui si spiegano molti curiosi problemi.* Rome, 1681.

CERUTI, B., CHIOCCO, A.: *Musaeum Francisci Calceolarij junioris.* Verona, 1622.

COLONNA, F.: *Minus cognitarium Stirpium ac etiam rariorum nostro coelo orientium Stirpium Ekfrasis... Item de Aquatilibus aliisque animalibus quibusdam libellu.* Rome, 1606.

——: *Minus cognitarium stirpium pars altera.* Rome, 1616.

——, MAJOR, J. D.: *Opusculum de purpura.* Kiel, 1675.

DAVILA, P. F.: *Catalogue systématique et raisonné des curiosités de la nature et de l'art, qui composent le Cabinet de M. Davila, avec figures en taille douce, de plusieurs morceaux qui n'avoient point encore été gravés. Tome premier.* Paris, 1767.

FAVART D'HERBIGNY, C.-É. Abbé: *Dictionnaire d'Histoire Naturelle, qui concerne les Testacées ou les Coquillages de Mer, de Terre & d'Eau-douce. Avec la Nomenclature, la Zoomorphose, & les différens systêmes des plusieurs célèbres Naturalistes anciens & modernes.* Paris, 1775.

GEOFROY, E.-L.: *Traité sommaire des coquilles, tant fluviatiles que terrestres, qui se trouvent aux environs de Paris.* Paris, 1767.

GERSAINT, E. F.: *Catalogue raisonné d'une collection considérable de diverses Curiosités en tous genres, contenuës dans le Cabinets de feu Monsieur Bonnier de la Mosson.* Paris, 1744.

GESSNER, K.: *Historiae Animalium: Liber III qui est de Piscium & Aquatilium animantium natura. Cum iconibus singulorum ad vivum expressis fere omnib. DCCVI. Continentur in hoc Volumine, Gulielmi Rondelerii quoq., medicine professoris Regij in Schola Monspeliensi, et Petri Bellonii Cenomani, medici hoc tempore Lutetiae eximij, de Aquatilium singulis scripta. Ad invictissimum Principem, Divuum Ferdinandum Iperatorem semper Augustum, &c.* Zurich, 1558.

GEVE, G.: *Amusemens de tous le mois.* Hamburg, 1755.

GIOVIO, P.: *De Romanis piscibus libellus.* Rome, 1524.

GUALTIERI, N.: *Index Testarum Conchyliorum quae adservantur in Museo Nicolai Gualtieri philosophi et medici collegiati florentini Regiae botanices florentinae Academiae socii in pisano Athenaeo medicinae professoris emeriti, et methodice distributae exhibentur tabulis CX.* Florence, 1742.

IMPERATO, F.: *Dell'historia naturale di Ferrante Imperato napolitano libri XXVIII, nella quale minutamente si tratta della diversa condition di miniere, e pietre. Con alcune historie di Piante, & Animali; fin'hora non date in luce.* Naples, 1599.

KNORR, G. W.: *Les Delices des Yeux & de l'Esprit, ou collection générale de differentes espèces de Coquillages que la Mer renferme.* 2 vols. Nuremberg, 1764–1773.

——: *Delices physiques choisies, ou choix de tout ce que les trois regnes de la Nature renferment de plus digne des recherches d'un amateur curieux, pour en former un Cabinet choisi de curiositez naturelles, ouvrage communique cy-devant au public par George Wolfgang Knorr celebre artiste de Nuremberg continue par ses heritiers avec les descriptions et remarques de Philippe Louis Stace Müller professeur public ordinaire en Philosophie à l'Université d'Erlang et traduit en français par Mathieu Verdier de la Blaquiere, Conseiller à la Chambre Provinciale de Bayreuth.* Nuremberg, 1766.

LAMARCK, J.-B.-P. de Monet de: *Système des Animaux sans vertèbres, ou Tableau général des classes, des ordres et des genres de ces animaux; présentant leurs caractères essentiels et leur distribution d'après les considérations de leurs rapports naturels et de leur organisation, et suivant l'arrangement établi dans les galeries du Muséum d'Histoire naturelle, parmi leurs dépouilles conservées.* Paris, 1801.

LANGE, C.-N.: *Methodus Nova et Facilis Testacea Marina Pleraque, quae huc usque nobis nota sunt, un suas debitas et distinctas Classes, genera, et species distribuendi....* Lucerne, 1722.

LEERS, A.: *Catalogue systematique d'un magnifique Cabinet de très-belles Coquillages & crustacés....* Amsterdam, 1767.

LEGATI, L.: *Museo Cospiano annesso a quello del famoso Ulisse Aldrovandi e donato alla sua patria dall'illustrissimo signor Ferdinando Cospi.* Bologna, 1677.

LINNAEUS, C.: *Sistema Naturae per regna tria naturae secundum classes, ordines, genera, species.* Leiden, 1735.

LISTER, M.: *Historiae Conchyliorum.* London, 1685–1692.

MARSILI, A. F.: *Relazione del ritrovamento dell'uova di chiocciole in una lettera al sig. Marcello Malpighi.* Bologna, 1683.

MARTINI, F. H. W., CHEMNITZ, J. H.: *Neues systematisches Conchylien-Cabinet.* Nuremberg, 1769–1786.

MARTYN, T.: *The Universal conchologist: exhibiting the figure of every known shell accurately drawn and painted after nature, with a new systematic arrangement.* London, 1784.

MATTIOLI, P. A.: *Commentarii in sex libros Pedacii Dioscoridis Anazarbei de medica materia, iam denuo ad ipso autore recogniti, et locis plus mille aucti. Adiectis magnis ac novis plantarum, ac animalium iconibus.* Venice, 1565.

MENDEZ DA COSTA, E.: *Elements of Conchology: or An Introduction to the Knowledge of Shells. By Emanuel Mendes da Costa, Member of the Academia Caesar. Imper. Nat. curios. Plinius IV and of the Botanic Society of Florence. With seven plates, Containing Figures of every Genus of Shells.* London, 1776.

MERCATI, M.: *Metallotheca Opus Posthumum, Auctoritate, et Munificentia Clementis Undecimi Pontifici Maximi e tenebris in lucem eductum; Opera autem, et studio Johannis Mariae Lancisii archiatri Pontificii illustratum.* Rome, 1717.

MOLL, J. P. C. von: *Testacea Microscopica aliaque minuta ex generibus Argonauta et Nautilus ad naturam delineata et descripta a Leopoldo Fichtel et Jo. Paulo Carolo a Moll. Cum 24 tabulis Aeri incisis.* Vienna, 1803.

MONTAGU, G.: *Testacea Britannica or Natural History of British Shells, Marine, Land, and Fresh-Water, including the most minute: systematically arranged and embellished with figures.* London, 1803–1808.

MOSCARDO, L.: *Note overo memorie del Museo di L. M. nobile veronese Academico Filarmonico, dal medesimo descritte e in tre libri distinte.* Padua, 1656.

MURRAY, A.: *«Fundamenta Testaceologiae. Praeside D. D. Carl v. Linné propo-*

sita ad Auctore Adolpho Murray Stockholmiensi Prosect. vic. ad Theat. Anat. Holm. Upsaliae 1771. Junii 29», in *Caroli a Linné, Amoenitates Academicae seu Dissertationes variae physicae, medicae, botanicae, antehac seorsim editae nunc collectae et auctae cum tabulis aeneis.* Vol. VIII, Erlangen, 1785.

OLIVI, G. B.: *De Reconditis et praecipuis collectaneis, ab honestissimo... Francisco Calceolario... in musaeo adservatis.* Venice, 1584.

[OUDAAN, M.]: *Catalogue systematique d'une superbe & nombreuse Collection de coquillages en partie très-rare & perfaitement beaux; de coraux, madrepores, et lithophytes; ... le tout rassemblé avec beaucoup de jugement & à grand fraix par le feu Sieur Oudaan c. Collection qui sera vendue publiquement dans la maison du Défunt sur le Nieuwe Haven à Rotterdam, à commencer depuis le 18 Novembre 1766 par le Libraires J. Bosch, J. Burgulier et R. Arrenberg, qui distribuisent le present Catalogue.* Rotterdam, 1766.

PENNANT, T.: *British Zoology. Crustacea, Mollusca, Testacea.* Vol. IV, London, 1777.

PERRY, G.: *Conchology, or the Natural history of shells, containing a new arrangement of the genera and species....* London, 1811.

PETIVER, J.: *Aquatilium animalium Amboinae, etc., icones et nomina.* London, 1713.

PLANCUS JANUS [BIANCHI, G.]: *Ariminansis de Conchis minus notis Liber cui accessit specimen aestus reciproci Maris superi ad littus portumque Arimini.* Venice, 1739.

POLI, G. S.: *Testacea utriusque Siciliae eorumque historia et anatome tabulis aeneis illustrata.* Parma, 1791–1795.

RÉAUMUR, R. A. F. de: in *Memorie appartenenti alla storia naturale della Real Accademia delle scienze di Parigi recate in italiana favella.* Vol. V, class II., Venice, 1749.

REDI, F.: *Esperienze intorno alla generazione degl'insetti. Osservazioni intorno agli animali viventi che si trovano negli animali viventi. Esperienze intorno a diverse cose naturali e particolarmente a quelle che ci son portate dall'Indie al rev.mo padre Atanasio Chircher.* Naples, 1687.

REGENFUSS, F. M.: *Choix de coquillages et de crustacés peint d'après nature gravés en taille douce et illuminés de leurs vraïes couleurs par François Michel Regenfuss graveur du Roi. Publié par ordre du Roi.* Copenhagen, 1758.

REMY, P.: *Catalogue raisonné des tableaux, desseins, estampes, bronzes, terres cuites, laques, porcelaines, ..., madrépores, coquilles et autres curiosités... qui composent le cabinet de feu M. Boucher... (Vente au Vieux Louvre, le 18 février 1771).* Paris, 1771.

RONDELET, G.: *Libri de Piscibus Marinis, in quibus verae Piscium effigies expressae sunt. Quae in tota Piscium historia contineantur, indicat Elenchus pagina nona et deci-*

ma. Postremo accesserunt Indices necessarij. Lyons, 1554.

——: *Universae aquatilum Historiae pars altera, cum veris ipsorum Imaginibus. His accesserunt Indices necessarij.* Lyons, 1555.

RUMPF, G. E.: *Thesaurus imaginum Piscium Testaceorum; quales sunt Cancri, Echini, Echinometra, Stellae Marinae, &c. Ut & Cochlearum; ... quibus accedunt Conchylia, ... Conchae Univalviae & Bivalviae; ... Denique Mineralia ...* Leiden, 1709.

RUYSCH, F.: *Thesaurum Animalium primus. Cum figuris aeneis.* Amsterdam, 1710.

SALVIANI, H.: *Aquatilium animalium historia, liber primus, cum eorundem formis, aere excussis.* Rome, 1558.

SCILLA, A.: *La vana speculazione disingannata dal senso. Lettera responsiva Circa i Corpi Marini, che Pietrificati si trovano in varij luoghi terrestri. Di Agostino Scilla pittore Accademico della Fucina, detto lo Scolorito. Dedicata all'Illustrissimo signore, il Signor D. Carlo Gregori Marchese di Poggio Gregorio, Cavaliero della Stella.* Naples, 1670.

SEBA, A.: *Locupletissimi rerum naturalium Thesauri accurata descriptio et iconibus artificiosissimis expressio per universam physices historiam.* 4 vols., Amsterdam, 1734–1765.

SLOANE, H.: *Voyage to the islands Madera, Barbados, Nieves, S. Christophers and Jamaica with the natural history of the herbs and trees, four-footed beasts, fishes, birds, insects, reptiles, etc. of the last of those islands... illustrated with the figures of the things describ'd.* 2 vols., London, 1707–1725.

TERZAGO, P. M.: *Musaeum Septalianum Manfredi Septalae patrii mediolanensis industrioso labore constructum... descriptum.* Tortona, 1664.

WOOD, W.: *General Conchology; or a description of Shells, arranged according to the Linnean System, and Illustrated with Plates, Drawn and Coloured from Nature.* Vol. I, London, 1815.

WORM, O.: *Museum Wormianum seu historia rerum rariorum, tam naturalium, quam artificialium, tam domesticarum, quam exoticarum, quae Hafniae Danorum in aedibus authoris servantur.* Leiden, 1655.

Selected bibliography

ALEXANDRE, S.: «Les livres de coquillages aux temps modernes: reflets de la conchyliophylie et de la conchyliologie», *Art and Fact* 12 (1993), pp. 90–107.

——: «Raretés d'Amboine et des Antilles: Impact culturel du coquillage tropical dans la Néerlande au XVIIᵉ siècle», *Art and Fact* 9 (1990), pp. 76–90.

BARTEN, S. (ed.): *Die Muschel in der Kunst: von der Renaissance bis zur Gegenwart.* Exhibition catalogue. Zurich, 1985.

BASSO PERESSUT, L.: *Stanze della meraviglia: i musei della natura tra storia e progetto.* Bologna, 1997.

PINAULT SØRENSEN, M.: «Dézallier d'Argenville, l'Encyclopédie et la Conchy-

CARPITA, V.: «Agostino Scilla (1629-1700) e Pietro Santi Bartoli (1635-1700): il metodo scientifico applicato allo studio dei fossili e la sua trasmissione ai siti e monumenti antichi», *Atti della Accademia Nazionale dei Lincei: Rendiconti della Classe di Scienze morali, storiche e filologiche* 17 (2006), pp. 307–384.

COOMANS, H. E.: «Conchology before Linnaeus», in *The origins of Museums: the cabinet of curiosities in sixteenth and seventeenth century Europe.* Edited by O. Impey, A. Macgregor. Oxford, 1985, pp. 188–192.

COX, J. A.: *Les coquillages dans la nature et dans l'art.* Paris, 1979.

DANCE, S. P.: *A History of Shell Collecting.* Leiden, 1986.

FINDLEN, P.: *Possessing nature: museums, collecting, and scientific culture in early modern Italy.* Berkeley, 1996.

HOGENDORP PROSPERETTI, L. Van: «'Conchas legere': Shells as Trophies of Repose in Northern European Humanism», *Art History* 29, 3 (June 2006), pp. 387–413.

JAHN, I. (ed.): *Geschichte der Biologie.* Hamburg, 2002.

LABBÉ, J., BICART-SÉE, L.: *La collection de dessins d'Antoine-Joseph Dezallier d'Argenville reconstituée d'après son «Abrégé de la vie des plus fameux peintres».* 1762 ed., Paris, 1996.

LEONHARD, K.: «Shell collecting: on 17th-century conchology, curiosity cabinets and still life painting», in *Early Modern Zoology: The Construction of Animals in Science, Literature and the Visual Arts.* Edited by K. A. E. Enenkel, P. J. Smith. Leiden, 2007, pp. 177–216.

LUGLI, A.: *Naturalia et mirabilia: Il collezionismo enciclopedico nelle Wunderkammern d'Europa.* 3d ed., Milan, 2005.

MAYR, E.: *The growth of biological thought.* Cambridge, 1982.

MORELLO, N.: «Le 'conchiglie stavaganti' da Cardano a Lister», in *Il Meridione e le scienze (secoli XVI–XIX).* Edited by P. Nastasi. Palermo, 1988, pp. 257–279.

——: *La nascita della paleontologia nel Seicento: Colonna, Stenone e Scilla.* Milan, 1979.

OLMI, G.: *L'inventario del mondo: Catalogazione della natura e luoghi del sapere nella prima età moderna.* Bologna, 1992.

——, TONGIORGI TOMASI, L.: *De piscibus: la bottega artistica di Ulisse Aldrovandi e l'immagine naturalistica.* Rome, 1993.

——, ZANCA, A. (eds.): *Naturacultura: l'interpretazione del mondo fisico nei testi e nelle immagini. Atti del convegno internazionale di studi, Montova, 5–8 Ottobre 1996,* Florence, 2000.

OTTAVIANI, A.: «Il fascino indiscreto delle nature ancipiti: un saggio della »istoria naturale« nei secoli XVII e XVIII», *Giornale critico della filosofia italiana* 20, 2-3 (2000), pp. 316–369.

liologie», *Recherches sur Diderot et l'Encyclopédie* 24, 3 (April 1998), pp. 101–138.

——, SAHUT, M.-C.: «Panaches de mer, lithophytes et coquilles (1769), un tableau d'histoire naturelle par Anne Vallayer Coster», *Revue du Louvre* 1 (1998), pp. 57–70.

PINON L.: *Livres de zoologie de la Renaissance, une anthologie: 1450–1700.* Paris, 1995.

POMIAN, K.: *Collectionneurs, amateurs et curieux. Paris-Venise: XVIᵉ–XVIIIᵉ siècle.* Paris, 1987.

RAPPAPORT, R.: *When geologists were historians, 1665-1750.* London, 1997.

ROSSI, P.: *I segni del tempo: Storia della Terra e storia delle nazioni da Hooke a Vico.* Milan 1979.

SCHAER, R.: *Tous les savoirs du monde: encyclopédies et bibliothèques, de Sumer au XXIe siècle.* Exhibition catalogue, Paris, 1996.

SCHIZZEROTTO, G. et al.: *Il libro naturalistico-malacologico illustrato dal Quattrocento al Settecento.* Exhibition catalogue, Mantua, 1975.

SCHLOSSER, J. VON: *Die Kunst- und Wunderkammern der Spätrenaissance.* 1908, 2d ed. Braunschweig, 1978.

SCHNAPPER, A.: *Le géant, la licorne et la tulipe: histoire et histoire naturelle.* Paris, 1988.

SMITH, R., MITTLER, TH., SMITH, C. (eds.): *History of Entomology.* Palo Alto, 1973.

THOMAS, I.: *Coquillages: De la parure aux arts décoratifs.* Paris, 2007.

TOGNONI, F.: «Nature described: Fabio Colonna and natural history illustration», *Nuncius: Journal of the History of Science* 20, 2 (2005), pp. 347–370.

TONGIORGI TOMASI, L.: «Aspetti e problemi del libro illustrato di soggetto naturalistico nell'Europa del Settecento», in *Gli spazi del libro nell'Europa del XVIII secolo.* Vol. I, Ravenna, 1995, pp. 295–310.

——: «The study of natural sciences and botanical and zoological illustration in Tuscany under the Medicis from the sixteenth to the eighteenth centuries», *Archives of Natural History* 28 (2001), pp. 179–194.

WENDT, H.: *Die Entdeckung der Tiere.* Munich, 1980.

WILLMANN, R.: «Die Erfassung der Artenvielfalt vor Linné», in *Biodiversitätsforschung.* Edited by R. GRADSTEIN, R. WILLMANN, G. ZIZKA. Stuttgart, 2003.

——, RUST, J.: «The Zoology and Botany in Albertus Seba's *Thesaurus*», in *Albertus Seba's Cabinet of Natural Curiosities.* Cologne, 2001, pp. 26–39.

Acknowledgements

This reprint of Antoine-Joseph Dezallier d'Argenville's *La Conchyliologie, ou Histoire naturelle des coquilles de mer, d'eau douce, terrestres et fossiles* is based on a copy in the possession of Claire Cernoia, President of Vasari Rare Books and Prints, Paris (www.vasaribooks.com). We would like to thank her for her full support. Special thanks go to Professor Willmann's assistants Christina Förster, Anna Wulschner and Julian Leander Willmann, for their help. The original volume was digitally reproduced by the Digitalisierungszentrum der Staats- und Universitätsbibliothek Göttingen and our thanks go to Martin Liebetruth at the GDZ for his invaluable collaboration.

The Authors

Veronica Carpita studied art history at the University of Pisa and the Scuola Normale Superiore di Pisa. Her numerous publications focus on the great antiquarian and scientific collections of the early modern era, including Cassiano dal Pozzo's Museo Cartaceo, Nicolas-Claude Fabri de Peiresc's famous cabinet and the first systematic work of conchology, Agostino Scilla's *La vana speculazione disingannata dal senso*, published in Naples in 1670.

Rainer Willmann holds a chair in zoology at Göttingen University, where he is the director of the Zoological Museum. A specialist in phylogenesis and evolution, he also conducts research into biodiversity and its history. He is a co-founder of the Centre for Biodiversity and Ecology Research at Göttingen University.

Sophia Willmann studied biology. She is a specialist in the behaviour of marine organisms. In 2007 she took part in whale research at the Port Elizabeth Museum in Port Elizabeth, South Africa. She is also the author of children's books that focus on biology.

Danksagung

Der vorliegende Nachdruck von Antoine-Joseph Dezallier d'Argenvilles *La Conchyliologie, ou Histoire naturelle des coquilles de mer, d'eau douce, terrestres et fossiles* erfolgte auf Grundlage des Exemplars von Claire Cernoia, President of Vasari Rare Books and Prints, Paris (www.vasaribooks.com). Wir danken ihr für die freundliche Unterstützung. Den Mitarbeitern von Professor Willmann, Christina Förster, Anna Wulschner und Julian Leander Willmann, sei für ihren Einsatz herzlich gedankt. Die digitale Reproduktion des Originals wurde von dem Göttinger Digitalisierungszentrum der Staats- und Universitätsbibliothek Göttingen durchgeführt, und unser Dank geht an Herrn Martin Liebetruth vom GDZ für die gute Zusammenarbeit.

Die Autoren

Veronica Carpita hat Kunstgeschichte an der Universität von Pisa und der Scuola Normale Superiore di Pisa studiert. Im Zentrum ihrer zahlreichen Publikationen stehen die großen antiquarischen und naturwissenschaftlichen Sammlungen der Frühen Neuzeit, etwa das Museo Cartaceo von Cassiano dal Pozzo, das berühmte Kabinett Nicolas-Claude Fabri de Peiresc's sowie das erste systematische Werk der Muschelkunde von Agostino Scilla, *La vana speculazione disingannata dal senso*, Neapel 1670.

Rainer Willmann ist Professor für Zoologie an der Universität Göttingen und Direktor des dortigen Zoologischen Museums. Seine wissenschaftlichen Hauptinteressen liegen in den Bereichen Stammesgeschichtsforschung und Evolution sowie in der Biodiversitätsforschung und ihrer Geschichte. Er ist Mitbegründer des Forschungszentrums für Biodiversitätsforschung und Ökologie an der Universität Göttingen.

Sophia Willmann studierte Biologie. Den Schwerpunkt ihrer Interessen bilden die marinen Organismen und ihr Verhalten. 2007 hat sie an den Untersuchungen über Wale am Port Elizabeth Museum in Port Elizabeth, Südafrika, mitgearbeitet. Sie ist auch Autorin von biologischen Kinderbüchern.

Remerciements

La présente réimpression de *La Conchyliologie, ou Histoire naturelle des coquilles de mer, d'eau douce, terrestres et fossiles* d'Antoine-Joseph Dezallier d'Argenville a été réalisée à partir de l'exemplaire en possession de Claire Cernoia, President of Vasari Rare Books and Prints, Paris (www.vasaribooks.com). Nous la remercions pour son aimable concours. Nous tenons également à remercier pour leur engagement les collaborateurs du professeur Willmann, Christina Förster, Anna Wulschner et Julian Leander Willmann. La numérisation du volume de l'édition originale a été réalisée par le Digitalisierungszentrum de la Bibliothèque Universitaire de Göttingen et nous remercions Martin Liebetruth du GDZ pour son excellente collaboration.

Les auteurs

Veronica Carpita a étudié l'histoire de l'art à l'université de Pise et à l'Ecole normale supérieure de Pise. Ses nombreuses publications se consacrent aux grandes collections scientifiques et d'antiquités du début des Temps modernes, depuis le Museo Cartaceo de Cassiano dal Pozzo jusqu'au célèbre cabinet de curiosités de Nicolas-Claude Fabri de Peiresc, en passant par le premier traité systématique de conchyliologie, *La vana speculazione disingannata dal senso*, publié à Naples en 1670.

Rainer Willmann occupe la chaire de zoologie à l'université de Göttingen, où il est directeur du musée zoologique. Spécialiste de phylogénétique et d'évolution, il mène également des recherches sur la biodiversité et son histoire. Il est enfin le cofondateur du Centre pour la recherche sur la biodiversité et l'écologie de l'université de Göttingen.

Sophia Willmann a étudié la biologie. Cette spécialiste du comportement des organismes marins a pris part en 2007 à une recherche sur les baleines au Port Elizabeth Museum de Port Elizabeth (Afrique du Sud). Elle est aussi l'auteur de livres pour enfants consacrés à la biologie.

Photo Credits

Agenzia Fotografica Scala, Antella, Florence: pp. 7, 27, 31, 32; Araldo De Luca, Rome: p. 36; Bildarchiv der Österreichischen Nationalbibliothek, Vienna: p. 9; Kunsthistorisches Museum, Vienna: p. 35; Museum Boijmans Van Beuningen, Rotterdam, on loan from the Foundation P. en N. de Boer: p. 22; Niedersächsische Staats- und Universitätsbibliothek Göttingen: pp. 10–12, 15, 18; Rheinisches Bildarchiv, Cologne: p. 30; © Studio Fotografico Paolo Tosi, Florence: p. 29; Wadsworth Atheneum Museum of Art, Hartford, CT: p. 25; The Pierpont Morgan Library, New York: p. 21.

Front cover: **Conidae** Cones / Kegelschnecken / Cônes
Back cover: **Gastropoda** Freshwater Snails / Süßwasserschnecken / Coquilles d'eau douce

To stay informed about upcoming TASCHEN titles, please request our magazine at www.taschen.com/magazine or write to TASCHEN, Hohenzollernring 53, D-50672 Cologne, Germany; contact@taschen.com; Fax: +49-221-254919. We will be happy to send you a free copy of our magazine which is filled with information about all of our books.

© 2009 TASCHEN GmbH
Hohenzollernring 53, D-50672 Köln
www.taschen.com

Project managing: Petra Lamers-Schütze, Cologne
Editing: Antonia Reiner-Franklin, Ottawa (Carpita)
Scientific editing of the plate commentaries: Yves Finet, Geneva
English translation: Antonia Reiner-Franklin, Ottawa (Carpita);
Joan Clough, Penzance, England (Willman)
French translation: Isabelle Baraton, Saint-Benoît (Carpita);
Michèle Schreyer, Cologne (Willmann)
German translation: Verena Listl, Rome (Willmann)

Design: Sense/Net, Andy Disl and Birgit Eichwede, Cologne
Production: Ute Wachendorf, Cologne; Elaine Kwok, Hong Kong

Printed in China
ISBN 978-3-8365-1111-7